This book records an important exhibition of late medieval Flemish art in Cambridge collections, held at the Fitzwilliam Museum, Cambridge, from July to September 1993. Included are paintings, sculpture, tapestry and coins from the Fitzwilliam Museum and Queens' College, and illuminated manuscripts, printed books and furniture from Cambridge University Library, from Girton, Gonville & Caius, King's, Peterhouse, St John's, Sidney Sussex and Trinity Colleges, and from the British Library and Holkham Hall. Many of the manuscripts belonged to famous libraries of the Burgundian Netherlands, and all the leading illuminators then active in Flanders are represented. Three panels from Queens' College, recently attributed to the Master of the View of Sainte-Gudule, are perhaps the finest late medieval paintings from Brussels in Britain.

Splendours of Flanders, written by Alain Arnould and Jean Michel Massing, with contributions from Peter Spufford and Mark Blackburn, combines introductory essays and detailed catalogue entries. It is generously illustrated in colour and black-and-white.

SPLENDOURS OF FLANDERS

Splendours of Flanders
has been published to accompany the
exhibition of the same name held at the Fitzwilliam Museum,
Cambridge, from 13 July 1993 to 19 September 1993,
with the support of the Government of Flanders
and of Gemeentekrediet van België /
Crédit Communal de Belgique

SPLENDOURS OF FLANDERS

ALAIN ARNOULD AND
JEAN MICHEL MASSING

with contributions from
PETER SPUFFORD AND
MARK BLACKBURN

Crédit Communal Gemeentekrediet

CAMBRIDGE
UNIVERSITY PRESS

Published by the Press Syndicate of the University of Cambridge
The Pitt Building, Trumpington Street, Cambridge CB2 1RP
40 West 20th Street, New York, NY 10011-4211, USA
10 Stamford Road, Oakleigh, Victoria 3166, Australia

First published 1993

Printed in Great Britain at the University Press, Cambridge

*Catalogue records for this book are available from the British Library
and the
Library of Congress*

ISBN 0 521 44157 9 hardback
ISBN 0 521 44692 9 paperback

CONTENTS

SPLENDOURS OF FLANDERS, A CULTURAL AMBASSADOR TO ENGLAND

As the economic ties binding Europe together steadily gain in strength, the many nations and cultures within Europe vie with one another to assert their separate historical identities. Flanders is now at the heart of Europe, a position which reflects its key historical and cultural role. During the Burgundian period Flanders enjoyed what was in many respects a cultural Golden Age. Flemish painters had a European reputation, Flemish manuscripts, sculpture, textiles and other wares were widely exported, and Flemish artists and craftsmen worked all over Europe, directly influencing local styles of art and architecture.

I am thus delighted that the Fitzwilliam Museum of Cambridge should have organised *Splendours of Flanders*, which serves as a showcase of late medieval Flemish art. The Minister of Culture, Hugo Weckx, and I have decided to appoint this exhibition a Cultural Ambassador of Flanders. This honorary title is reserved for cultural projects and events which advance the reputation of Flanders at the highest level. As a Cultural Ambassador *Splendours of Flanders* will serve three purposes:

> to enhance the international image of Flanders by drawing attention to its cultural heritage;

> to encourage economic interest and activity in Flanders, promoting exports and attracting investment to an area whose cultural values, entrepreneurial spirit and creativity reflect and continue the achievements of the past;

> to focus the attention of both government and business on the importance of culture, and the need for both partners to support cultural activities.

The Government of Flanders has great pleasure in supporting an exhibition which serves these important aims, of which this book serves as a permanent record. It is a happy and more than symbolic coincidence that the official opening of the exhibition should take place on 12 July 1992, the day after the launch of the Flanders–Europe 2002 project, which will usher in the new millennium and, it is to be hoped, a new Golden Age. *Splendours of Flanders* will, I am confident, be a worthy Cultural Ambassador to England.

Luc Van den Brande
Minister-President of the Government of Flanders

A GOLDEN AGE OF FLEMISH ART

Flanders and the Netherlands are often called the Low Countries. And the flat landscape of East Anglia, which extends over the counties of Norfolk and Suffolk to Cambridge, is an overseas continuation of the low-lying region called the Flemish Polders.

This shared landscape lends an element of poetry to the close bonds between England and Flanders, which are reflected in many events in our shared histories.

Flemish knights and soldiers accompanied William the Conqueror to England, and were appointed to important administrative and military offices, as well as being granted land, and making their distinctive cultural contribution. When the counts of Flanders negotiated with the kings of England over the wool trade, they brought with them numerous artists, craftsmen and merchants. The dukes of Burgundy later entered into alliances with England against their French neighbour and enemy. Close diplomatic contacts led to an intimate cultural relationship, and Flemish painters, manuscript illuminators, carvers, tapestry weavers, and other artists and craftsmen came to England.

The Burgundian era was the Golden Age of the Flemish Primitives, when Jan and Hubert Van Eyck, Gerard David, Rogier Van der Weyden, Dieric Bouts, Hans Memling and many others were at the height of their powers. The Burgundian dukes were fervent collectors of illuminated manuscripts, and the production of religious books became a court art. Woodcarvers and sculptors produced beautiful and complex altarpieces, which were embellished with paintings and were used to decorate churches all over Europe. Tapestry from Arras, Tournai and, later, Brussels had an international reputation and Flemish weavers established tapestry workshops in many countries.

The rich and splendid culture of the court of Burgundy reflected the generous and discriminating patronage of the dukes themselves. Indeed for the Low Countries this period represented the zenith of artistic achievement in many fields.

Accurate knowledge of this period in our history is vital if we are properly to understand the complex interchange of influences and the other factors which lay behind this splendid achievement. A proper understanding of these phenomena is important not only for historians of the Middle Ages, but for all those interested in our artistic culture.

As the Flemish Minister for Cultural Affairs I am delighted that the Fitzwilliam Museum in Cambridge should be exhibiting a wide range of late medieval Flemish art of the highest quality. I am very grateful to all those who have contributed to the organisation of the exhibition and this book, and hope that *Splendours of Flanders* will bring much pleasure and enlightenment.

Hugo Weckx
Flemish Minister for Cultural Affairs and Brussels Affairs

A BANK WITH A CULTURAL STRATEGY

Over the past thirty years Gemeentekrediet/Crédit Communal, Belgium's leading bank, has pursued a consistent cultural strategy, whose aim is to encourage knowledge and appreciation of Belgium's urban heritage, in both its historic and artistic aspects. We have encouraged historical research and organised hundreds of exhibitions, some in small towns, others in such splendid locations as the Royal Palace in Brussels. And we have published numerous books on history and art.

Because Belgium's history is so closely involved in the history of Europe and because works of art from Belgium, and above all from Flanders, are widely distributed throughout the world, many of these projects have had an international dimension. We thus welcomed the Fitzwilliam Museum's plan to mount an ambitious exhibition of late medieval Flemish art from Cambridge collections. This important scholarly and artistic event provided the opportunity to develop a new form of collaboration, an exhibition to which the public travels, rather than the works of art. The exhibition is moreover an excellent start to the Flanders 2002 programme of the Flemish Community, in which Gemeentekrediet/Crédit Communal is participating at many levels, and a fitting prologue to the planned year of the Flemish Primitives.

Such an important exhibition deserves a proper record. We are thus delighted that Gemeentekrediet/Crédit Communal and Cambridge University Press have combined to produce this handsome and scholarly book. The bank has enjoyed working with such eminent partners as the Cambridge University Press and the Fitzwilliam Museum. We are grateful to them and their staff, and to Alain Arnould and Jean Michel Massing, the authors of the book; their work will be a source of delight for the British and Belgian public. We hope that *Splendours of Flanders*, set in one of Europe's oldest university cities, will be a contribution to the understanding of the history and culture we all share.

François Narmon
President of the Board of Directors
Gemeentekrediet/Crédit Communal

FLANDERS IN CAMBRIDGE

We do not know when Richard, Viscount Fitzwilliam, acquired the Flemish painting of the *Annunciation* shown in this exhibition; it was at his death ascribed to Dürer. But is clear that in the last decade of his life Fitzwilliam purchased the great majority of the manuscripts which he left to the University of Cambridge in 1816, along with the rest of his collections, 'for the purpose of promoting the Increase of Learning'. No fewer than nine of our Founder's manuscripts are included in this exhibition, which thus echoes an aspect of his mature taste, as well as serving the noble intention of his bequest.

The exhibition, extensively as it draws on the Fitzwilliam Museum's own holdings, is not an in-house affair. Its ambition is to present a conspectus of the remarkable riches of Flemish art to be found in Cambridge. The task we had set ourselves would have proved impossible had our requests for loans not been met with exemplary munificence. Our lenders are detailed in this book, but the large contribution from the Syndics of the University Library deserves special acknowledgement, as do the generous decision of the President and Fellows of Queens' College to lend their remarkable altarpiece panels; and the kindness of Viscount Coke and the Trustees of the Holkham Estate, and the British Library, who have added a signal extra-Cambridge, and in the first case East Anglian, contribution.

It is probable that the Queens' altarpiece was already in England before the Reformation, a reflection of the long historic links between Flanders and East Anglia. Their continued vitality is demonstrated and reinforced by the enlightened action of Gemeentekrediet/Crédit Communal and the Government of Flanders in agreeing to support the exhibition. The Fitzwilliam Museum is deeply grateful to M. Luc Van den Brande, Minister-President of the Government of Flanders, to M. Hugo Weckx, Minister for Cultural Affairs, and to M. François Narmon, President of the Board of Directors of Gemeentekrediet/Crédit Communal. We are also deeply indebted to His Excellency Baron H. Dehennin and the Belgian Embassy in London, and to Mr Peter D. Roscow

of the Belgian-Luxembourg Chamber of Commerce in Great Britain, for their help during the negotiations which led to this happy outcome. Baron Vaes KCMG, M. Alain Camus, the Koning Boudewijnstichting/Foundation Roi Baudouin, Mr Richard Day and Mr Robin Porteous also provided assistance. At Gemeentekrediet/Crédit Communal M. Jean-Marie Duvosquel and M. Joost De Geest gave energetic support to this international development of the bank's cultural policy, now more than thiry years old. M. K. Rogiers of the Government of Flanders and M. F. De Crits of the Ministry for Cultural Affairs were also helpful at every stage. Generous contributions towards our costs have been received from Sidney Sussex College, from the Seminar in the History of the Book, from Professor Anne H. Van Buren, Professor James H. Marrow, Professor Joseph Koerner and Mr Edward Speelman to whom we render thanks.

The Fitzwilliam Museum has long mooted a Flemish show. That the idea has now come to fruition is due to the energy, scholarship and perseverance of Dr Alain Arnould and Dr Jean Michel Massing who in early 1990 presented my predecessor, Professor Michael Jaffé, with a first detailed scheme. The selection of the works and most of the writing of this book has been in their hands. The Museum is heavily in their debt, as it is to their fellow authors, Peter Spufford and Mark Blackburn, and to Cambridge University Press where Rose Shawe-Taylor, Caroline Murray and Frances Brown have seen this book through to production. Sally Jeffery has designed it with her customary care and elegance, as well as contributing to the exhibition's design.

Within the Museum, the brunt of the burden of this exhibition has been sustained by Camilla Boodle, Development Officer, and by Robin Crighton, Keeper of Applied Arts. Fiona Brown, the Museum's Registrar, has been responsible for organisational smooth running, while Andrew Morris and Andrew Norman carried out the necessary photography under severe pressure of time, as did their colleagues at the University Library, Leslie Goodey

and Dudley Simons. To all these and to the many others within and without the Museum, who have assisted in various ways and who are listed below, we are deeply grateful.

Simon Jervis
Director, Fitzwilliam Museum

Acknowledgements. Andries Van den Abeele, Lorne Campbell, Alec Cobbe, the Community of Blackfriars, Robert Copley, The Courtauld Institute of Art, Darwin College, Albinia de la Mare, Albert Derolez, Ghislain Dhoop, Hélène Dubois, the Electors of the Munby Fellowship, Christopher de Hamel, John Hardy, George Henderson, Victoria Hyde, Brian Jenkins, Peter Jones, Benoît Kervyn de Volkaersbeke, Elizabeth McGrath, David McKitterick, Rosamond McKitterick, Lawrence W. Nichols, Jeannine O'Grody, Annabel Perkins, Suzanne Reynolds, Jane Ringrose, Nicholas Rogers, Clare Sargent, Antoine De Schryver, Dries Sel, Raymond van Uytven, The Warburg Institute, Wolfson College, Patrick Zutshi; in the Fitzwilliam Museum, Craig Hartley, Jane Munro, Julia Poole, David Scrase, and Assistant Staff throughout the Museum; in the Hamilton Kerr Institute, Christopher Hurst, Ann Massing, Ian McClure, Renate Woudhuysen, and past and present students whose condition reports on Flemish paintings in the Fitzwilliam were of great help.

LENDERS TO THE EXHIBITION

Cambridge University Library
The Fitzwilliam Museum

The Mistress, Fellows and Scholars of Girton College
The Master and Fellows of Gonville & Caius College
The Provost and Fellows of King's College
The Master and Fellows of Peterhouse
The President and Fellows of Queens' College
The Master and Fellows of St John's College
The Master and Fellows of Sidney Sussex College
The Master and Fellows of Trinity College

The British Library
Viscount Coke and the Trustees of the Holkham Estate
Mr J. R. Porteous

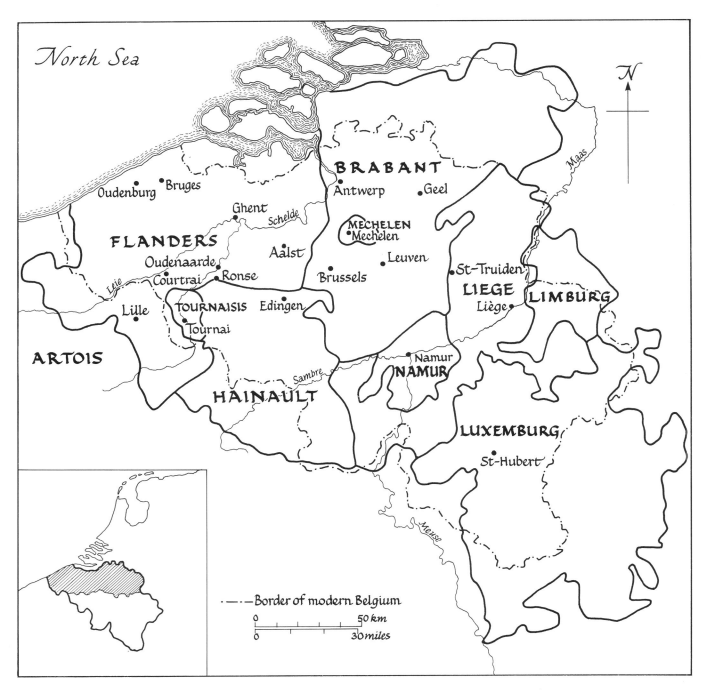

North Sea

BRABANT

FLANDERS

ARTOIS

HAINAULT

NAMUR

LIÈGE

LIMBURG

LUXEMBURG

Oudenburg • •Bruges
Ghent
Oudenaarde
Courtrai • •Ronse
Lille •
TOURNAISIS • •Edingen
Tournai •
Aalst
Brussels
Schelde
Leie
Antwerp •Geel
MECHELEN
•Mechelen
•Leuven
St-Truiden•
Liège•
•Namur
St-Hubert•

Maas

Sambre

Meuse

· — · Border of modern Belgium

| 0 | | | | | 50 km |
| 0 | | | | 30 miles | |

County of Flanders and adjoining principalities showing boundaries during the Burgundian era
(map by B. Kervyn); (inset) modern Flanders in Belgium

xiv

The Burgundian Netherlands

Peter Spufford

What is now known as Flanders was in the fifteenth and early sixteenth centuries the heartland of the Burgundian Netherlands. The total extent of the Burgundian Netherlands was much greater than modern Flanders and included the larger part of the lands that make up the modern kingdom of the Netherlands and large tracts of northern France as well as the whole of the modern kingdom of Belgium and the modern Grand Duchy of Luxemburg (see map, p. xiv). The lands that were brought together around 1430 to form the Burgundian 'state' had for centuries been independent principalities straddling the notional boundary between the kingdom of France and the Holy Roman Empire, but too far removed from the influence of king or emperor to be properly controlled by either. The most important of these principalities were the duchy of Brabant, focussed on Leuven and Brussels, and the county of Flanders, focussed on Ghent, but far smaller than modern 'Flanders'. That they came together at all was a result of genetic chance, of an extraordinary lack of children in a wide cousinhood, that made Philip the Good heir to so many principalities. These principalities had long been rich. The income of the fourteenth-century count of Flanders alone was a third of that of the king of France. This wealth came primarily from the fact that the industrial heartland of late medieval Europe stretched through a number of them. It is no wonder that, when all these principalities had been united in the hands of Philip the Good, he became the richest ruler in western Europe, richer even than the kings of France, or England, or Naples, or Castile, let alone the impoverished emperor.

The first duke of Burgundy to have any connection with the area was Philip the Bold, a younger son of John II of France, and his brother, Charles V's right-hand man in driving Edward III out of France. John II gave him the duchy of Burgundy, from which the dynasty took its name, on the then eastern border of France, as an appanage in 1363 to support his standing as a French royal prince, in the same way that his brothers were given the duchies of Anjou and Berry to support them. Like Charles V himself, all three of his brothers were passionate book collectors and commissioners of splendidly illuminated texts.

One of the greatest diplomatic coups of Charles V was securing Margaret, the heiress of Louis de Mâle, the last of the Dampierre family to rule Flanders, as the bride for his brother Philip in 1369 (see genealogy, p. 3). However Margaret and Philip did not inherit the county of Flanders itself until 1384. At the same time they also inherited the county of Artois, the fertile principality immediately to the south of Flanders, and the county of Burgundy (the Franche Comté) to the east of the duchy of Burgundy, but within the empire, which had been ruled by Louis de Mâle's mother.

During Charles V's lifetime Philip had been a loyal supporter of his brother. After Charles' early death Philip became the mainstay of the new king, his young nephew Charles VI. Although he founded a Charterhouse in Burgundy, just outside Dijon, and arranged for his burial there, Philip the Bold spent most of his time in his palace in Paris. During Charles VI's minority, and again during his madness as an adult, Philip the Bold was effectively ruler of France. When his wife Margaret eventually inherited Flanders and Artois they did not move there, although Philip did use the resources of the kingdom to make certain that they secured her inheritance, and used French royal troops to crush local resistence to their rule in Flanders.

Such use of force was however atypical of Philip's diplomatic way of proceeding. Much more typical was his reliance on a vast sequence of arranged marriages, for which he used every available member of his extended family. One of the principal objectives of his marriage policy was the continuation of the alliances within the Low Countries that already existed, binding together the houses of Dampierre (counts of Flanders), Leuven (dukes of Brabant), and Bavaria (counts of Holland and Hainaut) on whose equilibrium the peace and prosperity of the whole region depended. His endeavours to maintain equilibrium in the Low Countries unintentionally

brought about their eventual unification. Nothing was further from his own intentions. When his wife's widowed and childless aunt, Joanna, became old and infirm, Philip deliberately did not arrange for her duchy of Brabant, already almost as wealthy as Flanders, to be united with Flanders. Instead he saw it as a remarkable opportunity for endowing their second son, Anthony, with a suitable principality, with which to found another new dynasty. Philip left his third son, another Philip, with the three smaller counties of Nevers, Rethel and Etampes which were also subtracted from the potential inheritance of his eldest son John. Thus, when he died in 1404, he left three sons each about to be established in an independent principality of his own.

Philip's eldest son, John the Fearless, was an utterly different man from his urbane, diplomatic father, who had had the skills to smooth over ruffled feelings and bring compromise. Whereas Philip had ruled France by skill and strength of personality, John now failed to rule France by force and aggressiveness.

As a young man John had led the forces of France, on his father's behalf, on the ill-fated crusade that ended in disaster at Nicopolis. John himself was captured by the Turks, along with the larger part of his army, and only returned to France after a huge ransom had been paid from the French treasury.

John's attempts to dominate France were no more succesful than his crusade. His murder of his cousin Louis of Orléans led first to the civil war between Armagnacs and Burgundians, and then to Henry V's invasion of France on the Burgundian side. With English support the Burgundian forces looked set to win overwhelmingly. The dauphin, who by 1419 was the leader of the Armagnac party, as a last resort made a pretence of suing for peace, so that he could get close to John. The dauphin then took the opportunity of the parley on the bridge at Montereau of murdering John, a properly violent end to a violent life.

Like his father, John lived primarily in Paris, in the newly rebuilt Hôtel d'Artois, because his ambitions were so clearly centred on control of the kingdom. His visits to the Low Countries were infrequent. Flanders and Artois were for him merely sources of wealth to be spent in his vain political struggles in France. However, he did not, somewhat surprisingly, manage to disturb the peace of the Low Countries. When he was in the Low Countries, John pursued the same policy of equilibrium as his father and his maternal grandfather. The triple alliance between the major powers continued, John met at intervals not only with his brother Anthony, the duke of Brabant, but also with William, the ruler of Holland and Hainaut, to whom the brothers were doubly allied by marriage.

Philip the Good, a young man both more pious and more sensuous than most, when he succeeded, on his father's murder, to Flanders, Artois and the Burgundies, could hardly be a friend of the dauphin. He reinforced the alliance with Henry V, and the Burgundian and English forces soon contrived to dominate France to the extent that they were able to 'pacify' France by the Treaty of Troyes in 1420, by which Charles VI, by now old as well as feeble, disinherited the 'dauphin' in favour of his daughter Catherine who married Henry V. Soon after the birth of a son to Catherine, Charles VI, and then, surprisingly, Henry V, died, leaving the infant Henry as nominal king of both kingdoms. At this stage Philip remained, like his father and grandfather, a French prince, living in Paris. Philip shared the government of France, on behalf of the young Henry, with Henry V's younger brother, John Duke of Bedford, who married Philip's sister. For nearly a decade Philip and John continued to rule northern and eastern France, whilst their young king began to grow up in England.

In the course of the 1420s the political map began to change. In France the dauphin, now Charles VII, with the assistance of the houses of Anjou and Brittany, gradually increased his power, which had initially been limited to the environs of Bourges. Furthermore the meddling of Bedford's younger brother, Humphrey of Gloucester, regent for Henry VI in England, in the affairs of the Low Countries put a strain on the Anglo-Burgundian alliance. The affairs of the Low Countries were indeed ripe for meddling. Philip the Good consequently began to spend more and more time in the Netherlands, and less and less time in France. His uncle, William of Bavaria, had died leaving only one child, a daughter Jacqueline, or Jacoba. As the ruler of the two counties of Holland and Hainaut, perhaps together as rich as Brabant or Flanders, she was very attractive as a marriage partner. Her cousin John who had succeeded Anthony as duke of Brabant married her to keep her principalities in the family. It was all to no effect. They had had no children by the time their marriage broke up. An earlier marriage had been no more productive, and it began to be apparent that Philip the Good would eventually inherit Holland and Hainaut. Jacqueline was, however, too strong minded to be dictated to by her cousin, Philip, and treated as though she were already dead by him, or by her own subjects. After her flight from John, she bigamously married a third time, Humphrey of Gloucester, who attempted to invade Hainaut. Philip was keen to preserve his succession. In 1425 he moved in and three years later was declared 'ruwaert en oir' (guardian and heir) of the two principalities. When Jacqueline married for a fourth time, Philip became count of Holland and of Hainaut definitively in 1433, with control of Zealand and claims to Friesland. Meanwhile, in Brabant, on the other side of the family, Anthony's sons, despite three marriages between them, one to Jacqueline, had no children either, and when they

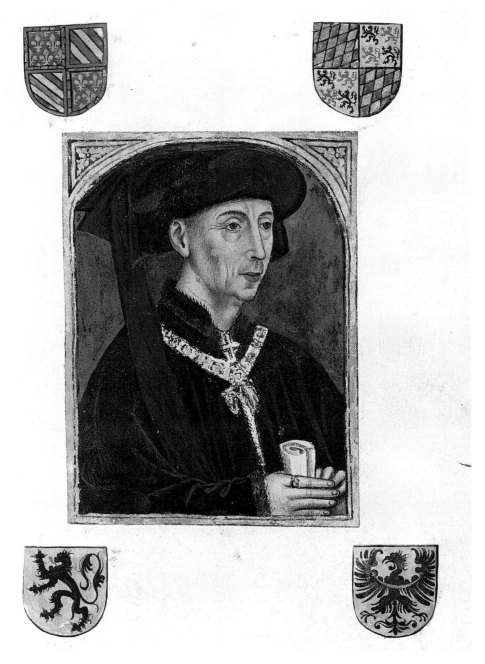

Figure 1. Philip the Good, Fitzwilliam Museum MS. 187, fol. 91r, cat. no. 47

too died young, the duchies of Brabant and Limburg also devolved on Philip in 1430. The principalities of the three dominant houses of the Netherlands had thus in a very short space of time all come into the hands of one man.

It was not at all clear, however, what would happen to them, for Philip himself, despite two marriages, had as yet no legitimate children! His third marriage, to Isabel of Portugal, produced only a single surviving child, Charles, so there was no occasion for the lands that had come together to be split up straight away, as had happened two generations earlier. As well as the lands that fell to him by lack of heirs, Philip quite deliberately made moves to extend his lands. The old count of Namur was also childless. Philip bought the reversion of the county. He did the same with his elderly aunt, Elizabeth, the childless duchess of Luxemburg, although he had actually to use force to make that claim good when she died. When the prince-bishop of Utrecht died, Philip had one of his bastard sons appointed. When the prince-bishop of Liège died, he had one of his nephews appointed. When the

prince-bishop of Cambrai died, he had one of his bastard half-brothers appointed. Philip also arranged for the bishopric of Tournai to be vacated so that he could see that the President of his Council was provided for. All the bishops of the Netherlands with territorial states became 'Burgundian' in this way. Philip's attention was consequently increasingly taken up with the affairs of the Low Countries rather than France.

In France Philip abandoned the young Henry, and accepted reparations for his father's murder, at the peace conference at Arras in 1435, which was a great diplomatic coup for Charles VII. Philip was confirmed in his *de facto* rule over Picardy, the lands along the Somme, and nominally became first peer in Charles VII's France. Charles, however, was too sensible ever to allow so powerful a man as Philip any say in the running of his France. Charles followed up his advantage by driving the Lancastrian troops, immeasurably weakened by the loss of Burgundian support, out of Normandy and Gascony in turn.

Philip no longer spent most of his time in Paris. The Hôtel d'Artois was deserted. Philip was now perpetually on the move between the various castles and palaces that he had inherited, in Arras, in St Omer, in Bruges, in The Hague, in Hesdin, in Lille, in Ghent and in Brussels. Gradually first his duchess, Isabel, and then Philip himself came to prefer the old palace of the dukes of Brabant on the Coudenberg above Brussels. Philip twice rebuilt it, on a larger and yet larger scale, and Brussels gradually became in some sense the capital of his newly acquired 'state'. The nobility of his various principalities came to build themselves hôtels in Brussels to be near their ruler and his court, and bought themselves country estates in north Brabant within a day's journey of Brussels. The rulers of client states, often but not always relatives, like the counts of Etampes and Nevers, the dukes of Cleves, Julich and Guelders, as well as more distant clients like the counts of Nassau and Württemberg or the dukes of Bourbon and Savoy also built themselves houses in Brussels, as did the client prince-bishops like those of Utrecht and Liège. The cadets of some of these rulers, like the Egmonts, the Ravensteins and the Montferrands, were permanently based in Brussels. It is no wonder that in the middle years of the fifteenth century Brussels was the fastest growing city in western Europe.

Political institutions were gradually created to go with the new court. A new order of chivalry, the Golden Fleece, as prestigious as the Garter, was created to hold together the nobility of the various lands in devotion to their sovereign. A new nobility was created, and the old nobility enriched and given titles of honour, whilst rules of etiquette were evolved for them, that influenced behaviour in all the courts of Europe to the end of the *ancien régime*. A common 'national' coinage was also created, and the habit grew up of summoning together general assemblies of the representatives of the estates of Philip's different lands, the origin of the later Estates General. The auditing bodies, the Chambre des Comptes or Rekenkamers, although not yet formally united, were run by a common personnel. Philip also brought into existence a common court of last resort, the Grand Conseil, yet another sign of national sovereignty and of distancing from king or emperor.

The Burgundian nobility, whatever their origin, whether Picard or Flemish or Brabançon, not only met together socially at court and in political assemblies, and held down administrative posts for their ruler, but gradually came to have a common set of attitudes. They naturally intermarried, but they also educated their children together at the university of Leuven, to which Philip sent his own bastard sons. Philip had humanist teachers imported from Italy and, as a consequence, the next generation of Burgundian nobility, administrators and higher clergy shared a common education, and that was a new-style Renaissance one. Philip himself saw to it that his own library, the greatest library of any contemporary ruler, should contain copies of the key new texts of the Renaissance, and commissioned translations of them into French for himself. In this, as in much else, Philip showed himself an aesthete and a collector. His passion for collecting beautiful objects was not limited to manuscripts and jewels, plate and paintings, buildings and tapestries, but extended to fine food and wine, and beautiful women. His handsome, strikingly dressed figure, combined with the seductive attractions of wealth and power, enabled him over the years to form a collection of beautiful women even larger and finer than President Kennedy's (fig. 1). With thirty-three known mistresses, it is a little surprising that he had only twenty-six bastards. As well as seeing that they were properly educated Philip saw that his illegitimate children were appropriately placed in life. Cornelius and Anthony who commanded troops were given secular lordships, David and Philip became in turn prince-bishops of Utrecht, and Raphael de Mercatellis was enabled to pursue his inherited passion for book collecting by appointment as abbot of the rich and famous abbey of St Bavo at Ghent.

Just as Philip had moved his centre of operations from Paris to Brussels, so he had gradually changed in himself. He had been born a Frenchman, apparently destined to be the greatest of the royal princes, but when he died in 1467 he had become a Netherlander and the richest ruler in Europe.

The golden age of Burgundy, which began with Philip the Good and lasted for a century, depended on wealth, the wealth of the ruler and the wealth of the dominant nobility. Without wealth there could have been no great building projects, no patronage of the visual arts, no great libraries, no extravagant feasts and festivals. Without

wealth Flemish painting and music could not have been the most acclaimed in Europe.

The bases of this wealth were not essentially rural rent-rolls from agricultural tenants, although these were also important, but urban rent-rolls from commercial and industrial tenants. In the mid fifteenth century Flanders and Brabant were amongst the most densely populated parts of Europe, only rivalled by parts of Lombardy and Tuscany. There was a belt of major towns which stretched from Calais on the coast to Cologne on the Rhine (see map, p. xiv). In the county of Artois there was St Omer as well as Arras; in the county of Flanders there were Bruges, Ghent, Ypres, Lille and Douai; in the bishopric of Tournai, there was Tournai; in Hainaut there were Valenciennes and Mons; in the lordship of Mechelen there was Mechelen; in the duchy of Brabant there were Leuven, Brussels and Antwerp; in the county of Namur, Namur; in the bishopric of Liège, Liège, Huy and Dinant; and, just beyond the Burgundian frontier, lay the the imperial city of Aachen. For the time these were major cities, but it must be remembered that the population of Europe was at a low ebb by the mid fifteenth century after a century of repeated waves of bubonic plague. Mid fifteenth-century Bruges had a population of perhaps 45–50,000, which made it as big as London or Florence, the population of which had dropped to a half since the mid fourteenth century. Besides these major towns there were numerous minor towns, like Wervik and Hondschoote in the county of Flanders, and as well as those who actually lived in the towns there were many who lived in the surrounding countryside who farmed such tiny plots of land that they could not survive without some urban employment as well. The effects of continued industrial and commercial prosperity were employment opportunities which brought in migrants to take the place of those who had died, so maintaining a higher density of population than elsewhere, but also ensuring higher rents and higher prices for foodstuffs than elsewhere, which made the southern Netherlands a better place than most to be a landlord in mid fifteenth-century Europe.

The industry of the area was very varied, and also frequently shifting. The most famous of the traditional industries of the area had for long been the manufacture of the most luxurious heavy woollen cloth, using the finest English wool. In the thirteenth century the towns of Flanders, like Ghent, Ypres and Douai, had had a virtual monopoly of production of such high-quality cloth for the nobility of Europe. In the fourteenth century these centres were joined by Brussels and Mechelen, but there was also competition from elsewhere, from Tuscany, England and even Holland. By the mid fifteenth century the manufacture of luxury woollen cloth was in decline, but still survived. More important by now was the production of cheaper and lighter fabrics, using cheaper Castilian wool, for sale throughout northern, central and eastern Europe. This cheaper cloth was produced in rural Flanders and Brabant and its smaller towns, like Wervik and Hondschoote, rather than the great traditional guild-dominated woollen cities. As well as woollen fabrics the area was also noted for its linen fabrics, particularly those from Hainaut around Ath and Mons, but also from around Tournai, and from Flanders around Lille and Courtrai.

The southern Netherlands were also noted for their metallurgical industries. Brass was used very extensively in the later Middle Ages. It is an alloy of copper and zinc. Although in the final product there is much more copper than zinc, to achieve this result much more zinc ore (calamine) was needed than copper ore. The largest brass industry of medieval Europe therefore grew up in the vicinity of calamine deposits. The principal calamine deposits worked in medieval Europe lay in the hills to the east of Liège. These fed brass manufacture not only in Aachen and Liège, but also in the Meuse valley at Huy and Dinant, and further west at Mechelen. There was a continuous tradition of brass founding of large objects in the Meuse valley from the twelfth century onwards. Bell founding had a continuous market in the late Middle Ages, and there was also a market for other church furnishings in brass. Brass lecterns, for example, were exported in considerable numbers. That in King's College Chapel, Cambridge, is a remarkable, if rather late example. Monumental brasses had a considerable commercial success and were sold to customers from the Iberian peninsula to Scandinavia and Poland. In the course of the fifteenth century more efficient cannon began to be made of brass rather than iron. The armies of Charles the Rash provided a considerable home market, but cannon from Mechelen were also widely exported. As well as such large objects, there was an international market for domestic brassware. Cooking pots were essential for the kitchen. From the thirteenth century brass cauldrons began to replace earthenware, and brass mortars replaced stone ones; by the fifteenth century brass kettles were being produced as well. Brass candlesticks, brass ewers, brass aquamanile, brass handwashing sets and indeed all sorts of brass tableware were also exported. Dinant was the most important centre for the production of such tableware, which was consequently known as 'Dinanderie'. After the capture and burning of Dinant in 1466 it never recovered. Its brass workers were scattered and brass working, already important at Mechelen and Aachen, became yet more important still, and developed at Brussels, Namur and Antwerp. In addition to being the European centre for brass working, the area around Liège had the most important coal mines of medieval Europe and in the county of Namur there was considerable iron working.

The fifteenth-century Low Countries also harboured

an extensive manufacture of luxuries, and the growth of the Burgundian court provided a large and increasing market for them. In the fifteenth century the weaving of tapestries was heavily concentrated in the Southern Netherlands. Arras was for long the centre of the industry and gave its name to the product – 'arras' or 'arras cloth'. However, it was not alone. Tournai was already almost as important a producer as Arras at the beginning of the fifteenth century, and in the middle of the century Brussels, with direct access to the court market, rapidly increased in importance. As well as famous tapestries commissioned by Philip the Good and Charles the Rash, others were sold through Bruges and later Antwerp and distributed throughout Europe. Carpets as well as tapestries were woven in the Low Countries and also sold at the Antwerp and Bergen op Zoom fairs, for covering tables and walls as well as floors, as yet another replacement for a hitherto imported oriental luxury. To tapestries and carpets must be added the production of manuscripts and paintings, not only for home consumption but also for export.

In the mid fifteenth century Bruges was the key distribution point for all of northwestern Europe, and, depending on it and run by its merchants, the seasonal fairs at Antwerp and Bergen op Zoom. It was through Bruges that the textiles, metalwares, tapestries, carpets and luxuries were shipped out. Bruges was itself the most important place for the production of manuscripts, and later of printing, as well as the centre of the book trade. Equally it was through Bruges that raw materials came in, for example Castilian wool, and English wool via Calais, and dyestuffs and alum, all for the woollen industry. English merchants also brought tin, Bretons brought salt and canvas, Gascons brought wine, as did the Portuguese and the Castilians, who also brought iron and citrus fruits, as well as wool. The Italians brought silks, satins, velvets and damasks, increasingly of their own manufacture, but also from the Middle and Far East, as well as cloves, pepper, ginger and other spices from India, along with pearls and jewels. The Hanseatic merchants from the Baltic brought furs, amber, salt cod and herring, and of course took away not only the manufactures of the Netherlands, but also the goods brought by Italians, Spaniards, Gascons, Bretons and English.

A series of routes ran across the southern Netherlands, from Bruges and its outports at Sluys and Calais to Maastricht and Cologne. As well as Cologne merchants themselves, other Rhinelanders also approached Flanders and Brabant overland. They carried away a far larger quantity of goods than they brought with them, not only locally manufactured textiles and metal goods, but also many of the wares brought into Flanders through Bruges, for distribution by road and river throughout the 'German' empire and beyond. In return they brought only a limited quantity of goods, like copper from the Harz or wine that had been shipped down the Rhine. The balance was made up by payments of Slovakian gold, and, increasingly from the 1460s, of silver from the newly opened and newly reopened silver mines of central Europe. More and more this land trade was dominated by entrepreneurs, like the Fuggers and Welsers, from the increasingly prosperous cities of south Germany, Nuremberg, Augsburg, Regensburg and Ulm. By the end of the fifteenth century the most important overland route in Europe was that from Venice to Antwerp, developed by these south German merchants, which joined the trade of the Mediterranean to that of the North Sea and the Baltic.

The end of Philip's long reign was clouded by animosity and corruption. In his old age Philip rarely took political initiatives himself any longer, except with regard to Pius II's projected crusade to recover Byzantium from the Turk, an echo, perhaps, of his father's crusade when he had been a small boy. He left government to men he had trusted for decades, like Nicolas Rolin, who were growing old with him. However, in 1457 Philip's Chancellor, Rolin, and his cronies, were eased out by the Croys and their hangers on, using the pretext that they had been unduly keen on lining their own pockets at the expense of their duke and his subjects. The Croys were themselves very considerable pensioners of the king of France and directed Burgundian policy at the behest of their paymaster. They were eventually ousted in their turn by the heir Charles, called by the English 'the Rash' or 'the Bold', according to differing translations of 'Téméraire'. The reign of Charles thus effectively began in 1465, although he did not actually inherit until his father's death two years later.

Looking back from the end of the century Wielant, the president of the Parlement, in his *Antiquités de Flandre* emphasised the differences between the somewhat frivolous Philip and the ultra-austere Charles. Even allowing for exaggeration for the sake of effect, it is quite clear that they were utterly different in temperament. Charles was one of the new generation of rulers who took over in the 1460s, like his brother-in-law Edward IV in England and Louis XI in France, who were dedicated to continuous government. For them the business of government was what gave them pleasure: administration, justice, finance and, in Charles' case, war. The new generation of young men around Charles were, of course, also different from Rolin and the Croys. They were the products of the new humanist education promoted by Philip. They had been indoctrinated with Ciceronian precepts of service to the state.

Charles quite clearly looked more towards the Empire than to France. The 'Grand Ducs de Ponent', the great dukes of the West, although richer than any European

kings, were still only dukes. The way to a royal title lay through the emperor. A former emperor had, after all, made Bohemia into a kingdom. Charles did not entirely neglect France. He did after all join in the league of the Public Weal and defeat Louis XI at the battle of Montlhéry. Apart from reacquiring Picardy, and ensuring that his nominally French lands were not functionally dependent on the jurisdiction of the Parlement of Paris, Charles was most concerned to negotiate a durable peace with the king of France as neighbour rather than as over-lord. Charles and Louis made such a peace in 1475. This secured Charles' western frontier whilst he pursued his ambitions within the Empire: in the duchy of Guelders, in the archbishopric of Cologne, in the duchy of Lorraine, in Alsace, in the Breisgau and in the Vaud. His Renaissance pursuit of 'Glory' was not, however, entirely successful. This was in despite of the care and precision with which he ran his army, which, like his other new cen-tralised institutions, was a very model to the other 'new' monarchies.

The year 1473 saw his careful negotiations for a crown come to nothing. The emperor Frederick III, instead of crowning him at Trier, slipped away furtively and fear-fully, lest a crowned Charles, with a kingdom stretching from the Swiss border to Friesland, might prove too mighty, and might even seek to succeed Frederick as emperor in place of Frederick's own son. Although Charles defeated the combined German relieving force at Neuss in 1475, he failed to take the city or impose his nominee on the archbishopric of Cologne. After his non-coronation at Trier, and his ambiguous success at Neuss, Charles' reign ran into the sands. His embroilment with the Swiss and the towns of the upper Rhine brought a sequence of military defeats, at Grandson, and at Morat in the Vaud, and eventually in 1477 before Nancy in Lorraine, where, having lived by the sword, he perished by the sword.

Like Philip the Good, Charles left a single heir, his daughter Mary, so there should once again have been no question of dividing the Burgundian state. However, immediately the death of Charles was known to him, Louis XI broke the peace of 1475 and invaded the Burgundian lands. In the south the two Burgundies were seized by the French armies and Lorraine and Alsace were lost. In the north it was a different story. The French armies seized Picardy and entered Artois, but got no further. The general assembly of estates declared the united Netherlands inseparable. The charters of privi-leges of 1477 may have shifted power from the monarch to the estates, but these assemblies were dominated by a nobility united behind their duchess. Taxes were raised for the defence of their homeland on an unprecedented scale, greatly surpassing the amounts raised by Charles for aggressive purposes. The French armies were brought to

a standstill halfway through Artois. The French attempts to bring the inhabitants to their knees by a scorched earth policy only strengthened the quality of resistance. The French troops found themselves an unpopular army of occupation in unfriendly territory, liable to be waylaid and cut down by the inhabitants whenever they moved about in small numbers. Louis launched expensive but ineffective campaigns year after year. After the initial suc-cesses in Picardy and southern Artois, owing as much to bribery and treachery as military skill, Louis never won a battle, and indeed suffered one major defeat, at Guinegate in 1479. Louis' attempted acquisition of the Burgundian state by force was his greatest mistake, according to his former secretary Commynes, who claimed to have advised for diplomacy rather than force. It certainly ruined Louis. When he died in 1484 Louis left France deeply in debt, although he had enjoyed greater revenues than any king of France before him.

Patriotic reaction to the French invasions after 1477 completed the process of nation building that had been gradually occurring since genetic chance had united the Netherlands half a century earlier. At the time Mary's official historiographer, Molinet, was able to write of the men of Artois as 'bons bourguignons', and treat Frenchmen as foreign enemies.

Of Mary herself we know little. At a time of crisis her sex rendered her incapable of leading troops for the defence of her 'kingdom'. Her youth and inexperience on succeeding to her 'throne' were compounded by a lack of experienced counsellors. Too many had died with her father at Nancy or were prisoners in French hands until ransomed, whilst her Chancellor and leading general, Guillaume Hugonet and Guy de Brimeu, lord of Humbercourt, were executed by the men of Ghent on false information, spread by Louis, that they were in col-lusion with France. She acquired experience and compe-tence painfully and fast, and was soon inspiring very con-siderable affection and loyalty in her subjects, even to the extent that people like the Chalons, princes of Orange, were prepared to lose all their estates in the Burgundies because of their support for her. She shared her grand-father Philip's affection for learning and the arts. In her patronage she was notably seconded by her step-mother, Margaret of York (fig. 2). Also like Philip the Good, Mary loved hunting, and can be seen doing so in a number of manuscripts. It is ironic that she should have died of a hunting accident in 1482 at the early age of 25. It turned out to be a greater calamity for her people than the death of her father in 1477. The husband that she had chosen, with the approval of her general assembly of estates, was the equally young, good-looking and inexperienced Maximilian (fig. 3), the yet more impoverished son of the impoverished emperor who had fled from her father's intended coronation. Mary had even had to provide

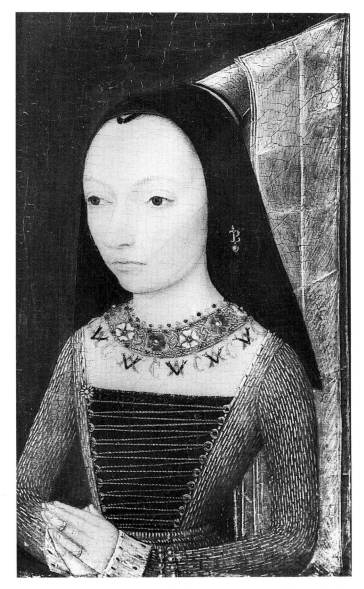

Figure 2. *Portrait of Margaret of York* by an anonymous Master, Paris
Musée National du Louvre (photograph by courtesy of the Réunion des
Musées Nationaux)

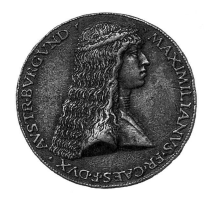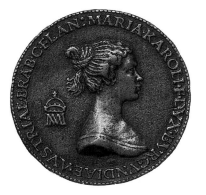

Figure 3. Bronze medal of Maximilian of Austria and Mary of Burgundy by Giovanni
Candida, Washington National Gallery of Art, Samuel Kress Collection, 1957.14.819 (SC)
(photograph by courtesy of NGA, Washington)

Maximilian with pocket money for the journey before he could afford to come from Vienna to marry her. Mary's leading subjects felt that Maximilian's role as consort was merely to provide their ruler with heirs, and in this he proved competent.

Mary's son Philip so much inherited the striking good looks of his parents that he acquired the soubriquet 'the Handsome' (fig. 4). However in 1482 he was merely a child, not yet four years old. His subjects expected a council of regency to rule, and that the otherwise incompetent Maximilian, his conjugal duties no longer being required, would probably return to Austria. Maximilian on the other hand saw himself not only as guardian of his son's person, but also of his son's lands, something that had, with admirable foresight, been specifically excluded by the marriage treaty. Maximilian tried to force his pretensions on his son's unwilling subjects and the consequence was a civil war that lasted intermittently until 1492. However, in 1489, Maximilian had at last taken himself away. It was, as civil wars so often are, a very tangled affair, from which Maximilian emerged with very little credit. In 1488 he had the humiliation of being arrested in Ghent and kept in a vast wooden cage. After his departure from the Netherlands Maximilian's supporters were ultimately, but very nominally, successful, owing to the victories of Albert of Saxony and his German mercenaries.

The civil war did far more damage to the Netherlands, particularly to the county of Flanders, than Louis' determined and expensive invasions. It was at this juncture that Antwerp came to replace Bruges as the principal entrepôt of northwestern Europe for commodities as diverse as sugar and copper, cloth and books. However, it ought to be added that many of the key merchants at Antwerp, both Flemings and foreigners, were exactly the same people as had traded together at Bruges. In 1493 the young Philip the Handsome finally took over the government himself, with the support of his principal subjects. Many of his courtiers, counsellors and administrators were themselves the sons, grandsons and even great-grandsons of the men who had surrounded his mother, his grandfather and his great-grandfather. Philip was very much a Netherlander, and ruled with the assistance of a truly 'Burgundian' nobility, led by members of great, long-established families like the Croys, the Berghes, the Lalaings, the Lannoys and the Nassaus. The estates that as recently as 1488 had been leagued together against Maximilian provided enthusiastic backing for Philip, who, they felt, was one of their own people and not an incompetent and overbearing foreign intruder like Maximilian. Some of Charles' innovations, central administrative offices, like the Parlement and Chambre des Comptes at Mechelen which had been disbanded since his death were re-established by his grand-

son, Philip the Handsome. A short north–south axis came into existence at the heart of the Netherlands, between Antwerp as the port and economic focus at one end, and Brussels, the court and social focus at the other, with Mechelen as the administrative centre between them.

One last unfortunate legacy of Maximilian's catastrophic intrusion into government was the marriage that he arranged for Philip with Joanna, one of the daughters of the 'Catholic Kings', Ferdinand and Isabella of Aragon and Castile, as part of a great anti-French coalition. When Joanna's brother Juan died unexpectedly, she found herself heir to her parents' kingdoms. After Isabella died, Philip took Joanna to Castile in 1506 to claim that throne, accompanied by a group of Flemish advisers. They were 'Flamencos' to the Castilians, and came to be hated for what looked like a Burgundian takeover of the Castilian state.

Philip left one of the Croys, William lord of Chièvres, as his lieutenant to govern the Low Countries during what was intended as only a brief temporary absence. However, Philip died suddenly in Castile soon after his arrival there in 1506. Generation after generation the fortunes of the Burgundian dynasty had been shaped by a plague of unexpected early deaths.

Philip the Handsome's elder son, Charles, later to be the emperor Charles V (cat. no. 9), had been left behind in the Netherlands and was brought up in Mechelen as a Fleming. Maximilian's half-hearted attempt to intrude himself once again as ruler of 'Burgundy' was repulsed with ease. The acceptable member of the ruling family to take up the reins of government was Philip's newly widowed sister, Margaret, the thoroughly competent dowager duchess of Savoy, a native-born Flemish speaker. She not only brought Charles up, since his mother was out of her mind as well as out of the country, but also ruled his subjects for him most efficiently until he came of age in 1515. When Charles too went off to Spain to claim both his mother's kingdoms in 1517, Margaret again took up the burden of rule until her death in 1530.

The young Charles was surrounded by yet another generation of Burgundian nobility. When he went to Spain, he took many of them with him. There they too were resented as intruders, and not unreasonably so, for this new wave of hated Flamencos were given all the best jobs in church and state alike. The greater noble families of Castile were not pleased to have their aspiring clerical relatives passed over and to see a Croy installed as archbishop of Toledo, the principal see in the Spanish kingdoms. As time went on Charles replaced his Flemish advisers by Spaniards, and Charles himself gradually became more and more Spanish in outlook. At the beginning, in 1518, the Spanish kingdoms had a Flemish king with Flemish advisers; but at the end of his reign in 1555,

the Netherlands had a Spanish ruler with Spanish counsellors. The Burgundian takeover of Castile and Aragon had turned into a reverse takeover of the Netherlands by Spaniards.

In the fourteenth century Philip the Bold saw to it that his children could speak Flemish, and every member of the family could do so, down to Margaret of Savoy and her nephew Charles. However, when Charles abdicated in 1555 and presented the peoples of the Netherlands with his son and successor, they were horrified to find that Philip could speak no Flemish. He was a Spaniard, a foreign monarch. The 'native', Flemish-speaking, Burgundian dynasty had come to an end. The Burgundian 'nation' brought slowly into existence from the 1430s onwards, had, equally gradually and imperceptibly, lost its independence from the 1530s onwards.

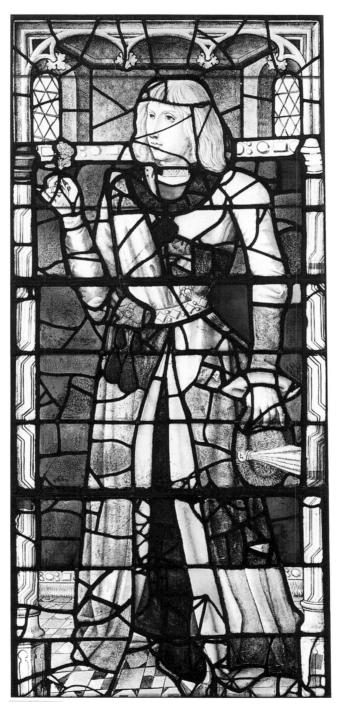

Figure 4. Philip the Handsome, stained glass window formerly in the Chapel of the Precious Blood in Bruges, London, Victoria and Albert Museum (photograph by courtesy of KIK, Brussels)

Flemish art in Cambridge collections

Alain Arnould and Jean Michel Massing

One of the first important exhibitions of Flemish art in London was held at the Burlington Fine Arts Club in 1892. The show included sixty paintings, a large number of which are today in museums.[1] This was followed by a loan exhibition of works by Flemish and Belgian painters held at the art gallery of the Corporation of London (Guildhall) in 1906; in the first gallery were eighty early works from public and private collections in Britain and abroad, among them the Hinckaert diptych (cat. no. 4).[2] Of much greater scope was the 1927 Exhibition of Flemish and Belgian art, with 752 items including paintings, tapestries, sculptures, drawings and engravings. The opportunity was taken, as is explicitly stated in the introduction to the catalogue, to bring together works which had been dismembered. All the great artists, in fact, were represented, often by masterpieces;[3] the splendid *Virgin and Child* (cat. no. 11) by Joos Van Cleve was there, as well as the fifteenth-century drawing on vellum after Robert Campin's *St Veronica* (cat. no. 14). A large memorial volume was published; edited by Sir Martin Conway, it included a section on paintings by Tancred Borenius and on tapestry by Albert Frank Kendrick, with Campbell Dodgson on drawings and engravings.[4] Manuscripts were included only in the last of the great Flemish exhibitions in London held at the Royal Academy of Arts in 1953–4. The chronological scope, from 1300 to 1700, was more restricted than in the case of most of the previous shows. Altogether 626 works were exhibited. Out of seventy-two manuscripts, twelve came from Cambridge; among the

paintings shown were the Hinckaert panel (cat. no. 4), the *Transfiguration* by Albert Bouts (cat. no. 5), Joos Van Cleve's *Virgin and Child* (cat. no. 11), as well as the two fifteenth-century drawings after Robert Campin (cat. nos. 14 and 15).[5]

Netherlandish paintings had been exported to Britain since the fifteenth century. The 'large flat paintings in oyl after the manner of Albert Dure', which George Vertue saw in Queens' College, Cambridge, sometime between 1741 and 1752, are the wings of a dismantled Flemish altarpiece which may have come to England before the Reformation (cat. no. 1). This Brussels polyptych, with a carved corpus and painted wings by the Master of the View of Sainte-Gudule, was probably sent to England directly after being painted.[6] Imported Flemish altarpieces were not unusual at this period. Perhaps the best-known example is the Ashwellthorpe triptych by the Master of the Magdalene Legend, with its central panel representing the Seven Sorrows of Mary. The patron saints on the wings as well as the coat of arms identify the donors as Christopher Knyvett and his wife Catherine. The altarpiece, as it happens, provides the earliest surviving testimony to a Norfolk family commissioning Flemish art.[7] Artistic influence from the Netherlands was also transmitted through prints, as can be seen, for example, in the paintings of the chancel screen of Worstead church.[8] Trade flourished with the Netherlands; not only in wool, cloth and bricks, but also in books, manuscripts and other artifacts.

1. London, Burlington Fine Arts Club, 1892, *Exhibition of pictures by Masters of the Netherlandish and allied Schools of XV and early XVI centuries.*

2. Alfred George Temple, *Illustrated catalogue of the exhibition of works by the early Flemish painters*, London, 1906; there was also an unillustrated edition.

3. London, Royal Academy of Arts, 1927, *Exhibition of Flemish and Belgian art (1300–1900).* See also *Exhibition of Flemish and Belgian art (1300–1900): illustrated souvenir*, London, 1927; a more lavish production is *Flemish and Belgian art 1300–1900*, London, 1927. There were also private exhibitions such as, London, Tomás Harris Ltd, 1935, *Catalogue of the exhibition of early Flemish painting.*

4. Sir Martin Conway (ed.), *Catalogue of the loan exhibition of*

Flemish and Belgian art, Burlington House, London 1927: a memorial volume, London, 1927.

5. London, Royal Academy of Arts, 1953–4, *Flemish Art 1300–1700.* Worth mentioning is an exhibition held in Belgium: Bruges, Groeninge Museum, 1956, *L'Art flamand dans les collections britanniques et la galerie nationale de Victoria* (no loan, however, came from Cambridge).

6. Jean Michel Massing, 'Three panels by the Master of the View of Ste-Gudule in the Chapel of Queens' College, Cambridge', *The Burlington Magazine*, 133, 1991, pp. 690–3.

7. Andrew W. Moore, *Dutch and Flemish painting in Norfolk: a history of taste and influence, fashion and collecting*, London, 1988, pp. 84–5, no. 4, colour plate 1.

8. See Moore, as in note 7, pp. 81–2, fig. 50.

But if the Queens' College panels perhaps came to England in the fifteenth or early sixteenth century, the remaining paintings in the exhibition were all later bequests or gifts which testify to the generosity of numerous discerning collectors. Richard, Seventh Viscount Fitzwilliam of Merrion, who had a Dutch grandfather, founded the Fitzwilliam Museum in 1816 by bequeathing his collection of paintings, illuminated manuscripts, prints, music and printed books to the University of Cambridge 'for the purpose of promoting the Increase of Learning and other great Objects of that Noble Foundation'. About half of the 144 paintings were Dutch or Flemish, including the panel of the *Annunciation* (cat. no. 8).[9] The next major bequest came from Daniel Mesman with 246 mainly Netherlandish works; no early paintings, however, were among them.[10] The *Transfiguration* by Albert Bouts (cat. no. 5) was given by Richard Ellison in 1857; he bought it, 'black as my hat', from a restorer of paintings in Lincoln. Joos Van Cleve's *Virgin and Child* (cat. no. 11) and the drawing on parchment after the Master of Flémalle's *St Veronica* (cat. no. 14) were bequeathed by the Reverend R. E. Kerrich, part of an extensive collection of books, drawings, prints and manuscripts; he also gave fourteen Dutch and Flemish paintings, including the seven sketches for Rubens' *Triumph of the Eucharist* and the design for the title-page of the *Pompa introitus . . . Ferdinandi.*[11] Most of the collection, including the two works in the exhibition, came from the collection of his father, the Reverend Thomas Kerrich, best known for his catalogue of prints after Maarten van Heemskerck.[12] Most important was Charles Brinsley Marlay's bequest of 1912. In addition to a large art collection, he left a capital sum of £80,000 for its housing and upkeep. The catalogue of his pictures lists various fifteenth- and sixteenth-century works.[13] Two Flemish paintings have been included in the present exhibition: the anonymous triptych of the *Lamentation* (cat. no. 3), as well as the little *Virgin and Child* attributed to Cornelis Van Cleve (cat. no. 13). The shutter with the *Entombment* on one side and the *Virgin of the Annunciation* on the other (cat. no. 2) was given by Sir Herbert Thompson in 1929.

In the 1930s there were also generous donations of early Flemish art. The year 1935 saw the bequest by Thomas Henry Riches of two small paintings by Ysenbrant (cat. no. 10). A year later, Arthur W. Young bequeathed the *Adoration of the Kings* from the School of Joos Van Cleve (cat. no. 12) which had come from the famous Beckford collection. Then in 1937, upon the death of Leonard Daneham Cunliffe, the museum received a large collection, including seven paintings; among them was the *Portrait of Charles V* (cat. no. 9) which had been in the Bernal collection, and the two anonymous panels with arched tops representing *St Barbara* and *St Catherine* (cat. no. 6). *The Descent from the Cross* after Robert Campin was bequeathed in the same year by Charles H. Shannon (cat. no. 15).[14] During the war (1943) Mrs Sigismund Goetze presented the museum with the altarpiece wing, with two donors, by the Master of the Magdalene Legend (cat. no. 7).[15] As for the splendid panel of *c.* 1505 representing Philip Hinckaert before the Virgin (cat. no. 4), this was first exhibited in Bruges, in the famous *Exposition des Primitifs flamands* of 1902, which gave such an impetus to the study of early Netherlandish painting. It was bequeathed in 1960 by Louis C. G. Clarke, Director of the Fitzwilliam Museum from 1937 to 1946, and received in 1961.

In addition to paintings, drawings, manuscripts and books, there is in Cambridge a unique collection of Netherlandish stained glass. Flemish influence can be seen in the windows of King's College Chapel – not surprisingly, since more than half of the glaziers came from the Netherlands.[16] Especially important is the influence of Dirck Vellert of Antwerp, the author of the two preliminary drawings still extant.[17] Less well known is the glass in the windows of the side chapels of the College.[18] This incomparable material includes not only a few outstanding pieces of continental origin, but also figured panels, heraldic memorials, quarries and fragments from various sources. Some of the glass dates from the reign of the Founder of King's College; much of it, however, was added in the last seventy-five years. Especially fine is a *Judgement of Zaleucus* acquired in 1984 from the collection

9. Carl Winter, *The Fitzwilliam Museum: an illustrated survey*, Cambridge, 1958, pp. 2–5. See also Cambridge, 1988–9, *The Dutch connection: the founding of the Fitzwilliam Museum*, Cambridge 1988, esp. pp. 5–71.

10. For the most important gifts before 1958, Winter, as in note 9, pp. 1–5 and 8–16; for the Daniel Mesman benefaction, see p. 8.

11. For Rubens' *Triumph of the Eucharist*, see Nora de Poorter, *The Eucharist series*, 1–2 (Corpus Rubenianum Ludwig Burchard, 2), London, 1978; for the title-page of the *Pompa introitus . . . Ferdinandi*, see J. Richard Judson and Carl Van de Velde, *Book illustrations and title-pages* (Corpus Rubenianum Ludwig Burchard, 21), London, 1978, 1, pp. 327–34, and 2, figs. 273–4.

12. Thomas Kerrich, *A catalogue of the prints which have been engraved after Martin Heemskerck*, Cambridge, 1829. For Kerrich, see the *Dictionary of national biography*, London, 1892–3, vol. 11, pp. 67–8.

13. William George Constable, *Catalogue of pictures in the Marlay bequest, Fitzwilliam Museum, Cambridge*, Cambridge, 1927; Winter, as in note 9, pp. 9–10. See also the tapestry mentioned below.

14. For this bequest, Winter, as in note 9 above, p. 13; also Fitzwilliam Museum, 1979, *All for art: the Ricketts and Shannon collection*, ed. by J. Darracott, Cambridge, 1979.

15. Winter, as in note 9 above, p. 14; see also the three sculptures mentioned below.

16. Hilary Wayment, *The windows of King's College Chapel, Cambridge* (Corpus vitrearum medii aevi, Great Britain, 1), London, 1972; Hilary Wayment, *King's College Chapel, Cambridge: the great windows. Introduction and guide*, Cambridge, 1982.

17. Karel G. Boon, 'Two designs for windows by Dierick Vellert', *Master Drawings*, 2, 1964, pp. 153–6.

18. Hilary Wayment, *King's College Chapel, Cambridge: the side-chapel glass*, Cambridge, 1988.

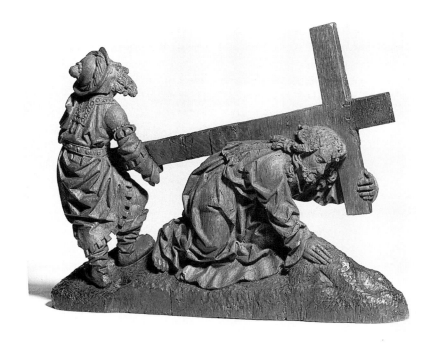

Figure 5. *Christ on the way to Calvary*, Fitzwilliam Museum, M.7–1943

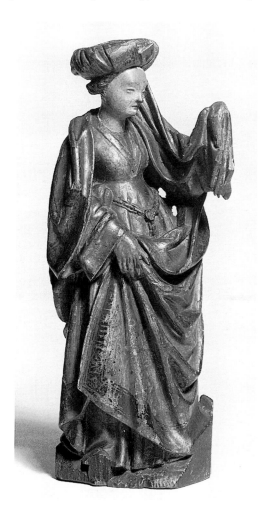

Figure 6. *Female Saint*, Fitzwilliam Museum,
M.6–1943

of Professor J. Q. van Regteren Altena, which is akin to the best roundels attributed to Dirck Vellert.[19] Quite exceptional, too, is another roundel of high quality representing a Soul before God, a fine Flemish work of *c.* 1480. It was acquired by the College in 1989 from the collection of the late Jean Lafond.[20] More glass, some of it unpublished, can be found elsewhere in Cambridge. The Fitzwilliam Museum, for example, has a small but select collection including a roundel of a wild man and woman probably dating from the fourth quarter of the fifteenth century.[21]

Flemish sculptures, too, are found in the Fitzwilliam Museum. Especially notable are three works given by Mrs Goetze in 1943 and representing, respectively, *Christ on the way to Calvary*, *St Christopher*, and a female saint, all

dating from the beginning of the sixteenth century. The first relief shows Christ fallen under the Cross which he carries on his left shoulder (fig. 5). He is being helped by Simon of Cyrene, who turns his back to the spectator.[22] That of St Christopher, which still has most of its polychromy, shows the saint, with the Child on his back, wading through a stream (fig. 8). This refers, of course, to the river he crossed with the increasingly heavy infant Christ on his shoulders.[23] The third sculpture, clearly from Mechelen, shows an unidentified saint holding her mantle with one hand and lifting the edge of her veil with the other (fig. 6).[24]

Among the decorative arts from the Marlay bequest mention must be made of a Tournai tapestry representing the *Adoration of the Magi* (fig. 9). The scene is set within a

19. Wayment, as in note 18, pp. 204–5, no. and fig. 51a. See also Timothy B. Husband, *Stained glass before 1700 in American collections: silver-stained roundels and unipartite panels* (Studies in the history of art, Monograph series, 1), Washington, 1991, p. 91.

20. Hilary Wayment, 'A collection of 17 pieces of stained glass', *National Arts Collections Fund Review*, 1991, pp. 174–5.

21. John Block Friedman, *The monstrous races in medieval art and thought*, Cambridge, Mass., 1981, pp. 200–1, fig. 58.

22. M. 7–1943: H. 49 cm; W. 36.4 cm; D. 7.8 cm. Antwerp School,

according to H. D. Molesworth (1951), former Keeper of Sculpture at the Victoria and Albert Museum.

23. M. 5–1943: H. 60.2 cm; W. 21.6 cm; D. 12.1 cm; probably from Antwerp.

24. M. 6–1943: H. 37 cm; W. 15 cm; D. 6 cm. The lettering around the edge of the mantle is purely decorative. For sculptures from Mechelen, see Willy Godenne, 'Préliminaires à l'inventaire général des statuettes d'origine malinoise, présumées des XVe et XVIe siècles', *Handelingen van de Koninklijke Kring voor Oudheidkunde, Letteren en Kunst in Mechelen*, 61, (1957), 1958, pp. 47–127, pls I–LVIII.

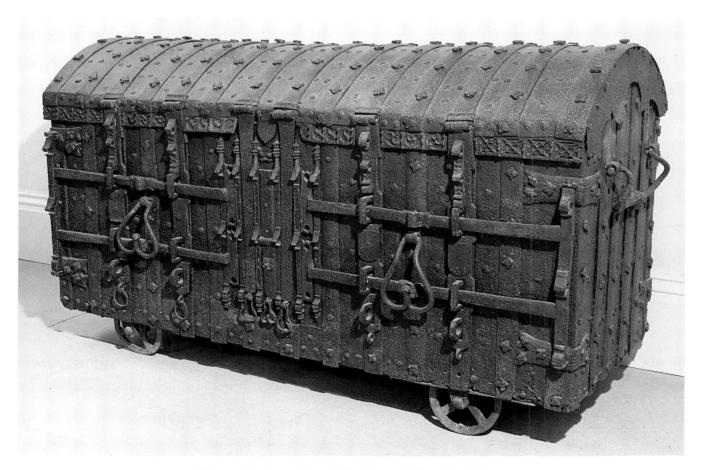

Figure 7. Iron-bound chest, Sidney Sussex College, Cambridge

gothic structure, with flowers in the foreground. The three Magi pay homage to the young infant on the lap of his mother. Melchior, the oldest, kneels on the ground. Behind him stand Balthasar and Caspar, the latter shown, in accordance with a late medieval tradition, as a Moor; to the right of the Virgin is St Joseph. The landscape in the background is full of detail, including a shepherd playing the bagpipes, a miller with his donkey and, between them, the Annunciation to the Shepherds. The tapestry is in excellent condition; the colours have not lost their intensity nor the faces their subtlety of modelling.[25]

Of great interest in Cambridge are two iron-bound chests of Flemish origin. The first and more handsome example was brought back from the Netherlands in 1618 by Samuel Ward, Master of Sidney Sussex College, who was an English delegate at the Synod of Dort (fig. 7).[26] It is not known when the second came to England, but it was in St John's College as early as 1605.[27] These chests, of so-called 'standard type', have wheels and wheel attachments quite similar to those of a famous Flemish example in the Gruuthuse Museum in Bruges.[28] The chest in St John's College is of wood covered with iron bands, the lid utilising the curve of the trunk. Metal bands are laid vertically and horizontally. On each side are handles made of metal strips attached to a ring. The trunk is raised on four iron wheels, each with three spokes. Most elaborate are the five hasps, four padlocks and four locks. There is also a bar which, when fixed, makes it impossible to move the hasps. Like the chest in Bruges, it dates from the second half of the fifteenth century.

Splendours of Flanders certainly does not emulate the large loan exhibitions organised earlier this century. Rather it aims to show to the visitor a selection of the extraordinary riches of Cambridge collections.

25. Mar. T. 30–1912. This tapestry is unpublished; 276.7 × 206 cm; with borders, 288 × 217 cm. For another tapestry of the same design and from the same workshop (274 × 216 cm), see Sotheby's, London, 13.12.1974, pp. 126–7, lot 223, illus. Bought by Mr Wilson Filmer from Durlacher in London in 1927; Lady Baillie; now Leeds Castle, Maidstone, Kent.

26. Michael Grant, *Cambridge*, London and Oxford, 1969, pp. 36–7, fig. 25, and p. 180, no. 25; Penelope Eames, 'Furniture in England, France and the Netherlands from the twelfth to the fifteenth century', *Furniture History*, 13, 1977, pp. 173 and 176.

27. Charles Ffoulkes, *Decorative ironwork from the XIth to the XVIIIth century*, London, 1913, p. 131, fig. 79; Eames, as in note 26, pp. 173 and 176. There is, in the archives of the College, a curious document, dated 'May 17 A⁰ Dⁿⁱ 1605', which describes the opening of the chest: 'The greate iron chest in the treasure house is thus opened:

1. The higher locke to the end next the streete, the senior dean's keye drawing backe the pegg westward as far as it will come, and liftinge upp the springe
2. To the locke under it the junior bursers key. first halfe put in, and then the whole key not turned round;
3. The middle locke the Mrs [Master's] whole key, first once turned and then the halfe
4. Key once turned; 4. the last locke of that side, the senior bursar's key
5. At eyther end of the chest there in a nayle to be turned out savewise, and then the presidents stopp key opene the locke at the east ende beeing put in as far as it can goe, and then turned aboute from northe to southe; the nayle next the courte wants a key
6. The little chests hanginge locke by the junior bursers key and the second locke by the Mrs [Master's] key.'

28. Eames, as in note 26, pp. 173 and 176, 175–6, no. 46, pl. 51.

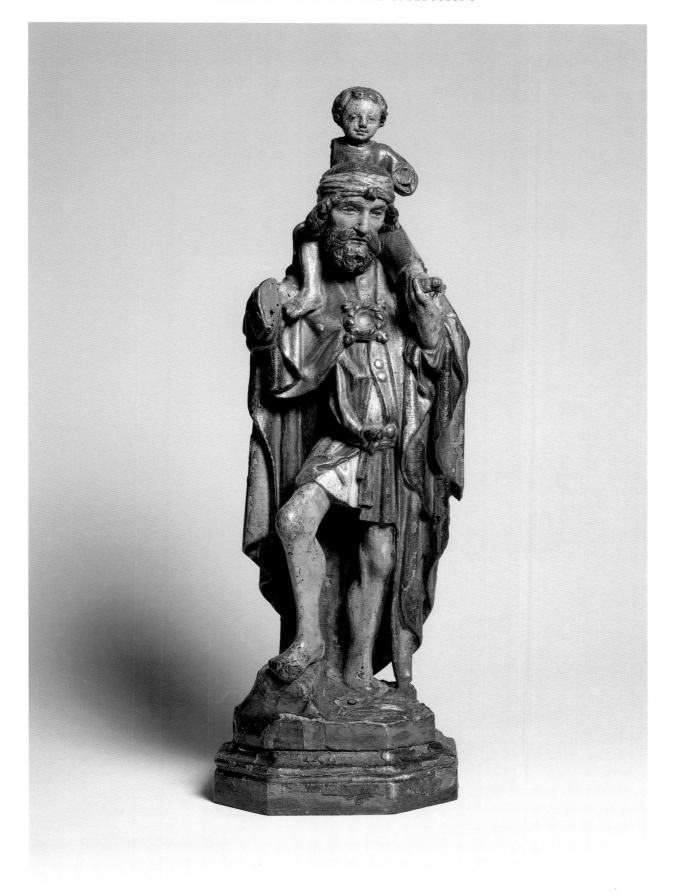

Figure 8. *St Christopher*, Fitzwilliam Museum, M.5–1943

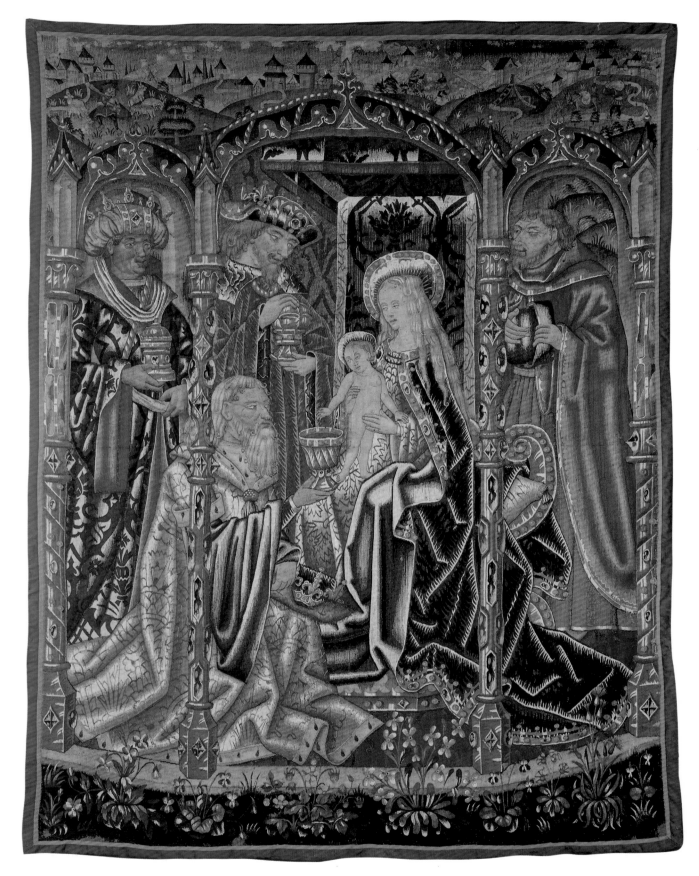

Figure 9. *Adoration of the Magi*, Tournai tapestry, Fitzwilliam Museum, Mar. T. 30–1912

CATALOGUE

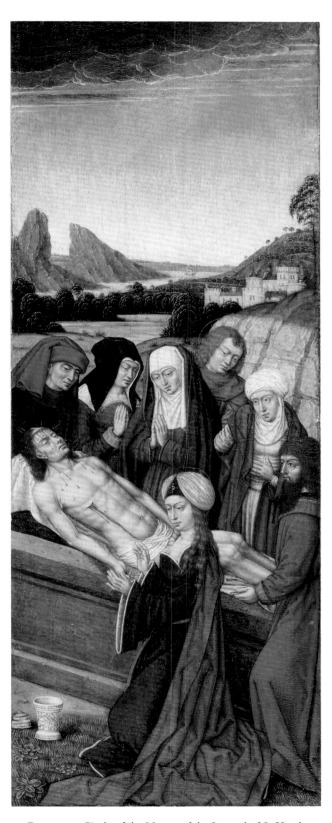

2, Circle of the Master of the Legend of St Ursula, *The Crucifixion*,
John G. Johnson collection, Philadelphia Musem of Art,
cat. nr. 322

Cat. no. 2a, Circle of the Master of the Legend of St Ursula,
The Entombment

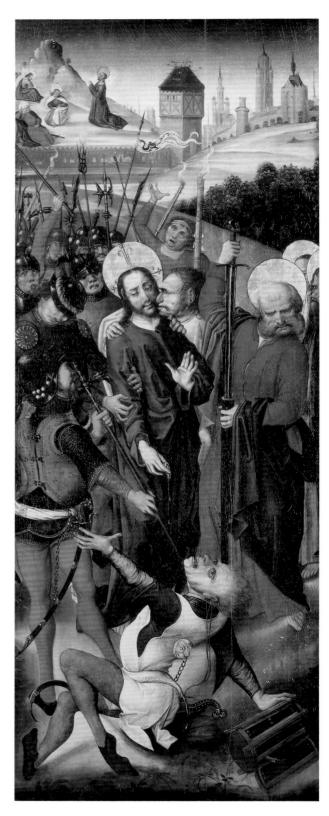

Cat. no. 1a, Master of the View of Sainte-Gudule, *The Betrayal,
with the Agony in the Garden*

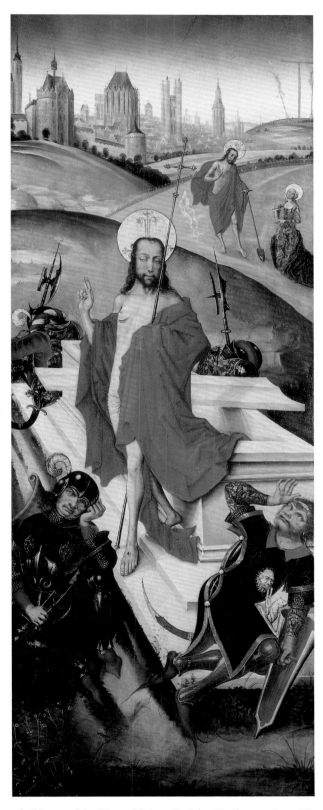

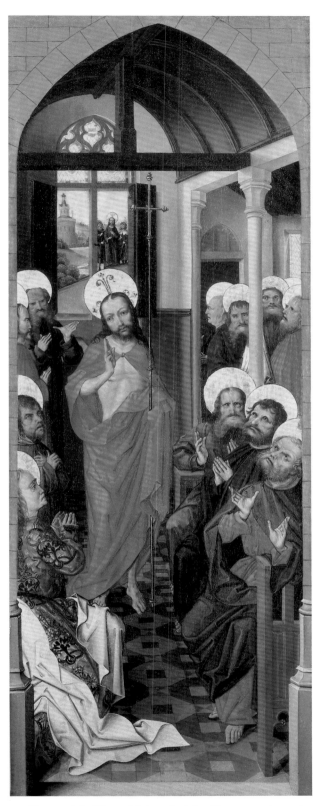

1b, Master of the View of Sainte-Gudule, *The Resurrection, with Christ appearing to Mary Magdalene*

1c, Master of the View of Sainte-Gudule, *Christ appearing to the Apostles, with the Pilgrims at Emmaus*

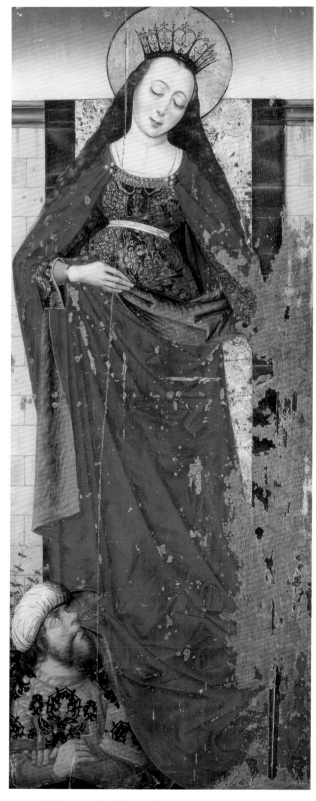

1d, Master of the View of Sainte-Gudule, *St Catherine*

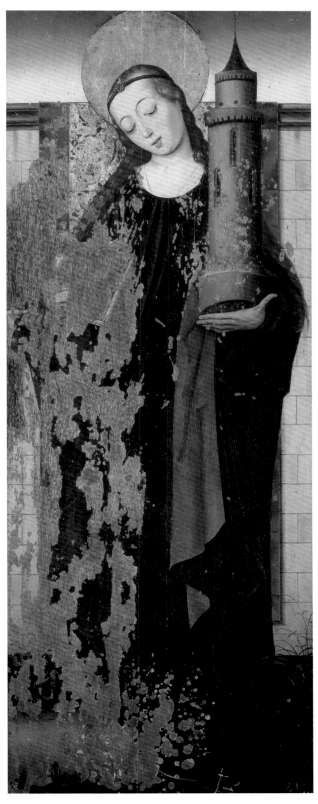

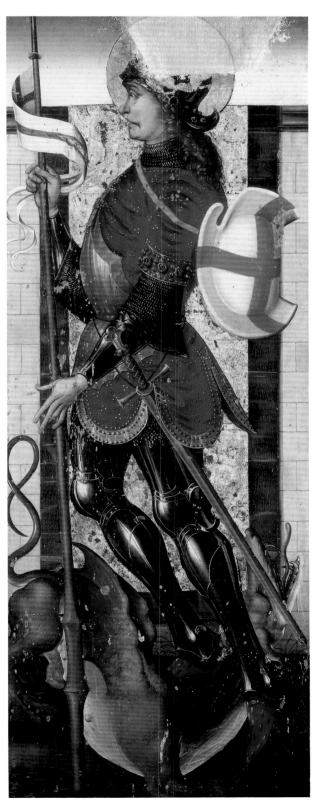

1e, Master of the View of Sainte-Gudule, *St Barbara*

1f, Master of the View of Sainte-Gudule, *St George*

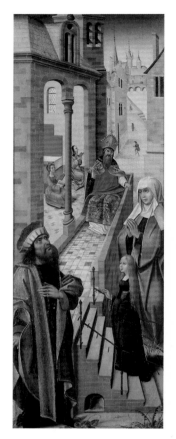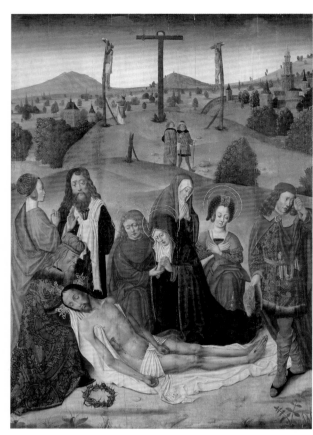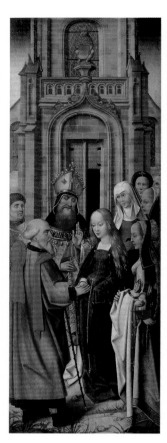

Cat. no. 3, Flemish School, triptych of *The Lamentation*, with *The Virgin presented to the Temple* and *The Marriage of the Virgin* on the wings

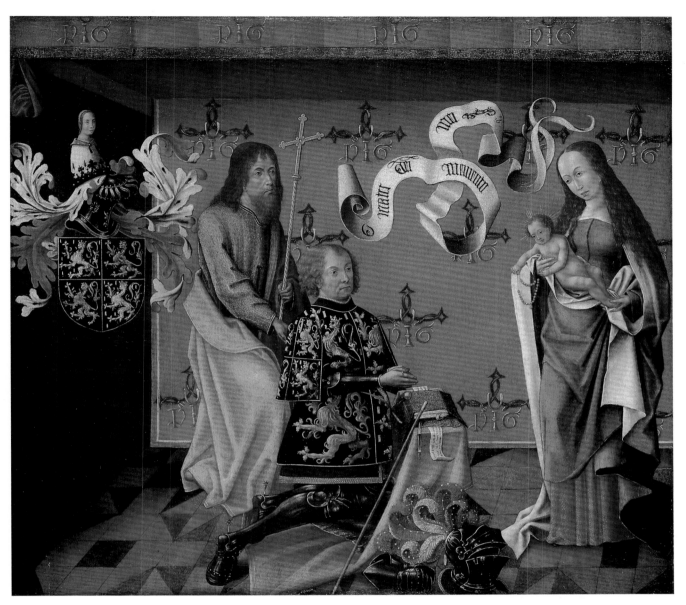

Cat. no. 4, Brabant School, *The Chevalier Philip Hinckaert, the Virgin and Child and St Philip*

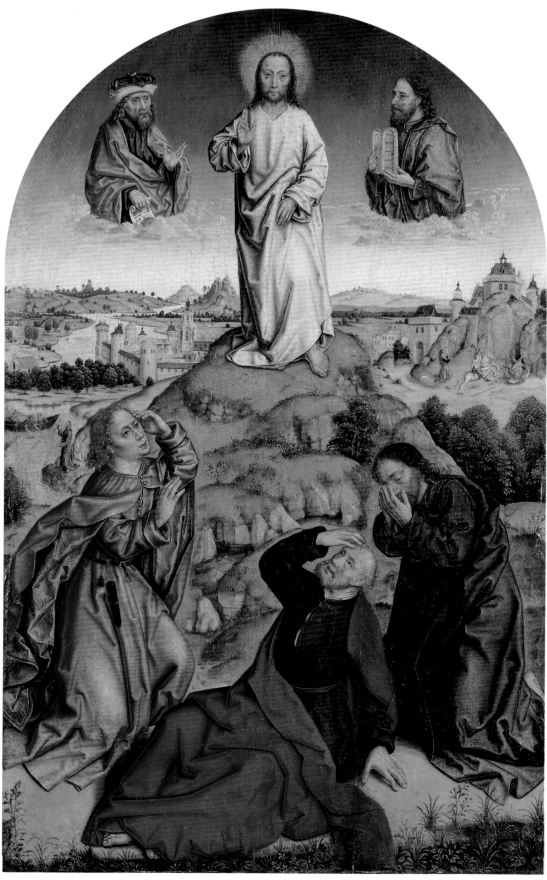

Cat. no. 5, Albert Bouts, *The Transfiguration*

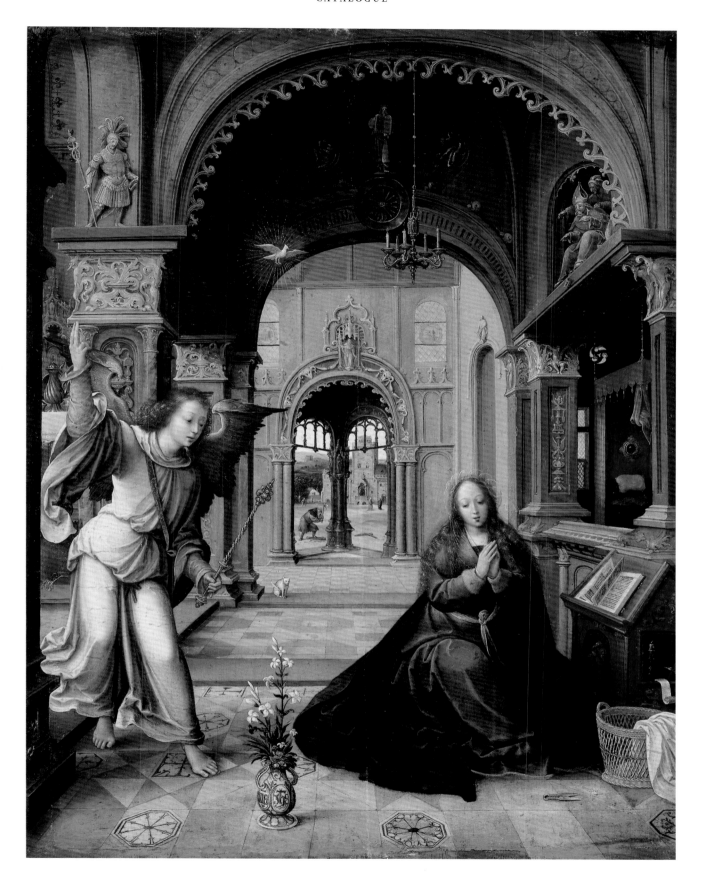

Cat. no. 8, Flemish School, *The Annunciation*

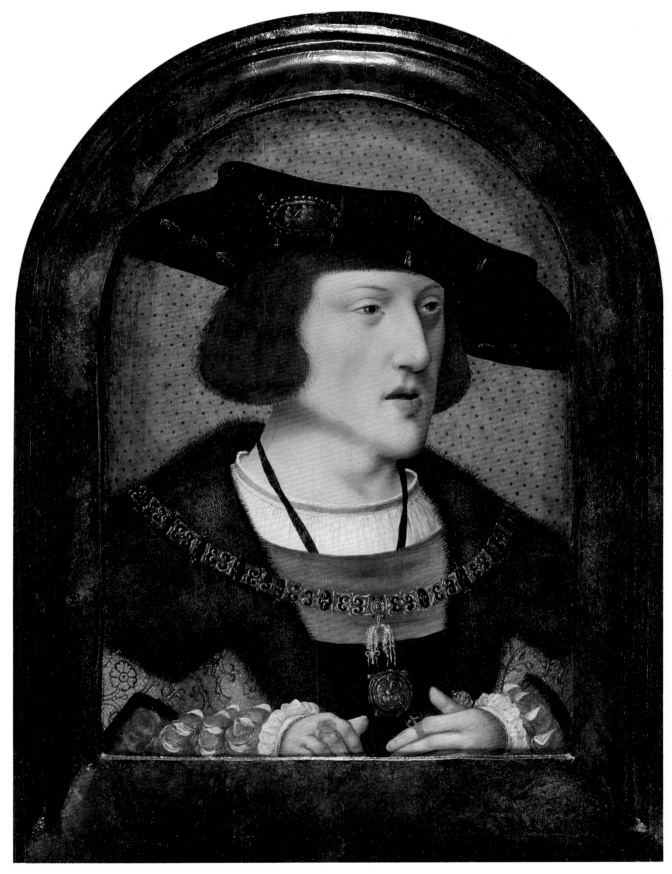

Cat. no. 9, Anonymous artist, perhaps after Bernard Van Orley, *Portrait of the Emperor Charles V*

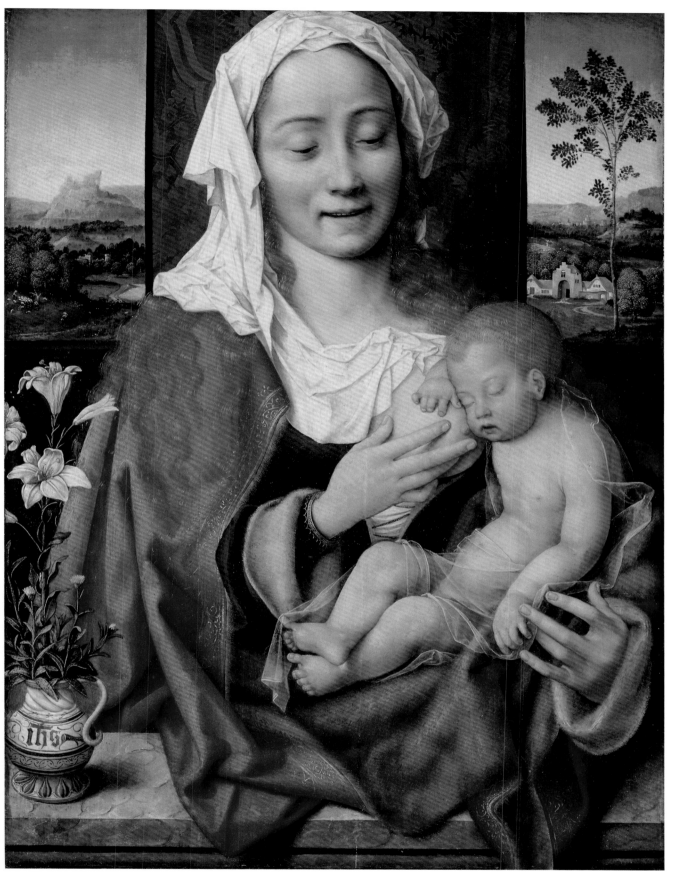

Cat. no. 11, Joos Van Cleve, *Virgin and Child*

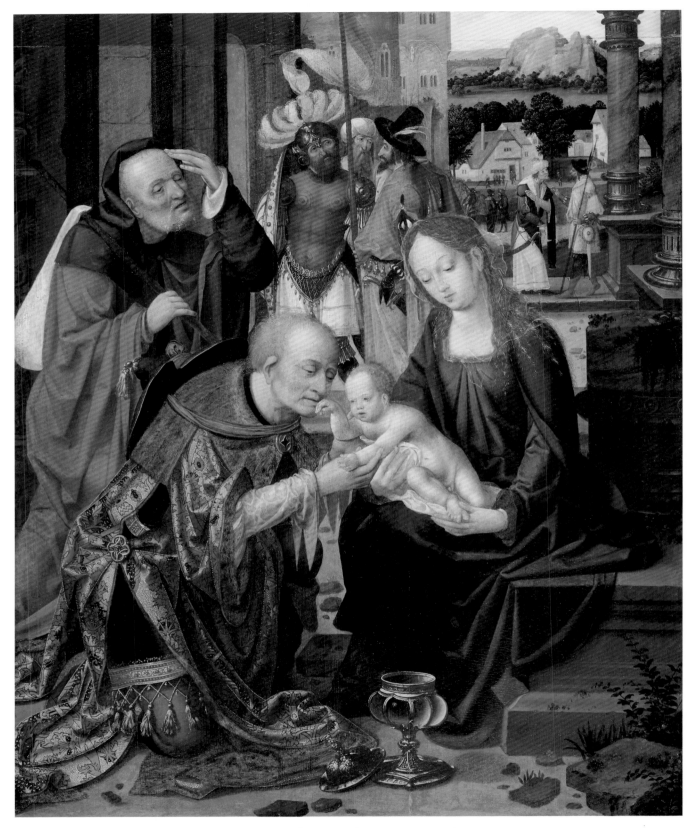

Cat. no. 12, School of Joos Van Cleve, *The Adoration of the Kings*

Early Netherlandish painting

Jean Michel Massing

The first quarter of the fifteenth century saw the transition from the so-called International Gothic style to a new realism exemplified by Robert Campin, the Van Eyck brothers and their followers. These were many: Rogier Van der Weyden and Petrus Christus, Dieric Bouts, Hans Memling and Gerard David, to mention only the most famous. Bruges and Ghent were the main centres, but also important were Tournai, Brussels, Leuven, and later Antwerp and Mechelen. In the Fitzwilliam Museum there are two fifteenth-century drawings after Campin: one represents *St Veronica* (cat. no. 14) while the other reflects the com-

position of the *Descent from the Cross* (cat. no. 15), of which only a fragment is known today.

Best represented in Cambridge collections, however, are paintings of the last quarter of the fifteenth and the first half of the sixteenth centuries. Most important perhaps are the three wings by the Master of the View of Sainte-Gudule (cat. no. 1), the anonymous *Annunciation* (cat. no. 8) and Joos Van Cleve's *Virgin and Child* (cat. no. 11), the last two works reflecting Renaissance tendencies. Least known without doubt is the Hinckaert panel (cat. no. 4).[1]

1. In the bibliography I have omitted museum handbooks and short lists, except for the earliest and the most important; later editions have been cited only when they added something of significance. Flemish paintings which are mentioned in the catalogue entries without any further reference can be found in the second edition of Max J. Friedländer's *Early Netherlandish painting*, under the appropriate artists. In all cases I have retained the traditional identification of the painters, although in many cases these attributions could be refined; works traditionally given to Adriaen Ysenbrant, for example, come from the numerous workshops which appear to have been influenced by his style. For those paintings which have been given conservation treatment at the Hamilton Kerr Institute of the Fitzwilliam Museum, University of Cambridge, further information concerning condition and in some cases painting technique can be found in the files kept at that Institute.

I

MASTER OF THE VIEW OF SAINTE-GUDULE

(a) *The Betrayal, with the Agony in the Garden*; (d) Reverse: *St Catherine*

Oil on panel, 154.4 × 61.2 cm

(b) *The Resurrection, with Christ appearing to Mary Magdalene;*

(f) Reverse: *St George*

Oil on panel, 154.9 × 61.2 cm

(c) *Christ appearing to the Apostles, with the Pilgrims at Emmaus*

(e) Reverse: *St Barbara*

Oil on panel, 154.8 × 61.3 cm

colour plates, pp. 22–5

Provenance: At least since 1741–52, Queens' College, Cambridge
References: Cambridge, Queens' College, MS. 75, folio 144r;
London, British Library, Add. MS. 23073, fol. 15r; Plumptre
1810, 2, pp. 341–2; Atkinson 1897, p. 384; Vertue 1938, p. 19;
Browne and Seltman 1951, pls. 110–13, with commentary;
Pevsner 1954, p. 116; Royal Commission 1959, 2, p. 170;
Spufford 1983, p. 7; Dubois 1987–8, esp. pp. 85–90, no. 12, figs.
72–6; Dubois 1989, pp. 44–5, 51, and 42, figs. 1–2; Massing
1991, pp. 690–3, figs. 22–9; Grössinger 1992, pp. 82–5, figs.
47–52

When he came to Cambridge in the mid eighteenth century,
George Vertue recorded in a notebook which begins in 1741 and
covers more than eleven years, 'large flat paintings in oyl after
the manner of Albert Dure representing several of Our Saviours
Miracles', in the Master's Lodge of Queens' College. 'A picture
of the Passion of our Sav.' kept in the gallery had already been
mentioned in an inventory of the President's Lodge (1717) made
at the death of Henry James, who was president of the College
from 1675 to 1717 (Cambridge, Queens' College, MS. 75, fol.
144r; I would like to thank Mrs C. D. Sargent for this reference).
The three paintings were also mentioned by Ann Plumptre
(1760–1818), the daughter of Robert Plumptre, President of the
College from 1760 until his death in 1788. In the second volume
of her *Narrative of a Three Years Residence in France* (1810), she
related them to four paintings of the Passion and Resurrection
of Christ in the cathedral of Saint-Sauveur in Aix-en-Provence:

Three of these were the exact counterpart of an old painting, the
friend, as it were, of my infancy, which long did hang, and I hope still
does hang, at the end of a gallery in the master's lodge at Queen's col-
lege, Cambridge. The picture was divided into three compartments;
and represented different parts of the passion, death and resurrection
of Jesus Christ; it was always reputed to have been the ornament of
some church in Catholic times.

Today the three panels representing the *Betrayal of Christ*, the
Resurrection, and *Christ appearing to the Apostles* with, respec-
tively, *St Catherine*, *St George* and *St Barbara* on their reverse,

are integrated into Frederick Bodley's design of the east end of
the new chapel (1890–1) of the College; according to T. D.
Atkinson (1897), they were transferred there from the old
chapel. Nothing is known about the early history of the panels
– the coat of arms (*Gules a fess argent*) in the tracery of the room
where Christ appears to the apostles is generic, simply relating
to the Habsburg family. In their *Pictorial history of . . . Queen's
College . . .*, Browne and Seltman (1951) tentatively attributed the
paintings to a painter called Schoene; they saw their 'coarseness
of conception, though not of execution', as characteristic of the
Cologne School. Nikolaus Pevsner (1954) described the panels
as South German, while the volume of the Royal Commission
on Historical Monuments saw them as Rhenish, probably from
Cologne. Less controversial is the dating, universally agreed to
be late fifteenth-century. My attribution of the panels to the
Master of the View of Sainte-Gudule has gained acceptance. In
her recent study of the Master, Hélène Dubois (1987–8) ranks
them among the thirteen works or groups of works which she
considers autograph.

In 1923, Max J. Friedländer coined the name of Master of the
View of Sainte-Gudule for an anonymous artist who worked in
Flanders in the last twenty years of the fifteenth century. That
he painted in Brussels cannot be doubted; he added a view of the
collegiate church of Sainte-Gudule in the background of his so-
called *Instruction pastorale*, a panel which probably represents St
Gery preaching, while Notre-Dame du Sablon appears in his
Portrait of a Man in the National Gallery, London, as well as in
his *Marriage of the Virgin* in Utrecht. He is also responsible for
painted wings of altarpieces with a definite Brussels origin. The
Master is often credited with a new, progressive approach in
reaction to the static style of the followers of artists like Rogier
Van der Weyden, Hugo Van der Goes or Memling. R.-A.
D'Hulst (1953) was the first to point to the link with Brussels
when he associated the artist with the painted wings of the Geel
and Strängnäs II altarpieces. Although the link with Strängnäs II
can no longer be accepted, the Passion altarpiece in Geel, which
seems to have been done in the artist's workshop, as well as

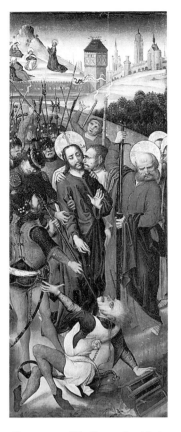

Cat. no. 1a, *The Betrayal, with the Agony in the Garden*

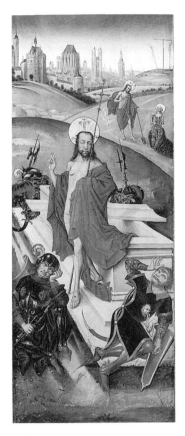

1b, *The Resurrection, with Christ appearing to Mary Magdalene*

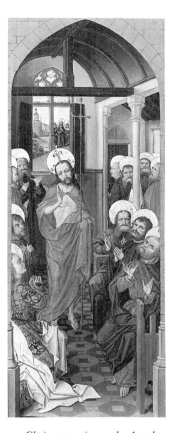

1c, *Christ appearing to the Apostles, with the Pilgrims at Emmaus*

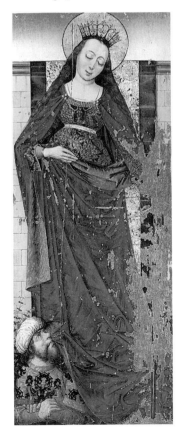

1d, *St Catherine*

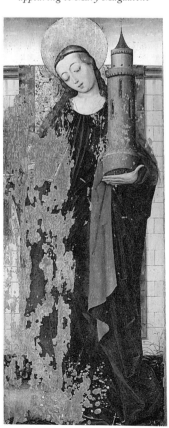

1e, *St Barbara*

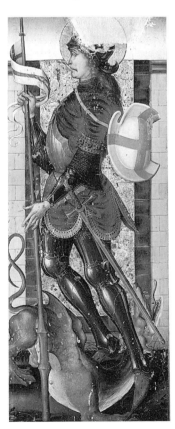

1f, *St George*

another at the Bowes Museum, Barnard Castle, provide valuable information about the original disposition of the Queens' College panels. These altarpieces have a sculpted corpus (or *huche*) with two painted panels on either side, as well as another smaller pair to cover the upper part. Their large wings showed the Passion of Christ, from the Agony in the Garden on the left, to Christ's Appearance to the Apostles on the right. The first panel of the Queens' altarpiece has the *Agony in the Garden*, with the Betrayal of Christ in the background. The next panel is lost; it would probably have shown Christ before Pilate, as on the Barnard Castle altarpiece. The scenes from the sculpted corpus would have shown the Passion, from the Flagellation to the Deposition (as at Geel) or the Entombment (as at Barnard Castle). The narrative continued on the two wings still extant, with the *Resurrection and Christ appearing to Mary Magdalene* on the first, followed by *Christ appearing to the Apostles*, with the pilgrims at Emmaus in the background. When closed, the altarpiece displayed, from left to right, a male (?) saint in profile (perhaps St Adrian, as in Geel), then St Catherine, St Barbara, and finally St George – all saints who are stock characters in the production of the Master of Sainte-Gudule and his workshop (see for example St Barbara and St Catherine on the exterior of the wings of a Passion altarpiece in the Musée des Arts Décoratifs in Paris).

The three wings in Cambridge show the Master as one of the most innovative artists in the Flanders of his time. This is especially apparent from the interior of the wings which are in excellent condition (the outer sides have large areas of paint losses; also a piece of wood has been inserted at the top of the panel with the Resurrection on one side and St George on the reverse). The Master built up his composition from an underlying drawing which is still visible in some areas, working in the traditional Netherlandish technique, glaze over glaze. This is particularly evident in the subtlety of tone which he used for the city of Jerusalem in the background of the Resurrection (the choir of Cologne Cathedral is probably represented here, as in other works by the Master; see Veronee-Verhaegen 1992, pp. 184–5 and figs. 3a–4c). Sometimes he painted with more boldness, as in the case of the hills where Christ appears to Mary Magdalene. There, a single thick stroke sometimes defines both form and colour. The compositions reflect an interest in narrative; attitudes are vivacious and expressive and gestures vigorously articulated. Exceptionally striking, perhaps, are the caricatured features of the Jews and other enemies of Christ: also the graphic rendering of the sleeping soldiers in the Resurrection and the manneristic effect of light and colour, as on the tunic of Malchus. The expressionistic qualities of his art seem to have been stimulated by German engravings.

The original location of the Queens' altarpiece is not known; it was certainly not Queens' College, as, when fully opened, it was wider than the old chapel. It was probably in England at the time of the Reformation, as it seems very unlikely that the panels were purchased between that event and 1741–52 (or, perhaps even 1717), when they were seen by Vertue. The altarpiece may have been sent directly in the late fifteenth century, like the triptych painted by the Master of the Magdalene Legend, a Brussels contemporary of the Master of Sainte-Gudule, for Christopher Knyvet and his wife Catherine, of Ashwellthorpe, Norfolk (Norwich, Castle Museum).

Lent by the President and Fellows of Queens' College, Cambridge JMM

1g, Reconstruction of the altarpiece, open

1h, Reconstruction of the altarpiece, closed

CIRCLE OF THE MASTER OF THE LEGEND OF ST URSULA

(a) *The Entombment*; Reverse: (b) *The Virgin of the Annunciation*

Oil on panel, 32.5 × 13 cm

colour plate, p. 21

Provenance: Wynn Ellis (sold Christie's, London, 27.5.1876, p. 8, lot 48); bought Sir Henry Thompson, Bart.; his son, Sir (H. F.) Herbert Thompson, Bart.; his gift to the Fitzwilliam Museum, 1929 *Accession no.* 1518a, 1518b
References: Goodison 1930, pp. 89–91, pls. B and D; Cambridge 1960, pp. 78–9, nos. 1518a–1518b, ill. pl. 38; Marlier 1964, p. 38, no. 35; Philadelphia 1972, pp. 59–60, no. 322; Wright 1976, p. 130; Levine 1989, pp. 69–70, 79–82 and 257–9, nos. N1b and N1a

This little oblong panel made of one piece of wood represents the *Entombment* on one side and the *Virgin of the Annunciation* on the reverse. J. W. Goodison (1930) identified it as the right shutter of an altarpiece of which the left wing shows the *Crucifixion* and, on the back, the *Angel of the Annunciation* (John G. Johnson collection, Philadelphia Museum of Art, cat. nr. 322). The central panel, which may have represented a *Descent from the Cross* or a *Lamentation*, is lost. When closed, the altarpiece displayed the *Annunciation* set in a niche and painted in grisaille. The angel holds a staff and greets the Virgin with the words 'Ave gratia plena d[omi]n[u]s tecum' (Luke 1.28) which form the opening of the 'Hail Mary'. When opened, the *Crucifixion* on the left wing showed Christ on the Cross between St John and the Virgin on one side, and on the other the Magdalene, who embraces the cross, and an unidentified nimbed saint with a crosier. Jerusalem is seen in the background; black clouds have gathered above Golgotha, to illustrate the darkening of the sky of the Gospels (Matthew 27.45; Mark 15.33; Luke 23.44). On the right panel – the little painting in Cambridge – is *Christ's Entombment*. His body is slowly lowered in the sarcophagus by Joseph of Arimathea and Nicodemus who hold, respectively, his head and his feet according to tradition. The Magdalene kneels in the foreground, with her pot of unguent on the grass beside her. She has evidently used its contents to anoint Christ's corpse. John and the Virgin appear too, as on the left panel, as well as the two Holy Women, Mary Cleophas and Mary Salome.

The Cambridge panel was cleaned and restored in 1982 at the Hamilton Kerr Institute. The surface to be painted with the Virgin of the Annunciation was chiselled out initially so that a frame remained, 5 mm in relief; tool marks are visible on the left side of the angel, under the scroll. A chalk ground was then brushed over both panel and frame in preparation for the paint layer. On the side of the *Entombment*, four strips of moulding were glued and attached with wooden nails to the panel to create a more conventional frame. Several nail holes on the left still indicate where hinges were attached. The paint layer is in good condition except for small losses along the numerous splits in the wooden panel and larger losses in the sky over the *Entombment*.

When it appeared in a London sale in 1876, the panel was attributed to Memling. The Philadelphia panel was attributed to Petrus Christus before it was judged by Valentiner (1913, p. 7 no. 322, ill. p. 200), to be from Bruges (about 1480); the 1941 catalogue of the Johnson collection attributed it to a follower of Rogier Van der Weyden. Goodison (1930), connected the two wings with the Master of the Legend of St Ursula (about 1495), a hypothesis he restated more firmly in the Fitzwilliam Museum catalogue (1960), proposing a stylistic link with the two shutters of an altarpiece with scenes from the legend of St Ursula in the Groeninge Museum in Bruges; the *Annunciation* painted in grisaille on the reverse of that altarpiece is quite close to the Cambridge/Philadelphia *Annunciation*; the formula, in fact, probably derives from Memling whose more sophisticated depiction, also in grisaille, appears on the outside of an altarpiece commissioned in Bruges by Heinrich Greverade, a merchant from Lübeck, in 1491. Representations of the *Annunciation* in grisaille on the outside of altarpieces are common; the tradition can be traced back to the Van Eyck brothers. The attribution of the two wings to the Master of the Legend of St Ursula remains problematic; Levine (1989), for example, has stressed significant discrepancies in style. His study of the underlying drawing also points to another artist, as yet anonymous. The two panels, in fact, seem to be by the same hand as a triptych owned by the Silbermann Galleries, Inc., of New York in 1963 (see Winston-Salem 1963: with an attribution to a French Master of about 1470 made by Max J. Friedländer in 1948). The central panel has *Christ in Heaven* surrounded by various saints holding scrolls inscribed with the *Credo* prayer. The left wing shows the *Last Judgement*, the right, the *Worshipping of the Golden Calf*, with Moses on Mount Sinai and the fall of the manna in the background. The *Annunciation* (with a scroll inscribed AVE GRATIA PLENA DOMINUS TECUM) is painted in grisaille on the outside of the wings.

Fitzwilliam Museum, Cambridge · · · · · · · · · · · · · · · JMM

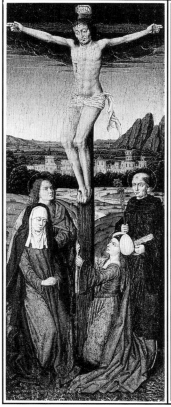

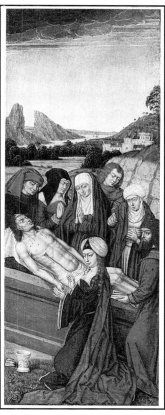

2, Circle of the Master of the
Legend of St Ursula, *The
Crucifixion*, John G. Johnson
collection, Philadelphia
Museum of Art, cat. nr. 322

Cat. no. 2a, Circle of the Master
of the Legend of St Ursula, *The
Entombment*

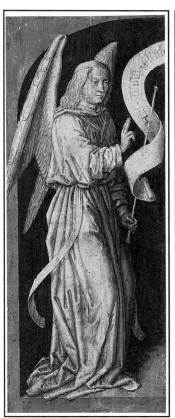

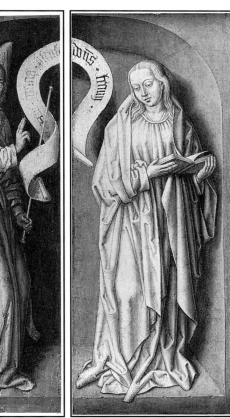

2, Circle of the Master of the
Legend of St Ursula, *The Angel
of the Annunciation*, John G.
Johnson collection, Philadelphia
Museum of Art, cat. nr. 322

2b, Circle of the Master of the
Legend of St Ursula, *The Virgin
of the Annunciation*

3

FLEMISH ARTIST, EARLY SIXTEENTH CENTURY

Triptych of *The Lamentation*, with *The Virgin presented to the Temple* and *The Marriage of the Virgin* on the wings

Oil on panel, 99.5 × 70.8 cm (for the central panel); 100.3 × 37.2 cm and 100.3 × 36.8 cm (respectively for the left and the right wings)

colour plate, p. 26

Provenance: Charles Brinsley Marlay; his bequest to the Fitzwilliam Museum, 1912 *Accession no.* M. 25
References: Constable 1927, pp. 24–5, no. 25, pl. xv; Cambridge 1960, pp. 40–1, no. M. 25, pl. 20; Wright 1976, p. 147

The central panel of this triptych illustrates the *Lamentation over the Dead Christ*. The three crosses, with the two thieves still hanging on them, are shown on Golgotha, within a landscape which includes a Flemish-looking Jerusalem to the right. The richly dressed Joseph of Arimathea supports Christ's head; a young man also clad in expensive garments and presumably Nicodemus is at his feet. Behind the corpse the Virgin kneels in prayer, supported by St John. The two Holy Women, Mary Cleophas and Mary Salome, are also shown, the latter (?) in conversation with a bearded man who is holding the nails in a cloth in his left hand. Mary Magdalene is close to Christ's feet as a reminder of the famous occasion in Luke 7.38, when a sinner came and 'began to wash his feet with tears, and wiped them with the hair of her head, and kissed his feet, and anointed them with the ointment', a passage which Catholic tradition always related to Mary Magdalene. In the left wing, the youthful Virgin leaves her parents Ann and Joachim to ascend the steps into the Temple, where, according to the Apocryphal Gospels, she spent her adolescence, while two young girls are seen inside the Temple. The High Priest greets her at the entrance. On the other wing is a represention of the wedding of the Virgin with Joseph. The betrothal, in the form of the *dextrarum junctio*, is blessed by the same High Priest. The Virgin has a number of female companions, her fellow students from the Temple, and on the other side is an unidentified man who could be one of the unsuccessful suitors.

Not much is known about the artistic context of the triptych. Max J. Friedländer, in the catalogue of the Marlay bequest, is recorded as having suggested that it was executed, *c.* 1510, by a Brussels painter, while the 1960 catalogue of the Fitzwilliam Museum connects it with the work of the Master of the Orsoy Altarpiece, an anonymous follower of Colijn de Coter who painted the shutters of an altarpiece in Orsoy (Périer-D'Ieteren 1984, pp. 34–6 and 47–9, p. 161, figs. E29a and b). Although the triptych was probably also done in Brussels, the relationship with the Master of the Orsoy Altarpiece cannot be accepted. An interesting compositional parallel exists with one of the wings of an altarpiece from the Abbey of Afflighem near Alost which shows the *Presentation of the Virgin to the Temple* along with an *Annunciation* (Périer-D'Ieteren 1984, pp. 19–20 and 25–7, p. 151, figs E15–E16). Other characteristics recall the paintings of the Master of the Tiburtine Sibyl, an anonymous follower of Dieric Bouts; the triptych, however, is clearly not by him.

Owing to its delicate condition the triptych could not be moved from the gallery in which it is normally displayed. Before its arrival at the Fitzwilliam Museum in 1912, the original panel was trimmed down to 1 mm and a cradle applied; this has caused structural deformations which are now obvious.

Fitzwilliam Museum, Cambridge JMM

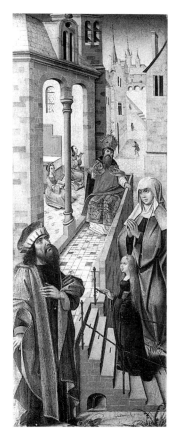
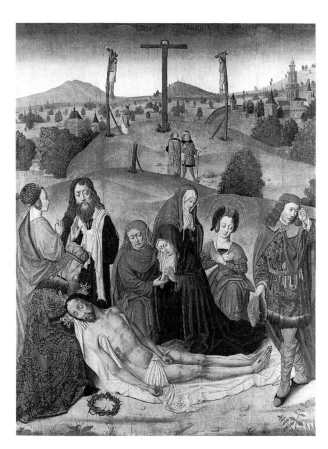
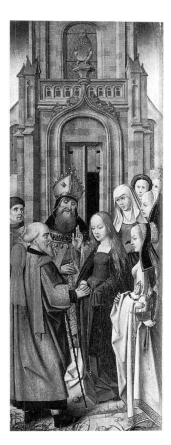

Cat. no. 3, Flemish artist, triptych of *The Lamentation*, with *The Virgin presented to the Temple*
and *The Marriage of the Virgin* on the wings

4

BRABANT SCHOOL

The Chevalier Philip Hinckaert, the Virgin and Child and St Philip

Oil on panel, 66.2 × 73 cm

colour plate, p. 27

Provenance: Walter Metcalfe; unidentified Essex parish church; returned to Walter Metcalfe by 1887; by 1902, Martin Colnaghi; by 1906, Charles T. D. Crews, London (sold Christie's, London, 1–2.7.1915, p. 43, lot 184); probably Charles B. O. Clarke, by whom bequeathed in 1935 to Louis Colville Grey Clarke; his bequest to the Fitzwilliam Museum, 1960, received 1961
Accession no. PD.19–1961
References: Green 1887, pp. 72–80, pl. XI; Bruges 1902, p. 14, no. 31; Temple 1906, pp. 41–2, nos. 34 and 39, fig. 39; Conway 1921, pp. 156–7; Birmingham 1936, p. 128, no. 879; London 1936, pp. 57–8, no. 133; London, 1953–4, p. 35, no. 109; Bergen-Pantens 1967, pp. 213–17; Wright 1976, p. 147

This painting may originally have formed the right wing of a diptych of which the left side represented *Calvary*, with Christ Crucified between the Two Thieves. The relationship between the two panels then in the collection of T. D. Crews was, however, called into question when the diptych was displayed in the famous exhibition of early Flemish paintings held in Bruges in 1902. In 1921 Sir Martin Conway described the *Crucifixion* as 'a rude and painful work' with figures taken directly from Rogier Van der Weyden. The poor quality of that panel may explain why the diptych was sold in two lots when the Crews collection was auctioned in 1915. The panel showing Hinckaert (lot 184) entered the collection of Louis C. G. Clarke, Director of the Fitzwilliam Museum from 1937 to 1946. The whereabouts of the *Crucifixion* (lot 185) is not known.

Philip Hinckaert kneels in front of the Virgin, with St Philip, his patron saint, behind him. Hinckaert is dressed in an armoured tabard worn over a shirt of mail; his arms are protected by avant-bras and condières, his legs by cuissards, genouillères and greaves. The shoes are clearly shown, together with the long-necked spurs. Hinckaert wears a sword but his helmet with its red and white plume and his gauntlets lie on the floor nearby. He kneels on a prie-dieu covered with a pink-red drapery. His prayerbook is laid in front of him, upon a strip of parchment covered with inscriptions which unfortunately remain illegible. Next to him a staff tipped with ivory may refer to a court office. Behind him is St Philip, his patron saint; the Virgin, who is the

object of his devotion, stands in front, the Child holding a rosary of red coral. As is appropriate she and the Child seem to look at him though he himself cannot see them. The whole approach is strongly decorative, with contrasting patterns formed by the pavement of white and coloured marble, the red hanging with a green fringe embroidered with devices and the canopy of the same colour. The emphasis is heraldic, with a large coat of arms painted on the left apparently 'floating' on the surface of the picture. The shield is quarterly, and surmounted by a crest. The quarters (1 and 4, *Sable, billetée a lion rampant argent crowned or*; 2 and 3, *Sable, a lion rampant or*) are those of the Hinckaert family, as found, for example, on a tomb in the church of Betekom near Brussels (see also Rietstap 1884–1954, I, p. 955 and Plates, 3, pl. CCI, s.v. Hinckaert). The crest too – a maiden's head over a floriated crest-coronet – is part of the family arms. His device, as well as the personal monogram, allows a definite identification of the knight, the letter P. standing for Philip, and G. for Gertrude, his wife. Not much seems to be known about the couple apart from the fact that Philip was *maître d'hôtel* to Philip the Handsome between 1493 and 1504. Hinckaert married his second wife, Gertrude van de Vuecht, in 1494. He died in 1505 and was buried in Steenockerzeel. Gertrude may have commissioned the panel at this date or shortly afterwards.

Better known was his ancestor, the Chevalier Gerrelin, alias Hinckaert, who was married to Margaret Van Mechelen. Gerrelin was lame and prayed to the Virgin, *O Mater Dei memento mei* for help; one day her answer came: *Marche droit Hinckaert*, with which he was cured. The miracle led to the family taking over the words of the Virgin as their motto and keeping the name of Hinckaert (from *hinckaerdt* – somebody who limps). A wooden leg is part of Philip's device, together with a heraldic knot formed with the leather strap used to fasten the peg to the stump. This also explains the inscription written in gothic lettering on the scroll (*O mater Dei memento mei*), which constitutes Philip's prayer. The painting is a striking example of late gothic art, even if there is an obvious tension between the heraldic and decorative elements and any attempt to achieve a homogenous space.

Fitzwilliam Museum, Cambridge JMM

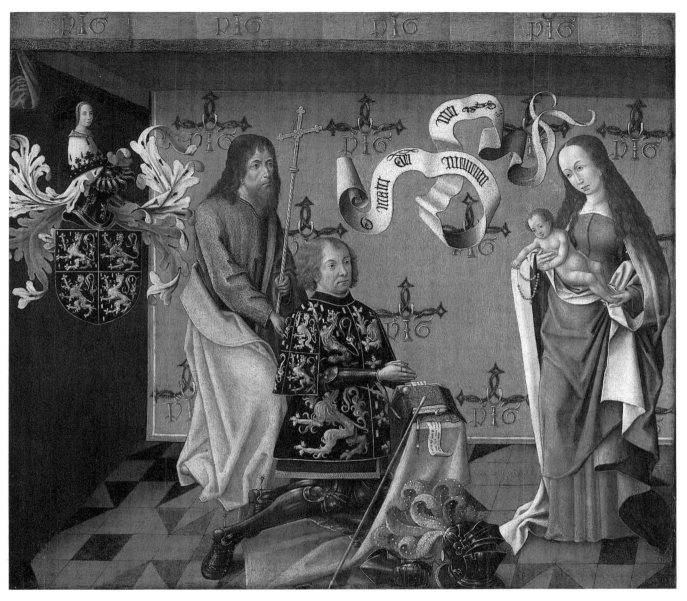

Cat. no. 4, Brabant School, *The Chevalier Philip Hinckaert, the Virgin and Child and St Philip*

5

ALBERT BOUTS

The Transfiguration

Oil on panel, 73.3 × 46 cm

colour plate, p. 28

Provenance: Probably Francis Radclyffe-Livingstone-Eyre, styled 6th Earl of Newburgh; his second son, Francis, styled 8th Earl; given by him to Father Bostock, of Leicester; the latter's housekeeper, who sold it to a dealer in Lincoln; bought there by Richard Ellison; his gift to the Fitzwilliam Museum, 1857
Accession no. 99
References: Colvin 1895, p. 39, no. 99; Earp 1902, p. 128, no. 99, fig. 99; Principal pictures 1912, p. xiv, no. 99, ill. p. 103; Friedländer 1925, 3, p. 115, no. 48; Schöne 1938, pp. 149, n. 1.3, and 195, no. 103*; London 1953–4, p. 21, no. 45; Cambridge 1960, pp. 8–9, no. 99, pl. 5; Friedländer 1968, 3, pp. 40 and 65–6, no. 48, pl. 63; Wright 1976, p. 24

The *Transfiguration* is mentioned in the synoptic Gospels (Matthew 17.1–13; Mark 9.1–12 and Luke 9.28–36). Closest to the painting is Luke's account:

And it came to pass . . . that he took Peter and James and John, and went up into a mountain to pray. And whilst he prayed, the shape of his countenance was altered: and his raiment became white and glittering. And behold two men were talking with him. And they were Moses and Elias, appearing in majesty. And they spoke of his decease that he should accomplish in Jerusalem. But Peter and they that were with him, were heavy with sleep. And waking, they saw his glory, and the two men that stood with him.

Albert Bouts shows Christ surrounded by a radiant nimbus and wearing a white robe; he stands on the mountain between the two prophets mentioned by the Gospels shown as heavenly apparitions as half-length figures in the clouds: Elias with a scroll, and Moses with the tablets of the Law. In the foreground can be seen the three apostles; from left to right John, Peter and James. The calling of Simon (called Peter) and Andrew is shown on the left; Jesus stands on the edge of the sea of Galilee, while the two brothers are in their boat, casting nets into the sea. Pentimenti show that the artist originally represented the Baptism of Christ here, but this scene was later overpainted. On the right St George can be seen killing the dragon to rescue the princess.

When it was first listed in 1895, the panel was attributed to the Master of the Brussels Assumption – that is to say probably Albert Bouts, the second son of Dieric Bouts, the famous painter of Leuven. Albert was likewise active in that town where he is first mentioned in 1473. His date of birth is not known, but he was still under age (i.e. under 25) in December 1476. He was married to Maria Cocx by May 1481; after her death he married Elisabeth de Nausnydere. He died, old and affluent, in 1548. The Leuven historian Molanus mentioned that he painted an altarpiece of the *Assumption of the Virgin* for the chapel of the Virgin at Leuven, a work now identified with a triptych in Brussels (see Wéra 1951, pp. 139–44). This work, together with signed *Annunciations* respectively in Munich, Berlin and Stockholm, constitutes the basic evidence of the artist's style. The *Transfiguration* is clearly by his hand; like other works of his, it has a rounded top. The composition is restless, with dramatic animation. The landscape is rendered with precision, and trees and bushes are clearly individualised though not necessarily botanically specific. The town is full of anecdotal detail, as in other works by the master (for these characteristics, see Friedländer 1968, 3, p. 39).

The support is an oak panel composed of three vertical pieces. Richard Ellison, in a letter of 1857, specified that he acquired the painting 'from a picture restorer in Lincoln who had found it broken in two pieces and "black as my hat" in a cupboard'. Several extensive retouches can be seen along the joints; a *Malrand* is also visible.

The position of John in the foreground is almost identical to the figure of Moses on a shutter showing the scene of the *Burning Bush* (San Antonio, Marion Kogler McNay Art Institute). There is no evidence, however, as claimed by Schöne, that the composition of the *Transfiguration* is based on a lost work by Hugo Van der Goes and, ultimately, on a prototype devised by Dieric Bouts. More relevant, perhaps, is a panel by Gerard David in Bruges which also shows the *Transfiguration* (Friedländer 1971, 6b, p. 103, no. 184, pl. 195).

Fitzwilliam Museum, Cambridge JMM

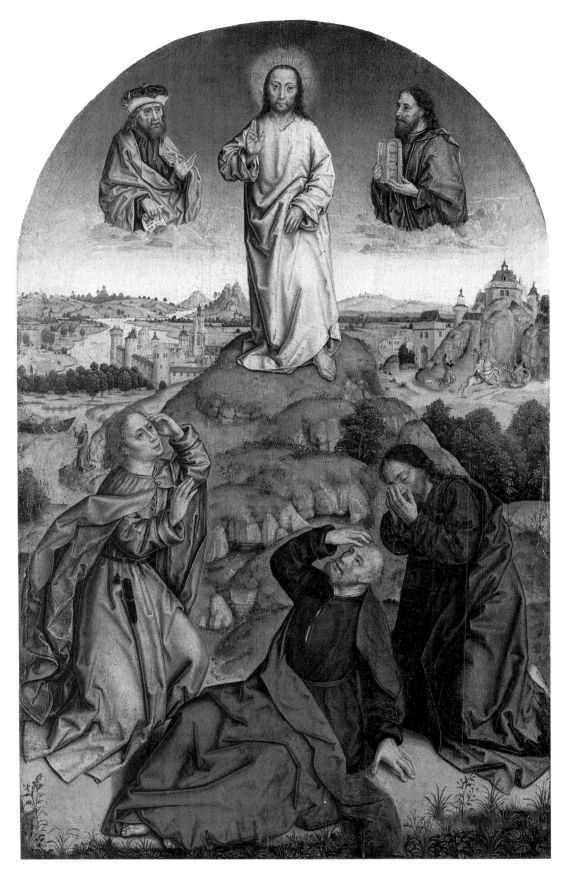

Cat. no. 5, Albert Bouts, *The Transfiguration*

6

FLEMISH SCHOOL

(a) *St Catherine of Alexandria*

Oil on panel, 86.7 × 32 cm

(b) *St Barbara*

Oil on panel, 87 × 32.3 cm

Provenance: Anonymous owner (sold Christie's, London, 12.7.1912, p. 14, lot 58); bought Messrs. Pawsey and Payne, London; sold by them to Leonard Daneham Cunliffe; his bequest to the Fitzwilliam Museum, 1937 *Accession no.* 2307, 2308
References: Cambridge 1960, p. 40, nos. 2307 and 2308; Wright 1976, p. 147

The two panels representing St Catherine and St Barbara were probably originally wings of a triptych. The central panel, which must have been of a rather uncommon shape, probably showed the *Virgin and Child*, with additional figures. On the left shutter St Catherine is represented seated, wearing a rich dress of red brocade with blue hanging sleeves. She has a book open on her lap and, as attributes, a sword and a ring. She is crowned, for she was meant to be the daughter of a king. The ring relates to her mystical wedding, the sword to her martyrdom. So do the little scenes in the rocky background, that on the left representing her in prayer in front of the wheel with iron spikes on which she was to be executed, but which was destroyed by an angel, and that on the right showing the episode of her beheading. St Barbara, on the right wing, sits facing St Catherine. She, too, reads a book, and holds a peacock feather. This alludes to the fact that the twigs with which she was beaten by her father were transformed into peacock feathers. In the background can be seen the construction of the tower in which she was imprisoned. Barbara's father can be seen threatening to lock her up there if she does not renounce Christianity, while on the other side is a woodcarver working on a column. Because both saints were said to have studied the Christian religion at an early age, and because St Catherine came from Alexandria, a city famous for its scholarly tradition, Catherine and Barbara were often seen as protectors of schools and students. They were, in fact, particularly popular as they were two of the Fourteen Intercessors. With St Dorothy and St Margaret they were also known as the *quatuor virgines capitales*. They are commonly found together, as here: for example, on wings of altarpieces by the Master of St Sang and the Master of 1518; or on others by Jan Provost, Joos Van Cleve and Jan Gossart (the two panels in the Fitzwilliam Museum were attributed to Jan Gossart in 1912, probably because of this). The saints, however, are elsewhere shown seated only in paintings by the Master of the Embroidered Foliage (Friedländer 1969, 4, p. 100, pl. 111, Supp. 129) and the Master of Frankfurt (Friedländer 1971, 7, p. 77, nos. 136 and 136a, pl. 106). Their work certainly suggests a plausible context for the Fitzwilliam Museum panels which were probably also done in the first quarter of the sixteenth century.

Fitzwilliam Museum, Cambridge JMM

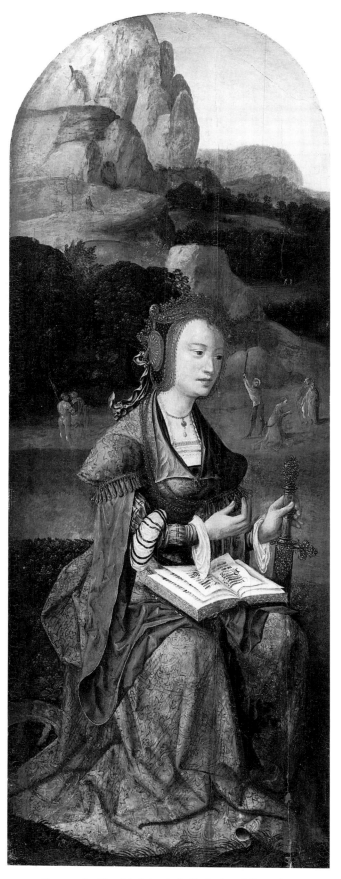

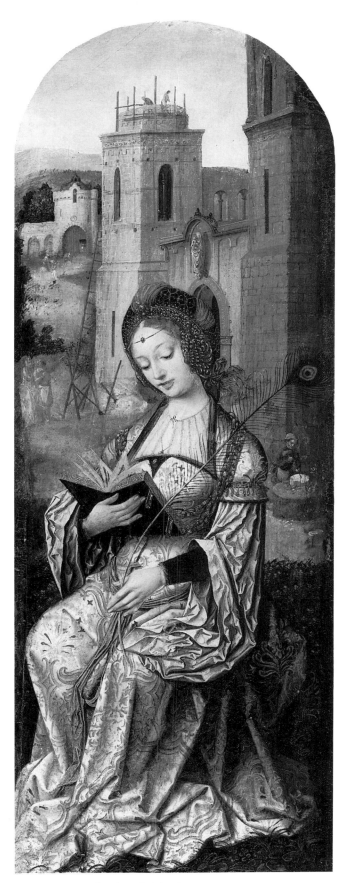

Cat. no. 6a, Flemish School, *St Catherine of Alexandria*

6b, Flemish School, *St Barbara*

7

MASTER OF THE MAGDALENE LEGEND

Two Donors

Oil on panel, 54 × 27.3 cm

Provenance: L. Gauchez, Paris (sold Christie's, London, 30.6.1888, p. 5, lot 77); bought Richter; Mrs Sigismund Goetze; her gift to the Fitzwilliam Museum, 1943 *Accession no.* 2549
References: Manuel 1939, pp. 24–7, figs. 2–3; Cambridge 1960, p. 77, no. 2549, pl. 37; Wright 1976, p. 129

When it was sold in 1888, this little shutter with two donors was attributed to Rogier Van der Weyden. The husband and wife are shown in front of a crenellated grey wall and an intensely blue sky. Both figures are praying; the woman is dressed in a dark brown dress with a black collar and a white headdress, the man simply in dark clothes. The panel has been convincingly attributed to the Master of the Magdalene Legend, an anonymous painter whose name derives from a dismantled altarpiece depicting the life of Mary Magdalene. The panel in the Fitzwilliam Museum is, in fact, close to two shutters in the Rijksmuseum in Amsterdam which show two donors with their patron saints.

Other parallels could be mentioned; the headdress of the woman, for example, is strikingly similar to that on the left wing of an altarpiece of the *Virgin and Child* formerly on the Dutch art market (Friedländer 1975, 12, p. 90, no. 4, pl. 4). The painting, in short, has many of the characteristics of the Master of the Magdalene Legend; the very format, with the donors shown close to the frame, is typical, as are features such as the large heads and long fingers which seem jointless – all characteristics noted by Max J. Friedländer in his account of the style of this artist.

The panel has a history of problems with adhesion of the paint layer; there are many losses due to flaking. In 1939, a photograph of the panel in raking light was used to illustrate irregularities of paint surface in the *Manuel de la conservation et de la restauration des peintures*, Paris, Office International des Musées, 1939.

Fitzwilliam Museum, Cambridge JMM

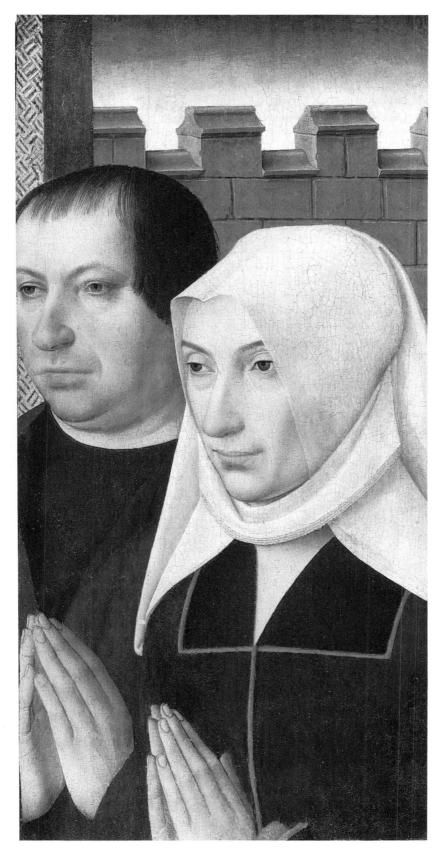

Cat. no. 7, Master of the Magdalene Legend, *Two Donors*

8

FLEMISH SCHOOL

The Annunciation

Oil on panel, 68 × 54 cm

colour plate, p. 29

Provenance: Founder's bequest, Fitzwilliam Museum, 1816
Accession no. 98
References: Key [n.d.], p. 12; Colvin 1895, p. 13, no. 98; Earp 1902, pp. 20–1, no. 98, fig. 98; Principal pictures 1912, p. 8, no. 98, ill. p. 20; Friedländer 1930, 8, p. 170, no. 103; Cambridge 1960, p. 39, no. 98, pl. 21; Friedländer 1972, 8, p. 105, no. 103, pl. 101; Wright 1976, p. 147; Eisler 1989, p. 198

In the first catalogue of paintings in the Fitzwilliam Museum published in or around 1817, this splendid *Annunciation* was listed as being by Albrecht Dürer (see also Earp 1902, p. 238). It was later given to Herry Met de Bles, whose name was wrongly linked to a group of Flemish mannerist paintings on the basis of a false signature (for the real Met de Bles, see Friedländer 1975, 13, pp. 23–7, 78–82, and 110–11). The 1960 catalogue of the Museum is more cautious observing that the painting resembles the work of two Antwerp artists, the so-called Jan de Beer (for his Annunciations, see Friedländer 1974, 11, p. 69, nos. 24 and 25, pls. 19 and 21) and the Master of 1518, but that it is also close to Bernard Van Orley. Max J. Friedländer, as early as 1930, saw it as a work by the latter, associating it with another painting attributed to him, an *Annunciation* in the National Gallery in Oslo which shares a number of elements with the top right wing of an altarpiece of the *Death of the Virgin* of 1520 attributed to the artist (Brussels, Musée de l'Assistance Publique). The date of the Cambridge panel, for Friedländer, must be around 1517. However Farmer (1981) did not include it among works closely connected to Bernard Van Orley. Despite Professor Michael Jaffé's reattribution of this panel to Jean Bellegambe by comparison with the *Adoration of the Magi* at Arras (Genaille 1976, p. 26, no. 28, fig. 24), I would prefer to keep open the problem of authorship.

In the Fitzwilliam Museum picture, the *Annunciation* is set within an elaborate and fanciful structure combining romanesque, gothic and renaissance features. The Virgin kneels on the right, her hands joined in prayer. An illuminated book is open on a wooden desk which stores more books and a candlestick. Next to her, a white cloth thrown over a basket, a pair of scissors and a ball of string allude to her virtuous attention to domestic tasks. Various flowers, in a blue and white earthenware jar bearing the monogram of Christ (IHS), convey a symbolic message; the lily, of course, alludes to the Virgin's purity. The white cat may allude here, as it sometimes does elsewhere, to the fact that the devil is trapped by Christ's Incarnation like a mouse by a cat. The Angel is entering from the left and the Holy Ghost also descends from this direction, in the form of a dove encircled with rays of light. The setting looks more religious than domestic perhaps because it is meant to allude to the Temple, but the artist has stressed the humanity of the scene; the Virgin's chamber can be seen on the right, almost entirely occupied by her bed with a green coverlet and a red canopy. Joseph is shown outside, chopping wood, apparently unaware of the miraculous event. Various figurative sculptures reinforce the religious context. On the second archway Moses is represented between two circular reliefs of Samson with the Lion and Cain killing Abel. To the left stands a rather exotic-looking figure whose caduceus suggest that he should be Mercury. On the right, over the Virgin's chamber, a seated priest and an attendant perhaps intended to be prophets both point to the Annunciation. These sculptures, except for the Mercury, clearly allude to the Old Testament and, in at least some cases, to the prophets announcing the Messiah. Most interesting is a pentimento which shows that the decoration of one of the floor tiles was originally a double-headed eagle, a well-known Habsburg symbol. This may have had no specific reference to the patron, although a direct link cannot be completely excluded.

Fitzwilliam Museum, Cambridge JMM

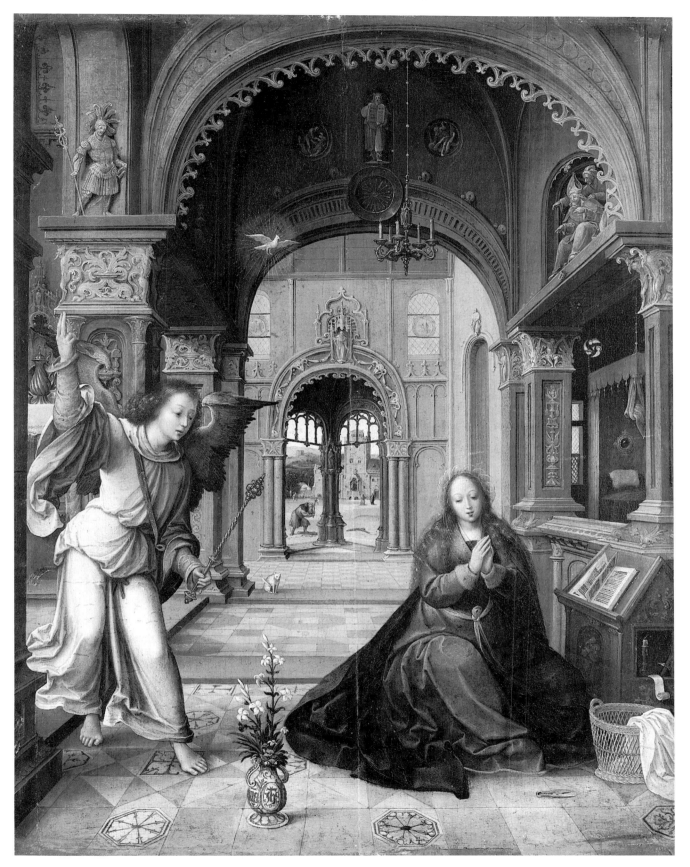

Cat. no. 8, Flemish School, *The Annunciation*

9

ANONYMOUS ARTIST, PERHAPS AFTER BERNARD VAN ORLEY

Portrait of the Emperor Charles V

Oil on panel, 34.3 × 23.8 cm

colour plate, p. 30

Provenance: Ralph Bernal (sold Christie's, London, 5.3.1855, p. 93, lot 1115); bought Morant; Sir John Ramsden, Bart. (sold Christie's, London, 11.7.1930, p. 15, lot 45); bought Joubert; Leonard Daneham Cunliffe; his bequest to the Fitzwilliam Museum, 1937 *Accession no.* 2309
References: Cambridge 1960, pp. 76–7, no. 2309; Wright 1976, p. 129

When sold in 1855 as part of the famous collection of Ralph Bernal, this little portrait was described as a painting by Jan Gossart representing Philip le Bel, an attribution which was retained in the 1930 Christie's sale catalogue. The sitter was, however, identified as Charles V (see the manuscript annotation to the sale catalogue in the Warburg Institute Library, London), son of Philip the Fair and Joanna of Castile, who was born in 1500 and died in 1558. At the death of his father in 1506, Charles inherited a large part of Europe, including Spain and the Netherlands. His paternal grandmother, after all, was Mary of Burgundy, the daughter of Charles the Bold and first wife of Emperor Maximilian. In 1516 he became king of Spain, and he succeeded his grandfather Maximilian I as Holy Roman Emperor in 1519. The painting shows the young prince in three-quarter length, facing towards the right. His features are rendered dispassionately, with no attempt to conceal his down-curving nose and loose-lipped open mouth. He wears a black hat with a badge which, unfortunately, has not proved easy to identify. He is dressed in a gold brocade coat with a rich fur collar over a black and red robe; the fashionably slashed areas reveal his linen chemise. He wears on a chain the famous Burgundian Order of the Golden Fleece which he received in 1501.

The portrait is similar in type to a large number of representations of the young Charles V said to be based on originals by Bernard Van Orley, who enjoyed the patronage of Margaret of Austria, Regent of the Netherlands from 1515 until her death in 1530. That painter is indeed known to have painted the young Charles who was brought up by Margaret in Mechelen until he left the Netherlands in 1517. We have evidence, for example, that Van Orley made portraits of the six children of Philip the Handsome in 1515. The year after, he executed another portrait of Charles, in competition with Jan Gossart. Michel Sittow, too, is sometimes said to have painted the young prince (Sass 1970, pp. 57–76). All the portraits of Charles made during his youth in the Netherlands are known only through copies. The Cambridge panel belongs to a version in which both of Charles' hands are visible; he holds the hilt of his sword. The best-known and most elaborate exemplars are perhaps in the Galleria Borghese in Rome (see Baldass 1944, pp. 155–6, fig. 137) and in the cathedral of Saint-Sauveur in Bruges (Terlinden 1965, p. 40, fig. 26). Closest to the Fitzwilliam Museum painting, however, is a picture sold in London in 1931 (Sotheby's, 11.3.1931, p. 17, lot 83, with both painter and sitter wrongly identified), which came also from the Bernal collection, via that of H. G. Bois. All these paintings have a gilded background dotted with red. But, in the Fitzwilliam painting, Charles is not shown – as in other portraits – as king of Spain (with a badge including a double 'C' for Carolus, and a crown), so the Cambridge panel must have been done shortly before his accession to the Spanish throne in 1516.

The Cambridge painting has traditionally been attributed to the Master of the Magdalene Legend; but it seems that we are rather dealing here with a variant probably produced in a workshop which will remain unidentified (for the problem raised by such portraits, see Campbell 1985, p. 130).

The panel was cleaned and restored at the Hamilton Kerr Institute in 1991. The sitter's face is relatively undamaged but the gold background of the painting has undergone alteration with time and is now abraded, the underlayer showing through in many areas. The brown and yellow marbled effect of the frame has also changed and is now undoubtedly darker than when it was originally painted, owing to the natural aging of the oil medium. The support, an oak panel with integral frame painted to imitate marble and with an arched top, is rare at this period.

Fitzwilliam Museum, Cambridge JMM

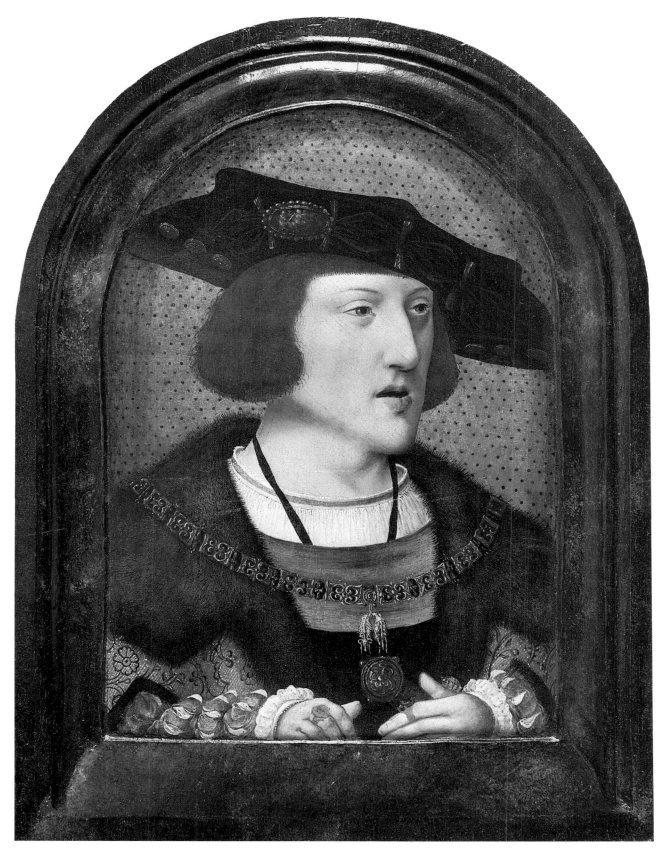

Cat. no. 9, Anonymous artist, perhaps after Bernard Van Orley, *Portrait of the Emperor Charles V*

'ADRIAEN YSENBRANT'

(a) *St Jerome*

Oil on panel, 24.9 × 8.1 cm

(b) *A Male Donor*

Oil on panel, 25.2 × 8 cm

Provenance: Thomas Henry Riches; his bequest to the Fitz-william Museum, 1935, received 1950 *Accession no.* PD.11– 1950, PD.12–1950
References: Cambridge 1960, pp. 65–6, nos. PD.11–1950 and PD.12–1950; Wright 1976, p. 95

These two little panels must surely have been the wings of a trip-tych with the *Virgin and Child* in the centre. On the left side St Jerome is holding a scourge and beating his breast with a stone, while praying in front of a crucifix attached to a tree; the red hat and the lion whose face presses up against the frame constitute his attributes. The right wing shows a donor dressed in black, praying; he too is set in a finely painted landscape, in which the trees are defined with subtlety and delicacy against the chiaroscuro of the background. Jerome was painted many times by 'Ysenbrant' and his workshop: there are notable examples in St Petersburg and Philadelphia; others are in private collections. Most interesting, perhaps, is a triptych in Hamburg in which St Jerome, on the central panel, is flanked by St Catherine and Mary Magdalene on the wings. Also noteworthy are the shutters of a little altarpiece in Budapest which depict respectively St John the Baptist and St Jerome, in an arrangement similar to that in another triptych in Bruges (Groeninge Museum), which has the Madonna and Child at the centre.

A large number of paintings have been grouped around the diptych of the *Sorrows of the Virgin* attributed to Adriaen Ysenbrant in the Church of Our Lady in Bruges. Ysenbrant's place of birth is not known, but he became a master of the Bruges guild in 1510 and died there in 1551. No painting, however, can be securely given to him (following an established convention I have retained his name, but within inverted commas). Some authors have tried to identify the artist responsible for the paint-ings as Aelbrecht Cornelisz., who is best known for a well-doc-umented altarpiece of the *Coronation of the Virgin* in Bruges (Church of St James); Cornelisz. is first mentioned in 1513 in that city where he died in 1532.

The various paintings attributed today to 'Ysenbrant' do not form a homogeneous group; rather they reflect the influence of one individual over a number of workshops that worked more or less in his style, some of them evidently for the export market. This was, after all, a period of artistic mass production; it is well known that between 1515 and 1530 Aelbrecht Cornelisz. himself booked up to five stands in the Bruges market to sell his works. The 'Ysenbrant' style is typified by a loosened blurring brushwork and an interest in chiaroscuro values. The literally repetitive charac-ter of some of the 'Ysenbrant' paintings is demonstrated by the fact that some examples, such as the St John the Baptist (though not the St Jerome) in the Budapest triptych mentioned above, show traces of pouncing (see Urbach 1987, pp. 50–2, pls. 32–5).

When the Cambridge panels were restored at the Hamilton Kerr Institute in 1992 it was noticed that the underlying draw-ing of the St Jerome is freely sketched, with a brush; the thick-ness and tonality of the lines vary, as can be seen in the head of the lion. The panel with the donor, however, was executed with the help of a cartoon; dotted lines are clearly visible with infra-red reflectography. These lines were made by pouncing small particles of carbon black through the holes in the cartoon; later they were reinforced with a pen. A small *Malrand* is visible on the front of both panels. In both cases the reverse is covered with black paint.

Fitzwilliam Museum, Cambridge JMM

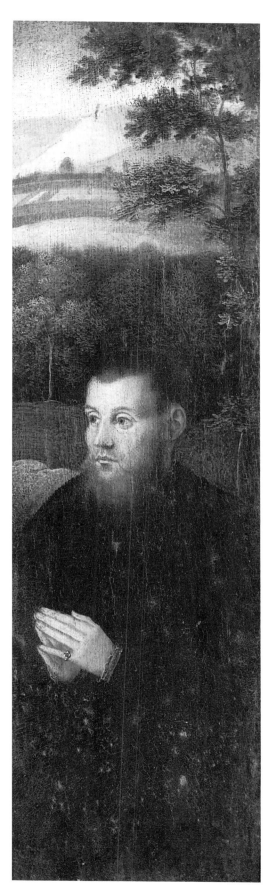

Cat. no. 10a, 'Adriaen Ysenbrant', *St Jerome* 10b, 'Adriaen Ysenbrant', *A Male Donor*

II

JOOS VAN CLEVE Active 1511–1540/41

The Virgin and Child

Oil on panel, 61 × 45.1 cm

colour plate, p. 31

Provenance: Perhaps Rev. Thomas Kerrich; his son, Rev. Richard Edward Kerrich; his bequest to the Fitzwilliam Museum, 1873
Accession no. 104
References: Colvin 1895, p. 39, no. 104; Earp 1902, pp. 128–9, no. 104, fig. 104; Principal pictures 1912, p. XIV, no. 104, ill. p. 104; Conway 1921, pp. 152–3 and 402; Friedländer 1916, p. 184, pl. 21; Winkler 1924, p. 255; Baldass 1925, pp. 19 and 31, fig. 29; London 1927(1), p. 86, no. 218; London 1927(2), p. 71, no. 218; London 1927(3), p. 142, no. 218; T. Borenius, in Conway 1927, p. 92, no. 218; Friedländer 1931, 9, p. 136, no. 59, pl. XXXIV; London 1953–4, p. 29, no. 80; Winter 1958, pp. 199–202, no. and pl. 48; Friedländer 1972, 9a, p. 62, no. 59, pl. 34; Cambridge 1960, pp. 20–1, no. 104, pl. 9; Wright 1976, p. 39; Hand 1978, pp. 209–11, and p. 304, no. 65, fig. 76; Treasures [n.d.], p. 42, no. 41, ill. p. 43; Hand and Wolff 1986, p. 56.

When the *Virgin and Child* was first listed in the *Brief catalogue of the pictures in the Fitzwilliam Museum* (1895), it was described as a work by the Master of the Death of the Virgin, an artist who took his name from two altarpieces of this subject in Cologne (Wallraf-Richartz-Museum) and in Munich (Alte Pinakothek). This artist has since been identified as Joos Van der Beke, alias Joos Van Cleve, a painter who died in Antwerp in 1540 or early 1541. His date and place of birth are not known, but he became a master in Antwerp in 1511, which would suggest a birth date of around 1485. He was co-deacon to the guild of painters in the years 1519, 1520 and 1525 and registered apprentices in 1516, 1523, 1535 and 1536. He married Anna Vijdt and from this marriage had two sons, Cornelis, born in 1520 and Jozijne, in 1522. He made his will on 10 November 1540. He must have died soon after, as his wife is mentioned as a widow on 13 April 1541. According to Lodovico Guicciardini's *Descrittione . . . di tutti Paesi Bassi* (1567), Joos Van Cleve travelled to France where he painted the king, the queen and various princes. He may have been there from 1529 to 1534, painting portraits of Francis I and Eleanor of Austria. He also produced various compositions of the Virgin and Child of which the Fitzwilliam Museum has this superb example. As was revealed in an examination with infra-red reflectography at the Hamilton Kerr Institute, Joos Van Cleve outlined his picture with a clear, precise underdrawing, using hatched lines in the shadows. He placed the Virgin behind a stone parapet in front of a cloth-of-honour; she holds in her left arm the Child who has just fallen asleep after feeding at her breast, an iconographic detail chosen to stress Christ's humanity. The landscape is neatly defined, with bluish mountains in the distance. On one side a shepherd can be seen with his flock, on the other a country residence. The blue and white pitcher on the parapet (with the christological IHS painted on the side) contains flowers, including white lilies symbolising the Virgin's purity. Her face is rendered in subtle sfumato which also helps capture the tenderness of her joyful expression. Her smile too, and the artist's interest in chiaroscuro values, recalls Leonardo da Vinci, whose work Van Cleve may have seen in the collection of Francis I. The *Virgin and Child*, one of the finest pictures of the artist's maturity, was probably painted in France about 1530. The composition became popular in the sixteenth century (see Cambridge 1960, p. 20, and Friedländer 1972, 9, p. 62, nos. 59a–b, pl. 74), but none of the copies conveys the subtlety of the original.

Fitzwilliam Museum, Cambridge JMM

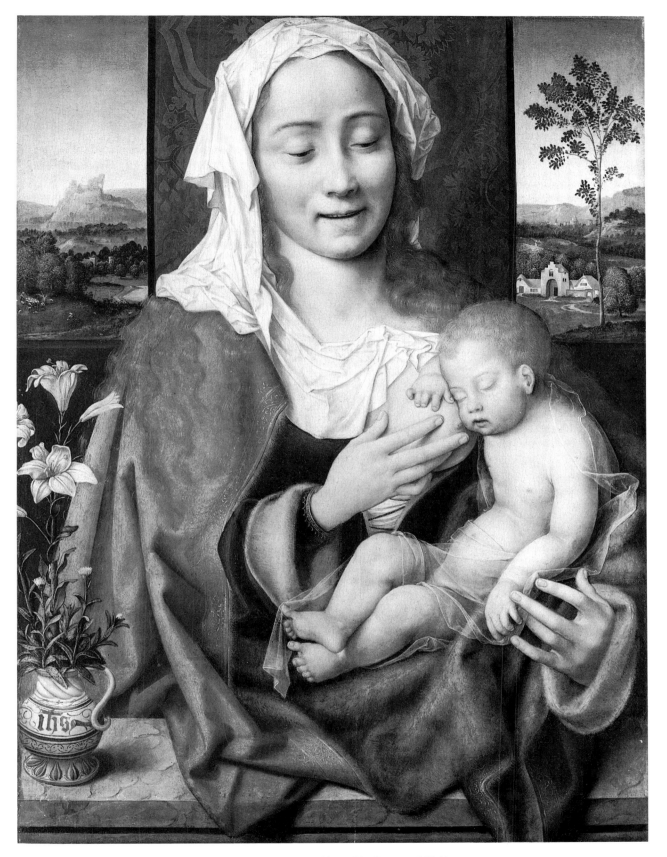

Cat. no. 11, Joos Van Cleve, *The Virgin and Child*

I2

SCHOOL OF JOOS VAN CLEVE

The Adoration of the Kings

Oil on panel, 87.3 × 70.5 cm

colour plate, p. 32

Provenance: William Beckford; dukes of Hamilton (sold Christie's, London, 17.6.1882, p. 20, lot 76); bought there by Arthur W. Young for £525; his bequest to the Fitzwilliam Museum, 1936 *Accession no.* 1784
References: Hamilton Palace 1882, p. 20, no. 76; Cambridge 1960, pp. 21–2, no. 1784, pl. 21; Wright 1976, p. 39; Davies 1968, p. 103; McClure 1988, p. 10, pls. 1–2

In the Hamilton Palace sale catalogue, the *Adoration of the Magi* was described as a work by Jan Gossart (J. de Mabuse). It represents, however, a well-known composition by Joos Van Cleve used for the central panel of a number of altarpieces which show the two missing Magi on the wings. The Cambridge panel, too, must have been the centre of a triptych. It represents one of the Magi, probably Melchior, richly clad in an orientalising costume, kneeling in front of the Child and kissing his hand, a detail mentioned in, among other works, the *Meditationes vitae Christi* by the Pseudo-Bonaventure. A glass goblet mounted as an elaborate cup is laid on the ground next to him. Joseph stands behind him greeting the Kings with a gesture of reverence. In the background are soldiers and other figures from the retinue of the Magi, some of them certainly meant to look like orientals. They are shown against a background of a few houses which probably represents the town of Bethlehem in front of a background of bluish rocky mountains.

The oak panel is composed of three vertical planks and a fourth added horizontally along the top. The top strip is an addition, with later paint, which has little or no craquelure. When the painting was cleaned and restored at the Hamilton Kerr Institute in 1979 the addition was not removed in order to retain the composition, since the original panel must have been cut down. The original paint layer is worn in several areas, particularly on the Virgin, the Child, the king's head and the background architecture. Clear, precise underdrawing, hatched in shadow areas, is visible in infra-red light.

Two triptychs, one in Detroit (Institute of Arts) and the other in Naples (Museo di Capodimonte), which are both of high quality, are often claimed as Joos Van Cleve's original composition. The numerous copies (see Cambridge 1960, p. 22; Friedländer 1972, 9a, p. 53, nos. 10, 10a and 10b, pls. 20–1) display variations, especially in the structure of the background and the definition of details, but the same formula is used for the central figures. They all reflect the popularity of the composition in an expanding market.

Fitzwilliam Museum, Cambridge JMM

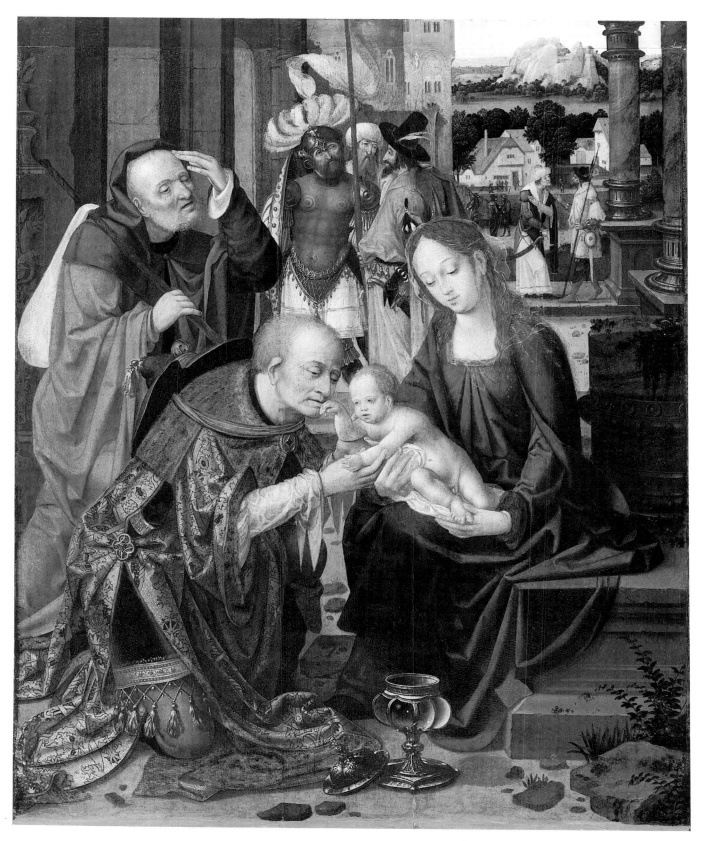

Cat. no. 12, School of Joos Van Cleve, *The Adoration of the Kings*

13

ATTRIBUTED TO CORNELIS VAN CLEVE

The Virgin and Child

Oil on panel, 24.8 × 18.8 cm

Provenance: William Angerstein (sold Christie's, London, 2.2.1883 and following day, p. 14, lot 207); bought Martin Colnaghi; Charles Brinsley Marlay; his bequest to the Fitzwilliam Museum, 1912 *Accession no.* M.17

References: Constable 1927, pp. 20–1, no. 17, pl. XIII, no. 17; Friedländer 1931, 9, p. 135, no. 56a; Friedländer 1937, 14, p. 117, no. 4; Cambridge 1960, p. 21, no. M.17; Friedländer 1972, 9a, p. 62, no. 56a, pl. 71; Wright 1976, p. 39

When it was sold in 1883, as part of the famous collection of William Angerstein, this charming little panel was described as a *Madonna and Child* by Jan Gossart. It was later attributed to the School of Joos Van Cleve before being linked to the work of his son, Cornelis. Cornelis Van Cleve was born Cornelis Van Beke; he was better known as 'Sotte Cleve', 'Daft Cleve', as he seems to have become insane in England in 1555. He was probably born in 1520 in Antwerp where he returned in 1560, to die seven years later. His formation as an artist is not recorded in Antwerp documents, perhaps because he did not have to be automatically registered as an apprentice, being the son of a painter. He may have become a master on the death of his father in 1540/1. In any case,

his art owed much to his father's, although it became increasingly Italianate; especially important seems to have been the influence of Andrea del Sarto. Although a large number of paintings are attributed to Cornelis none of the attributions are absolutely secure. The little Fitzwilliam Museum panel shows the Virgin with a transparent gauzy headdress. The Child in her arms holds her thumb with one hand and, with the other, raises an apple to his mouth. The fruit has symbolical importance, alluding to the apple of Eden and to the role of the Virgin as a co-redemptrix. The little painting displays a softness of form and an interest in chiaroscuro. It is, in fact, a version of a rather popular composition known today in a number of examples (see Cambridge 1960, p. 21; Friedländer 1972, 9a, p. 62, nos. 56a–d, pl. 71).

Until its recent restoration at the Hamilton Kerr Institute (1992) the original wooden support was extended by 1–1.5 cm on all four sides. The whole panel was also glued onto another piece of wood of the same size as the extended original. All these later additions have now been removed.

Fitzwilliam Museum, Cambridge JMM

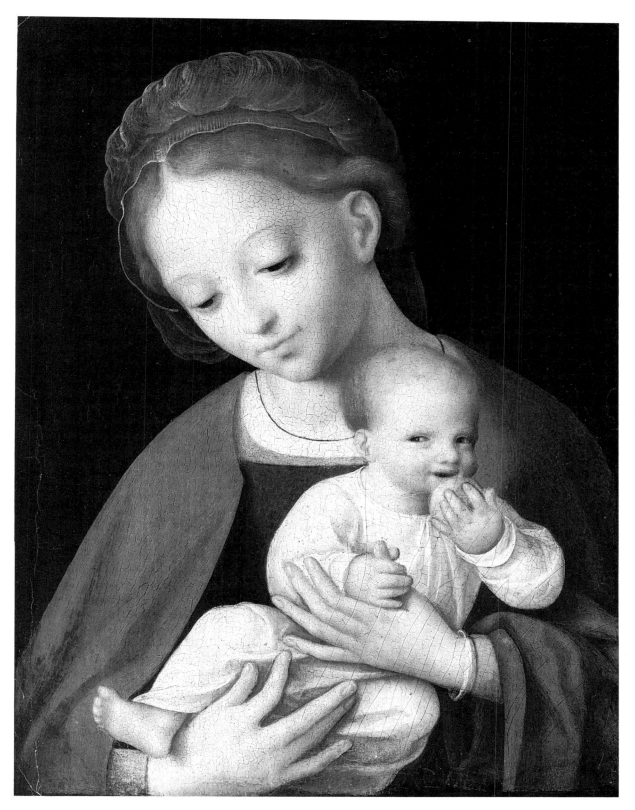

Cat. no. 13, Attributed to Cornelis Van Cleve, *The Virgin and Child*

14

WORKSHOP OF ROBERT CAMPIN, THE MASTER OF FLÉMALLE

St Veronica

Pen and ink drawing with ink washes, on vellum, 36.5 × 15.8 cm

Provenance: Rev. Thomas Kerrich, who bought it in London in April 1791; Rev. Richard Edward Kerrich; his bequest to the Fitzwilliam Museum, 1872

Accession no. 604

References: Pearson 1887, p. XIV, no. VI, p. 103, no 33, pl. VI; Hasse 1894, p. 32; Tschudi 1898, p. 15; Weizsäcker 1900, p. 199; Colvin, in Vasari Society 1906–7, pp. 13–14, no. 21, pl. 21; Principal pictures 1912, p. XIV, no. 604, ill. p. 105; Winkler 1913, p. 50, n. 1; Meder 1919, p. 171; Conway 1921, p. 121, n. 3; Friedländer 1924, 2, p. 111; London 1927 (I), p. 154, no. 511; C. Dodgson, in Conway 1927, pp. 183–4, no. 511; Destrée 1928, p. 10; Fierens-Gevaert 1928, 2, p. 18; Destrée 1930, p. 17; Popham 1932, p. 8; Tolnay 1939, p. 57; Winter 1950, p. 45, pl. XIV; London 1953 p. 62, no. 241; Scharf 1953, p. 355; London 1953–4, p. 137, no. 503; Winter 1958, pp. 155–7, no. 37, pl. 37; London 1959, no. 52; van Hasselt 1960, pp. 47–8, no. 60; Wilensky 1960, 1, p. 520, and 2, pl. 38; Friedländer 1967, 2, pp.71–2, pl. 89A; Sonkes 1969, pp. 83–6, no. B25, pl. XIIIb; Davies 1972, p. 251

Fundamental to the definition of the *œuvre* of the Master of Flémalle are three panels representing the *Virgin*, *St Veronica* and the *Trinity* in the collection of the Städelsches Kunstinstitut in Frankfurt. Reputedly from the Abbey of Flémalle, they are traditionally considered as wings of a large altarpiece whose centrepiece is supposed to have been destroyed in 1793 during the battle of Neerwinden. A number of paintings have been grouped around the three works, constituting the production of an innovative artist who has been identified with Robert Campin, a painter who was probably born some time between 1375 and 1379 and died in 1444. He is first recorded in Tournai in 1405–6. He purchased citizenship there in 1410, which would imply that he was born elsewhere. His work in Tournai is well documented; commissions came from the municipality and local churches as well as from private citizens. He seems to have enjoyed aristocratic protection, as Margaret of Burgundy, Countess Dowager of Hainaut and Holland, once intervened in his favour when he was condemned for leading a dissolute life. Campin is known to have had pupils: Jan de Stoevere, the son of a Ghent painter, but also two identifiable artists, Jacques Daret and the more famous Rogier Van der Weyden. Both were strongly influenced by him.

The panel of *St Veronica* in Frankfurt was traditionally, but as it seems probably wrongly, identified as the inner right wing of the Flémalle altarpiece (with the *Trinity*, now detached, on its reverse), the *Virgin and Child* being on the outer right wing; most art historians agree in dating them around 1435. Veronica, with the transparent sudarium, is shown in front of a backdrop of Lucchese silk brocade. The story of the saint having captured the likeness of Christ while wiping the sweat from his face (hence *sudarium*) on the way to Golgotha first appears towards the end of the Middle Ages, the first representations dating from the fourteenth century. The story's appeal was clearly in the fact that the image on the *sudarium* was a *vera icon*, a true likeness of Christ's face – hence Veronica's name.

The Cambridge drawing follows the Frankfurt panel very closely. In the undated manuscript list of the Kerrich and Van Sittart collections preserved in the Fitzwilliam Museum's Department of Paintings, Drawings and Prints, the drawing is attributed to Holbein. However, in the manuscript catalogue of the Thomas Kerrich collection to which the Museum had access in 1967 (it belonged to a descendant of Kerrich's daughter) it is described (on p. 22) in Kerrich's hand as 'St Veronica . . . a very antient minute drawing in Indian Ink, very much in the style of/of [sic] Martin Schoen. Somebody has cut it out all round in the outlines, and / pasted it on another piece of paper, which is a pity. I got it in London / Ap. 1791.' It first enters the literature with an attribution to Rogier Van der Weyden, as does the panel in Frankfurt. But when Tschudi, in 1898, isolated the artistic personality of the Master of Flémalle, he described the present drawing as a copy, a conclusion followed by most if not by all scholars (Colvin, in 1906–7, defended it as autograph). Although there are a few simplifications in the drawing – the *sudarium* of fine silk does not show the marks of the folds, the broad jewelled hem of Veronica's dress has been omitted, etc. – the dependence on the painting is clear. The draughtsman has given slightly younger features as well as a stockier aspect to the saint, whose headdress has been widened; he has not, however, properly differentiated the different articles of clothing, nor has he managed entirely to capture all the structural and sculptural quality of his model. The draughtsmanship itself, as well as the use of ink washes, suggests a probable date in the last quarter of the fifteenth century.

K. G. Boon suggested orally that the drawing may not be Netherlandish but could perhaps be German, tentatively putting forward the name of the Master of the Playing Cards.

Fitzwilliam Museum, Cambridge JMM

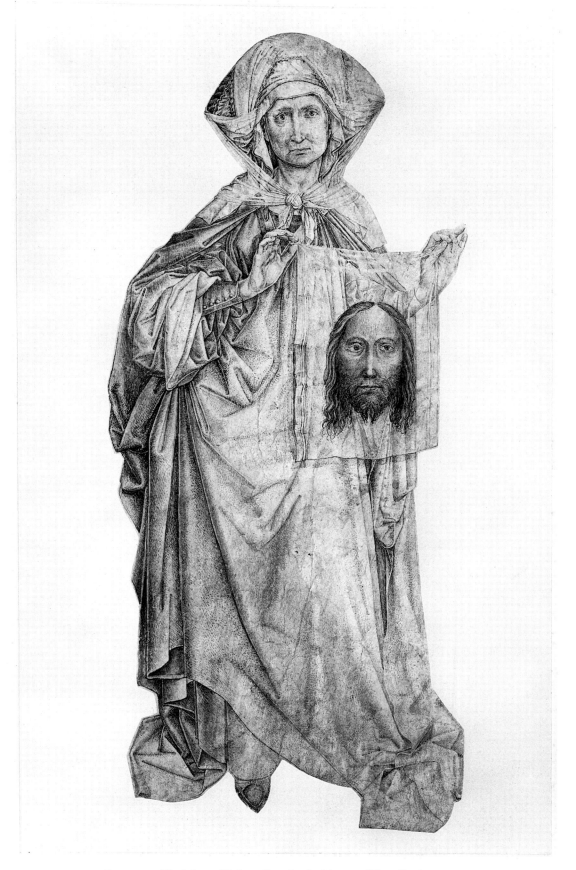

Cat. no. 14, Workshop of Robert Campin, the Master of Flémalle, *St Veronica*

15

AFTER ROBERT CAMPIN, THE MASTER OF FLÉMALLE

The Descent from the Cross

Brush drawing in ink, with body-colour and red chalk, on paper, 27.5 × 25.9 cm

Provenance: Thomas Banks; Mrs Lavinia Forster; Ambrose Poynter; Sir Edward John Poynter (sold Sotheby's, London, 25.4.1918, p. 53, lot 253); bought Charles Ricketts and Charles H. Shannon; on loan to the Fitzwilliam Museum from 1933 to 1937; Charles H. Shannon bequest to the Fitzwilliam Museum, 1937 *Accession no.* 2272

References: London 1927(1), p. 154, no. 512; C. Dodgson, in Conway 1927, p. 184, no. 512; Michel 1930, p. 273; Beenken 1951, p. 48; London 1953, p. 62, no. 242; Scharf 1953, p. 355; London 1953–4, p. 137, no. 504; van Hasselt 1960, p. 49, no 61; Walker Art Gallery 1963, p. 41; Sonkes 1969, pp. 129–32, no. C.21, pl. XXXIb; Davies 1972, p. 250; Campbell 1974, p. 641.

Robert Campin (the Master of Flémalle) was, together with the Van Eyck brothers, one of the most important Flemish artists of the early fifteenth century (see also cat. no. 14). He had a crucial role in the development of the new realistic approach, not only in his own works but through those of his pupils, of whom Rogier Van der Weyden was the most remarkable. Of Campin's triptych of the *Descent from the Cross* only a fragment of the left wing is preserved; it shows Gestas, the bad thief, bound to his Cross, with two onlookers next to him (Frankfurt, Städelsches Kunstinstitut). The composition is, however, recorded in a triptych representing *Christ taken down from the Cross* (Liverpool, Walker Art Gallery). Closer to the style of the original are two fifteenth-century drawings, respectively in the Fogg Art Museum, Cambridge, Mass., and the Fitzwilliam Museum. The first of these, representing Dysmas, the good thief, bound to his cross, is a good early copy perhaps executed in the master's workshop (see Sonkes 1969, pp. 127–9, no. C20, pl. XXIa). The *Descent* in the Fitzwilliam Museum is a fine copy of the central panel which is probably no later than the third quarter of the fifteenth century.

The drawing includes all the figures in the Liverpool triptych, except for one Holy Woman on the left and the praying angels in the sky. The draughtsman has concentrated solely on the figures, omitting both cross and ladder. Joseph of Arimathea is presumably the bald man holding the body of Christ from above, while Nicodemus supports his legs in accordance with tradition. Mary Magdalene, who will kiss Christ's feet, and another man raise their arms to receive Christ's body. On the left, the Virgin is fainting in John's arms, as one of the Marys approaches. On the other side stand two men rather unconcerned, probably meant as Jews.

It seems clear that the draughtsman copied the figures one by one, including the Magdalene raising her foot – in Campin's original this was on the first rung of the ladder. The absence of context is notable, as is the way in which the figures are copied piecemeal, without a full understanding of their underlying structure. As a result the composition appears more fragmented than it must have been in Campin's original. Campin's composition was extremely influential. The formula was widely used (Walker Art Gallery 1963, pp. 41–2, and Davies 1972, pp. 249–50), for example, *c.* 1440, in the *Hours of Catherine of Cleves*, but also in many later paintings.

Fitzwilliam Museum, Cambridge JMM

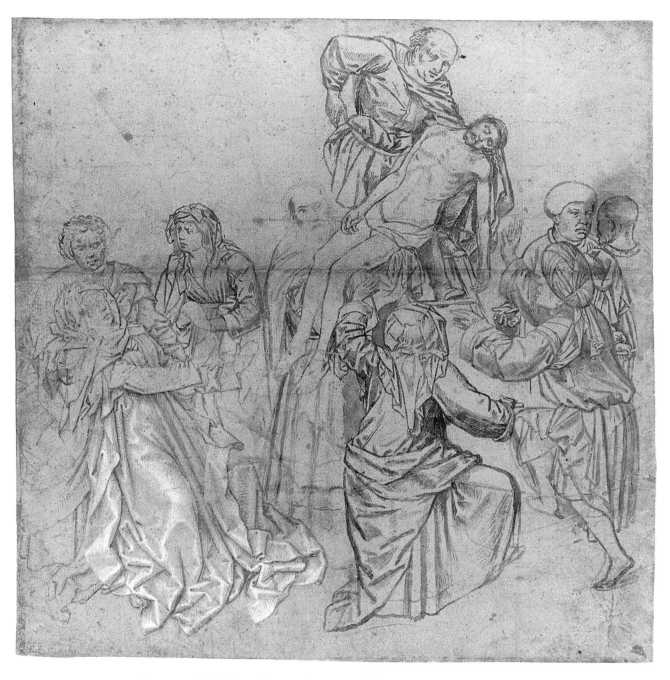

Cat. no. 15, After Robert Campin, the Master of Flémalle, *The Descent from the Cross*

Books of Hours and prestigious prayerbooks

Alain Arnould

Since at the Burgundian court art was a passport to recognition and prestige, many merchants and bankers were eager to express their ambition to belong to the upper circles by commissioning art. They built palace-like houses and very often turned to major artists for their orders for altarpieces. But public art was not the only field to attract commissions. Many people had to confine themselves to less ambitious projects. They turned to smaller house-altars, portraits and, above all, to Books of Hours. During the fifteenth century these Books of Hours were produced in their hundreds in towns like Bruges or Ghent. Work was organised almost like a production line, starting with the parchment-maker, going on to the person who prepared the layout by ruling the parchment, the copyist and the artists who, according to the wish of the customer, designed and executed various degrees of illumination. The high demand for Books of Hours was related to the success of the *Devotio Moderna*, a religious movement which Geert Groote had started in the Netherlands in the fourteenth century and which, amongst other things, had encouraged lay people to say regular prayers. Towards the end of the century another form of prayerbook developed, the so-called Rosary Psalter. Although these were in demand among a certain public, often with a Spanish link, their popularity never really rivalled that of Books of Hours.

Despite giving the impression of being very similar to each other, Books of Hours display many variations. In essence they consist of a calendar, a series of Hours dedicated to the Virgin Mary, the Holy Spirit or the Holy Cross and the Vigil of the Dead. Often a litany and some prayers to the Virgin, such as the popular *Obsecro te* or the *O Intemerata* have been added. After a brief invitatory the Hours consist of prayers combined with psalms for each of the seven moments of prayer: Matins, Lauds, Terce, Sext, None, Vespers and Compline. Within this standard programme there was room for variation. In fact every diocese or important place had its own specificities. The saints listed in the calendar were adapted according to the popularity of a particular saint in a diocese. Typical Flemish saints are Saints Bavo, Lieven, Amelberga and Donatian. In the region around Tournai, St Piat was an obligatory entry in the calendar. Specifically English saints are Saints Oswald, Edmund, Mildred and Hugh of Lincoln. The selection of saints in the litany can also help to point to a particular town.

Very soon the need for illustration of the various sections of Books of Hours arose. This fulfilled different roles. First the various degrees of illumination gave different sections of the manuscript a hierarchy. At the bottom of the scale were the non-figurative initials, principally foliate and penwork initials indicating the lower divisions of the texts: the beginning of a psalm, verse or response. More important texts were introduced by historiated initials, picturing a scene related to the contents of the prayer in the eye of the letter. One step higher were small miniatures which often accompanied the litany. The beginning of the Hours was indicated by a full-page miniature. Similar steps could be indicated in the border illustration: minor subdivisions would have limited border decoration, while important headings would be accompanied by four-sided borders. Thus the illustration of the manuscript helped the reader to find his or her way around it. The illustration of a manuscript also fulfilled other functions. Its richness and elaboration mirrored the wealth and status of its owner. If one so wished and if one could afford it, it was possible to commission specific elements to be included in the manuscript. This could be a miniature with one's portrait and/or patron saint, or, more commonly, could include the coat of arms, motto and emblem of the owner. Thus the Book of Hours became a status symbol. One way of adding lavishness to a manuscript was to extend its decoration programme to the calendar. For each month a border illustrating an activity typical of that month and sometimes the appropriate sign of the zodiac was added.

The production of Books of Hours was well regulated. All major Flemish towns had a guild to which artists had to be affiliated. These guilds were not only powerful economic lobbies but also looked after the welfare of their fellows by, for instance, setting up almshouses for retired members and their widows. They fixed and scrupulously controlled quality standards, protected their trade against dumping and enacted protectionist measures against foreign imports. In Bruges, the book illuminators were originally members of the painters' guild, but because the city was such a thriving book production centre illuminators and other professionals of the book trade there joined forces and *c.* 1457 founded the separate guild of St John the Evangelist. A chapel in the Eeckhoute monastery was used for the religious services which the guild organised for its members.

While in the Netherlands Books of Hours were without doubt the most commonly produced books by far, in Italy their production was less extensive. A few other European regions enjoyed a reputation for Books of Hours. Notably, Rouen and Utrecht grew to be major production centres.

This catalogue devotes an important place to Books of Hours, not only because they were produced in vast quantities in Flanders during the late Middle Ages, but also because of Viscount Fitzwilliam's particular enthusiasm for collecting this category of manuscripts. Many of them are among the outstanding treasures which he gave to the University in 1816. In all his books he has consistently noted on the first page or title-page when the volume joined his collection.

16

Liturgical Psalter and Book of Hours

c. 1450, Flemish

Illuminated manuscript on parchment, 115 × 83 mm, 453 folios

Provenance: Francis Edwards; Viscount Lee of Fareham; his bequest, 1947; presented by his widow to the Fitzwilliam Museum, 1954 *Accession no.* MS.4–1954
References: Wormald and Giles 1982, pp. 500–2

This manuscript combines the psalms with the usual components of a Book of Hours. The script is particularly delicate and on many pages the ascenders of the upper and the descenders of the bottom lines have been decorated with so-called *cadella*. These were added once the text had been written and lend a supplementary beauty to the layout of the pages.

Eight of the psalms are introduced by historiated initials featuring King David. They follow the traditional iconography of the Psalter which goes back to the fourteenth century and maintained its popularity during the fifteenth century in manuscripts such as the Breviary of Philip the Good. The various offices of the Hours are introduced by historiated initials of the traditional cycles of the Life of the Virgin and the Life of Christ.

The initials have traditionally been attributed to the Masters of the Gold Scrolls. A comparison between Fitzwilliam Museum, MS. 80 (cat. no. 37) and this codex does reveal similarities. Illustrations in both manuscripts share the features of gold scrolls in the background, and borders separated from the text by blue and red bars. Both manuscripts use similar colours and motifs. The artists also have a similar style with a fine if somewhat stiff rendering of faces. However, the historiated initials in MS. 80 are of a lower artistic quality than the illustrations of this manuscript.

Fitzwilliam Museum, Cambridge AA

Cat. no. 16 fol. 193r, *The Trinity*

17

Book of Hours

c. 1460, Bruges

Illuminated manuscript on parchment, 190 × 130 mm, vii + 113 + i folios

colour plate, p. 97

Provenance: Gift of Johannes de Nollet, abbot of the St Giles Monastery in Liège to his brother Nicholas (1650); Herbert Charles Marsh (*c.* 1850); P. Grierson; his gift to the Fitzwilliam Museum, 1974 *Accession no.* MS.1–1974
References: Wormald and Giles 1982, pp. 574–6

For people with a less flamboyant lifestyle and small financial means the market offered Books of Hours with fewer illustrations. Fitzwilliam Museum MS.1–1974 is a fine example of this category. Rather than having a miniature for each office of the day, as was the case for more luxurious Books of Hours, this manuscript contains miniatures only at the beginning of the Hours of the Cross, of the Holy Spirit, the Mass of the Virgin, the *Obsecro te* (a popular prayer to ask for the Virgin Mary's intercession), the Hours of the Virgin and the seven Penitential Psalms.

Two copyists worked on this volume. Both used a formal script, which is larger than scripts normally used in Books of Hours. The first scribe (fols. 1–91) wrote his text on pages ruled in purple ink for seventeen lines. His portion is accompanied by dentelle and foliate initials, and six miniatures with borders. The latter are by an epigone of the Masters of the Gold Scrolls. The artist has drawn on past models of this School but lacks the enthusiasm of their early productions. The miniature intro-

ducing the Penitential Psalms, a Last Judgement with Christ calling the souls out of their graves while the Virgin and St John the Baptist kneel in intercession, relies on a composition encountered in other manuscripts of this School (Fitzwilliam Museum, MS. 80, fol. 91v, see cat. no. 37). The same applies to the Annunciation (fol. 34r), but here the artist has elaborated the background and the plain wall of the exemplar has become an open landscape (Fitzwilliam Museum, MS. 80, fol. 20v). The miniature with Madonna and angel (fol. 18r) which introduces the Mass to the Virgin Mary, is a unusual subject for a Book of Hours, although it can be found in other Books of Hours of the School of the Gold Scrolls (Vatican Library, Ross. 63, fol. 17v or Germany, private collection, fol. 62r in reverse (see Plotzek 1987, no. 53)). The position of the Virgin – sitting on two large cushions next to a grass bench – is a traditional symbol of her humility: she is prepared to sit on the ground though she is crowned as a queen.

The second scribe who worked on this manuscript wrote his text on pages ruled in red ink for nineteen lines (fols. 92–112). Apart from the stylistically different full border marking the first page of his text, this section has no illustrations.

Fitzwilliam Museum, Cambridge AA

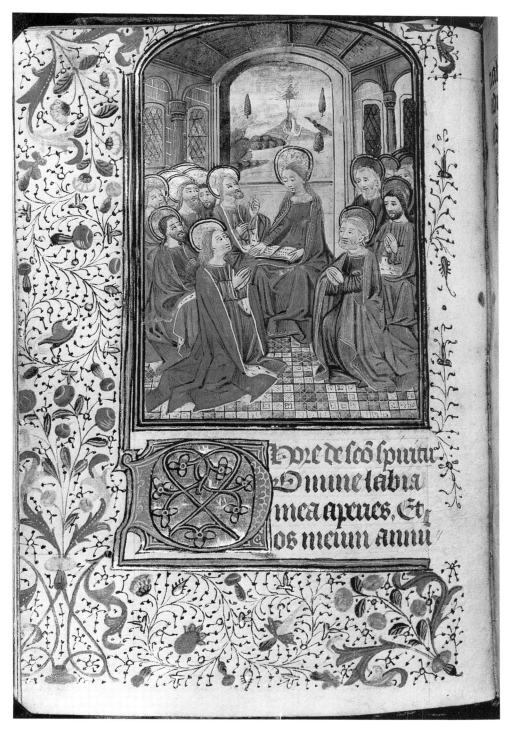

Cat. no. 17 fol. 12v, *Pentecost*

18

Book of Hours

c. 1465, Hainaut

Illuminated manuscript on parchment, 175 × 120 mm, ii + 190 + ii folios

colour plate, p. 98

Provenance: Enghien family; Girton College, Cambridge
Accession no. MS. 1

This manuscript has not previously been published in any detail. The following description may be useful for reference:

Texts: fol. 1r–12v: calendar, scarcely filled in; noteworthy saints, all written in black: St Aldegundis (30 January), St Servatius (13 May), St Amelberge (10 July), St Louis of Toulouse (19 August; in another hand), St Louis (25 August), St Bertin (5 September), Sts Remy and Bavo (1 October); fols. 14r–22v: Hours of the Cross; fols. 24r–31v: Hours of the Holy Ghost and a hymn to the Holy Ghost ('Veni Sanctus Spiritus mentes tuorum . . .'); fols. 32r–51v: 'Obsecro te' and 'O Intemerata' and suffrages to Sts John the Baptist, Peter, Hadrian, Sebastian, Christopher, Anthony, Nicholas, Hubert, Francis, Mary Magdalene, Catherine, Barbara, Margaret, Appolonia; fols. 53r–125v: Hours of the Virgin: after lauds a quinion with six additional psalms was inserted (fols. 78r–87r). Instructions on how to read them were written in French. On fol. 77v there is a prayer in Flemish. Compline is followed by the 'Salve Regina', a prayer to St Anne in Flemish (fols. 125v–126r) and a suffrage to St George (fol. 129r) in Latin; fols. 128r–140v: Seven Penitential Psalms; fols. 140v–146r: Litany; fols. 147r–168r: Hours of the Dead; fols. 168v–181v: Pater Noster, Ave Maria, Credo, Magnificat (incomplete); fols. 182r–190v: prayers in Latin and Flemish. Dentelle initials of one or two lines height; foliate initials of four/five lines height in combination with full borders at the beginning of major texts. Thirteen miniatures of five lines height with a saint of each of the suffrages in combination with single border (see above), Twelve full-page miniatures in combination with full border: fol. 13v: Crucifixion (pelican, vine, lamb and other animals); fol. 23v: Pentecost (hunting scenes); fol. 31v: Pietà (harvest); fol. 45v: Lord of Enghien and St Hubert; fol. 52v: Annunciation (falcon hunting, angel playing the harp, playful hunting); fol. 88v: Nativity; fol. 94v: Circumcision; fol. 100v: Epiphany; fol. 119v: Assumption (man fights a dragon); fol. 126v: Saint George killing the dragon (the Princess with her sheep); fol. 127v: David in prayer (acrobat, playing monkeys, spinning boars and courting birds); fol. 146v: Resurrection of Lazarus (jousting animals). 18th century binding. On fol. 124r there are traces of some letters in pencil.

The illumination of this manuscript was undertaken in two stages. The first took place in the 1460s when a very fine artist painted the miniatures. A few of them are on inserted leaves. Originally many had blank rectos, on which prayers were later added. The miniatures are surrounded by borders of curling acanthus and flowers which were painted by two artists. The borders where figures have been included were probably painted by the same artist who painted the miniatures. These borders have vivid colours and the choice of figures seems to be carefully planned. Some borders appear to contain scenes chosen specifically to complement the main subject of the miniature. On fol. 13v the borders around the Crucifixion miniature include among others a vine, a pelican and a lamb, all symbols referring to the death of Christ. Another artist, probably an assistant, produced borders characterised by duller colours and brown rather than black dots. The major artist of this Book of Hours shows a particular skill in depicting landscapes. He likes to sketch his views around a path which meanders towards the horizon. Houses and cities often enclose the composition. His weakness is the architecture, where he has problems painting a correct perspective. The Nativity and Epiphany scenes take place in the same setting, but the compositions have been inverted, as can be seen in the changed position of the door and of the roof window. This was possibly to avoid a too overt repetition of compositions. This major artist is also responsible for the miniature which shows the person who commissioned the manuscript. He is represented kneeling on a prie-dieu on which his coat of arms hangs. St Hubert kneels down in front of him. St Hubert was the first bishop of Liège, who was converted to Christianity after a stag appeared to him with a Crucifix between his antlers. In a rare iconographic motif, an angel brings him a stole to indicate his vocation to the priesthood. On one of the trees in the background hangs the same coat of arms as on the prie-dieu. The commissioner of this Book of Hours can be identified as a member of the Enghien family, whose fief was the village of Enghien in Hainaut. In fifteenth-century art, the choice of saint to be represented with the commissioner is mostly determined by the first name of the patron. However, no member of the Enghien family was called Hubert. The prominence given to St Hubert among the suffrage miniatures probably reflects a special devotion of the lord of Enghien, possibly connected with a foundation. It is, however, more likely that it derives from a passion for hunting, of which St Hubert was the patron saint.

Slightly later, another artist has inserted a miniature with a representation of St George. He has contrived a dramatic staging of St George killing the dragon. Although the dragon is already bleeding to death, horse and squire have to fight on valiantly in order to rescue the princess who, together with a sheep, has been chosen as the dragon's sacrifice. In the border she is praying for a good outcome to the battle. The borders in Ghent-Bruges style contrast with the marginal decoration elsewhere in the manuscript. A prayer to St George was added

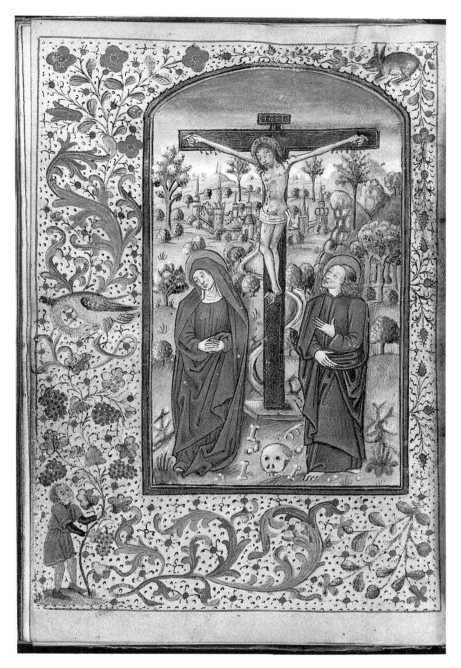

Cat. no. 18 fol. 13v, *Crucifixion*

on the back of the miniature of fol. 127 and a further miniature complemented this addition. In its turn, the back of the St George miniature and the blank fol. 125v provided space for an additional prayer, this time a prayer to St Anne in Flemish.

It is unclear where this manuscript was produced. Although the presence of Flemish prayers makes it clear that towards the end of the fifteenth century it was in the hands of a Flemish reader, the calendar indicates an original provenance within the diocese of Tournai. The member of the Enghien family may well have turned to nearby Mons to find a suitable workshop.

Lent by the Mistress, Fellows and Scholars of Girton College, Cambridge (*on deposit at Cambridge University Library*) AA

19

Book of Hours

c. 1470, Flemish

Illuminated manuscript on parchment, 105 × 67 mm, 301 folios

colour plate, p. 99

Provenance: Coat of arms on fol. 184v (or on a fess azure three mullets of the field between three gates), erroneously identified by F. Wormald and Phyllis M. Giles (Cambridge 1966) as of the Slachec family of Utrecht, probably covers the original one; Founder's bequest, Fitzwilliam Museum, 1816 *Accession no.* MS. 143
References: James 1895, pp. 326–30; Cambridge 1966, p. 46

Both text and illumination of this manuscript were made in two phases. The eleven quires between fols. 68 and 155, containing the Hours of the Virgin and some other prayers to the Virgin, and the six plus one incomplete quires between fols. 251 and 301 containing the Office for the Dead were written and illuminated by scribes and artists other than those who worked on the rest of the manuscript. The illumination of the quires between fols. 68 and 135 and fols. 251 and 301 consists of borders and historiated initials. None of the miniatures which may have once faced the introductions to the successive Hours has survived. The borders are single framed and there is no bar to separate border from text. Among dull acanthus leaves the artists have painted *drôleries* which are exclusively secular in subject matter, and which demonstrate a preference for fantastic birds. The historiated initials of this portion of the manuscript are probably by the same artist as the borders and depict figures in delicate fashion.

The illustration of the other quires consists of borders, historiated and foliate initials, and single-leaf miniatures inserted into the regular quires of the manuscript. The historiated initials are attached to borders framed with double lines on the outside and with a golden-red and blue bar on the inside. The landscapes with crumbling rocks, distant towns situated on the horizon-line and subtle skies are one of this artist's specialities. The motifs of the borders incorporate little scenes sometimes related to the miniatures they accompany. They include angels, apes or bears among bright acanthus and floral elements.

The artist of the borders and initials of fols. 68–135 and 251–301 has affinities with the miniature production of the Northern Netherlands. The style of the remaining borders and miniatures is clearly Flemish, by an artist who also painted the miniatures in the Sachsenheim Hours (Stuttgart, Landesbibliothek, Cod. brev. 162) and who has been identified as Lieven Van Lathem. Lieven Van Lathem is known to have had numerous family and professional contacts with the Northern Netherlands so that a collaboration with a northern artist is not surprising. In another Book of Hours, Lieven Van Lathem had already collaborated with the Master of Catharine of Cleves, a Northern Netherlandish artist. Miniaturists were often given instructions for the compositions of their images, which were written at the lower edge of the page. This Book of Hours has preserved some of them (e.g. fol. 243r).

Among the interesting themes of the miniatures is a St Quirinus (fol. 226r). This Roman martyr and patron saint of the city of Neuss, near Düsseldorf, is only rarely represented in Flemish art and his cult was not at all widespread in the Southern Netherlands. His presence in this Book of Hours may be connected to the unsuccessful siege which Charles the Bold conducted against the city of Neuss in 1474–75. The original owner could well have learned about the devotion of the people of Neuss to Quirinus during the siege. If this is correct, the manuscript must be dated after 1475, a period during which Lieven Van Lathem had established himself in Antwerp. This date would, however, question the chronology of the Sachsenheim Hours, normally dated in the late 1460s, and would need further investigation.

Fitzwilliam Museum, Cambridge AA

Cat. no. 19 fol. 216r, *St Adrian*

20

Book of Hours

c. 1480, Bruges

Illuminated manuscript on parchment, 130 × 90 mm, ii + 225 + ii folios

colour plate, p. 100

Provenance: B. de Saussaye; Founder's bequest, Fitzwilliam Museum, 1816 *Accession no.* MS. 86
References: James 1895, pp. 215–16

The calendar in this Book of Hours points towards a French, possibly Parisian destination for the manuscript. Typical Flemish saints such as Bavo or Donatian are absent, but saints with an exclusively French veneration such as Geneviève, Maturin, Mamert or Wandrille have been included.

The miniatures and border decoration belong to a group of codices characterised by the use of grisaille or semi-grisaille. This use of grisaille was already widespread in panel-painting, where the reverses of wings were often painted in dominant greys. In miniature painting, too, the technique had been used by outstanding artists, most notably by Jan de Tavernier, who during the 1460s illuminated manuscripts almost exclusively with grisaille miniatures. During the late 1470s the fashion was taken up by the workshop of Willem Vrelant. In the miniatures of some of his manuscripts of this period he limits his colours to greys of all possible shades, with gilt highlights. Red and sometimes blue are used for carnations and to break monotony. The same principle was applied in the borders, using the traditional motifs of the Vrelant workshop (curling acanthus and a few flowers) but restricting the colours to greys, gold and blue. This self-imposed restriction of colours lends a delicacy to the manuscript. This manuscript was not executed by Vrelant himself but by an artist familiar with his style and typologies. The movements of the rather dumpy figures are stiff.

As is often the case in Flemish Books of Hours, the theme of King David imploring God for forgiveness opens the section containing the seven Penitential Psalms. They were written when David, traditionally thought of as the author of the Psalms, was expressing contrition for his sins. For a moment he abandons the symbols of his authority, his throne and crown, and asks God for forgiveness.

Fitzwilliam Museum, Cambridge

AA

Cat. no. 20 fol. 142r, *The Penitent David*

21

Book of Hours

c. 1485, Ghent?

Illuminated manuscript on parchment, 147 × 105 mm, iii + 171 + iv folios

colour plate, p. 100

Provenance: Sixteenth century in Spain; seventeenth century Don Antonio Villadiego de Montoya; Paris, Techener; Henry Yates Thompson; Pickering and Chatto; Noel Barwell; given to the Fitzwilliam Museum by a group of members of the University of Cambridge, 1903 *Accession no.* MS. 268
References: London 1953–4, p. 158, no. 590; Cambridge 1966, pp. 46–7; Cambridge 1976, no. 4; Wormald and Giles 1982, pp. 211–15; Pächt and Thoss 1990, 2, p. 33; Kren 1992, pp. 134 and 192, note 17 (by Brinkmann)

At least two artists have contributed to the illumination of this codex. The calendar miniatures are from the hand of an artist working in the style of Willem Vrelant. An artist from the same workshop also contributed some borders in this characteristic style.

The majority of the borders are, however, much more original. Among the manuscripts illustrated in the *trompe-l'œil* fashion of the Ghent-Bruges style a few are distinguished codices with borders on a black background. This fashion, popular around 1490, may have been sparked off by a few precious manuscripts which were written on black-tinted parchment. In this manuscript they are particularly lively thanks to the variety of motifs and scenes of animals. Borders on a black background of a similar style can be found in a Book of Hours, once in possession of René Héron de Villefosse (present location unknown).

The artist of the miniatures attaches great importance to landscapes and takes great care in organising his compositions in different levels, complementing the main scene on the foreground with one or more subsidiary scenes in further levels. This gives the composition a fascinating sense of perspective. He also depicts his figures in a lively way. Brinkmann has christened the artist the Master of Fitzwilliam MS. 268, after this manuscript. Besides the Villefosse and the Fitzwilliam manuscripts, Brinkmann has added three other manuscripts to his œuvre. The introduction miniature of a copy of the Ordinance of Charles the Bold (London, British Library, Add. MS. 36619), is also by this artist.

In the miniature of St Nicholas this playing with different levels takes the form of distinguishing principal scenes from secondary ones. In the background, a ship, in an allusion to the saint's legend, is carrying St Nicholas' body on its journey from Myra to Bari. In the foreground St Nicholas is represented with the three children he saved from the butcher's knife. Since the prayers to St Nicholas and St Catherine are the only ones to be complemented by a full-page miniature, this may be an indication of the christian names of the patrons of the book. In the miniature of St Nicholas, a nobleman is kneeling down in front of the saint. In the window above him, the coat of arms may well be his.

The presence of John the Hermit in the calendar on 19 March may be a link with the Northern Netherlands, as this saint was only included in the calendar of the diocese of Utrecht, but the earliest provenance for the manuscript points to Spain.

Fitzwilliam Museum, Cambridge AA

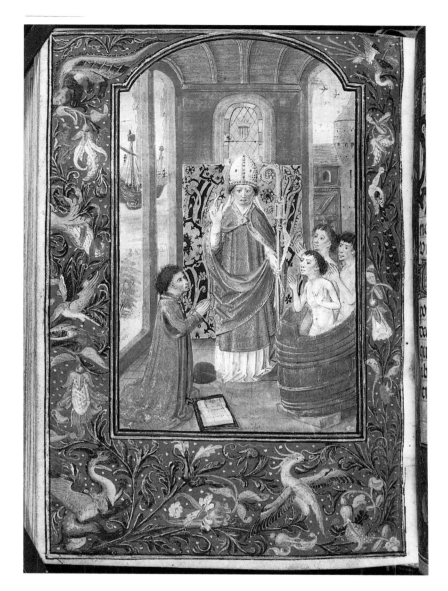

Cat. no. 21 fol. 138v, *St Nicholas with Donor*

22

Miniature of *Pentecost*

c. 1485, Valenciennes?

Illuminated leaf on parchment, 120 × 80 mm

colour plate, p. 101

Provenance: Roermond, M. Guillon; Antwerp, Alfred A. de Pass; his gift to the Fitzwilliam Museum, 1920 *Accession no.* MS. 304
References: London 1953–4, p. 158, no. 591; Ringbom 1965, fig. 166; Cambridge 1966, p. 46; Wormald and Giles 1982, p. 294; Kren 1983, p. 39, n. 29; Cambridge 1989, p. 35; Kren 1992, p. 207, note 18

This single leaf, which was almost certainly once part of a lavish Book of Hours, has traditionally been attributed to Simon Marmion. Simon Marmion was one of the most talented miniaturists working in Valenciennes and Bruges during the third quarter of the fifteenth century. Shortly after his death in 1489, Jean Lemaire des Belges heralds him in his *Couronne margaratique* as 'the prince of illumination'. Unfortunately, archival evidence for his work and whereabouts is scant and no works can securely be attributed to him on the basis of documentary evidence. It is assumed that Simon Marmion was a painter as well as a miniaturist and that he is responsible for an altarpiece representing the life of St Bertin. Charles the Bold and his wife Margaret of York entrusted him with important commissions. Marmion died in Valenciennes in 1489 after four decades as a practising artist.

Ringbom (1965) pointed out that the Pentecost composition of the Fitzwilliam Museum miniature could also be seen in two other Books of Hours: the Flora Hours (Naples, Bibliotheca Nazionale, MS. I.B. 51) and in the Huth Hours (London, British Library, Add. MS. 38126), both attributed to Simon Marmion. In all three the scene of Pentecost is pictured in close-up, a device inaugurated by Marmion during the 1460s. The Fitzwilliam Museum Pentecost combines elements from the two other Pentecost miniatures. The central position of the Virgin Mary and the two apostles in the foreground link the Fitzwilliam leaf to the Huth Pentecost, while the double circles around the Holy Spirit sprinkling flames over the assembly, the animation of the apostles, especially the bearded apostle in the left foreground, and the shortened faces looking up to the descent of the Holy Spirit, indicate a link with the Flora Pentecost. It is difficult to establish a chronology for the three miniatures. If the superior quality of the composition of the Fitzwilliam leaf is the product of experiments conducted in the Huth and Flora Hours, then it must be dated after these two manuscripts. However, a date of the Huth Hours 'shortly before Marmion's death' leaves little space for further activity by Marmion. Could it be that Marmion's death interrupted the painting of further miniatures for a third Book of Hours in the style of the Flora and Huth Hours?

Fitzwilliam Museum, Cambridge AA

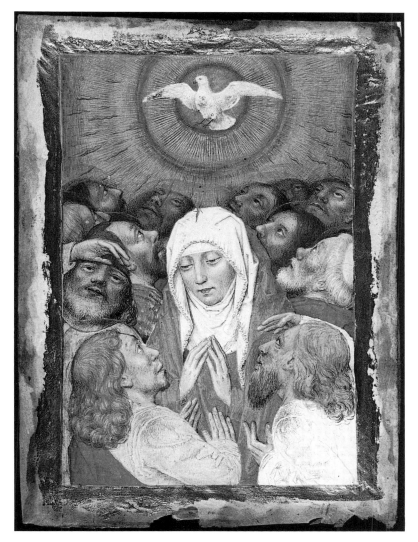

Cat. no. 22, *Pentecost*

23

Book of Hours

c. 1490, Bruges?

Illuminated manuscript on parchment, 175 × 120 mm, iv + 81 + iv folios

Provenance: Frank McClean bequest to the Fitzwilliam Museum, 1904 *Accession no.* MS. McClean 98
References: James 1912, pp. 213–15

This manuscript is a routine product typical of what was produced in Bruges in the 1490s. Along with the fashionable Ghent-Bruges style with its *trompe-l'œil* borders, the more traditional acanthus borders continued to be painted well into the sixteenth century. On the whole they are associated with less ambitious miniatures. The artist of MS. McClean 98 lacks the sense of detail and balanced composition of his more talented contemporaries. Parts of the Crucifixion miniature derive from a composition already used in the circles of the Master of Mary of Burgundy by the Master of the Lübeck Bible (Pächt and Thoss 1990, 2, p. 82). There the artist involves the beholder by painting the horses *en buste* in the foreground. The Fitzwilliam Museum artist probably saw this part of the composition but, failing to see the purpose of this device of the Master of the Lübeck Bible, he placed the group behind a hill. This in fact distances the soldiers from the beholder and diminishes the drama of the image.

The miniature which accompanies the prayer to St Dympna is a rare iconographic theme. Dympna was the daughter of a seventh-century British king, who came to Geel, near Antwerp, to escape the incestuous intentions of her father. The father pursued and ultimately killed his daughter. At the translation of her body into the main church of Geel during the thirteenth century numerous sufferers from insanity and epilepsy were miraculously cured. St Dympna became the patron saint of the mentally ill. This resulted in the commitment of the town of Geel to the care of the mentally ill, a tradition still honoured today. In the manuscript Dympna is represented without specific attributes, probably because the artist did not know her standard iconography (sword and chained demon). It is therefore unlikely that her presence in the book is an indication as to where the manuscript was produced. Had the manuscript been produced in or around Antwerp, the artist would doubtless have known how to represent the saint. Dympna's presence among the memoriae and in the litany of this Book of Hours probably only indicates a special devotion to her.

The full-page miniatures were painted on single leaves. In this manuscript, two miniatures were inserted in the wrong place: the Pentecost scene which was supposed to introduce the Hours of the Holy Spirit now faces the beginning of the Hours of the Cross. The Crucifixion miniature introduces the Hours of the Holy Spirit. It is not known whether this mistake occurred when the book was first bound or when it was rebound in the nineteenth century.

Fitzwilliam Museum, Cambridge

AA

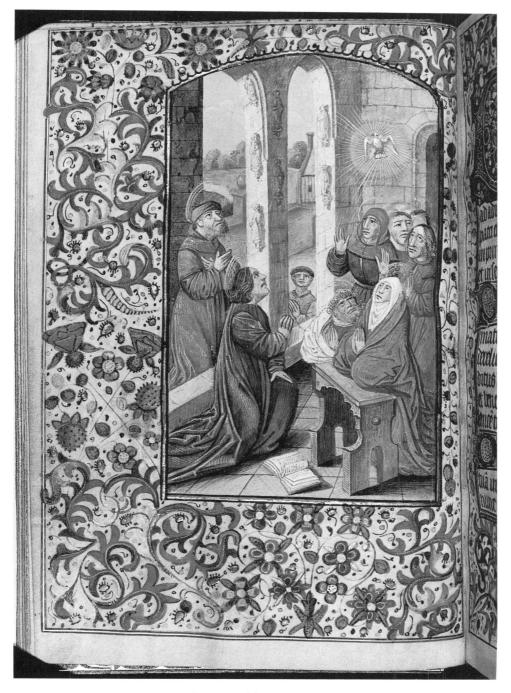

Cat. no. 23 fol. 10v, *Pentecost*

24

Book of Hours

c. 1490, Tournai

Illuminated manuscript on parchment, 160 × 110 mm, i + 161 + i folios

colour plate, p. 101

Provenance: Sixteenth century Marie Cocq; Samuel Sandars; his gift to Trinity College, 1877 *Accession no.* MS. B. 13.11
References: James 1900, pp. 391–2

The calendar points explicitly towards Tournai: it includes the dedication day of the Cathedral of Our Lady, and the feast and translation of the local St Piat and St Brixe. This is confirmed by the saints mentioned in the litany. The Hours of the Virgin are also explicitly for the use of Tournai.

The manuscript was almost certainly produced in or around Tournai. The fashion for the Ghent-Bruges border style reached Tournai as it did every other Flemish town, as well as centres outside Flanders. The script and illumination of the manuscript give the impression of a non-specialist product, possibly produced by someone for his own domestic use. Besides the textual elements, an iconographic detail also points towards Tournai as the place of production of this manuscript. In the opening miniature of the Penitential Psalms (fol. 88v), behind the penitent David, a townscape is represented. In fifteenth-century Flemish art, townscapes are rarely identifiable with specific locations, but in this instance one element in the landscape has a local resonance. The watergate bridging the river behind David was no doubt inspired by the thirteenth-century Pont des Trous which was built over the river Schelde as part of Tournai's fortifications.

As seat of the diocese which covered most of the Southern Netherlands and Northern France, Tournai enjoyed its cultural heyday during the first half of the fifteenth century. Major artists such as Robert Campin (see cat. nos. 14 and 15) and Rogier Van der Weyden worked for a time in the town. During the whole of the fifteenth and sixteenth centuries, the production of tapestries remained a significant economic and artistic activity, but very little is known about manuscript production in Tournai. Between 1431 and 1500 the names of some sixty illuminators on parchment and paper who belonged to the painters' guild are recorded. Their output could thus never have rivalled that of towns like Bruges, Ghent or Brussels. Moreover the Reformation, the French Revolution and two World Wars destroyed a great deal of the local art collections and archives so that our knowledge of this important centre remains inadequate.

An inscription tells us the book was once owned by Marie Cocq, who was a religious at the Hôpital Comtesse in Lille. Nothing more is known about her, but her handwriting is datable to the sixteenth century.

Lent by the Master and Fellows of Trinity College, Cambridge

AA

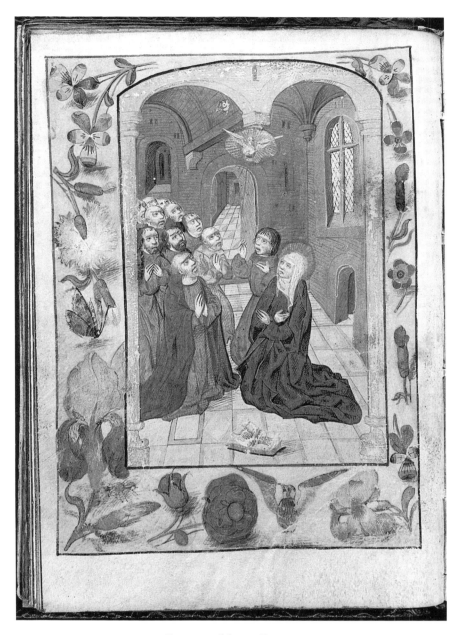

Cat. no. 24 fol. 14v, *Pentecost*

25

Diurnale with a binding by Ludovicus Bloc

c. 1500, Flemish

Manuscript on parchment, 72 × 60 mm, ii + 305 + i folios

Provenance: Eighteenth century, T. Baker; his gift to St John's College *Accession no.* MS. I. 39

References: James 1913, pp. 260–1

This little prayerbook is an example of a portable book, to be used during travelling. The sizes of Books of Hours were fairly standard. This allowed flexibility in their production, especially with regard to the insertion of miniatures. Smaller books such as the St John's College example displayed here are rare, probably because they were more likely to be lost.

This sober manuscript, written in minute script by one hand, has a typical late fifteenth-century Flemish binding. Various binders, especially in Bruges and Ghent, designed a panel with two rows of animals entwined in a vinebranch in the centre. These motifs are surrounded by a text of which the main part reads *Ob laudem / xpristi librum hunc / recte ligavit / Ludovicus Bloc*

(Ludovicus Bloc has bound this book to the Glory of Christ). Compared to the method of using small single stamps, panel stamps made it possible to decorate bindings more quickly. If the size of the book required it, the panel stamp could be repeated two, four or six times. The presence of the binder's name on bindings functioned both as an advertisement for his work and as a guarantee of quality.

Ludovicus Bloc entered the guild of St John the Evangelist in 1484 sponsored by another binder, Jan Guillebert (see cat. no. 69). Until at least 1526 he remained active in the guild. He died in 1529. All the bindings ascribed to Ludovicus Bloc are tooled with text panel stamps. Bloc used at least two variants. The St John's College one represents the first type. The second type used a slightly different series of animals and is a little larger.

Lent by the Master and Fellows of St John's College, Cambridge

AA

Cat. no. 25, Binding by Ludovicus Bloc

26

Three leaves from a Book of Hours

(a) *The Flight into Egypt*
(b) *The Lamentation for the Dead Christ*
(c) *The Mass of St Gregory*

c. 1510, Bruges?

Miniatures on parchment, 150 × 105 mm, 114 × 100 mm, 140 × 100 mm

Provenance: Charles Brinsley Marlay; his bequest to the Fitzwilliam Museum, 1912 *Accession no.* MS. Marlay Cuttings Fl 5
References: Wormald and Giles 1982, pp. 97–8

The miniature depicting the Flight of the Holy Family into Egypt would, in its original context, have introduced the Office of Vespers in the Hours of the Virgin. The *Legenda aurea*, a popular collection of the lives of the saints by the Dominican author Jacobus de Voragine, tells us that during the journey of the Holy Family to Egypt, idols tumbled from their columns. It further recounts that the soldiers who asked locals for information were told that the Holy Family had passed 'before the wheat came up'. In fact the family had passed by only the day before, and the wheat had grown to maturity overnight. Unaware of this miracle (the Miracle of the Sower), the soldiers grew discouraged. Both episodes are illustrated in the miniature.

It is more complicated to work out the original context for the Lamentation. The sentence at the top of the folio is the end of the recommendation for Compline of the Hours of the Cross, the beginning of which is on the other side of the leaf. This implies that the miniature is painted on the verso side, something which is confirmed by the narrow border on what would have been the spine-side of the manuscript. Traditionally the Lamentation or Deposition illustrates the Office of Compline of

the Hours of the Cross, but the miniature is never placed at the end of the office. The writing of a text above a miniature is also strange: normally, opening texts are written under the miniature.

On the recto of the third leaf is a representation of the apparition of the suffering Christ to Pope Gregory the Great during Mass. During the consecration, Gregory had a vision in which Christ appeared with all the instruments of His Passion. Throughout the Middle Ages, devotion to St Gregory was very popular because it was rewarded with a large amount of indulgences.

On the recto of the St Gregory leaf are instructions for indulgences mentioning how Pope Julius II doubled the indulgences for prayers to St Gregory. This implies that the manuscript dates from after 1503, when Julius II was elected Pope. One can be more precise and suggest 1506 as a *terminus post quem* because it was in that year that Julius II launched the appeal for the new church of St Peter in Rome. As part of his efforts to raise money, he authorised an increase in the selling of indulgences, later strongly criticised by the Reformers. The style of the miniatures is hardly distinctive but typical of the production of Bruges in the first decade of the sixteenth century.

Fitzwilliam Museum, Cambridge AA

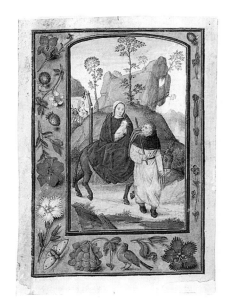

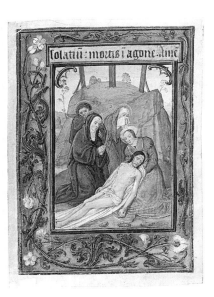

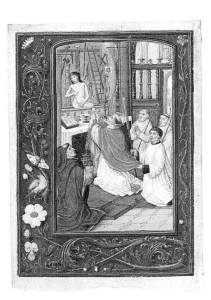

Cat. no. 26a Marlay Cutting Fl 5a, *The Flight into Egypt*

26b Marlay Cutting Fl 5b, *The Lamentation for the Dead Christ*

26c Marlay Cutting Fl 5c, *The Mass of St Gregory*

27

Four miniatures

(a) *Four Apostles*

(b) *Four Apostles*

(c) *Four Female Penitent Saints*

(d) *Four Female Saints*

c. 1510, Bruges

Miniatures on parchment, 230 × 157 mm, 230 × 160 mm, 232 × 122 mm, 225 × 153 mm

Provenance: Said to be from the Celotti and Rogers collections; Thomas Miller Whitehead; Charles Brinsley Marlay; his bequest to the Fitzwilliam Museum, 1912 *Accession no.* MS. Marlay Cuttings Sp 2–5

References: Wormald and Giles 1982, pp. 144–6; Brinkmann 1987; Cambridge 1992 (by Brinkmann); Scailliérez 1992

These four leaves are part of a set of eleven full-page miniatures which survive in various public and private collections. All eleven belong to the same ensemble which may have included other miniatures that are now lost. They have in common their size, their formula of four scenes within a larger frame, and their script. As Brinkmann (1987) has shown, two artists are responsible for them. The Master of the Lübeck Bible was the main artist who painted MS. Marlay Cutting Sp 3. In the 1480s this itinerant Flemish artist travelled through Northern Europe and illustrated the Bible printed by Stephan Arndes in Lübeck in 1494. His career culminated in the first decade of the sixteenth century in Bruges, where he collaborated on the illumination of the spectacular Spinoza Hours (Malibu, Getty Museum, Ludwig MS. IX.8).

The iconography of Marlay Cutting Sp 3 is inconsistent. Four apostles are portrayed as standing in niches of Renaissance architecture. A grisaille tondo depicts their lives. A large script with idiosyncratic letters, resembling printed characters, identifies them thus: in the upper part St Bartholomew and St Philip and in the lower St Andrew and St Paul. However, a closer look reveals a mistake which throws into doubt the identification of St Andrew. This figure stands next to St Paul, in itself of some significance, and holds a Cross. Because he holds it diagonally, it has been assumed that it stands for the saltire Cross on which St Andrew was crucified. Two other attributes, however, argue against this view. In his right hand the apostle holds a book and in his left, as well as the Cross, a key. These are clearly the attributes of St Peter, not of St Andrew. Yet in the tondo related to this particular apostle, the Crucifixion of St Andrew, not St Peter, is depicted. There has clearly been a misunderstanding: two people must have been involved in the painting of the miniature and failed to link their respective endeavours. One artist would have painted what amounts to the borders, namely the architectural frame, and another the figurative scenes. If this is the case, only the apostles of Marlay Cutting Sp 3 are the work of the Master of the Lübeck Bible.

The purpose of these eleven miniatures is puzzling. Each miniature has a common theme: Marlay Cutting Sp 2 and 3 feature apostles, Marlay Cutting Sp 4 features four penitent women saints, Marlay Cutting Sp 5 four virgins or women defenders of the faith. Other miniatures of the set also share a common denominator: women martyrs (Berlin, Kupferstichkabinett, KdZ641), religious (formerly Brussels, Cardon collection) and women renowned for their motherhood (Sotheby's, London, 8.7.1957, lot 61), scenes of the life of the Virgin and of Christ (Sotheby's, London, 11.12.1972, lots 10, 11 and 12). As Brinkmann (1987) has pointed out, this iconographic programme would be very odd for a Book of Hours or breviary. It is, in fact, very doubtful that the miniatures were ever designed to be inserted into a manuscript. As Brinkmann has observed, the borders around the miniatures are symmetrical. This is a most unusual layout for manuscripts, where the border on the outside margin is wider than on the inside. Also, the scenes are set in pairs. The protagonists look at each other, thus accentuating the symmetry of the composition. It is therefore conceivable that these illustrations would have had an independent existence, for instance as an altarpiece. The architectural borders then fulfil the role of a frame and emphasise the devotional aspect of the images. This explains the blank versos of the miniatures and the need to label the saints. Other altarpieces painted on vellum around 1500 have survived, the most famous being the Stein Quadriptych, now in Baltimore. Simon Bening and his workshop produced more of these altarpieces (formerly Namur, Balat collection, Paris, Musée National du Louvre or San Lorenzo de El Escorial; see Scailliérez 1992). Even so, it is difficult to find a consistent iconographic programme. Notwithstanding an overall theme for each of the leaves, it is hard to detect a common denominator for the whole collection.

Whatever the function of these leaves may have been, they were certainly aimed at a Spanish public. This is indicated by the language of the inscriptions above and below the images and by the choice of saints. St Thais was a fourth-century courtesan at the court of Alexandria who burned all her possessions publicly in a square of Alexandria; on the Cardon miniature, St Ildefonse was a seventh-century Benedictine and archbishop of Toledo. Both these saints were little known in Flanders but venerated on the Iberian peninsula. Trading links between Flanders and Spain were very strong during this period and the manuscript could well have been commissioned for or by a Spaniard living in the Netherlands.

Fitzwilliam Museum, Cambridge AA

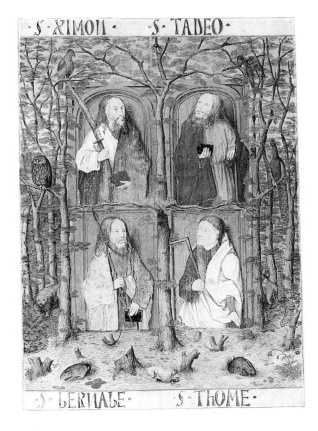

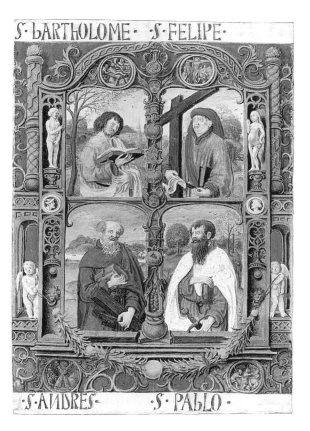

Cat. no. 27a Marlay Cutting Sp 2, *Four Apostles*

27b Marlay Cutting Sp 3, *Four Apostles*

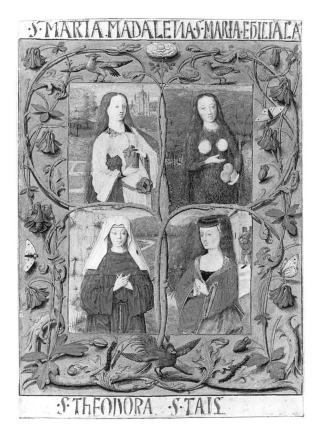

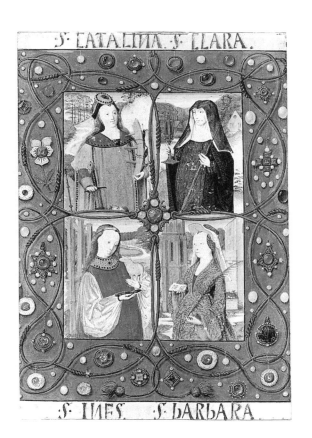

27c Marlay Cutting Sp 4, *Four Female Penitent Saints*

27d Marlay Cutting Sp 5, *Four Female Saints*

28

Book of Hours

c. 1510, Bruges

Illuminated manuscript on parchment, 192 × 133 mm, ii + 185 folios

colour plate, p. 102

Provenance: John Malcolm of Poltalloch (d. 1893); C. W. Dyson Perrins; Sotheby's, London 9.12.1958; Henry Davies; his gift to the Fitzwilliam Museum, 1975 *Accession no.* MS.1058–1975
References: Wormald and Giles 1982, pp. 590–5; Brinkmann 1987, pp. 134–9; Cambridge 1992 (by Brinkmann)

This is the most spectacular Flemish manuscript to be given by Henry Davis to the Fitzwilliam Museum in 1975. Every page is decorated with a border in the Ghent-Bruges style. The book opens with a calendar. Each page presents fifteen days of the month with their saints. The left column lists the 'golden numbers'. The middle column includes letters from A to G in order to work out the day of the week. When 1 January, marked by the letter A, falls on a Sunday, then all other dates marked by an A would also be Sundays. The right column provides a list of saints, the more important written in red ink, the more obscure in black. These lists are framed by figurative borders which consist of a sign of the zodiac for each month and a scene depicting an activity typical of the time of year. The principle of featuring interior scenes under a vast arch is also found in calendars of other Books of Hours painted by the same artist (Germany, private collection (Plotzek 1987, no. 74) or Munich, Bayerische Staatsbibliothek, Clm. 28345).

After the calendar, the various Hours are introduced by a miniature. Every office within an Hour is introduced by a large historiated initial and figurative border. To complete the illumination of the book, every page has a border with a variety of motifs projected onto a plain coloured background.

Such an extensive illumination programme is necessarily a collaborative enterprise, and in this manuscript we can identify four artists. The most attractive miniature features the Garden of Gethsemane and is by the Master of the Dresden Prayerbook. Brinkmann suggested that it was the Dresden Master, by then an old man, who coordinated the illumination of the manuscript. By cleverly painting a continuous landscape in the border and main scene, he guides the beholder's eye straight from the right upper corner to the main scene of Christ praying in the Garden of Gethsemane. The other episodes of the arrest of Christ are depicted in the border with a great sense of drama.

The calendar and the majority of the miniatures are by an artist labelled the 'Painter of Add. MS. 15677', after a Book of Hours in the British Library, London. His figures are rather rigidly positioned in stereotyped compositions. Another more gifted artist painted some apostles: his style is very close to the Master of James IV of Scotland. His miniature of the portrait of Christ goes back to an Eyckian composition. However, the artist has developed the presentation by framing it in an architectural setting, with *trompe-l'œil* statues of saints and, at the bottom, with the episode of St Veronica drying Christ's face. Rather than holding the globe in his hands Christ rests it on the frame, laying his hand on it. This, together with the reflections in the globe and the shadows in his garments, increases the impression that Christ is appearing on a balcony to bless the reader of the prayerbook. On the opposite page, borders with peacock feathers were taken from the repertoire of the Master of Mary of Burgundy (Oxford, Bodleian Library, Douce MS. 219–220, fols. 97v–98r); they were also used by the Master of the First Prayerbook of Maximilian in the Rothschild Hours (Vienna, Österreichische Nationalbibliothek, Cod. Ser. n. 2844) and in a Book of Hours in a private collection (König 1991, no. 24). Finally, an enigmatic artist identified with the Master of the Lübeck Bible (see cat. no. 27) contributed three illustrations to this Book of Hours. He has a very idiosyncratic palette and his images are characterised by a somewhat baroque monumentality. His historiated initial of St Luke painting the Madonna's portrait, the surrounding Tree of Jesse illustrating the opening words of St Luke's Gospel (fol. 36r), and the miniature of St Michael (fol. 165r) are unique works of an innovative artist.

The Rothschild Hours display other parallels with MS.1058–1975. The series of roundels with saints which surround the calendar pages in the Rothschild Hours are echoed in the roundels of the Crucifixion miniature. The border with the battle of the sea monster and the wildmen emerging from a grotto is also to be found in the Rothschild Hours. These borders, the historiated initials and other miniatures were painted by artists from the circle of the Master of the Prayerbooks of *c.* 1500. The Master himself specialised in the illustration of Books of Hours in Bruges, but he excelled in the illustration of secular themes (see cat. no. 71).

Fitzwilliam Museum, Cambridge AA

Cat. no. 28 fol. 9r, *September, Harvesting Grapes*

29

Two leaves from a Rosary Psalter

(a) *The Presentation in the Temple*

(b) *The Ascension*

c. 1520, Bruges

Miniatures on parchment, *c.* 100 × 80 mm

colour plate, p. 102

Provenance: Henry Yates Thompson; his gift to the Fitzwilliam Museum, 1895 *Accession no.* MS. 257(a) and (b)
References: Kupfer-Tarasulo 1979; Wormald and Giles 1982, pp. 186–7; Marrow 1984, p. 541; Dogaer 1987, p. 177; Hindman 1989, passim; König 1991, p. 542

These two leaves are part of a set of sixteen miniatures which illustrated a Rosary Psalter. During the later Middle Ages, the Rosary became a popular way of praying. Although it is only from the fifteenth century onwards that St Dominic is credited with the introduction of the devotion of the Rosary, there is evidence that the practice was already widespread in the thirteenth century. The pious exercise consisted of reciting ten Hail Marys fifteen times, each time focussing on one joyful, sorrowful or glorious mystery of the life of the Virgin. Very often these mysteries were associated with one of the 150 Psalms, hence the name Rosary Psalter. Rosary Psalters are small volumes so they are easily portable.

In the Ascension scene, the apostles and the Virgin Mary have gathered while Christ is taken to heaven, leaving only his footsteps behind. The second miniature features the Presentation of Christ in the Temple. Simeon the priest receives the Child from Mary. Behind her Joseph and the prophetess Anna carry a candle, an allusion to the Candlemas processions which were held on the feast of the Presentation.

The two Fitzwilliam Museum leaves belong to a Rosary Psalter which comprised a short meditation and miniature for each of the fifteen mysteries. Eleven other leaves and one title-page are now in Boston (Mass.), Public Library, MS. Med. 35; two remain untraced. The fact that the prayers were written in Spanish and in a round gothic script indicates that the psalter was intended for export to Spain.

The Boston and Cambridge miniatures are unanimously attributed to Simon Bening. With Gerard Horenbout, Simon Bening (1483–1561) was one of the last two major Flemish illuminators. He worked in Bruges as well as in Antwerp, ending his days in Bruges. His style is one of great refinement, and his production rivalled the best of contemporary panel-paintings. The Boston/Cambridge Rosary can be dated around 1520, on the basis of a stylistic comparison with another manuscript illuminated by Simon Bening, the Imhof Prayerbook (Sotheby's, London, 21.6.1988, lot 107). Bening produced at least four Rosary Psalters, all of which can be linked with Spain. As is customary with Simon Bening, he repeats certain compositions. The composition of the Ascension miniature is essentially the same as that in the Beatty Rosary, also illuminated by Bening (Dublin, Chester Beatty Library, MS. Western 99).

The scribe was possibly Antonius Van Damme. Antonius, who had joined the guild of St John the Evangelist of Bruges at the latest in 1499, collaborated with Simon Bening on various occasions. The earliest proof of collaboration dates back to 1511, when Antonius transcribed the so-called Imhof Prayerbook in Antwerp. Five years later Bening sent Van Damme to pay his entrance dues to the Bruges guild of scribes and illuminators to which both belonged. In 1531 he wrote a Book of Hours (now New York, Pierpont Morgan Library, MS. M. 451). Towards the end of his career, in 1545, another Rosary Psalter illuminated by Simon Bening (now Amsterdam, Bibliotheca Philosophica Hermetica) was written by Antonius, this time in Bruges. A few leaves from a prayerbook and a Book of Hours of Mencia de Menoza (possibly Madrid, Instituto de Valencia de Don Juan) were also copied by him. It thus appears that Antonius Van Damme followed Simon Bening when the latter moved from Antwerp to Bruges. Van Damme copied manuscripts in different script styles. The Imhof Prayerbook was written in Burgundian *Bastarda* while others, especially those to be exported to Spain, were written in a round gothic script. The rounded gothic script of the Boston/Cambridge leaves is comparable to the Mendoza Hours and the 1545 Rosary Psalter. All three may well have been written by Antonius Van Damme over a period of twenty or more years.

Fitzwilliam Museum, Cambridge AA

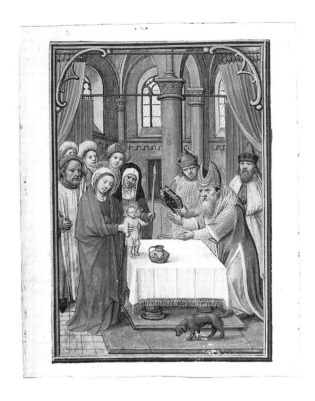

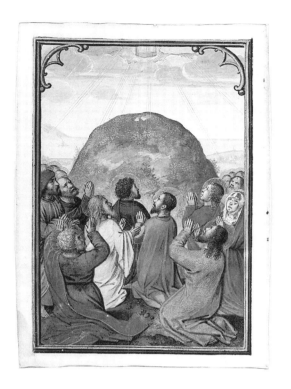

Cat. no. 29a MS. 257a, *The Presentation in the Temple*

29b MS. 257b, *The Ascension*

30

Speculum Humanae Salvationis

c. 1460, Northern France?

Illuminated manuscript on parchment, 375 × 260 mm, 48 folios

Provenance: Founder's bequest, Fitzwilliam Museum, 1816
Accession no. MS. 23
References: James 1895, pp. 51–9; Cambridge 1992 (by B. Cardon)

From the very beginning of Christianity, but especially during the Middle Ages, authors have explored the parallels between the Old and the New Testaments. Episodes of the Old Testament were believed to prefigure passages of the New Testament. Thus, for scenes from the New Testament, called types, antetypes were found from the Old Testament and occasionally from the Apocryphal books and pagan antiquity. This approach to reading the Bible became known as typology. Artists from all disciplines were inspired by writings on the subject. During the fifteenth century, the *Biblia Pauperum* and the *Speculum Humanae Salvationis*, both based on juxtaposing images and texts of the Old and New Testaments, enjoyed great popularity. They were among the few texts to be published as blockbooks, a printing technique consisting of printing from a carved wooden panel.

The text of the *Speculum Humanae Salvationis* was written by an anonymous author during the first quarter of the fourteenth century. Two traditions of the text developed. The first is confined to the Italian peninsula, the second was widespread in northern Europe. More precisely, Jean de Stavelot, a monk from the monastery of St Laurent in Liège, transcribed the text in 1428 and it is this version which is included in the Fitzwilliam Museum *Speculum*. As usual in *Speculum* texts, there are four

columns spread over two pages with a miniature at the head of each one. On the left is the scene from the New Testament, while the other three are antetypes from the Old Testament. The manuscript is opened at the pages where Christ enters the city of Jerusalem weeping. This is compared with Jeremias lamenting the abandoned Jerusalem. The third miniature features David's triumphant entry into Jerusalem after having killed the giant Goliath, another antetype for Jesus' triumphant entry. The fourth miniature shows Heliodorus struck by a rider on horseback and two other men. Heliodorus, the chancellor, had been sent by the king to rob the Temple. His plans were discovered and he was beaten out of the town. This episode was regarded as a parallel to Christ's expulsion of the money lenders from the Temple. Jerusalem is the common denominator between all four episodes.

Stylistically the manuscript is close to another *Speculum*, now in the monastery of Einsiedeln. Cardon (Cambridge 1992) has demonstrated that both manuscripts belong to the same tradition and were probably produced in the same workshop. It is, however, unclear where this workshop was situated. The artists appear to have used examples from Books of Hours illustrated in northern France as well as in the Southern Netherlands. We must therefore look for an area where these influences would intermingle in order to establish a place of production for the Fitzwilliam Museum and Einsiedeln *Specula*.

Fitzwilliam Museum, Cambridge AA

Cat. no. 30 fols. 16v–17r, *The Entry into Jerusalem, Jeremias laments Jerusalem, David with the Head of Goliath, Heliodorus struck by a Rider on Horseback*

31

Five miniatures from a Book of Hours

(a) *The Crucifixion*

(b) *The Annunciation*

(c) *The Virgin and Child with St Anne*

(d) *The Last Judgement*

(e) *The Assumption of the Virgin*

c. 1522, Bruges

Miniatures on parchment, *c.* 180 × 130 mm

colour plates, pp. 104–5

Provenance: Albrecht of Brandenburg; Marquess of Londonderry, 1856; Reverend E. Dewick; given by the Friends of the Fitz-william to the Fitzwilliam Museum, 1918 *Accession no.* MS. 294
References: London 1953–4, p. 165, no. 620; Wormald and Giles 1982, pp. 270–3; Dogaer 1987, p. 177; Sotheby's, London, 21.6.1988, p. 86

These five miniatures were part of a famous Book of Hours owned by Albrecht of Brandenburg, once in the First Viscount Astor collection and sold at Sotheby's in 1988. Some of the miniatures of this Book of Hours were cut out of the manuscript before 1856 and are now to be found in libraries in Stockholm, Montreal, Amsterdam, New York and the Fitzwilliam Museum. Albrecht of Brandenburg (1490–1545) was archbishop and elec-tor of Mainz. He was an active patron of the arts and purchased works of art from major artists such as Dürer, Grünewald and Cranach. During the 1520s, Albrecht of Brandenburg sent his agent Hans Schenitz to the Netherlands. There Schenitz com-missioned from Simon Bening the Book of Hours from which these five miniatures come.

In these miniatures, Bening respects the traditional layout of a manuscript page. Unlike his other works, where all the scenes are integrated in one picture, the main subject and complemen-tary scenes are still separated as miniature and border. Bening's style can be characterised by the use of bright colours for the main protagonists while the backgrounds are painted with subtle nuances of tone. Bening's compositions are rarely noted for their originality. The Fitzwilliam Museum miniatures illustrate very well his practice of borrowing from predecessors. The compositions of the Crucifixion and the Assumption of the Virgin are borrowed from the Master of Mary of Burgundy. The miniature of St Anne and the Virgin and Child is a composition which remained popular in Bruges and Ghent paintings and manuscripts for decades. The first instance of a similar repre-sentation of the Christ Child in his mother's and grandmother's laps seems to date back at least to the 1460s when it appears in the Breviary of Philip the Good. The Prayerbook of Jacob Ruebens (Brussels, Koninklijke Bibliotheek, MS. IV 167), dated as late as 1547, contains a miniature based on the same composition.

Fitzwilliam Museum, Cambridge AA

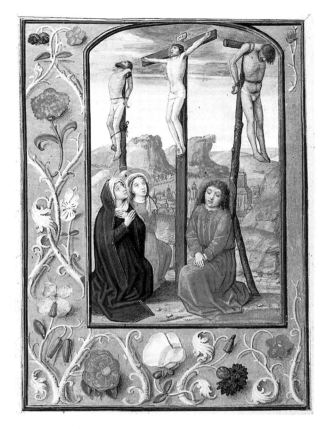

Cat. no. 31a MS. 294a, *The Crucifixion*

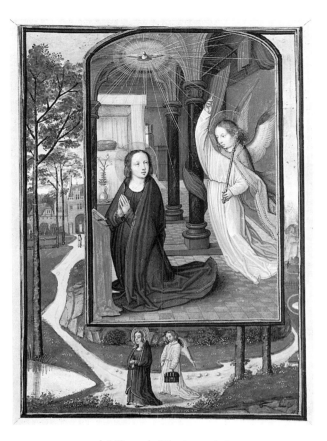

31b MS. 294b, *The Annunciation*

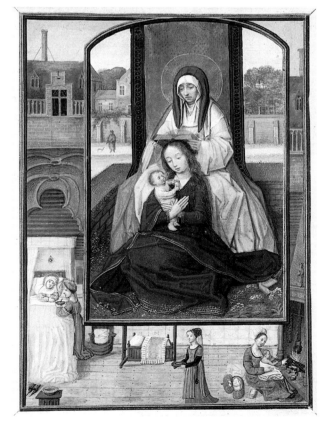

31c MS. 294c, *The Virgin and Child with St Anne*

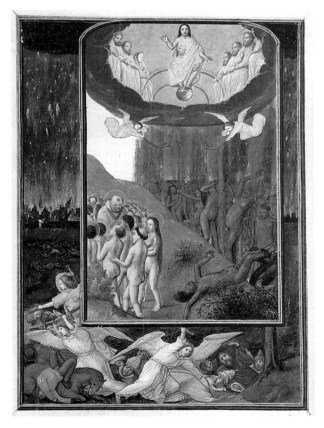

31d MS. 294d, *The Last Judgement*

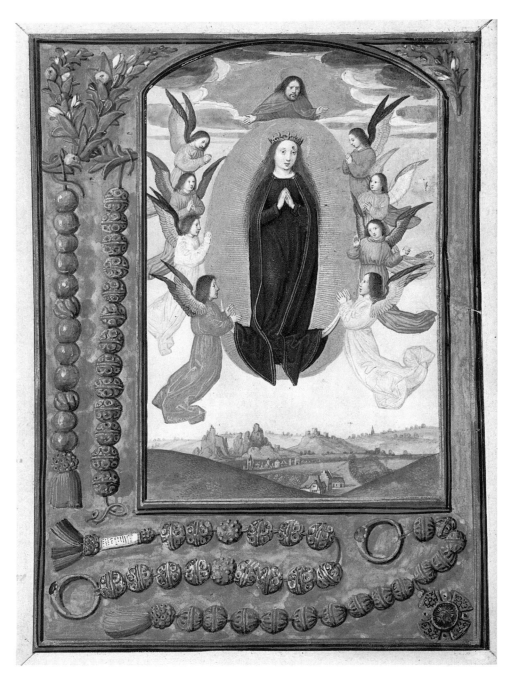

31e MS. 294e, *The Assumption of the Virgin*

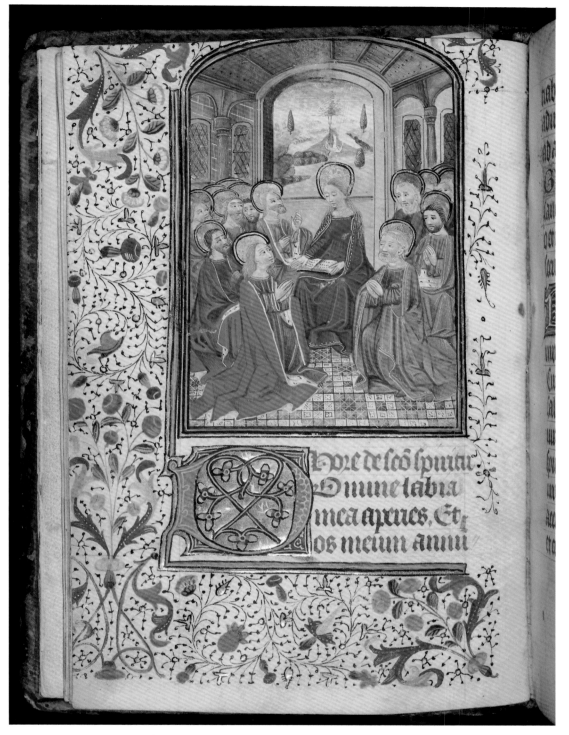

Cat. no. 17 fol. 12v, *Pentecost*

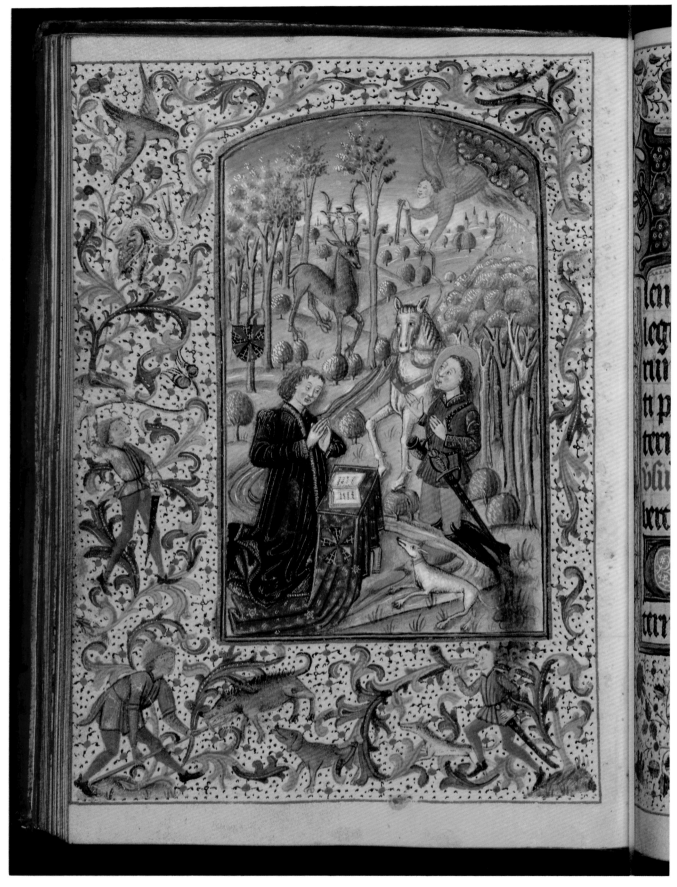

Cat. no. 18 fol. 45v, *St Hubert and the Lord of Enghien*

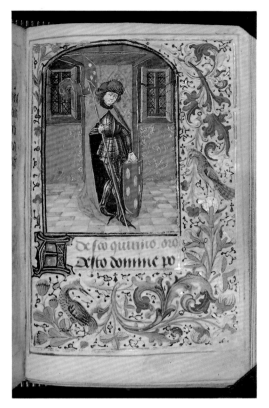

Cat. no. 19 fol. 226r, *St Quirinus*

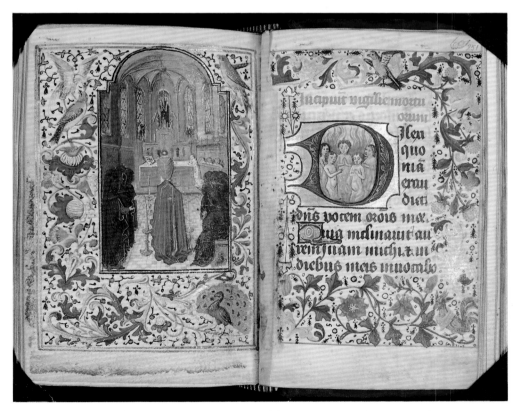

Cat. no. 19 fol. 250v, *Officium Mortuorum*; fol. 251r *Five Naked Souls among Flames*

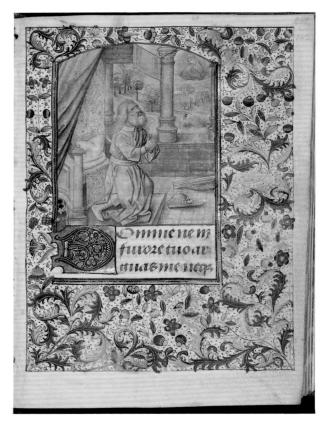

Cat. no. 20 fol. 142r, *The Penitent David*

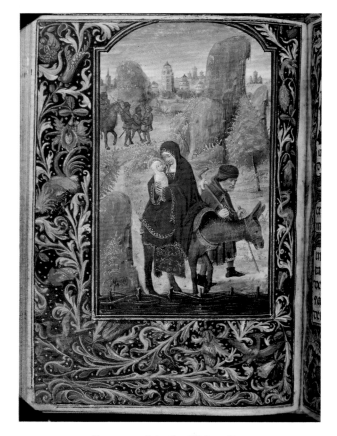

Cat. no. 21 fol. 58v, *Flight to Egypt*

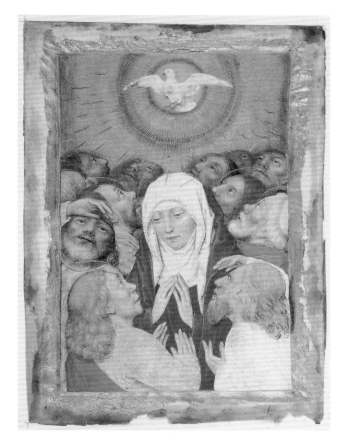

Cat. no. 22, *Pentecost*

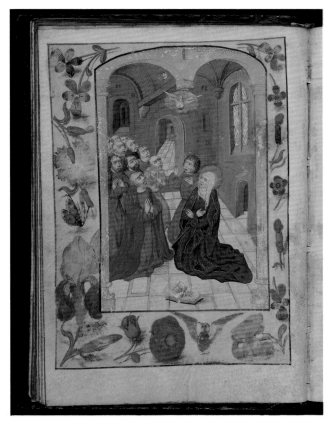

Cat. no. 24 fol. 14v, *Pentecost*

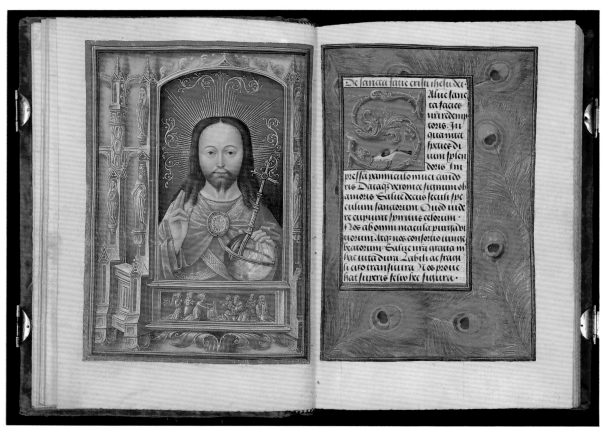

Cat. no. 28 fol. 13v–14r, *The Holy Face – Imago Christi*

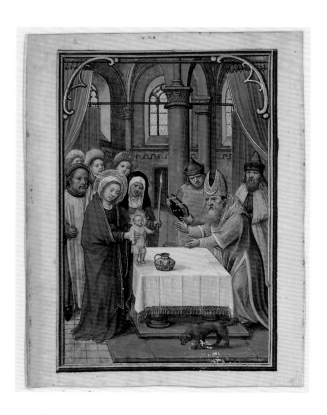

Cat. no. 29a MS. 257a, *The Presentation in the Temple*

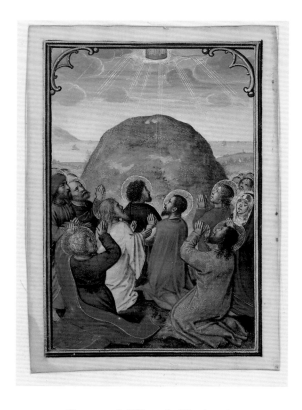

Cat. no. 29b MS. 257b, *The Ascension*

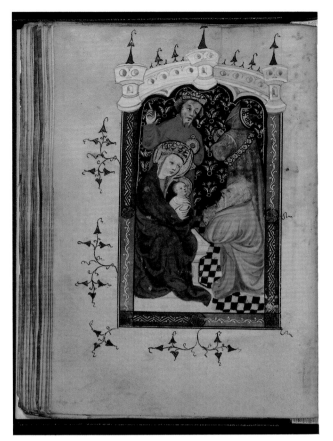

Cat. no. 32 fol. 49v, *Epiphany*

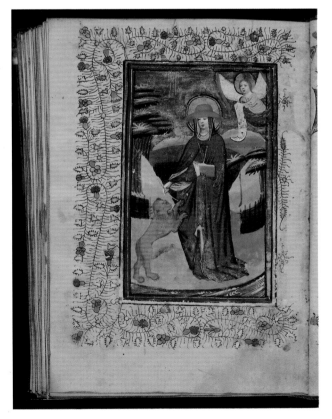

Cat. no. 33 fol. 104v, *St Jerome*

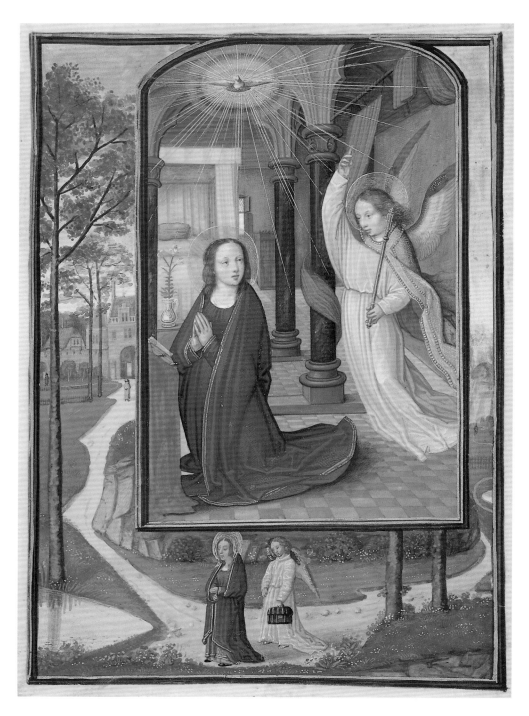

Cat. no. 31b MS. 294b, *The Annunciation*

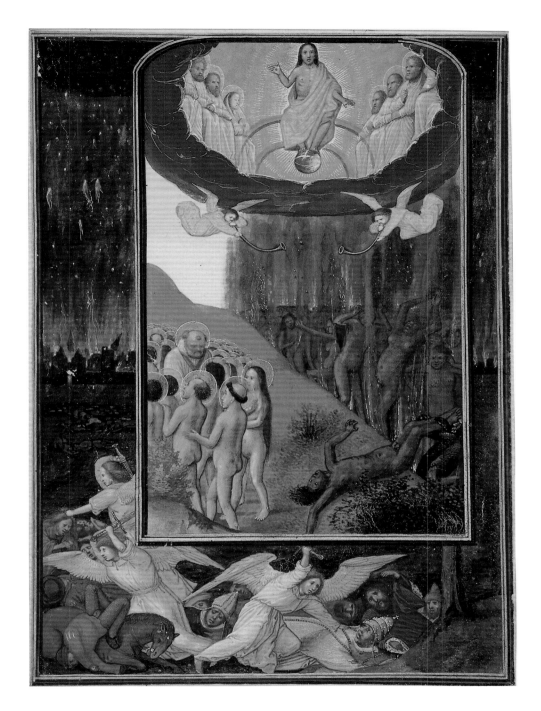

Cat. no. 31d MS. 294d, *The Last Judgement*

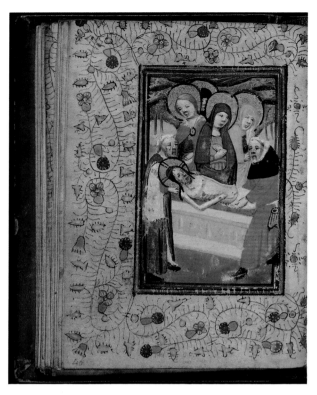

Cat. no. 35 fol. 90v, *The Entombment*

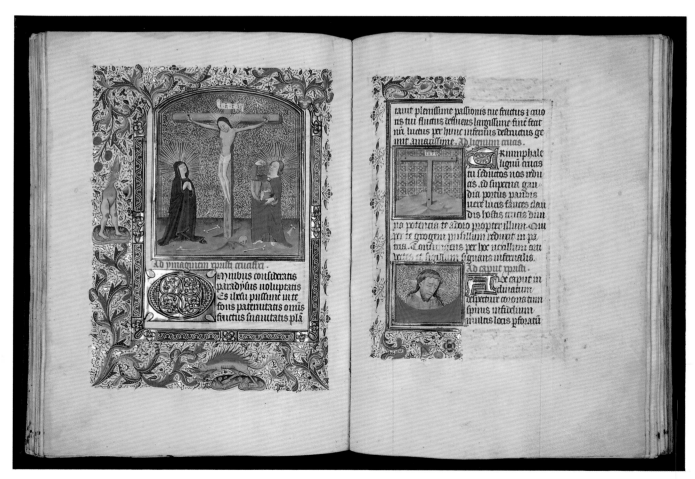

Cat. no. 36, fols. 49v–50r, *Crucifixion, the empty Cross and head of crucified Christ*

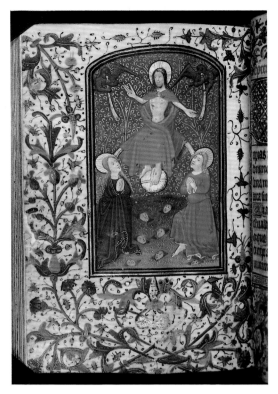

Cat. no. 37 fol. 91v, *Last Judgement*

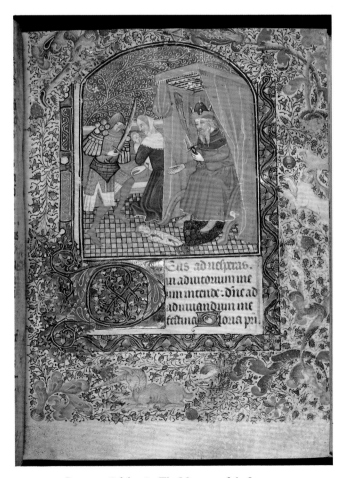

Cat. no. 38 fol. 26r, *The Massacre of the Innocents*

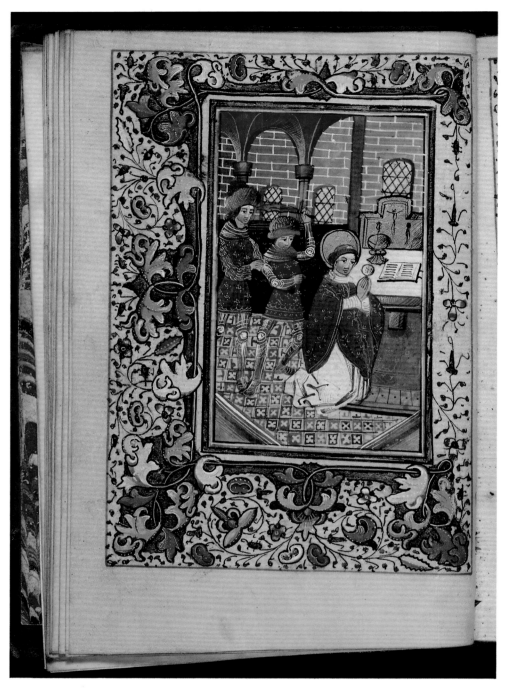

Cat. no. 39 fol. 22v, *The Murder of St Thomas Becket*

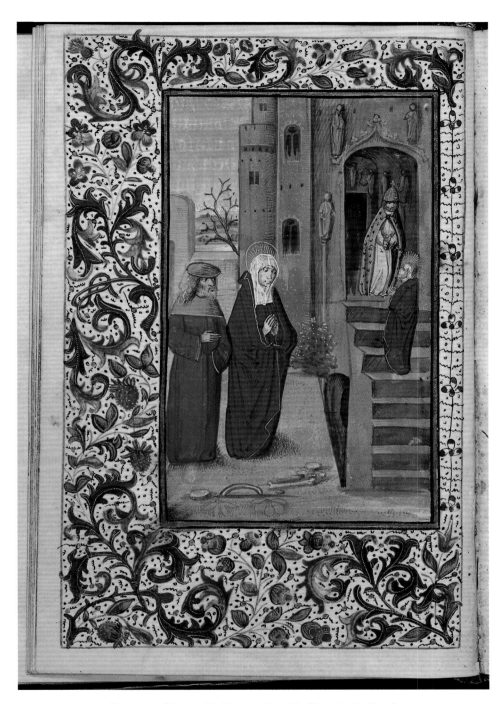

Cat. no. 41 fol. 73v, *The Presentation of the Virgin in the Temple*

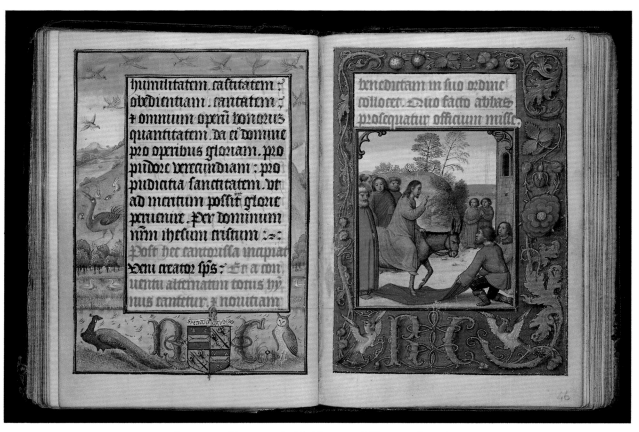

Cat. no. 42 fols. 45v–46r, *The Entrance of Christ into Jerusalem*

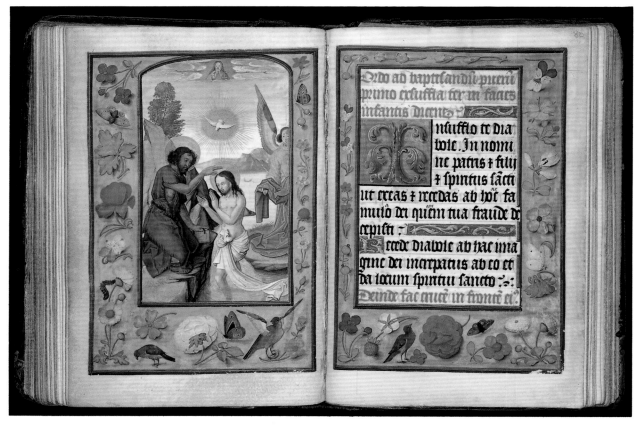

Cat. no 42 fols. 79v–80r, *Baptism of Christ*

Cat. no. 43 fol. 48r, *St Anne, Virgin and Christ*

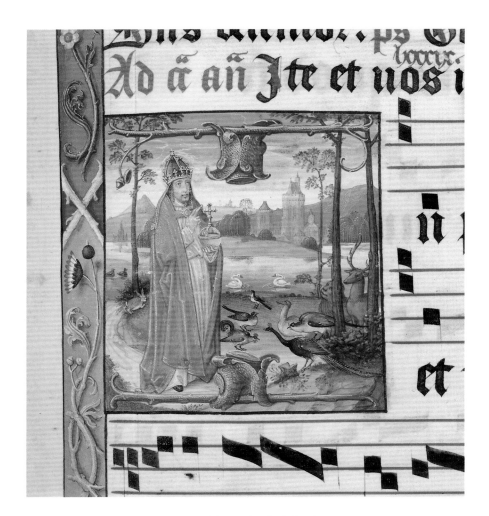

Cat. no. 44 fol. 84r, detail, *God as Creator*

Flemish books for English readers

Alain Arnould

Trade between Flanders and England was always of great importance for both countries. Throughout the Hundred Years' War, commercial links were threatened by political considerations. Wool formed the lion's share of the trade between the two nations. Another product which managed to win a place for itself on the fringe of these export activities was the book. Throughout the fifteenth century, but especially during its first decades, Flemish books crossed the North Sea in large numbers.

One category of books was particularly popular with English readers, namely Books of Hours. The contents of the English Book of Hours differed from those of dioceses on the Continent. The diocese of Sarum (Salisbury) had developed a particular order of prayers which had come to be generally accepted throughout England. A very few Books of Hours follow the use of York. Although some secular manuscripts and incunables produced in Flanders were exported to England, especially during the last decades of the century, this never occurred in the same numbers as Books of Hours. On the Continent, Books of Hours had developed from Psalters as a result of the growing importance of private devotion. In England too, this trend was noticeable, but the English workshops for manuscript production were not able to meet the increased demand. Thus the English faithful turned to the Continent and soon Flemish Books of Hours were being exported to the English market. Because of its geographical proximity Flemish Books of Hours enjoyed particular popularity in East Anglia.

Nicholas Rogers (1982) has devoted a major study to this category of Books of Hours and found that more than two hundred still survive. Compared with the English Books of Hours produced around the same time, the Flemish *Horae* betray their origins in a variety of ways. Exceptionally, as in Ushaw, St Cuthbert College, MS. 10, the scribe has supplied a complete colophon mentioning that he, Johannes Heineman had finished his work in Bruges on 21 January 1408. Sometimes, the manuscripts were exported in blind-stamped bindings which clearly point to a Flemish binder. Another common way of establishing Flemish provenance is to examine the calendar. Naturally, the calendar will include many saints who are not usually included in Flemish

Books of Hours. Sts Edmund, Oswald, Magnus, Hugh of Lincoln and Etheldreda were little known names on the other side of the North Sea. Mistakes in the spelling of typical English saints are probably due to the fact that they were written by a Flemish-speaking scribe. Moreover, scribes did not always confine themselves strictly to the English calendar, and sometimes included saints such as Bavo or Amelberga. In some instances the *Horae* start with an explicit indication that the following Hours were according 'to the use of the English church'. The decoration is also specially adapted to the English market. Compared to the illustrations of Books of Hours for the continental market, the iconographic programmes are quite distinct. The cycle of the events of the Life of the Virgin which normally accompanies the Hours of the Virgin is replaced by scenes from the Passion of Christ. Very often these miniatures were painted on single leaves and then inserted into the book when required. Compared to English books of the time, the style is different and clearly in the Flemish tradition. It is of course very difficult to argue on the grounds of style alone. Nicholas Rogers (1982) has shown that English illuminators also contributed to the production of Flemish Books of Hours. They could paint their contribution once the manuscript had reached England but, in other instances, English artists established themselves in Flanders and collaborated with their Flemish colleagues.

It is very difficult to know which Flemish towns produced Books of Hours for the English market. Explicit information pointing to one town rather than another is rare. Bruges seems to have produced the majority but other centres were certainly also involved. Some artists seem to have specialised in the production of Books of Hours but no names have come down to us. In some instances they worked for specific patrons but, in most cases, Books of Hours were made for a general public and were personalised after they had been bought. This could be done by painting an ownership mark or by adding the names of some members of the family to the calendar.

References: Colledge 1978; Rogers 1982; Armstrong 1983; Hellinga 1991

32

Book of Hours (Use of Sarum)

c. 1400, Bruges

Illuminated manuscript on parchment, 195 × 130 mm, ii + 109 + ii folios

colour plate, p. 103

Provenance: Badingham or Heveningham (Suffolk); Thomas Roberts?; Edmund Roberts (1553); Royal Library, given to Cambridge University Library, 1715 *Accession no.* MS. Ii.6.2
References: Cambridge 1856, 3, pp. 497–8; Rogers 1982, pp. 64–78 and 341; Cardon 1989, pp. 219–24

This manuscript has not previously been published in any detail. The following description may be a useful complement:

21 miniatures (excl. fols. 20, 21, 29, 30, 74, 104, 105 and 106 missing): fol. 10v (Trinity), fol. 12v (Face of Christ), fol. 14v (St Michael), fol. 16v (St Christopher), fol. 18v (Sts John the Baptist and John the Evangelist), fols. 22v (St George), fol. 24v (St Catherine), fol. 26v (St Margaret), fol. 30v (St Anne), fol. 33v (Annunciation), fol. 37v (Visitation), fol. 44v (Nativity), fol. 47v (Annunciation to the Shepherds), fol. 49v (Epiphany), fol. 51v (Massacre of the Innocents), fol. 53v (Flight into Egypt), fol. 55v (Presentation in the Temple), fol. 59v (Virgin), fol. 68v (Crucifixion), fol. 75v (Christ with the Instruments of the Passion), 84v (Mass of the Dead); modern binding.

This Book of Hours consists of two separable entities which were produced independently: the text and the illustrations. The miniatures were part of a standard iconographic programme. The artist painted them on the versos of singletons and probably sold them in this state. The purchaser could then select his pictures according to his text. In many cases the singletons were cut in two (fol. 49v) so that the illustrations could be inserted next to the appropriate prayer. In other instances the singletons were left together (fols. 47–51). The main advantage of this system is its flexibility: the miniatures could be produced separately and inserted in various quantities and at the places the owner wished. The flexibility was further enhanced by having wide margins around the miniatures. This allowed the miniatures to be bound with text leaves of various sizes. The main disadvan-

tage of this system was that it left numerous pages blank. In this manuscript, the owner, probably Edmund Roberts, wrote additional prayers on these pages.

All twenty-one miniatures are surrounded by alternating blue and red blocks and topped with a baldachin with three towerlets. This creates the impression of depth, as if the beholder was catching a glimpse of a scene through a window. This sense of depth is also emphasised by the colour variation of the baldachin, white on the left and pink on the right. Little vignettes fill what otherwise would be large blank borders. The figures are too large in comparison with the frames. They are depicted in front of a black screen which resembles a tapestry with various motifs. No landscapes are used.

It is difficult to date this manuscript precisely but it must be situated around 1400, perhaps a little earlier. It belongs to the first wave of Books of Hours which were exported to England. Two other Flemish Books of Hours with similar canopy-like frames and produced in this period for the English market have survived. London, British Library, Sloane MS. 2683 and one sold at Sotheby's, London, 2.3.1935, show stylistic and compositional resemblances to MS. Ii.6.2. A comparison with Books of Hours in Bruges, Groot Seminarie, MS. 72/175 and New York, Metropolitan Museum of Art, Lehman collection, MS. 20, shows that the architectural framing of the miniature was not uncommon around that period in Flanders.

The presence in the calendar of the obits of Margery, wife of John Carbonell of Badingham, and Margaret, wife of John Heveningham, points towards a Suffolk ownership. This is confirmed by the entry of the feast of St Etheldreda (17 October), the patron saint of Ely, in the calendar and by the addition of a prayer to the East Anglian saint at the end of the manuscript (fol. 102v).

Lent by the Syndics of Cambridge University Library AA

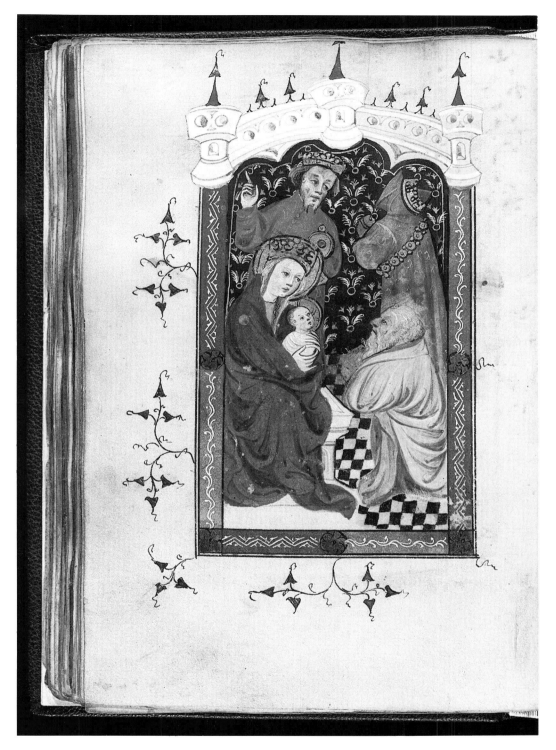

Cat. no. 32 fol. 49v, *Epiphany*

33

Book of Hours (Use of Sarum)

c. 1430, Bruges?

Illuminated manuscript on parchment, 200 × 135 mm, 120 + i folios

colour plate, p. 103

Provenance: John Benet of London (end of the fifteenth century); Thomas Nevile (d. 1615); his gift to Trinity College *Accession no.* MS. B.11.18
References: James 1900, pp. 359–61; Rogers 1982, pp. 284–5

The remarkable feature of this Book of Hours destined for the English market is the presence on all but four of the miniatures of a small mark, in the form of a gothic 'b'. In Bruges such marks were used to identify the book illuminators who were established there. In 1426 a conflict arose between the painters' guild and the bookmakers' guild. The former complained that the bookmakers constantly bought miniatures from Utrecht and therefore threatened the livelihood of the local painters. The outcome of the dispute was that the sale of single leaves was regulated more strictly. It was forbidden to buy or sell single-leaf miniatures which had not been painted by members of the guild. To implement this ruling each miniaturist of the guild had to register a sign with which he had to mark his miniatures. The marks of the Trinity College manuscript are probably examples of this practice. Marks with a clover and letter tau have been identified, but the gothic letter 'b' is most commonly found (Wigan, Upholland College, MS. 106; London, University of London Library MS. 509; London, Victoria and Albert Museum, Reid MS. 45; Oxford, Bodleian Library, MS. Canon. Liturg. 17 and MS. Rawl. Liturg.e.8, and cat. nos. 34 and 35). The Trinity College manuscript thus belongs to this group. Identification of these signs is problematic. In the two lists of signs of the Bruges guild of painters which survive, no gothic 'b' is to be found. It is of course possible that other Flemish towns feared similar competition from the Northern Netherlands and made similar rulings. The lack of any comparable archival information for other towns could be the result of a historical coincidence. The presence of the mark is thus no secure indication for the provenance of the manuscript.

The artist responsible for the miniatures is Claes Brouwer or someone who worked in his entourage. Brouwer's career developments are unknown apart from the fact that he illuminated part of a History Bible made in 1431 (now Brussels, Koninklijke Bibliotheek, MS. 9020–23). At that time Brouwer must have been in Utrecht. Later he seems to have come south to Flanders, most probably Bruges, where he produced miniatures for Books of Hours for the local market as well as for export. The style of the miniatures of the History Bible is close to the miniatures of the Trinity Book of Hours: the same palette, elongated faces and bodies enveloped in long straight draperies, figures overlapping the frame, and rudimentary landscapes. These characteristics can also be found in two other manuscripts included in this exhibition, which are stamped with the same 'b' mark (see cat. nos. 34 and 35). This artist has therefore also been called the 'b' Master.

The borders around the miniatures are composed of different motifs from the borders in the Fitzwilliam Museum leaf (cat. no. 34). Rather than having flowers in the corners, the Trinity leaves are limited to tendrils. Rogers (1982) identifies this hand with the artist who painted the borders of Gonville and Caius, MS. 241/127 (cat. no. 35). The borders around text pages are by another artist who uses spiral motifs in the corners.

Lent by the Master and Fellows of Trinity College, Cambridge

AA

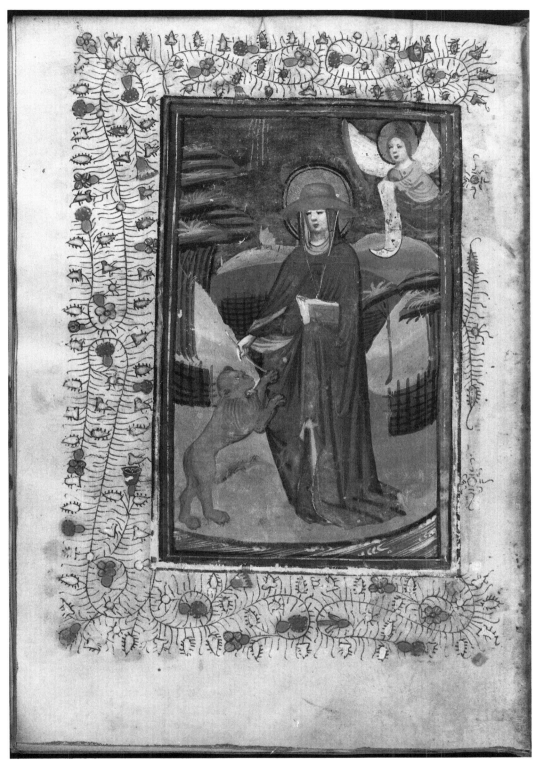

Cat. no. 33 fol. 104v, *St Jerome*

34

Single leaf from a Book of Hours: *The Entombment*

c. 1430, Bruges

Miniature on parchment, 170 × 120 mm

Provenance: Sotheby's, London, 18.6.1991, lot 33; given by the Friends of the Fitzwilliam to the Fitzwilliam Museum, 1991
Accession no. MS.27–1991
References: Witten 1983; Sotheby's, London, 18.6.1991, lot 33

In Books of Hours, Vespers of the Hours of the Cross are normally introduced by a miniature of the Entombment and this was most probably the function of this leaf. The three Marys watch the burial of Christ by Joseph of Arimathea and Nicodemus. In the foreground, two hills and minute trees serve as repoussoirs, situating the event at a distance from the beholder. In the background the same elements are echoed. The schematic landscape with its circular sky, its triangular rocks and little trees mirrors the foreground. The scene itself is situated on a stage-like oval delimited by a brown line at the bottom and rocks at the top. The distant background is represented in gold leaf.

Stylistically, the Entombment is close to a group of manuscripts, including the Trinity College manuscript in this exhibition (cat. no. 33), which have been associated with Claes Brouwer. The elongated faces, the treatment of the clothing and landscape, the static but balanced compositions and the palette are very close to his style. Also typical for Brouwer is the way he allows his figures to overlap the frame. Brouwer was a Northern Netherlandish artist who probably came to Bruges during the 1430s. When he arrived in Bruges, he had to comply with rules issued by the guild to protect its members by using a mark. In

this miniature the gothic 'b', which is assumed to be his mark, is visible in the upper right corner. The border is dominated by rinceaux interspersed with flowers in the corners, a style also encountered around other miniatures of the Brouwer School.

It is not known from which manuscript this leaf came, but another similar leaf which appeared on the market in 1983 almost certainly belonged to the same codex (Witten 1983). The miniature represents Christ before Pilate and obviously originated from the same workshop, since it also has a 'b' mark. The miniature has exactly the same dimensions, an identical border and illumination style. Another parallel are the texts on the reverse of the leaves. In both instances an early sixteenth-century hand has written a French prayer related to the respective miniature. Although it is possible that both leaves were originally part of one Book of Hours, it is more likely that the two leaves were never part of a manuscript. Single leaves with miniatures were commonly circulating in Bruges during the whole of the fifteenth century. The majority of them found their way to a manuscript, but some could very well not have found a buyer. The presence at the back of the leaves of a French prayer adds weight to this hypothesis: it seems as if the owner was unaware of the role of the miniatures in a standard Book of Hours and thus wrote his own meditation about the represented subject on the back of the leaf.

Fitzwilliam Museum, Cambridge AA

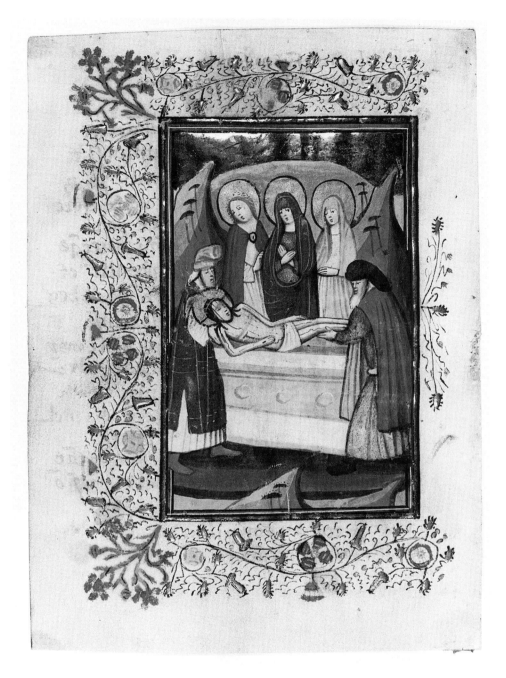

Cat. no. 34, *The Entombment*

35

Book of Hours (Use of Sarum)

c. 1430, Bruges and Ghent?

Illuminated manuscript on parchment, 114 × 72 mm, vi + 155 + v pages

colour plate, p. 106

Provenance: William Moore; his gift to Gonville and Caius College, 1659 *Accession no.* MS. 241–127
References: James 1907, pp. 292–3; Rogers 1982, pp. 272–4; Dogaer 1987, p. 36; Cambridge 1992 (by N. Rogers)

This is an incomplete Book of Hours made for the English market. When the manuscript was rebound, the miniatures were mixed up, so that it is now difficult to get an exact idea of its appearance in its original state. The calendar, which mentions all the important English saints, was probably written in England and added to the rest of the manuscript once it had crossed the Channel. Two artists contributed to the illustrations. The first is an artist who marked his miniatures with a red 'b' stamp (see cat. nos. 33 and 34). They are the usual bright but rather static images which characterise artists working around Claes Brouwer. The illustration of this part of the manuscript might thus probably be situated in Bruges.

The second is a more talented artist who painted the miniature of St John the Baptist on p. 106. His miniature is surrounded by borders in a style different from the rest of the manuscript. The miniature was originally meant to accompany a prayer to St John, who points away from himself towards Christ the Messiah. St John steps out of the landscape, which is screened by hills and a background of red and blue mosaics. The broad folds of his camel-hair garment give him a convincing posture. It has been suggested that this artist could be a pupil of the artist who painted a Book of Hours now in Baltimore (Walters Art Gallery, MS. W. 166). This places the St John miniature in the circle of the Master of Guillebert of Mets, who may have been active from Ghent rather than Bruges.

Lent by the Master and Fellows of Gonville and Caius College, Cambridge

AA

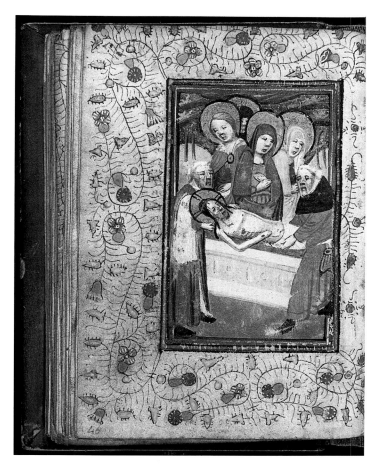

Cat. no. 35 fol. 90v, *The Entombment*

36

Book of Hours (Use of Sarum)

c. 1440, Flemish

Illuminated manuscript on parchment, 305 × 220 mm, 118 folios

colour plate, p. 106

Provenance: Lyons, A. Rosset; Hôtel Drouot, Paris, 17.6.1960; Henry Davis; his gift to the Fitzwilliam Museum, 1975 *Accession no.* MS.1055–1975
References: Wormald and Giles 1982, pp. 582–5; Rogers 1982, pp. 248–52; Dogaer 1987, p. 31; Smeyers and Cardon 1990, pp. 56, note 37 and 57, note 39

Produced in Flanders in the middle of the fifteenth century, this Book of Hours has all the elements of a product for the export to the English market. This is indicated by the calendar and the style of illumination. In the calendar, many obscure and less obscure English saints are included: St Malo, the Welsh apostle of Brittany, Alphege, archbishop-martyr of Canterbury, Milburga, foundress of a nunnery at Wenlock, Richard, misspelled Vicardus by the Flemish scribe, Cuthburga, the first abbess of Wimborne, whose name the scribe confused with Cuthbert. Yet three anomalies cast doubts on whether this Book of Hours ever crossed the North Sea before it was bought by Henry Davis in 1960.

First, it appears that towards the end of the fifteenth century, the then owner added to the calendar the name of St Florentius, the seventh-century Irish monk who christianised Alsace and became bishop of Strasburg. St Florentius never enjoyed a cult in England and it is more likely that his name was added at the initiative of an Alsatian reader, possibly an inhabitant of Niederhamslach where the church is dedicated to St Florence. Secondly, the name of St Thomas Becket, whose feast is written in red on 29 December, has remained untouched. In other Books of Hours for English use, mentions of St Thomas Becket have often been erased, along with other papal saints. Such intervention indicates that the book was in English possession during the Reformation. The fact that the name of St Thomas Becket was not erased from this Book of Hours may indicate it was not in England at that time. A third element is the prove-

nance of the book which was in French hands until it was bought by Henry Davis. Another possibility is that the book, after a brief stay in England, travelled back to the Continent with a Catholic who fled the Reformation persecution in England.

Besides the traditional parts of a Book of Hours, this manuscript also includes some salutations to the Crucifix. After a general prayer to the crucified Christ, there follow seven prayers to the wood of the Cross, the head and the five wounds of Christ, each of them illustrated by a miniature. Almost every page is decorated with splendid borders in which the occasional figure has been included.

The illustrations bear all the marks of an outstanding artist who was active in Bruges in the so-called Gold Scrolls workshop. This workshop was among the most prolific manuscript workshops in Bruges during the second quarter of the century. In its early stages, the artists were influenced by the Parisian illuminators from the circle of the Boucicaut Master. They specialised in the production of Books of Hours, many of which were written and illustrated specifically for the English market. One of the characteristics of this School, which has given it its name, is the use of red backgrounds, on which golden stems are drawn. The artists use the same composition patterns over and over again. In the Fitzwilliam Museum manuscript, a talented master was at work. Unlike other manuscripts from this workshop, the miniatures have been painted with great care and the compositions are set in a realistic space. The figures themselves are stiff and emotionless. The composition which the Master uses for the Passion of Christ (fol. 103r) is to be found in another major example from the Gold Scrolls workshop (Plotzek 1987, no. 53, fol. 156v), a manuscript which was also produced for the English market. Another manuscript close in both contents and style is a Book of Hours now in Rouen, Bibliothèque Municipale, MS. Lebeer 135.

Fitzwilliam Museum, Cambridge AA

Cat. no. 36 fols. 51v–52r, *Prayers to the Wounds of Christ, the Virgin Mary and St John the Evangelist*

37

Book of Hours (Use of Sarum)

c. 1450, Bruges

Illuminated manuscript on parchment 120 × 85 mm, ii + 146 folios

colour plate, p. 107

Provenance: Chipstead Place, Kent, F. Perkins; purchased by the Fitzwilliam Museum, 1891 *Accession no.* MS. 80
References: James 1895, p. 206–7; Dogaer 1987, p. 31

The Hours of the Virgin in this manuscript are described as being for the use of the English church and this makes it clear that it was produced for the English market. The calendar, however, is thoroughly Flemish. The original owner is unknown although an early owner had his coat of arms painted over the border of fol. 14r.

The miniatures form part of the vast production of the Masters of the Gold Scrolls. These artists produced Books of Hours using sets of compositions for their illustrations. Thus the miniature of the Last Judgement (fol. 91v) is also to be found in a Book of Hours illustrated by the same workshop, now Baltimore, Walters Art Gallery, MS. W. 246 (fol. 88v). The Fitzwilliam Museum manuscript belongs to the last production phase of the workshop. The scrolls on a plain background which had characterised its style between 1410 and 1440 were gradually replaced by more lively backgrounds. Architecture is painted with greater care. Although the landscapes lose some of their stiffness, they remain stereotyped with triangular hills and groups of trees which form a screen in the background.

Fitzwilliam Museum, Cambridge AA

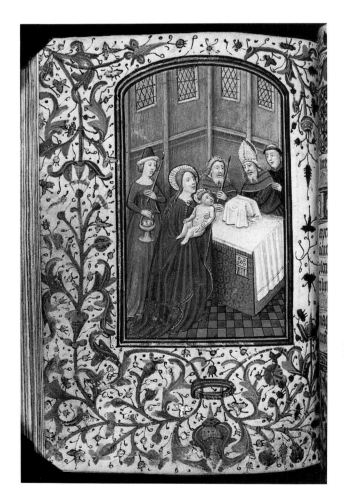

Cat. no. 37 fol. 67v, *The Presentation of Christ in the Temple*

38

Book of Hours (Use of Sarum)

c. 1450, Flemish

Illuminated manuscript on parchment, 155 × 110 mm, 128 folios

colour plate, p. 107

Provenance: A note on the fly-leaf reads, 'This MS was originally brought from Sudeley Castle in Gloucestershire'; Founder's bequest, Fitzwilliam Museum 1816 *Accession no.* MS. 52
References: James 1895, pp. 129–30; Rogers 1982, p. 251–2; Dogaer 1987, p. 31

The Flemish origin of this manuscript is attested by the saints included in the litany. Besides English saints such as Dunstan, Oswald, Edward and Botulph, a few typically Flemish saints were included such as Bavo, the patron saint of Ghent.

The manuscript has lost some of its text: the calendar has not survived and it probably contained more prayers to the saints than that to Mary Magdalene which is the first in this Book of Hours. Moreover, when it was rebound in the late-eighteenth century, the order of the prayers was completely confused.

The miniatures at the beginning of each prayer are by a late master of the Gold Scrolls School, whom Rogers has named the Master of the Wingfield Hours (New York, Public Library, Spencer, MS. 3). His execution is stiff and his compositions lack a clear spatial construction. The expressions of his figures are stereotyped. This is particularly apparent in the miniature for Vespers for the Hours of the Virgin which represents the Massacre of the Innocents. The artist has interpreted the biblical story rather freely. According to St Matthew's Gospel, Herod ordered that all male infants under the age of two should be killed, so that the child who was threatening his throne would also die. Here, the miniaturist has put a sword in Herod's hands and has made him an active participant in the massacre. The artist who painted the borders, although somewhat affected by *horror vacui*, displays a talent for mixing tendrils, flowers and animals.

Fitzwilliam Museum, Cambridge AA

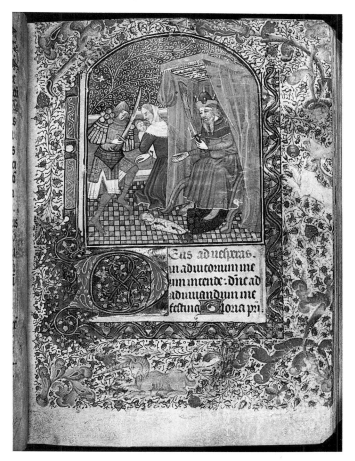

Cat. no. 38 fol. 26r, *The Massacre of the Innocents*

39

Book of Hours (Use of Sarum)

c. 1450, Bruges

Illuminated manuscript on parchment, 175 × 115 mm, 184 folios

colour plate, p. 108

Provenance: Elizabeth, countess of Caernarvon; Royal Library; given to Cambridge University Library, 1715 *Accession no.* MS. Ii.6.14
References: Cambridge 1856, 3, p. 510; Rogers 1982, 307–10 and 365

This manuscript has not previously been published in any detail. The following description may be a useful complement:

Variable quire structure with miniatures inserted as single leaves, some of them missing. Full borders around miniatures and opposite pages; historiated initials: fol. 46r (Holy Spirit), fol. 47r (St Michael), fol. 47v (Sts Peter and Paul), fol. 48r (St Andrew), fol. 48v (St Stephen), fol. 49r (St Lawrence), fol. 50r (St Nicholas), fol. 51v (All Saints), fol. 83r (Presentation of the Virgin in the Temple), fol. 86v (Adam and Eve and Three Crosses), fol. 87r (Crowned Christ), fol. 87v (Wounds in the left and right hands of Christ), fol. 88r (Five Wounds), fol. 88v (Wounds of the left and right feet of Christ), fol. 89r (Virgin and Child), fol. 89v (St John the Evangelist), fol. 90v (Crucified Christ); full-page miniatures: fol. 13v (Trinity), fol. 16v (St John the Baptist), fol. 18v (St George), fol. 20v (St Christopher), fol. 22v (St Thomas Becket), fol. 25v (Mary Magdalene), fol. 27v (St Catherine of Alexandria), fol. 29v (St Barbara), fol. 38v (Arrest of Christ), fol. 52bis missing (Christ before Pilate?), fol. 57v (Flagellation), fol. 59bis missing (Christ carrying the Cross?), fol. 62v (Crucifixion), fol. 65v (Entombment), fol. 68v (Deposition), fol. 96v (Last Judgement), fol. 114bis missing (Mass of the Dead?), fol. 140bis missing (Raising of Lazarus?), fol. 155v (Arma Christi), fol. 164v (St Jerome).

This manuscript illustrates another aspect of the production of Books of Hours in Flanders for English customers. Copyists in Flanders were not always aware of the liturgical peculiarities of Books of Hours for the English market. The calendar, which is traditionally found at the beginning of Books of Hours, often reflected the needs and requirements of a specific diocese with its local saints and festivals. This Book of Hours lacks a calendar. Instead six blank leaves at the beginning provided space for a calendar to be added once the book had reached its destination. This indicates that Flemish scribes, besides working for specific English patrons, also produced Books of Hours for the open market. To make them more attractive they offered the purchaser the opportunity of adding the calendar of his choice.

Another way of adapting the book to English tastes was to leave the borders around the miniatures and introductory pages undecorated. They could then be completed in a style popular in England. This is the case with this manuscript. An artist whom Rogers (1982) has baptised 'The Englishman' painted the borders. It is not clear whether he was an Englishman working in Bruges or whether he painted the borders once the book had reached England. His style consists of blue, red and green acanthus leaves on a golden background which grow from a bar around text or miniature.

Rogers argues that the master who painted the initials and miniatures was a member of the workshop of the Mildmay Master. This artist takes his name from the illustrations in a Book of Hours which has connections with Sir Thomas Mildmay of Moulsham (d. 1604), now Chicago, Newberry Library, MS. 35. This artist tends to repeat his compositions. He uses bright colours, and clearly outlines his figures, whose limbs are often badly articulated. His interest in landscape is limited to filling in the background. The Hours of the Virgin are illustrated with subjects normally encountered in Hours for English use. However, the Deposition and the Entombment seem to have been exchanged: usually they accompany respectively the Vespers and the Compline of the Hours of the Virgin, while here the opposite is true. The inclusion of a prayer and a miniature of St Thomas of Canterbury is another indication that the book was aimed at the English market. As is often the case, the name of St Thomas on the opposite page has been rubbed out, probably during the Reformation.

Lent by the Syndics of Cambridge University Library AA

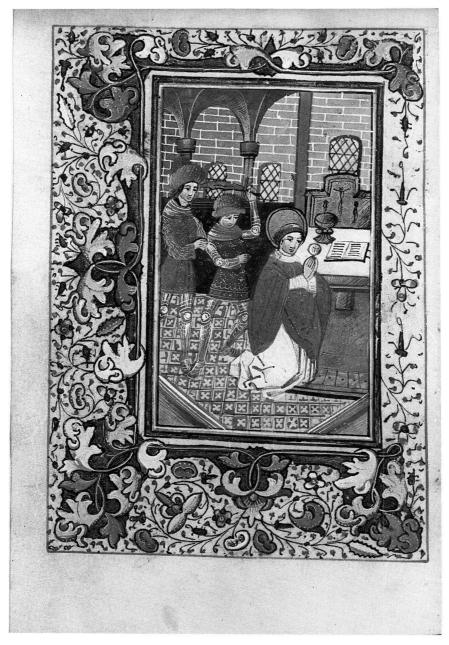

Cat. no. 39 fol. 22v, *The Murder of St Thomas Becket*

40

Book of Hours (Use of Sarum)

c. 1460, Bruges?

Illuminated manuscript on parchment, 235 × 170 mm, 186 folios

Provenance: Founder's bequest, Fitzwilliam Musuem, 1816
Accession no. MS. 53
References: James 1895, pp. 131–4; Rogers 1982, pp. 312–17

This exquisite Book of Hours contains a mixture of English and Flemish elements. This is true both for the calendar – which includes the occasional typical Flemish saint such as Bavo among the majority of English saints – and for the decoration. This blend of English and Flemish characteristics also appears in the borders. The flowers, birds and other motifs are clearly Flemish in style, but the foliate initials with their green, orange and blue burgeons have an English feel. Most of the dentelle and historiated initials, borders and miniatures are Flemish work. The iconographic programme of the miniatures also shows Flemish and English elements. In Flemish Books of Hours, the various offices of the Hours of the Virgin are illustrated by scenes of the Life of the Virgin. In the English tradition, the same offices of the Hours of the Virgin are accompanied by scenes of the Passion of Christ. This manuscript combines both miniature cycles: the scenes of the Passion of Christ are on inserted leaves, while the scenes of the Life of the Virgin are part of the regular quire structure, accompanying the opening sentences of every office. This combination occurs in a few other Flemish manuscripts produced for the English market. In a Book of Hours with miniatures attributed to the Gold Scrolls School (Baltimore, Walters Art Gallery, MS. W. 173) the twinning of the same subjects is distributed over miniatures and historiated initials.

The insertion of miniatures on single leaves is often an *ad hoc* solution for the illumination of the manuscript, but in this case the illumination has great homogeneity. Borders and miniatures are in perfect harmony. The same artist painted both cycles as well as the other miniatures and the historiated initials of the codex. The bright palette, the care for a detailed rendering of the landscape and the lively attitudes of his figures are typical of his work.

Fitzwilliam Museum, Cambridge AA

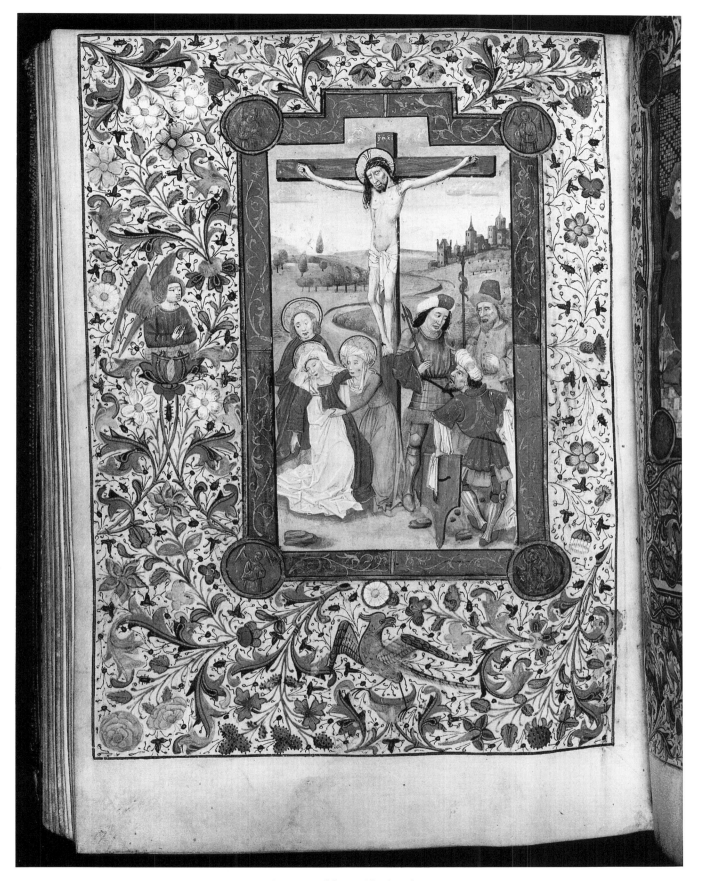

Cat. no. 40 fol. 63v, *The Crucifixion*

41

Book of Hours (Use of Sarum)

c. 1490, Bruges

Illuminated manuscript on parchment, 197 × 132 mm, ii + 141 + ii folios

colour plate, p. 109

Provenance: In England by the sixteenth century: signed on last leaf 'Elizabeth Scrope'; probably Holdsworth collection; received by Cambridge University Library, 1664 *Accession no.* MS. Dd.6.1

References: Cambridge 1856, 1, pp. 288–9; Rogers 1982, p. 376; Arnould 1991, 1, pp. 144–5

This manuscript has not previously been published in any detail. The following description may be a useful complement:

Quire structure is irregular; *textualis formata*; cardboard binding covered by leather *c.* 1800; fols. 1r–6v: calendar with noteworthy saints: 6 October: Translation of St Hugh (red); 13 October: Octave of St Hugh; 17 November: St Hugh (red); 20 November: St Edmund; 24 November: Octave of St Hugh. Papal saints and St Thomas of Canterbury have been erased; fols. 7 and 8: missing; fols. 9r–12v: 15 O's; fols. 13r-30v: Suffrages; fols. 31v–42v: Hours of the Virgin; fols. 43r–48r: Commemorations; fols. 48v–65r: Hours of the Holy Spirit; fols. 65v–69r: Meditation on the Salve Regina; fols. 69r–72v: O Intemerata – Obsecro te; fols. 73r–76v: Seven Joys of the Virgin; fols. 77r–83r: Meditation on the Passion of Christ; fols. 84v–97v: Seven Penitential Psalms; fols. 98r–114v: Hours of the Dead; fols. 115r–125v: Commendationes defunctorum; fols. 125v–130r: Psalms of the Passion; fols. 130v–139v: Psalter according to St Jerome; fols. 140v–143v: Prayers in Latin and English added by later hands. Paragraph marks, dentelle and foliate initials; small (six lines high) miniatures: St Michael (fol. 43v), Sts John the Baptist and Peter and Paul (fol. 44r), St Andrew (fol. 44v), Sts Lawrence and Stephen (fol. 45r), St Thomas Becket (fol. 45v), St Nicholas and Mary Magdalen (fol. 46r), St Catherine (fol. 46v), St Margaret (fol. 47r), Virgin and Child (fol. 65v), Golgotha (fol. 77r), Sancta Facies, Wounds of Christ, Pietà (fol. 77v). Full-page miniatures surrounded by borders: St John the Baptist (fol. 15v), St George (fol. 17v), Crucifixion (fol. 19v), St Anne (fol. 21v), St Catherine (fol. 23v), St Margaret (fol. 25v), St Mary Magdalen (fol. 27v), St Barbara (fol. 29v), Christ in the Garden of Gethsemane (fol. 31v), Betrayal of Christ (fol. 37v), Christ before Pilate (fol. 48v),

Flagellation (fol. 52v), Christ carrying the Cross (fol. 55v), Crucifixion (fol. 57v), Descent (fol. 59v), Entombment (fol. 61v), Deposition (fol. 70v), Presentation of the Virgin Mary in the Temple (fol. 73v), Last Judgement (fol. 81v), Resurrection of Lazarus (fol. 98v), Instruments of the Passion (fol. 125v), St Jerome (fol. 130v).

This Book of Hours was probably written and illuminated in Bruges during the 1490s. Different elements suggest that it was aimed at the English market. The prominence of St Hugh in the calendar points towards a use in the Lincoln diocese, where his tomb enjoyed great popularity among pilgrims. The Hours of the Virgin are introduced by a rubric which mentions that they follow the use of the English Church. The subject of the miniatures which introduce the Hours of the Virgin also indicates an English destination. Instead of having scenes of the Life of the Virgin Mary accompanying the Hours of the Virgin, the artist has opted for scenes from the Passion of Christ. By the second half of the sixteenth century the manuscript was certainly in England, as all allusions to papal saints and to St Thomas Becket have been erased.

Stylistically all borders were painted by one hand in a style which is close to some of the late manuscripts of Raphael de Mercatellis (see cat. no. 74). It uses the same motifs as the Mercatellis codices and the curling acanthus leaves are partially painted in shell gold. The small miniatures are in a different hand from the full-page miniatures. Some of the compositions of the large miniatures are similar to the Arenberg Hours (Malibu, Getty Museum, Ludwig MS. IX.8), a manuscript produced by the Vrelant workshop in Bruges during the 1460s. This is the case with the miniature of the Presentation of the Virgin to the Temple. The style of the miniatures can, however, not rival that of the Arenberg Hours. The artist fails to use convincing perspective and is not very concerned with the detailed rendering of his landscapes. The figures lack characterisation.

Lent by the Syndics of the Cambridge University Library AA

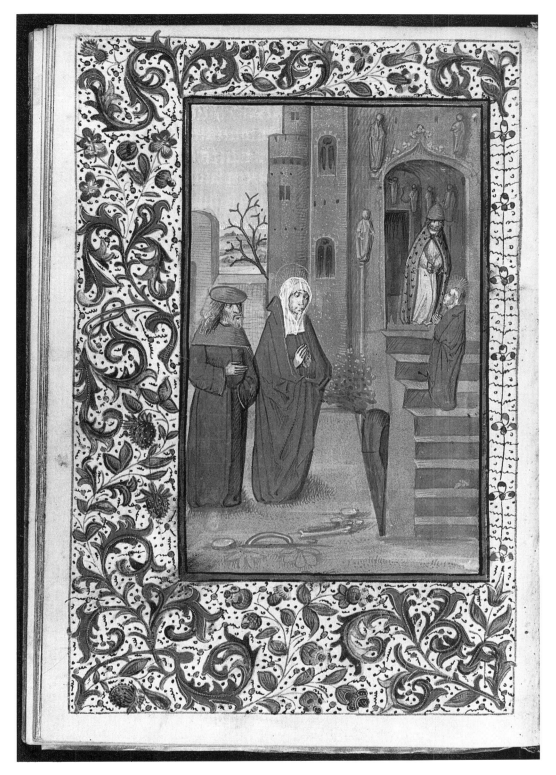

Cat. no. 41 fol. 73v, *The Presentation of the Virgin in the Temple*

Art for the Church

Alain Arnould

Much of the art produced during the Middle Ages was under the aegis of the Roman Catholic Church. Although the fifteenth century witnessed a renewal in private devotion, churches remained the most important centres of prayer for people of all social classes. It was in churches that the majority of sacraments – baptism, eucharist, confession, marriage and ordination – were celebrated. The churches accommodated private chapels for powerful guilds and prominent families. It was also in churches that people assembled for great festivals. Because churches played such an active role in public life, great importance was attached to commissioning art for them. Three groups of people were particularly active in this regard. First there were the secular and regular clergy whose need for liturgical books in the celebration of the sacraments led them to commission lavishly illuminated liturgical books. Missals guided the celebrant through the sacrament of the Mass. Generally, the illustration of missals was restricted to a Crucifixion miniature at the beginning of the Eucharistic Prayer. Occasionally, as in the Missal of Petrus Vaillant (Bruges, Groot Seminarie MS. 50/66), abbot of the Ter Duinen monastery in Bruges (1489–92), masses for specific feasts were also introduced by historiated initials. Pontificals were books used by abbots and bishops for the sacraments and ceremonies which only they could perform, such as ordination to the priesthood and the blessing of churches. Graduals and antiphonaries occupy a somewhat special place among liturgical books. They were used not by the celebrant but by the choir, which accompanied the offices and the Mass. The gradual is for the singers what the missal is for the priest, the antiphonary is for the choristers what the breviary is for the clergy. The choristers would gather around one manuscript which rested on a lectern. This practice meant that choral manuscripts had to be large in size so that the notes and text could be read from a distance.

Wealthy families also commissioned ecclesiastical art. In many cases they chose to commission altarpieces to be placed above the altar, sometimes in their private chapels. Of course, these commissions were carried out on the one hand for the glory of God but, on the other hand, considerations such as personal salvation and social status were not entirely absent. The portraits of the patrons, which are very often painted on the wings of the altarpieces, are there to present the donors to God and to the people praying at the altar.

The third group involved in the patronage of ecclesiastical art consisted of the guilds. Guilds played a crucial economic and social role in Flemish towns. They watched over the quality of their members' work by imposing long training periods and stringent quality controls. They anxiously controlled imports from other regions by means of protective legislation. They safeguarded the social welfare of their members by providing accommodation for widows and elderly members in almshouses. Guilds had a special place reserved to them in churches. A wealthy guild could afford its own chapel. Its decorative scheme would comprise an altarpiece, the guild's emblem and other symbols related to its activity. Smaller or less prosperous guilds were satisfied with a bench where their members sat during the services.

42

The Robert de Clercq Benedictional

c. 1525, Bruges

Illuminated manuscript on parchment, 200 × 140 mm, 118 folios

colour plate, p. 110

Provenance: Ter Duinen monastery in Bruges ('Liber beate Marie de Dunis' on back cover); unrecorded; Cambridge University Library *Accession no.* MS. Nn.4.1
References: Cambridge 1856, 4, pp. 490–2; London 1953–4, p. 165, no. 621; McKitterick 1986, p. 550; Testa 1986, pp. 44–5; Hindman 1989, p. 17

This manuscript was commissioned by Robert de Clercq, abbot of the wealthy Cistercian monastery of Ter Duinen in Bruges, between 1519 and 1557. The borders of this manuscript often integrate his coat of arms with mitre and staff, his motto 'sperans gaudebo' and his initials. In the miniature on fol. 4v the abbot kneels in front of the Cross, thus joining St John the Evangelist and the Virgin in their adoration of the Cross. Although the Cistercian rule demanded a sober and disciplined life, Robert de Clercq, like many of his predecessors at the Ter Duinen monastery had a feeling for artistic patronage. His benedictional and missal (now Bruges, Groot Seminarie, MS. 51/9) illustrate his taste for sophisticated liturgical manuscripts. The latter is dated 1547 and is not of as high a quality as the benedictional. Besides manuscripts, he commissioned linen and pewter for the monastery, on which his coat of arms was also applied. Robert de Clercq also had his portrait and coat of arms added to a diptych commissioned by his predecessor, Abbot Christiaan de Hondt (now Antwerp, Museum voor Schone Kunsten). Among the rites for which Robert de Clercq would have used this benedictional were the receptions of young men and women into the Cistercian order. During his thirty-eight-year rule, de Clercq professed forty monks in his own monastery and received many more nuns in other Cistercian monasteries for which he was also responsible. The only texts in the vernacular in the manuscripts are the marital vows which are included in both a French and a Flemish version. The worn condition of this particular page in the book testifies to the intensive use of the book by its owner.

The illustration of the manuscript is a very fine example of late book illumination in Bruges. The miniatures were painted by one artist. The borders, some of which he painted, go one step beyond the traditional flora and fauna motifs of the Ghent-Bruges border style by offering an extension to the main miniature. Thus in the border around the Crucifixion (fol. 4v), four episodes of the Passion of Christ are featured. The miniature with the image of Christ (fol. 69v) is surrounded by gems, which make the miniature appear as an icon displayed for personal devotion in a frame decorated with gems and jewels. Another less talented artist completed the decoration by painting the remaining borders. He used the less developed method of motifs on a plain background but also favoured borders with architectural motifs. On fol. 17v he has imitated his master's borders of jewels (fol. 69v) in an almost identical pattern.

The style of the miniatures is closely related to the minatures by Simon Bening dated 1521 and now in New York, Brooklyn Museum (Inv. nos. 11.502–11.505). If not by Bening himself, the miniatures of MS. Nn.4.1 must have been by a close associate working in the master's style showing a sense for details, monumental compositions and bright colours. The binding of the manuscript is by the famous Bruges binder Ludovicus Bloc, who died in 1529 (see cat. no. 25). Although the stamp may still have been used after Bloc's death, it is more plausible that the manuscript dates from before 1529. As Robert de Clercq took up his term as abbot in 1521, the manuscript should be situated between 1521 and 1529.

Lent by the Syndics of Cambridge University Library AA

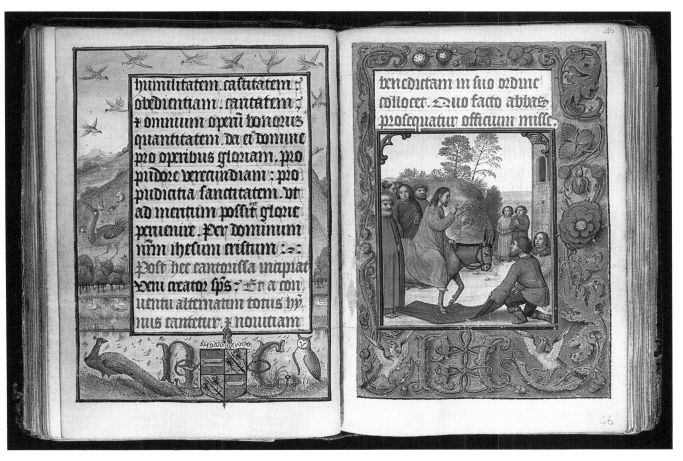

Cat. no. 42 fols. 45v–46r, *The Entrance of Christ into Jerusalem*

43

Antiphonary (*Sanctorale*)

c. 1510, Bruges?

Illuminated manuscript on parchment, 540 × 370 mm, 96 folios

colour plate, p. 111

Provenance: Quaritch; Frank McClean; his bequest to the Fitzwilliam Museum, 1904 *Accession no.* MS. McClean 57
References: James 1912, pp. 111–14

The manuscript here contains the Sanctorale, but because this started on a verso, it also contains the last folio of the Temporale. From this evidence one can assume that this antiphonary originally contained both the Common and Proper of Time (Temporale) and the Common and Proper of Saints (Sanctorale). In the latter years of the sixteenth century it was rebound and split in two: one volume for the Temporale, the other for the Sanctorale. The binding dates back to that intervention. At the end of the manuscript the last quire with the antiphons for the end of the liturgical year is missing.

This choral manuscript has all the levels of decoration traditionally encountered in large choirbooks. The verses of the prayers are introduced by fine penwork initials called 'versals'. Their delicate penwork decoration, exclusively in black ink, is often accompanied by animals or other *drôleries*. The repetition of some of these motifs suggests that the artist borrowed his subjects from an exemplar. Among the favourite motifs are the siren combing her hair in front of a mirror (fols. 10v, 28v and 70v) and a group of dogs surrounding a stag (fols. 45v, 53r, 58r, 67r and 74v). Alongside the 'versals' other penwork initials introduce the Psalms and other prayers. For the beginning of the prayers of the feasts of the Conversion of Paul, Sts George, Bernard, Michael, Simon and Jude a two- or three-stave-high multicolour penwork initial was drawn. Some prayers which were particularly important to the religious community using this book are introduced by historiated initials and a border in the Ghent-Bruges style. Neither the saints accompanied by large penwork initials nor those accompanied by historiated initials point towards a specific monastery, religious order or even geographical area. The presence of a large penwork initial for the Office of St Bernard is not sufficient evidence that this antiphonary was used in a Cistercian house. However, the style of the borders and historiated initials can be compared with others in choirbooks produced for monastic houses in and around Bruges *c.* 1500. It is thus probable that this antiphonary was owned by a community of religious from the Bruges region.

The border accompanying Mary Magdalene (fol. 46v) consists of plaited branches. The motif of plaited branches was already present in Ghent-Bruges book illumination of the 1490s, such as the Breviary of Queen Isabella of Castile (London, British Library, Add. MS. 18851, fol. 86r). The plaited branches of the Fitzwilliam Museum antiphonary show remarkable similarities to those found in a border of a breviary, possibly from the Cologne area, from around 1500 (fol. 124v) (E. König, *Leuchten des Mittelalter Katalog H. Tenschert* XXI, pp. 336–9). Even the motif of cherries alongside the branches is identical. It is also interesting to note that the composition of the St Stephen initial in the Fitzwilliam manuscript (fol. 57v) is identical to the historiated initial of the same subject in the Cologne breviary. It is unlikely that this similarity was the result of direct contact between the two manuscripts. It is more plausible that a Flemish artist moved to Cologne and took with him compositional patterns which were used in Flemish book illumination. This illustrates the impact of the style and compositions of the Ghent-Bruges School in a region such as the Rhine valley.

Fitzwilliam Museum, Cambridge AA

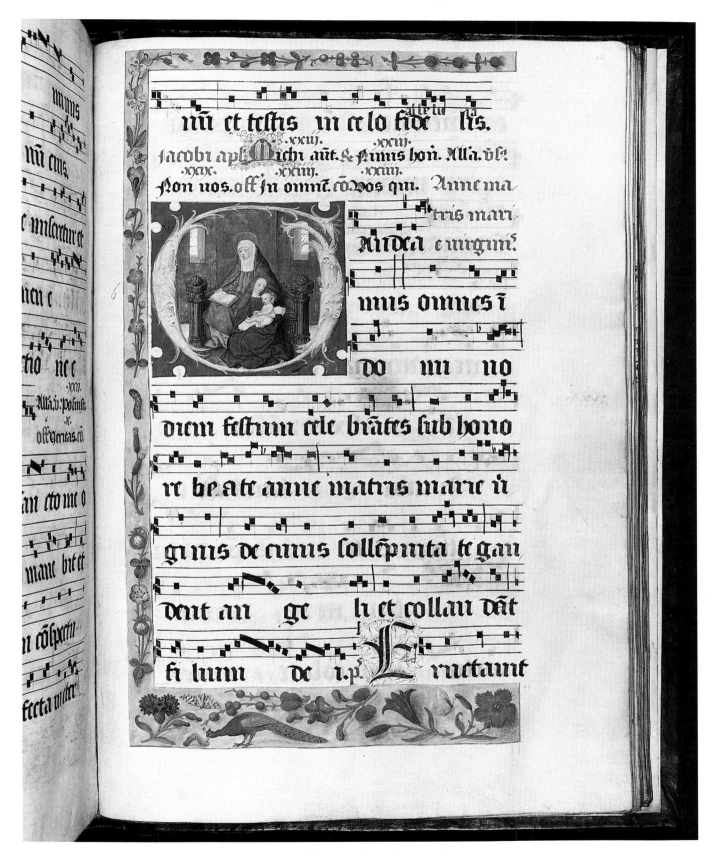

Cat. no. 43 fol. 48r, *St Anne, Virgin and Christ*

44

Antiphonary (Temporale, Winter Part)

c. 1510, Brabant?

Illuminated manuscript on parchment, 490 × 340 mm, 153 folios, eighteenth-century
binding, possibly with original clasps and bosses

colour plate, p. 112

Provenance: Founder's bequest, Fitzwilliam Museum, 1816
Accession no. MS. 41
References: James 1895, p. 93

Unlike the other antiphonary in this exhibition (cat. no. 43), this choirbook contains the antiphons for the Common and Proper of Time or the Temporale – that is for the feasts related to Christ and the Virgin Mary – as opposed to the Sanctorale, which deals with the antiphons for the feasts of the saints. Since liturgical choral manuscripts tended to be bulky, they were often divided into two volumes. This manuscript contains the prayers from the beginning of Advent till Easter.

Its decoration of 'versals' and penwork initials are routine work, but the five historiated initials and borders are of a high quality. The initial which depicts the Temptation of Christ, illustrating the Gospel reading of the first Sunday of Lent (Luke 4.1–13), is particularly fine. Christ undergoes a period of fasting, during which Satan appears to him and suggests that he changes stones into bread to eat. In the background, Christ is on top of the Temple in Jerusalem with Satan and at the top of a mountain where the devil offers him dominion over the whole world. The borders are still in Ghent-Bruges style but the ends have been indented, possibly to imitate Renaissance decorative motifs.

Towards the end of the Middle Ages monastic houses had lost a large share of the manuscript market. Choral manuscripts, however, were one category of books which largely remained under monastic control. Surviving antiphonaries and graduals dating from 1450 until well into the sixteenth century can nearly always be shown to have been produced by a monastic house. The competition from lay workshops and printers was minimal for various reasons. In the first place, the very complexity of the liturgical contents may have been a deterrent to lay workshops. Copying choral manuscripts has certain specific requirements. Every diocese, order and even monastery had specific feasts for patron saints and these would have to be included. The presence of musical notation required the scribe to have a basic knowledge of music. These two factors made the publication of antiphonaries and graduals a difficult project. Moreover, the large size of the volumes demanded specific technical resources, such as a large press, something few printers had.

Fitzwilliam Museum, Cambridge AA

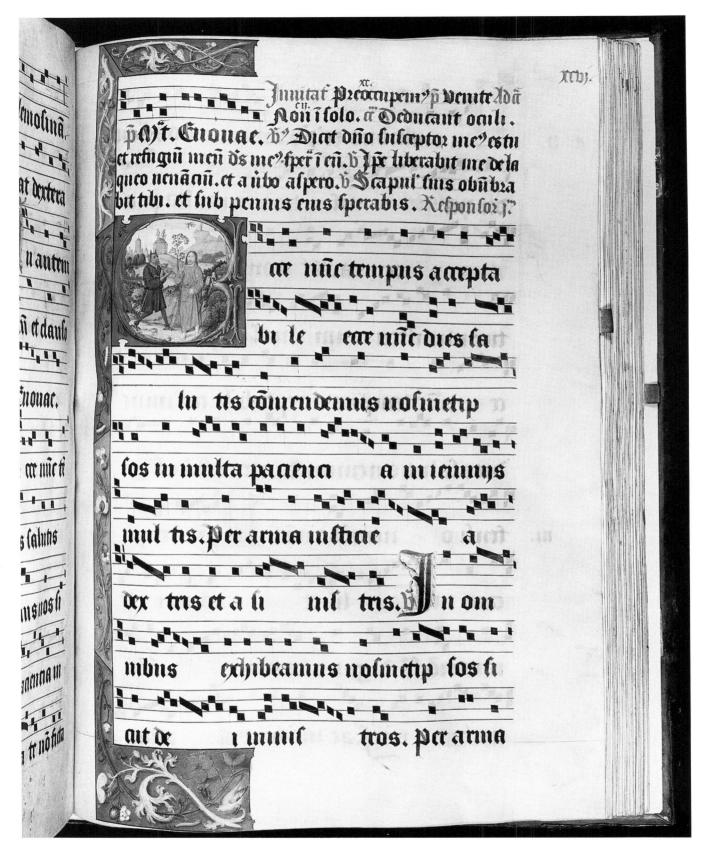

Cat. no. 44 fol. 96r, *Satan tempts Christ*

45

Four leaves from a Gradual

(a) *The Annunciation*

(b) *The Visitation*

(c) *The Ascension*

(d) *Saints Peter and Paul*

c. 1520, Brabant?

Historiated initials and text on parchment,
365 × 275 mm, 415 × 255 mm, 415 × 255 mm, 390 × 295 mm

Provenance: Charles Brinsley Marlay; his bequest to the Fitzwilliam Museum, 1912 *Accession no.* MS. Marlay Cuttings Fl 1–4
References: Wormald and Giles 1982, pp. 96–7

Graduals are to the Mass what antiphonaries are to the daily office. They bring together all the parts of the Mass which are sung by the choir. The two types of books resemble each other in layout and decoration. The 'versals' which introduce the verses in these fragments are crude and repetitive, while the miniatures for major feasts have an extra festive character. In later manuscripts such as this, historiated initials have developed into two entities: image and the actual initial are no longer integrated in one block. The initials have become an appendix to the illustrations, while for decades the form of the illustrations had been determined by the initial. Here the initials imitate Italian humanist models where the letter consists of branches. The initials are surrounded by borders in Ghent-Bruges style. As is often the case in later manuscripts, an extra decorative touch was added to the borders by ending the frame with an elegant twist.

Some motifs of these fragments hark back to the Master of Mary of Burgundy. There is, however, no reason to believe that the artist who painted the gradual was directly connected with this Master. By the 1520s the compositions of the Master of Mary of Burgundy were widely disseminated. The artist of these cuttings could have known the compositions through the works of Simon Bening or the Master of the Prayerbooks *c.* 1500, who both relied on the Master of Mary of Burgundy for their compositions.

In the first leaf, the artist has linked miniature and border by including the words the Angel Gabriel exchanged with the Virgin during the Annunciation on the vase in the border ('Ave Maria', 'Ecce Ancilla Domini'). In stylistic terms the leaf with St Peter and St Paul is of higher quality than the other three. By the 1520s, the Italian Renaissance had made its entry into Flemish art. The miniature of St Peter and St Paul betrays a typically Flemish perception of the Renaissance: renaissance motifs such as festoons are integrated in what is still a fundamentally gothic image.

In the early sixteenth century many monasteries had large choral manuscripts copied and illuminated. Some were produced within the monastery, but in other instances they were ordered from workshops of sister monasteries which specialised in these works.

The lack of specific prayers and comparative iconographic material makes it impossible to establish the provenance of these four cuttings.

Fitzwilliam Museum, Cambridge AA

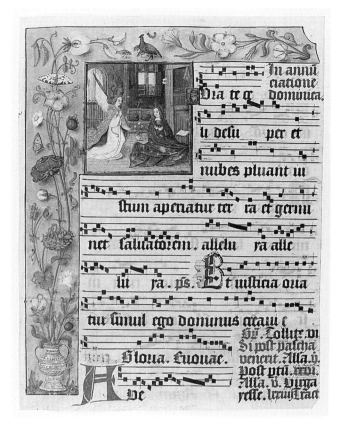

Cat. no. 45a Marlay Cutting Fl 1, *The Annunciation*

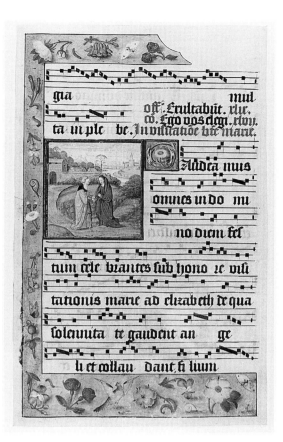

45b Marlay Cutting Fl 2, *The Visitation*

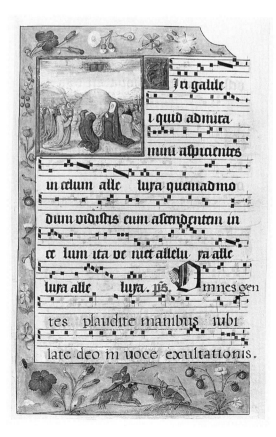

45c Marlay Cutting Fl 3, *The Ascension*

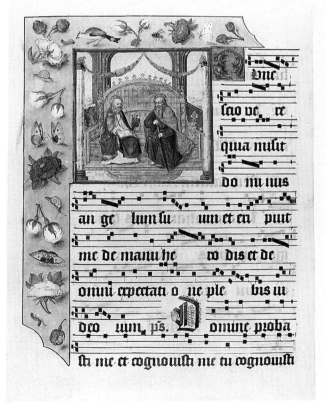

45d Marlay Cutting Fl 4, *Saints Peter and Paul*

Manuscripts for the court

Alain Arnould

Art played a crucial role during the reigns of all five dukes of Burgundy. Seldom had the commissioning of art been so much in vogue in northern Europe. This interest in the arts had not come out of the blue. All three brothers of the first duke of Burgundy, Philip the Bold (d. 1404), were enlightened patrons of the arts. Jean, Duke of Berry (d. 1416), Charles V, King of France (d. 1380) and Louis, Duke of Anjou (d. 1384), all attached great importance to the arts as a way of establishing their power and status. Their patronage produced masterpieces of unrivalled quality. However, it was mainly at the court of the dukes of Burgundy that Philip the Bold's patronage was to establish a tradition for his successors. For over a century the dukes would commission architecture, tapestries, paintings, sculpture, music and books, in order to proclaim their power and wealth.

Manuscripts enjoyed particular favour with the dukes. Philip the Bold gathered a fine personal library which his successor, John the Fearless, extended to some two hundred and fifty manuscripts. It was during Philip the Good's reign (1420–67) that the growth of the ducal library reached its peak. Charles the Bold inherited the library from his father, but his bellicose reign was unfavourable to a sustained increase in the number of accessions. Margaret of York, Charles' second wife, embraced the tradition and was the first woman at the court to assemble a library. It was centred around devotional literature. Mary of Burgundy, the last duchess, had little time to develop her love of books. Her Books of Hours and the present she made to Margaret of York (cat. no. 48) show, however, that she upheld the tradition of her ancestors. At the end of the Burgundian period, the Burgundian library consisted of over nine hundred volumes, an extraordinary number, only rivalled by the libraries of pope Nicholas V in Rome, Cosimo de' Medici in Florence and Cardinal Bessarion in Venice. For over one hundred years the dukes of Burgundy employed and commissioned the best artists they could find, attracting them to their court from all parts of their duchy.

Since art was so important to the dukes of Burgundy, those involved in court politics were quick to grasp that it also had a social dimension: art functioned as a passport to the ruling elite. Members of the Order of the Golden Fleece and others who collaborated with the dukes, such as Nicolas Rolin, Louis Van Gruuthuse, Anthony of Burgundy, Wolfart Van Borsele, Philip of Cleves or David, Bishop of Utrecht, were enlightened collectors and bibliophiles. Merchants and bankers followed suit and considered art an investment in terms of their social status. In many instances this feeling was mixed with genuine piety and/or intellectual interests. All the arts benefited from this patronage. Churches were given large altarpieces as mementoes of wealthy patrons. Any dignitary worthy of respect owned a small library or, at the very least, commissioned a Book of Hours where his coat of arms, motto and emblems were included in the illuminations. Romances and French verse translations of Latin texts, often written at the request of and dedicated to a patron, were also in high demand. Music was highly respected: court and cathedrals had their own choirs. Composers such as Gilles Binchois, Johannes Ockeghem and Jacob Obrecht enjoyed wide renown. In short, there was hardly a branch of the arts that did not flourish under the influence of the court and its entourage.

On the occasion of certain important festivals this resulted in spectacular public displays. The first visit of the duke to a town, a ducal wedding, baptism or funeral were the occasions for many artists to design street decoration and mount *tableaux vivants*. Among the most famous events were the Banquet of the Pheasant which Philip the Good organised in Lille in 1454, the entry of Margaret of York and Charles the Bold into Bruges in 1468 and the entry of Joanna of Castile into Brussels in 1496.

References: Huizinga 1919 remains a magnificent survey of the period; Prevenier 1983, esp. pp. 281–372; on the literature at the court of Burgundy, Doutrepont 1909; on music at the court of Burgundy, Strohm 1985; on Philip the Bold, de Winter 1985; on Philip the Good, Brussels 1967; on Charles the Bold, Brussels 1977; on Margaret of York, Kren 1992.

46

Book of Hours of Philip the Bold

1376–8 and 1390, Paris; 1450–5, Brussels

Illuminated manuscript on parchment, 253 × 178 mm, 257 folios

colour plate, p. 181

Provenance: Purbrook Heath House, Mrs W. F. Harvey; Viscount Lee of Fareham; his bequest, 1947; presented to the Fitzwilliam Museum by his widow, 1954 *Accession no.* MS.3–1954
References: Cambridge 1966, pp. 29–30; Wormald and Giles 1982, pp. 479–99; Köster 1984, p. 535; de Winter 1985, esp. pp. 189–94; Cambridge 1989; Van Buren 1993 (in press)

This particularly richly illuminated manuscript is extremely complex. Its creation comprises three stages over a period of seventy-three years. The oldest and largest part is the so-called *Grandes Heures* of Philip the Bold, the first Valois duke of Burgundy. Philip paid the Parisian writer Jean l'Avenant from 1376 to 1378 for the various stages in its production, including many little miniatures painted by two Parisian artists of the time, the Master of the Bible of Jean de Sy and the Master of the Coronation of Charles VI.

As early as around 1390 Philip the Bold had the book unbound for the addition of a few more prayers. His grandson, Philip the Good, who had inherited the manuscript, did the same around 1440, for inserting a gathering of *Memoriae* to saints venerated in the Hainaut and Flanders, and had it illustrated by no less than six artists. But the largest number of additions were made in September 1451, when according to a document discovered by Van Buren the duke paid his *varlet de chambre et enlumineur Dreux Jehan 10 livres et 16 sous* for the renovation and binding in two volumes of his *Grandes heures quotidiennes*. Indeed, Wormald (1982) observed years ago that these Fitzwilliam Museum Hours are continued in a second part: a book of prayers in Brussels, Koninklijke Bibliotheek, MS. 11035–37, containing several devotional texts in the hand of Philip's secretary Jean Miélot, one of which is dated 1451. These additions are likewise illustrated by many artists, perhaps as many as fourteen, and several of the pictures are pasted in

reserved spaces in the text. The artists include Willem Vrelant, Jan de Tavernier, the Master of Philip's *Roman de Girart de Roussillon* (Vienna, Österreichische Nationalbibliothek, Cod. 2549), all of whom produced other works for the duke. Van Buren suggested that the *Grandes Heures* were meant as a catalogue of contemporary miniaturists, reflecting Philip's taste and contacts with the artistic world. Imprints of devotional medals, which were sometimes sewn into prayerbooks, and wear on the miniatures reveal an intensive devotional use of the *Grandes Heures*, which Philip the Good evidently regarded as a precious treasure from the founder of his dynasty.

Dreux Jehan is an enigmatic figure, based in Brussels, who appears regularly in the ducal and other accounts from 1448 to 1464, but with no specification of work by his hand. Even his connection with the Fitzwilliam Museum Hours makes it difficult to identify his work, since so many artists took part. But certain clues point to editing by scribes in Brussels and by the Master of the *Girart de Roussillon*. MS.3–1954 thus confirms the long-held supposition that the *Girart* and the other manuscripts attributable to him are the work of Dreux Jehan.

The *Mass of St Gregory the Great*, one of the pasted-in miniatures, is by the Alexander Master, who was given the honour of painting the manuscript's only portrait of Philip the Good. From a side chapel, Philip kneeling on a prie-dieu covered by a carpet with his armorials, witnesses the Vision of St Gregory, in which Christ appears with all the symbols of his Passion. The altar itself is dominated by an altarpiece in reversed T-shape that shows Christ on the Cross flanked by the Virgin Mary and St John the Evangelist, and Sts Agnes, Peter, Paul, and Catherine of Alexandria. The design of the altar and the style of the figures appear to reflect a style older than that which would have been common in the 1450s.

Fitzwilliam Museum, Cambridge AA

cedr· claue₂ aculeis perfoꝛan· lancea vulne
rari· felle ⁊ aceto potari· tu domine per illas
sanctissimas passiones quas ego indign⁹
peccatoꝛ recolo· et per sanctam crucē tuam
libera me de penis inferni· ⁊ producere me dig
neris miserum peccatoꝛem quo perduxisti te
cum crucifixum latronem· Qui cum deo pa
tre ⁊ spiritu sancto viuis et regnas deus
per omnia secula seculoꝛ· Amen· Memorie
O doctoꝛ optime ecclesie sancte de sancti gregorii·
lumen beate gregori diuine legis amatoꝛ depꝛecare
pꝛo nobis filium dei· ꝟ Posm adiutorium super poten
tem· ⁊ exaltaui electum de plebe mea Oꝛemus· oꝛ·
Deus qui nos beati gregorii confessoris
tui atꝗ pontificis annua solempnitate
letificas· concede pꝛopicius· ut cuius opere atꝗ
doctrina scriptura tue misteria multa cogno
uimus· eius apud te semper patrocinia senci
amus· Per xpm dominum nostrum· Amen·

Deus qui uoluisti pꝛo redempcoē mūdi
a iudeis reproban· ⁊ a iuda traditore os
culo tradi· et sicut agnus innocens ad vieti
mam duci· ante conspectum anne· cayphe· py
lati ⁊ herodis indecenter offerri· a falsis testi
bus accusari· flagellis et obpꝛobriis uexari·
spinis coronari· spuris conspui· colaphis

Cat. no. 46 fols. 253v–254r, *Philip the Good and the Mass of St Gregory*

47

Statutes and Ordinances of the Order of the Golden Fleece

c. 1563, Ghent?

Illuminated manuscript on parchment, 300 × 200 mm, 153 folios

Three pieces of late fifteenth- and sixteenth-century illumination on parchment, glued onto blank folios: verso of pastedown, fol. ov (172 × 54 mm), fol. 92r (153 × 110 mm) and fol. 129r (220 × 200 mm); seventeenth-century gold-stamped binding

colour plate, p. 177

Provenance: Julius Chifflet, Chancellor of the Order of the Golden Fleece in 1648; Founder's bequest, Fitzwilliam Museum, 1816 *Accession no.* MS. 187
References: James 1895, pp. 395–6; Cockshaw 1984; Pächt and Thoss 1990, 2, pp. 105–8, figs. 111–6

The Order of the Golden Fleece was founded by Philip the Good in Bruges in 1430 on the occasion of his marriage to Isabella of Portugal. Prominent noblemen became members of the Order with the duke of Burgundy at its head. He consulted the Order as a government or advisory board in regular meetings or chapters, which were held in various cities of the duchy. Members had ceremonial gowns and the famous flint-and-steel collar with the fleece itself, a possible allusion to the legend of Jason and the Argonauts. Every member had a copy of the Statutes of the Order, which also included the coats of arms of past and present members. The Fitzwilliam Museum manuscript is such a copy, written in 1563 and probably made at the request of a member of the Order. It has Renaissance cartouches at the beginning of each chapter and border decoration in Ghent-Bruges style. The main reason for including this manuscript in the exhibition are three fragments of medieval illustration which have been pasted into it.

The first occurs on the verso of the lifted front pastedown and is a fragment of a border illumination. Besides blue and gold acanthus leaves and some other flowers, there are also heraldic symbols: two interlaced red and blue initials C and M, two pairs of briquets of Burgundy with sparks and two banderoles with the motto 'Je lay enprins, bien en aviengne' (I have started it, may good come from it). All these refer to Charles the Bold and Margaret of York. This fragment must thus date from after their wedding in 1468.

The second late medieval element in the manuscript is a portrait miniature of Philip the Good surrounded by four coats of arms, of which Burgundy and Flanders are identifiable (fol. 92r). It was painted on vellum which remained blank on the verso. The portrait is a copy after the famous portrait which Rogier Van der Weyden painted for the duke. The original portrait is lost but numerous copies give us a fair idea of its likeness. This miniature must have been copied from an exemplar which included the duke's hands, such as the portrait of Philip now in Windsor Castle. The duke wears a typically Burgundian large black hat, called a chaperon. Unlike other versions of this portrait, no jewel was pinned on the hat. Philip the Good wears the collar of the Golden Fleece as well as a golden cross. In his hands he holds

a document. The miniature is a fine version, one of the few to be painted on vellum. The origins of this copy are unknown. No text is written on the verso, so it could have been either an independent portrait, or an illustration for a manuscript. Dating the portrait is difficult. Copies were painted until well into the sixteenth century. This could be the date of the Fitzwilliam Museum version.

The third miniature which was pasted into this manuscript depicts a chapter of the Order of the Golden Fleece (fol. 129r). This miniature is not the only such representation of these meetings. Other examples of this composition occur as introduction miniatures in copies of the *Histoire de la Toison d'Or* by Guillaume Fillastre, bishop of Tournai between 1460 and 1473. This ambitious work was never completed and only three out of the planned six parts had been written by the author's death in 1473. The miniature shows Charles the Bold, presiding over the chapter held in Bruges in 1468 when Guillaume Fillastre delivered his sermon on the Order of the Golden Fleece which became the basis for his work. The meeting is attended by twelve knights. Charles' coat of arms surrounded by the collar of the Order is attached to his throne. In the foreground a bishop, who can be identified as Guillaume Fillastre and who is assisted by two secretaries, presents his work to the duke. Another member of the Order walks into the meeting, having taken off his hat. A French text is written on the verso of the miniature. Although the identification of the text is made difficult by the opacity of the glue used to paste it into the manuscript, it is almost certainly Guillaume Fillastre's text. At the bottom, a seventeenth-century hand has erroneously described the miniature as the chapter of the Order of the Golden Fleece at Valenciennes. This indicates that by then the miniature had already been taken out of its textual context.

The border on the verso of the pastedown probably came from the same codex as the miniature representing the chapter of the Golden Fleece. This becomes evident when comparing the two fragments with other introduction scenes of Guillaume Fillastre's *Histoire de la Toison d'Or*. Three manuscripts are relevant here: Vienna, Österreichisches Staatsarchiv, MS. 2, containing Book II of Charles the Bold's own set of the *Histoire* and Copenhagen, Kongelige Bibliotek, MSS. Thott 463 and 465, written for Philip of Cleves and consisting of Book II and III of the work (Pächt 1990 and Cockshaw 1984). All three open with the miniature of the chapter of the Golden Fleece surrounded by borders which comprise a section identical to the fragment on the pastedown. Having identified the subject of the miniature and established the link between the two fragments, one further

question arises: could the two Fitzwilliam Museum fragments have come from the missing volumes of the Vienna or Copenhagen set? This is unlikely. Although the motifs and style of the border are identical to those in the Vienna and Copenhagen manuscripts, the style of the miniature in the Fitzwilliam Museum transcript is very different. It lacks the detailed rendering of figures and clothing present in the Vienna and Copenhagen volumes. The composition is also slightly changed, with a man entering from the right instead of sitting around the table. The Fitzwilliam fragments must come from another set of the *Histoire*.

In the Fitzwilliam Museum manuscript, only the context of the portrait of Philip the Good remains enigmatic. The combi-

nation of the portrait and the coats of arms is puzzling. They do not occur in the Statutes of the Order of the Golden Fleece. As the portrait is also stylistically different from the other two fragments it probably never had anything in common with them until it was pasted into the same volume, possibly as late as 1648. This insertion was relatively easy to achieve as there were blank folios between the various chapters of the text. Julius Chifflet, a Besançon-born historian and author of a history of the Order of the Golden Fleece, probably realised the link between his manuscript and the fragments when he had them pasted into his manuscript of the Statutes of the Order.

Fitzwilliam Museum, Cambridge AA

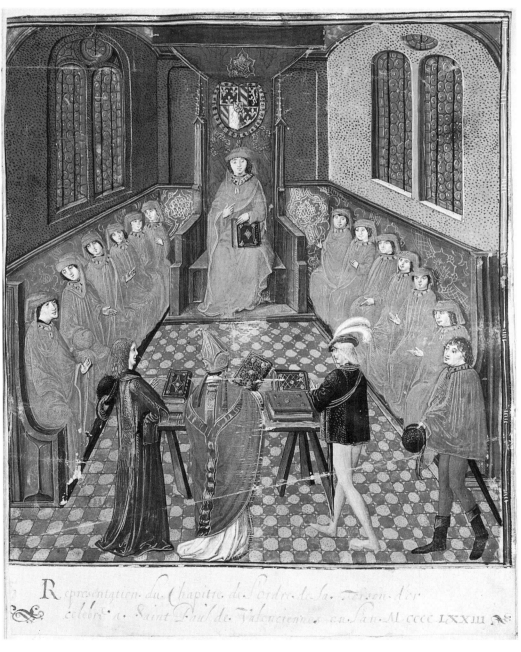

Cat. no. 47 fol. 129r, *Chapter of the Order of the Golden Fleece*

48

Chronicle of the Counts of Flanders

1477, Ghent

Illuminated manuscript on parchment, 410 × 295 mm, 293 folios (in 2 vols.)

colour plate, p. 178

Provenance: Margaret of York, whose coat of arms appears on fol. 2r and who has written her name on the last folio 'margarete d'Angleterre'; Thomas Coke, Holkham Hall *Accession no.* MS. 659
References: Pächt 1947, passim; London 1953–4, p. 159, no. 593; Brussels 1959, note 195; Lieftinck 1969, 1, pp. viii–ix; Hassall 1970, pp. 13–4 and pls. 25–30; Kren 1983, pp. 22–3; Hughes 1984, p. 73–4; Dogaer 1987, p. 149; Pächt and Thoss 1990, 2, p. 101; Kren 1992, p. 260

This manuscript has not previously been published in any detail. The following description may be a useful complement:

Quaternions; single purple ruling; signatures and catchwords; dentelle initials; four borders with acanthus and large flowers on a white background around twenty-two miniatures: fol. 2r: The legendary Liederik Van Harelbeke receives the county of Flanders from Charlemagne; fol. 8r: Robert the Frison defeats the army of Arnulf III, Count of Flanders near Cassel and becomes himself Count of Flanders; fol. 14r: Murder of Charles the Good in the cathedral of St Donatian in Bruges in 1127; fol. 58r: Lesleu of Senlis encourages his men to the battle; fol. 78r: Johanna of Constantinople attends the hanging of Bertrand de Reims, who was impersonating the count of Flanders, at Lille; fol. 86v: King Louis IX leaves for the Crusades; fol. 95r: King Louis takes the port of Damiette; fol. 107r: Beheading of King Conrad V, King of Sicily, at Naples in 1268; fol. 111v: Count of Artois conquers Bordeaux and Gascony for the French King; fol. 137v: A coalition army of Flemish towns beats the French army during the Battle of the Golden Spurs near Courtrai (11 July 1302); fol. 156v: The revenge of the French at the battle of Mons-en-Pevèle (1304); fol. 195r: Queen Elisabeth of France and her son Edward III are welcomed in Oxford (1326); fol. 204r: The French army defeats the Flemish at Cassel; fol. 207r: Edward III pays homage to Philip, King of France; fol. 221r: Jacob Van Artevelde leads a rebellion of the people of Ghent against the Count of Flanders; fol. 226r: The weavers of Ghent rebel against Jacob Van Artevelde (1345); fol. 245r: The kings of Castile and Portugal kill large numbers of Saracens at the battle of Granada; fol. 255v: The defeat of Philip VI of Valois, King of France, at Crécy (1346); fol. 267r: Jean II the Good taken prisoner by the English at the battle of Poitiers (1356); fol. 271r: Death of Charles de Bloys at the battle of Avray (1364); fol. 282r: Louis, Count of Flanders and the town of Bruges are defeated by Filips Van Artevelde and the people of Ghent at the battle of Beverhoutsveld (1382); fol. 284r: Filips van Artevelde and the

people of Ghent are defeated by the French army at Westrozebeke (1382).

The *Chronicle of the Counts of Flanders* is a survey of the history of the counts of Flanders by an anonymous author. This version starts with Liederik Van Harelbeke, the legendary first count of Flanders, and finishes in 1384 with the death of Louis de Mâle, the father-in-law of the first duke of Burgundy, Philip the Bold. Other chronicles of Flanders in the library of the dukes of Burgundy ceased in 1432. The main interest of the chronicler lay in Franco-Flemish conflicts, and it is therefore not surprising that most of the miniatures feature these episodes. From the introduction to the work it appears that a translation of the Chronicles from Latin into French was made in 1477 at the request of Mary of Burgundy. Because the marginal decoration of the opening page contains the coat of arms of Margaret of York, it is assumed that Mary commissioned the translation and the manuscript as a present to her stepmother, Margaret of York. The year 1477 was a particularly disastrous one for the Burgundian House since, in January of that year, Charles the Bold had been defeated and killed during the battle of Nancy. This present of Mary to Margaret thus came at a distressing time for Margaret of York.

Traditionally, the miniatures of the *Chronicle* have been attributed to the Master of Mary of Burgundy. More recently it has been suggested that the miniatures are an early work of the Master of the First Prayerbook of Maximilian I. Pächt and Thoss (1990) have pointed to the stylistic analogies between the Holkham Hall miniatures and those in a *Légende de St Adrien* (Vienna, Österreichische Nationalbibliothek, Ser. Nov. 2619) and in Johannes Brando's *Chronodromon* (Brussels, Koninklijke Bibliotheek, MS. 11 1169), attributed to the same artist. The Master of the First Prayerbook of Maximilian I can be placed in the circle of the Master of Mary of Burgundy, probably based in Ghent, and has been identified with Sanders Bening, a Ghent-born miniaturist and father of the celebrated Simon Bening. In the *Chronicle* he chose to use a semi-grisaille technique. Threatening dark grey clouds often fill the skies of battle scenes. Monotony has been carefully avoided by using colours for important parts of the compositions. His figures, with their bushy hair and beards, bear some of the hallmarks of the protagonists of Hugo Van der Goes' paintings. The cities with their walls and moats, their wooden and brick houses and emerging spires offer an idea of the appearance of a street in a typical Flemish town at the time.

Lent by Viscount Coke and the Trustees of the Holkham Estate

AA

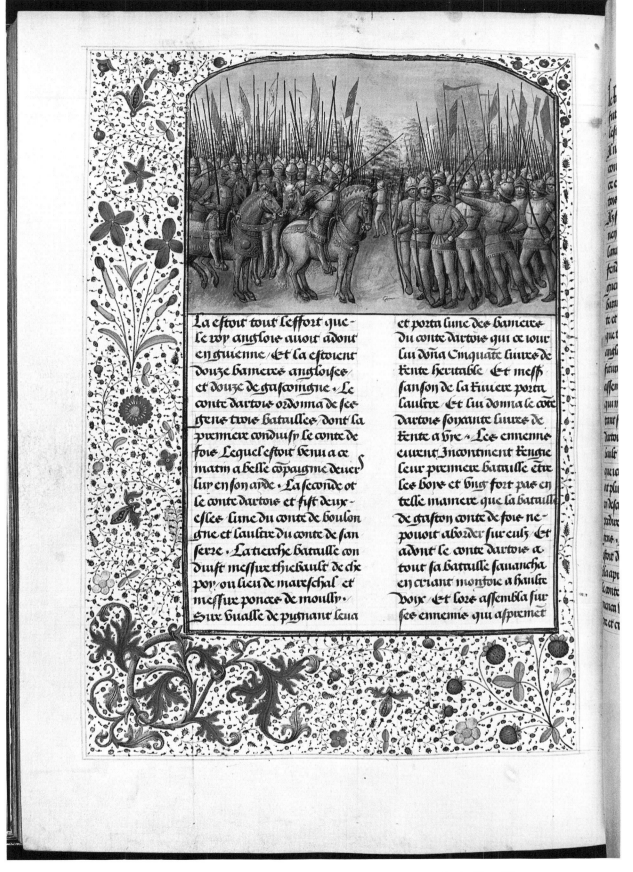

Cat. no. 48 fol. 121v, *The Count of Artois conquers Bordeaux and Gascony for the King of France*

49

Breviary of Margaret of York

c. 1470, Ghent

Illuminated manuscript on parchment, 260 × 185 mm, 263 folios

colour plate, p. 179

Provenance: Margaret of York; Thomas Gardiner 'Armigero'; his gift to St John's College *Accession no.* MS. H.13

References: James 1913, pp. 244–5; Pächt 1947, p. 64; London 1953–4, p. 159, no. 594; Brussels 1959, no. 198; Lieftinck 1969, pp. 1–7; Roosen-Runge 1981, p. 65; Kren 1983, p. 15, 20, note 3, 22; Hughes 1984, pp. 58–9; Testa 1986; Pächt and Thoss 1990, 2, p. 89; Kren 1992, pp. 14, 41, 58, 60, 65 and 261

The presence of the coat of arms of Margaret of York and of the motto of Charles the Bold, 'Bien en adviene', in various borders demonstrates that this breviary belonged to Margaret of York after she married Charles the Bold, the last duke of Burgundy, in 1468. Her library consisted of a small but fine collection of books with a strong devotional bias. This breviary was once one of the most splendid codices in her collection but was heavily mutilated before it came to St John's College *c.* 1618.

The miniatures are by one of the most influential Flemish miniaturists active during the reign of Charles the Bold: the Master of Mary of Burgundy. Lieftinck (1969) suggested the miniatures of this breviary were painted at the beginning of his career, when he worked for Margaret of York. Characteristic of his style are the elongated faces of his figures, their long and spiky hair, and the static compositions.

The Master of Mary of Burgundy was innovative in book illumination during the late 1470s and the 1480s. He changed the appearance of the border by developing a *trompe-l'œil* formula.

Instead of organising the borders around acanthus leaves on a white background, the artist paints motifs projecting shadows onto a plain-coloured background. This innovation was highly successful in Flemish book-illumination and spread all over Europe from the 1490s onwards. The Breviary of Margaret of York is on the borderline between these styles. Some pages still have the traditional spray and acanthus borders, others have the new illusionistic border style with delicate motifs set on a plain background.

The Master of Mary of Burgundy was also influential in the compositions he invented. A composition such as Christ washing St Peter's feet at the Last Supper has been repeated by artists such as the Master of the Prayerbook of Maximilian (Oxford, Bodleian Library, MS. Douce 311, fol. 311r) and Simon Bening (Dublin, Chester Beatty Library, MS. W.99, fol. 28v, or in the Grimani Breviary, Venice, Bibliotheca Marciana, lat. xi, 67, fol. 219v).

For reasons controversial among historians, St Andrew, who is represented in a miniature here, was the favourite saint of the Burgundian dukes. His attribute, the saltire cross, became a traditional emblem for the dukes. It was painted on military banners, included in borders of illuminated manuscripts and often accompanied the other symbols of the Order of the Golden Fleece.

Lent by the Master and Fellows of St John's College, Cambridge

AA

Cat. no. 49 fol. 103r, *St Andrew*

50

Feuillant de Joual, *Instruction d'un jeune prince*

René d'Anjou, *Le mortifiement de vaine plaisance*

Before 1468?, northern France, Hesdin or Valenciennes?

Illuminated manuscript on vellum, 306 × 220 mm, 66 folios

colour plate, p. 180

Provenance: Luxemburg family: H–G(?) monogram throughout the first text; Froimont (1558); Herman de Bourgoigne (1600) who lists his children on fol. 4r and v; Founder's bequest, Fitzwilliam Museum, 1816 *Accession no.* MS. 165
References: James 1895, pp. 365–6; Lyna 1927, pp. lxxviii–lxxx; Cambridge 1966, p. 45; Hoffman 1969, p. 245; Hoffman 1973, pp. 273–5; Hindman 1977, pp. 191–3; Plotzek and Eeuw 1982, pp. 194–5; Kren 1992, p. 191, note 6

Two texts have been included in this manuscript. The *Instruction d'un jeune prince* is a thirteenth-century treatise written by Feuillant de Joual for the benefit of Rudolf, the king of Norway. In a prologue and eight chapters the author offers instruction on how to govern wisely. The second text consists of a series of moral allegories.

Two distinguished artists contributed to the illumination. The first text is introduced by a presentation miniature where Rudolf, surrounded by his court, receives the manuscript from the author's hand. Presentation miniatures are common in Burgundian manuscripts. They aimed at flattering the commissioner, usually the duke or a prominent figure. The miniature is surrounded by a four-sided border of elongated acanthus leaves and cut flowers on a white background. An undeciphered monogram (H–G?) and a coat of arms of the Luxemburg family indicate the provenance. The monogram is repeated in a small border at the beginning of each chapter. A Book of Hours now in the Getty Museum, Malibu (Plotzek and Euw 1982, 2, pp. 185–95), contains the same coat of arms, which can be identified with that of Jacques of Luxemburg (1426–87). Jacques of Luxemburg became a member of the Order of the Golden Fleece in 1468 and, since the collar of this Order does not feature in the border of the Fitzwilliam Museum manuscript, it probably predates 1468. The miniature is the work of Simon Marmion, who was operating from Valenciennes (see cat. no. 22). The figures and colours which he uses bear his hallmarks: short necks, static and emotionless protagonists, a very soft palette and great care in painting the textures of textiles. The architecture with its two wide arches in which Marmion has staged his figures is purely imaginary and serves his composition. The style of the borders is analogous to those encountered in the early manuscripts of Margaret of York.

The second artist to be involved in this manuscript was Liédet. Loyset Liédet was active in Hesdin (northern France) before coming to Bruges in 1469. For a decade he led a productive workshop and he died in 1478. Liédet produced the eight miniatures for the respective chapters of the second treatise. His palette is brighter than Marmion's, his modelling clearer and his figures tall. The landscapes are less poetic, probably because their various components are not convincingly integrated. The iconography of the illustrations of the *Mortifiement de vaine plaisance* consists of a series of allegories. Altogether twelve illustrated copies survive with standard iconographic programmes. In Flanders three copies were produced: one in 1457, written and painted for Philip the Good, another copied in 1514, and the Fitzwilliam Museum copy. Although an artist who worked for Philip the Good like Liédet could have consulted the duke's copy, his miniatures are totally independent. He has only distantly respected the text of René d'Anjou. The main protagonists are Soul, Fear, Contrition and a narrator. Chapter one opens with a miniature representing Soul as a woman in dialogue with her heart. She reflects on the sinful nature of her heart and is so depressed that she faints. Fortunately Fear and Contrition come to comfort her.

In Hesdin, Liédet copied many compositions from Simon Marmion and his entourage, so that a collaboration of Marmion and Liédet in one manuscript is not surprising. If the manuscript really predates 1468, its production must be situated in northern France where Marmion and Liédet were established. This is consistent with what we know about Jacques of Luxemburg who spent part of his life in that region. However, in the stylistic evolution of the artists the miniatures would be better situated in the 1470s.

The binding of red velvet over wooden boards is original. The bosses which protect the binding when the manuscript was shelved horizontally, the clasps and the *fenestra*, or little window in which the title of the work can be read, are also contemporary. Velvet bindings were favoured by bibliophiles at the court of Burgundy such as the duke himself and Raphael de Mercatellis.

Fitzwilliam Museum, Cambridge AA

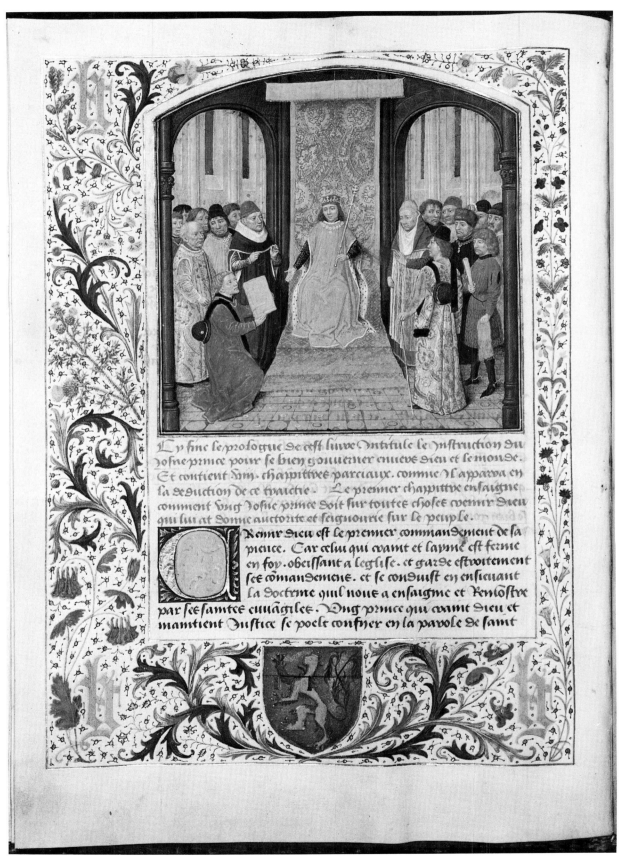

Cat. no. 50 fol. 10v, *The author presents his book to Rudolf of Norway*

51

The twelve Ladies of Rhetoric

c. 1470, Bruges

Illuminated manuscript on parchment, 275 × 203 mm, 61 folios

colour plate, p. 181

Provenance: Jean de Montferrant; Royal Library; given to Cambridge University Library, 1715 *Accession no.* MS. Nn.3.2
References: Cambridge 1856, 4, pp. 473–4; London 1953–4, no. 587; Cambridge 1976, no. 2; Bruges 1981, p. 254; Cambridge 1992 (by E. Bruinsma and C. Chavannes-Mazel)

During the years 1463 and 1464, three famous men exchanged correspondence on the theme of poetry. Georges Chastellain, the official chronicler of the duke of Burgundy, Philip the Good, was asked to judge the merits of the poetry of an up-and-coming young poet, Jean Robertet. Jean de Montferrant of Bugey, counsellor and 'chambellan' of Philip the Good and later 'maistre d'hostel' of Charles the Bold, functioned as intermediary. Only after Montferrant described in a long poem his vision of the twelve companions of Lady Rhetoric pleading in favour of Robertet does Chastellain agree to enter the debate. The manuscript comprises the correspondence between the three men.

Three contemporary illuminated manuscripts of this text are known to have survived: Paris, Bibliothèque Nationale, MS. fr. 1174, Munich, Bayerische Staatsbibliothek, Cod. Gall. 15 and the Cambridge University Library copy. All have miniatures of the same subjects, compositions and colours and rely on the same exemplar. The Cambridge manuscript is most probably the presentation copy for Jean de Montferrant. As Bruinsma and Chavannes-Mazel (in Cambridge 1992) have shown, the three copies were made by different scribes and artists.

The University Library's manuscript was commissioned by Jean de Montferrant, whose coat of arms appears on fol. 1r and on the two original clasps. The elegant script, called Burgundian *bastarda*, is typical of de luxe manuscripts produced for members of the court of the duke of Burgundy.

Each of the twelve poems, which have recently been attributed to Georges Chastellain, is illustrated by a miniature which features one of the companions of Lady Rhetoric. One miniature shows Eloquence sitting on a chair in an enclosed garden, full of flowers. Behind her, a river and town with wooden houses form an animated background. The qualities of the ladies are explained in a Latin motto, sometimes translated from the text, sometimes totally unconnected with it, in this instance 'Diffusa est gracia in labiis meis' (Grace is spread through my lips). Representations of Eloquence are rare in medieval art. This miniature of Eloquence endows her with an attribute of 'Temperance' – the compass – which she holds in her hand. The compass was probably intended to symbolise her capacity to measure the impact of verbal eloquence on an audience. The texts below the images make only occasional allusions to the picture. In flamboyant and pompous style they describe the virtues of Eloquence, comparing her amongst others with 'an angelic muse and a torrent of grace'.

The miniatures have often been associated with the circle of Philippe de Mazerolles, an artist of French origin. If this were so, the manuscript should be dated after 1467, when de Mazerolles came to the Netherlands. The style and the colour palette of the Robertet miniatures are, however, different from the de Mazerolles style. Unlike de Mazerolles, the artist of the Cambridge Robertet places an important emphasis on landscape.

Lent by the Syndics of Cambridge University Library AA

Cat. no. 51 fol. 27v, *Eloquence*

52

Book of Hours of Isabella of Aragon

c. 1510, Bruges

Illuminated manuscript on parchment, 230 × 140 mm, vi + 217 + vi folios

colour plate, p. 181

Provenance: Samuel Sandars; his bequest to Cambridge University Library, 1894 *Accession no.* Add. MS. 4100
References: London 1953–4, p. 162, no. 607; Cambridge 1992 (by L. De Kesel)

This manuscript has not previously been published in any detail. The following description may be a useful complement:

Quaternions; fols. 1–12: calendar; fols. 13–14r: Prayer to St Veronica; fols. 16r–42v: Hours of the Cross; fols. 44r–110v: Hours of the Virgin; fols. 123r–141v: Penitential Psalms; fols. 143r–180v: Vigil of the Dead; fols. 182r–186v: Passion according to St John; fols. 195r–215r: various prayers to the Virgin Mary; decorated initials; borders in Ghent-Bruges style throughout; calendar illustrations: fol. 1r (Aquarius, Man in front of open fire),fol. 2r (Pisces, men chopping wood), fol. 3r (Aries, working on the land), fol. 4r (Taurus, hunting), fol. 5r (Gemini, couple in garden), fol. 6r (Cancer, mowing), fol. 7r (Leo, reaping), fol. 8r (Virgo, threshing), fol. 9r (Libra, picking grapes), fol. 10r (Scorpio, sowing), fol. 11r (Sagittarius, thrashing acorns), fol. 12r (Capricorn, slaughtering of a pig); small miniatures: fol. 37v (Pieta), fol. 111r (St John the Baptist), fol. 111v (Sts Peter and Paul), fol. 112r (St Sebastian), fol. 112v (St Nicholas), fol. 113r (St Francis), fol. 113v (St Catherine of Alexandria), fol. 114r (St Barbara), fol. 117r (St Bernard), fol. 118v (St Athanasius); full-page miniatures: fol. 15v (Crucifixion), fol. 22v (Pentecost), fol. 43v (Annunciation), fol. 60v (Visitation), fol. 71v (Nativity), 76v (Annunciation to the Shepherds), fol. 85v (Presentation in the Temple), fol. 90v (Flight into Egypt), fol. 98v (Massacre of the Innocents), fol. 115v (Mass of St Gregory), fol. 122v (Penitent David), fol. 142v (Raising of Lazarus), fol. 181v (Arrest of Christ), fol. 186v (Flagellation), fol. 189v (Carrying of the Cross), fol. 190v (Christ nailed to the Cross), fol. 193v (Deposition), fol. 194v (Crucifixion); eighteenth-century red morocco binding.

It is debatable whether this lavish Book of Hours was ever owned by Isabella of Aragon. The manuscript was traditionally thought to be a gift from Isabella of Aragon to Isabella of Castile in 1505, but no contemporary evidence corroborates this hypothesis. The contents of the manuscript are more elaborate than the average Book of Hours. On top of the standard contents, the volume includes the Passion according to St John and various prayers to Our Lady.

De Kesel (in Cambridge 1992) has shown that up to three full-page miniatures are missing and that the illumination programme of this manuscript is due to a collaboration of different artists, who are grouped under the name of the Master of the Prayerbooks of *c.*1500. The fact that this name covers more than one artist explains why the quality of the miniatures in this manuscript and in others on which these artists have worked is so variable. The calendar illustrations and the full-page miniatures which fall under this attribution illustrate this. Whether the painter Gerard David, who is thought to have painted the miniature of the Nativity, was involved in the illumination is doubtful. During his life Gerard David had contacts with the Bruges illuminators and he influenced early sixteenth-century miniaturists such as Simon Bening. However, the four miniatures in the Breviary of Queen Isabella of Castile (London, British Library, Add. MS. 18851), which are generally accepted to be his work, show very different facial types and a more detailed treatment of the architecture.

Lent by the Syndics of Cambridge University Library AA

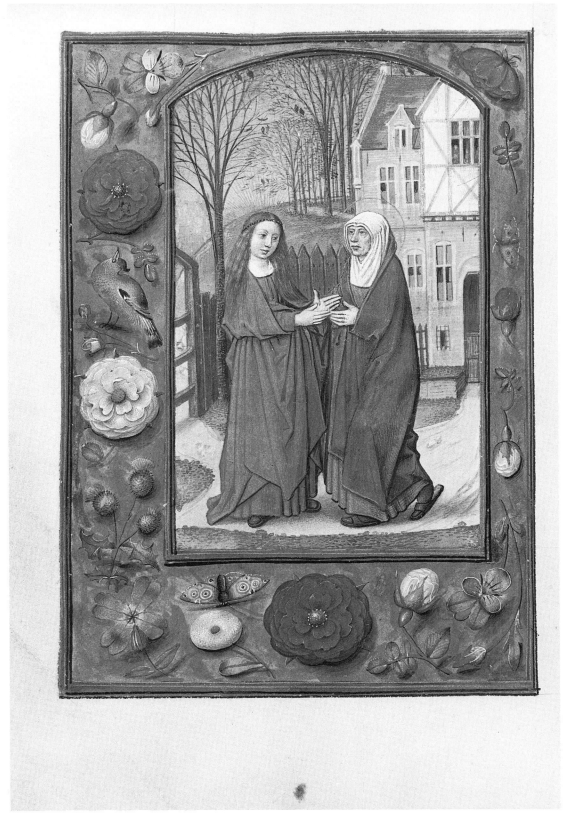

Cat. no. 52 fol. 60v, *The Visitation*

Introducing printing

Alain Arnould

In a milieu where manuscripts played such an important role in social and economic life, it is hardly surprising that the invention of movable type was greeted with considerable interest. From the 1460s onwards so-called blockbooks were printed, mainly in the Northern Netherlands. The printing process for these books consisted of printing a text and image carved on wooden panels. This was an expensive technique because the panels could not be re-used for other texts. This impediment would be overcome by Gutenberg's invention of movable type around 1454 which allowed letter fonts to be re-used for other books. Cutting letters was the task of a specialist craftsman. In some cases, as with Hendrik de Lettersnijder, he was employed by the printer and in others he can be identified with the printer. Each printer and letter-cutter had his own palaeographic preference and thus different types were used. In the nineteenth century three basic categories were recognised: gothic, bastarda and humanistic. This classification has been retained until the present day and is used in this catalogue, indicating respectively the number of the type used by a particular printer, the style of the letter and the height of the type.

Movable type was first used in the Low Countries in 1473. Germany and Italy preceded the Low Countries in adopting the new medium. Dirk Martens is to be credited with the introduction of the first press in the Southern Netherlands. He acquired his skill in Italy and set up his first press in Aalst in 1473. Aalst was not the most obvious place to start a printing press. It did not have an important economic function; neither did it have a wealthy court to commission books, nor the presence of a university which required textbooks. Soon presses began to appear in all major towns of Flanders and Brabant: Bruges (1473/74), Leuven (1474), Brussels (1475), Oudenaarde (1480), Antwerp (1482) and Ghent (1483). On the whole they were run by lay people. The only exception to this rule was the press of the 'Brethren of the Common Life' in Brussels. Faithful to their mission of propagating the faith, they published exclusively devotional literature. Other presses specialised in vernacular texts or illustrated editions.

In the early days of printing there was an unclear distinction between handwritten and printed books. Some printers, such as Colard Mansion in Bruges, had transcribed and illuminated manuscripts before embarking on printing. When it came to printing their aim was to imitate manuscripts as closely as possible, in script, layout and illustrations. Woodcuts were often coloured in to rival miniatures. The inclusion of illustrations in incunables required some experimentation but in 1484, when Mansion published his Ovid, the result was a magnificent book with monumental woodcuts. This would surely have been a book to tempt the most distinguished bibliophiles. In Antwerp, Claes and Gerard Leeu employed a cutter who produced some outstanding work in the illustration of Leeu's editions.

After having absorbed the technology from Germany and Italy and having attracted experienced printers such as Johannes de Westfalia or Gerard Leeu from respectively the Rhine valley and Gouda, Flanders produced a remarkable series of printers who would export their skills in various ways. Between 1474 and 1486 Dirk Martens travelled to Seville and Murcia where he imported books. William Caxton, after having acquired printing experience in Bruges, moved to Westminster and established printing in England. Judocus Badius moved to Paris where he established a successful workshop.

53

Ecce Homo

c. 1450, unknown origin

Single-leaf woodcut on paper, 190 × 133 mm

colour plate, p. 185

Provenance: H. Bradshaw; his gift to Cambridge University Library, 1868 *Accession no.* MS. Add. 5944(11)
References: Schretlen 1925, app. A; Oates 1954, no. 9; Pächt and Thoss 1990, 2, p. 109 and fig. 128

This woodcut is an indulgence of 80,000 years for anyone who would read the prayer to the Sacred Heart of Christ. Iconographic themes such as the Crucifixion, or the Man of Sorrows standing in front of the instruments of Christ's Passion, are a typical expression of the *Devotio Moderna*. This was a movement founded by Geert Groote (1340-84) in Deventer to reform the spirituality of lay people and the religious. In its focus on Christ's humanity and his Passion, Geert Groote opposed the *via antiqua* of scholasticism and Thomism. It became widely popular and his followers organised themselves in Communities of Brothers and Sisters of the Common Life. They attached great importance to private devotion, but worshipped within the fold of churches.

This image of the Crucified Christ is made especially dramatic by the application of red paint to represent blood flowing from Christ's body. This was a much practised way of appealing to the piety of the believer. Other examples where the same technique is used are Wolgemut's drawings (Berlin, Kupferstichkabinett, MS. 78 b 3a), and a drawing in a Flemish preaching manual in Vienna (Österreichische National-bibliothek, Cod. Ser. nov. 12784). Even more empathic is a drawing of a St Bernard and a nun embracing Christ on the Cross (Cologne, Rheinisches Bildarchiv), where blood flows out of Christ's wounds and covers his whole body.

Individual leaves such as these were widespread but very few have survived. This is the only known surviving copy of this Indulgence. It is difficult to tell when and where it was printed and the absence of a watermark reduces the chances of ever solving this problem. Contemporary paintings demonstrate that similar woodcuts were pinned to walls in churches and houses.

Lent by the Syndics of Cambridge University Library AA

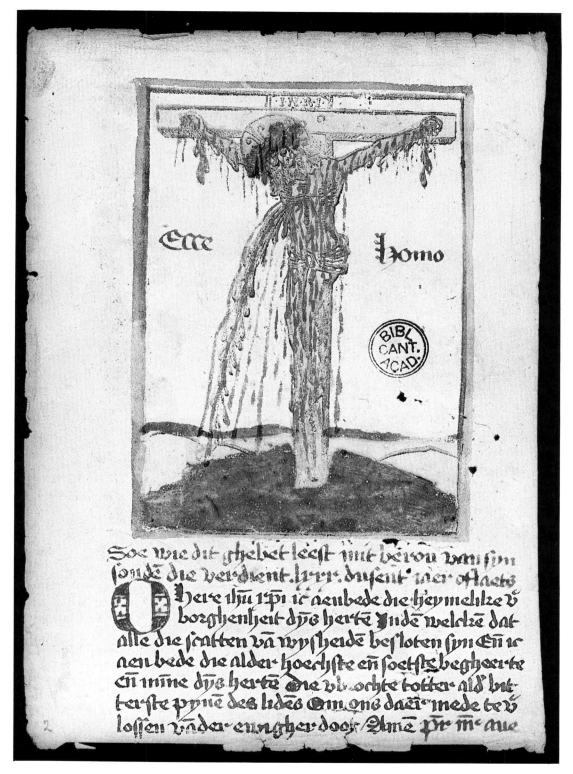

Cat. no. 53, *Ecce Homo*

54

Raoul Lefèvre, *Recuyell of the Histories of Troy*

Bruges?, William Caxton, 1473–4

Printed on paper with the 1:120 B type. Seventeenth-century leather binding, with traces of two clasps. The missing pages of this copy were replaced with leaves from a second copy which the University Library exchanged for another Caxton in 1960. Some of these pages are imperfect.

Provenance: Laurence Mountigue; Thomas Cook of Asheted (1628); Royal Library; given to Cambridge University Library, 1715 *Accession no.* Inc. 3.F.3.2 (3307)
References: Oates 1954, no. 3838; Hellinga 1966, 1, pp. 24 and 2, pls. 21–2; Cambridge 1976, no. 16, BMC, 9, pp. 129–30; Brussels 1973, pp. 166–9; Hellinga 1976

Although William Caxton is above all important for the introduction of printing into England, he also deserves a place in an exhibition of Flemish art. Between 1444 and 1476 he spent thirty-two years on the Continent. As merchant adventurer he traded with the Low Countries, became Governor of the English Nation in Bruges and mediated between the English and Burgundian courts when these countries imposed protectionist measures against each other. In 1468, the marriage of Charles the Bold and Margaret of York, whose patronage he actively sought, worked in his favour. In 1471 he settled in Cologne where he learned the printing craft. This career shift has often been considered as a continuation of Caxton's entrepreneurial spirit. In 1473 he went back to the Low Countries, before returning to his homeland where he would establish the first printing press in 1476.

Caxton's involvement in the production of this book was twofold. In the first place he translated the text, an extended version of the Trojan legend commissioned by Philip the Good from his Chaplain Raoul Lefèvre, from French into English.

In the book Caxton explains that he had started the translation in 1469 while he was in Bruges, but then abandoned the project. On the insistence of Margaret of York, he completed the work in Cologne in 1471. In the second place, Caxton also printed it, thus producing the first printed book in English. In the epilogue he mentions that it is the first book he has printed. However, Wynken de Worde, Caxton's assistant, claimed that Caxton collaborated in a Latin edition of Bartholomeus Anglicus' *De proprietatibus rerum*, while in Cologne.

Nowhere in the book does Caxton mention where it was printed, so that we cannot be absolutely sure that it was printed in Bruges. Hellinga (1976) has suggested that Caxton may have stayed in Leuven in 1472 where he could have worked with the printer Johann Veldener, whom he had known in Cologne and who had left the Rhenish town at approximately the same time as Caxton. The book's printing type, which closely resembles the handwritten *bastarda*, was Caxton's first. Some of the capitals recall those used by Johann Veldener in Cologne. The *Recuyell* was set by four compositors, using the same printing types, but indicating the ends of paragraphs in different combinations of dots. The pages displayed show the work of two compositors: B uses a single dot at the end of the paragraph while compositor C opts for a combination of dots.

Lent by the Syndics of Cambridge University Library ᴀᴀ

Cat. no. 54 fols 148v–149r, two pages set by different compositors. Left: compositor using single dot.
Right: compositor using multiple dots at end of sentences

55

Boethius, *Consolation de philosophie*

Bruges, Colard Mansion, 1477

Printed on paper with the Mansion 1A:162B type

colour plate, p. 182

Provenance: Rogier Willeron; Chapter of Salisbury Cathedral; Jerome de Winghe (?1557–1637); Theodore Galle (1571–1633/4); purchase/exchange, Cambridge University Library, 1870 *Accession no.* Inc.1.F.3.1(3304)
References: Weale 1872, p. 307; Oates 1954, no. 4579; Hellinga 1966, pl. 58; Brussels 1973, pp. 222–4; Cambridge 1976, no. 18; Arnould 1991, 1, pp. 216–17

This French translation of the Boethius text is based on previous translations. Mansion was clearly targeting the circles around the ducal court and therefore made provision for miniatures to be added at the beginning of each of the five books. This represents one of the three stages in Mansion's search for an adequate formula to integrate images in printed text in order to compete with the lavishly illuminated manuscripts of the period. The Cambridge University Library copy is the only one with its miniatures known to have survived. The copy received its full decoration as penwork initials, marginal decoration and miniatures had been filled in. It is remarkable to see how the miniatures are based on the same set as those of the miniatures in the Fitzwilliam Museum copy of the Arend de Keyser edition (see cat. no. 57). This is visible in the composition of the images and in the colours which are used in both cases. Philosophy is dressed in a black and yellow dress, while Boethius is in blue; the beds are red in both instances. However, it is clear that the artist of the Mansion edition was more talented than his colleague who painted the miniatures in the Fitzwilliam Museum copy. This resulted in a simplification of the compositions in the Fitzwilliam copy. For Book v for instance, the well-maintained garden with pruned trees in the Mansion edition has turned into a flat lawn in the Fitzwilliam copy. Where the view of the city is painted in minute detail in the Mansion edition, the miniaturist of the Fitzwilliam Museum copy has limited his view to one church.

It is very likely that the miniatures were only painted into this copy during the 1480s. This is confirmed by the fact that the miniatures from Book II onwards are surrounded by borders in Ghent-Bruges style, a fashion which only arose in the 1480s. The presence of traditional borders at the beginning of the Prologue and around the miniature of Book I indicates that the copy had started to be illuminated but that the process was soon interrupted. A few years later a second artist restarted the work and completed it.

This copy was owned first by a Bruges surgeon, Rogier Willeron, who inscribed his name on the back fly-leaf. How much he paid for it is unknown, but we do know that in 1482 one copy of this edition was sold at the Bruges guild of St John the Evangelist for ten shilling groot (Weale 1872). The receipt does not mention whether the copy was illuminated or not, but since the sum corresponds approximately to one day's wages for a mason in Bruges at the time, it is more likely to allude to a non-illustrated copy.

Lent by the Syndics of Cambridge University Library AA

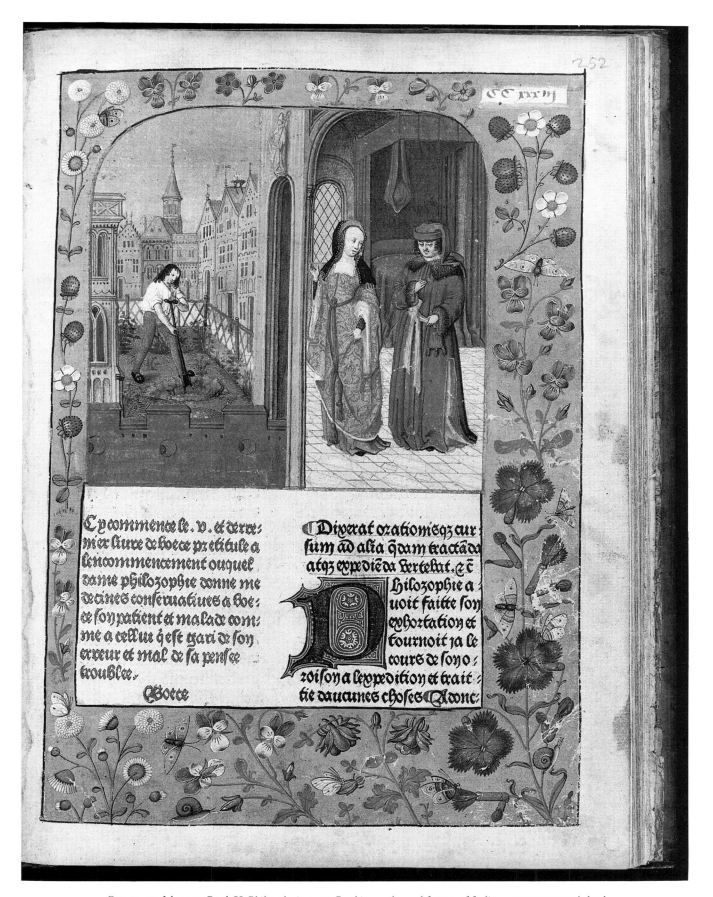

Cat. no. 55 fol. 252r, Book V, *Philosophy instructs Boethius on the good fortune of finding a treasure on one's land*

56

MASTER OF THE BOCCACCIO ILLUSTRATIONS

Boccaccio presents his Book to Mainardo Cavalcanti

Bruges, 1476; 209 × 171 mm

Engraving on excellent and fine paper; the image slightly trimmed on the right;
top left and right and bottom right corners missing; until recent conservation the top
corner figures were made up in a (nineteenth-century?) restoration; the line of the column
on the left has been strengthened by hand. There are some traces of paste on the verso, as
well as traces of contact with linen, possibly dating back to the printing process.

Provenance: probably Rev. Thomas Kerrich; Rev. Richard Edward Kerrich; his bequest to the Fitzwilliam Museum, 1873
References: Van Praet 1829, p. 30; Colvin 1878; Lehrs 1902, p. 137; Lehrs 1921, pp. 172–4, no. 2; Hollstein, 12, p. 118; Anzelewsky 1959; Brussels 1973, pp. 219–22

Colard Mansion plays a crucial role in the history of Flemish printing. Before becoming a printer he was a distinguished scribe and translator, working among others for the celebrated bibliophile Lodewijk Van Gruuthuse. Mansion soon seems to have understood the opportunities which the printing press offered. He published his first book, and at the same time the first book to be printed in Bruges, probably in 1474, perhaps after having trained or collaborated with William Caxton. In 1476 Mansion published the French edition of Laurent de Premierfait's translation of Boccaccio's *De casibus illustrium virorum et mulierum*. One of the important features of this edition is that, for the first time in the history of printing, engravings were used as illustrations. The creation of this edition is complicated and went through four stages. In the first phase, Mansion provided space for ten illustrations, one for the Introduction and nine others for the nine Books of the work. Mansion probably planned these spaces for miniatures, as he did with his Boethius in 1477 (see cat. no. 55). In 1829 Van Praet claimed to have heard of three copies where these miniatures had been painted, but none seem to have survived. Or did Van Praet mean engravings? By good fortune rather than careful planning, nine engravings with Boccaccio subjects came into Mansion's possession and he decided to include them in his edition. Unfortunately, the size of the spaces originally provided for the illustrations was too small to include the engravings so that he had to reset the first pages of each Book. In the second stage he therefore reduced the length of the introduction to allow for more space. In the third stage this intervention was extended to the other books except for Books I and VI. During the last stage, the space for the illustration of Book VI was also enlarged. Whether the engraving for Book VI was ever executed is doubtful as no copies seem to have survived.

Only three copies of the Mansion edition with nine pasted-in engravings have come down to us (Boston, Museum of Fine Arts; Amiens, Bibliothèque de la Ville; and in Schweinfurt, Germany, Collection O. Schäfer). Besides these three copies loose engravings have also survived. The Fitzwilliam Museum example is one of only two known surviving engravings of the first state of the illustration of the introduction. It shows Boccaccio presenting his work to his friend Mainardo Cavalcanti. They are surrounded by the Pope, the emperor, a king, a ruler and a prelate to whom one would normally dedicate a work. However, Boccaccio prefers to offer his work to his friend as he knows that very few people in authority take the lessons of history into account.

The artist was probably a miniaturist familiar with the art of the Master of the Dresden Prayerbook (see cat. no. 28). He paints his figures with large round heads, and the compact figures of the Dresden Master recall the protagonists of the Boccaccio engraving.

Fitzwilliam Museum, Cambridge

AA

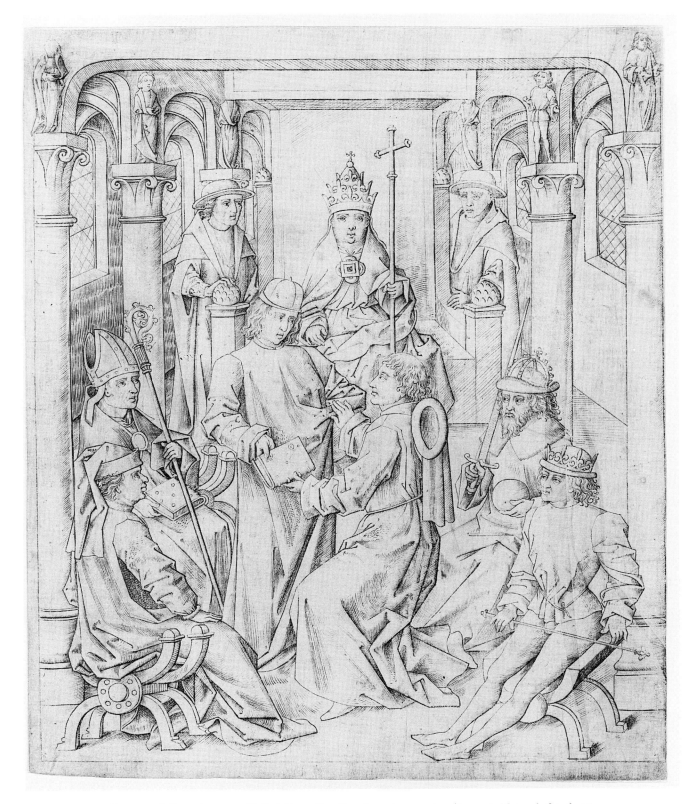

Cat. no. 56, *Boccaccio presents his Book* De casibus illustrium virorum et mulierum *to Mainardo Cavalcanti*

57, 58 and 59

Boethius, *De consolatione philosophie*

Ghent, Arend de Keyser, 1485

Printed on paper with the de Keyser 3:126G and 1:97B types

colour plates, pp. 182–183

Provenance: Cat. no. 57, Cobrysse 1542; purchased by the Fitzwilliam Museum, 1892; cat. no. 58, purchased by Cambridge University Library, 1870; cat. no. 59, Duke of Sussex (1773–1843); H. Bradshaw; his gift to Cambridge University Library, 1870 *Accession nos.* cat. no. 57, Sayle 338; cat. no. 58, Inc. 2.F.7.1 (3465); cat. no. 59, Inc. 1.F.7. 1(3464)
References: Chawner 1908, no. 181; Sayle 1916, no. 338; GKW no. 4574; Oates 1954, no. 4003; Hellinga 1966, 2, pls. 122 and 135; BMC, 9, pp. 206–7; Arnould 1991, 1, pp. 205–20

The edition of Boethius' famous text from Arend de Keyser's presses in Ghent is the most spectacular to come on the book market in late fifteenth-century Europe and ranks among the most impressive incunables produced in the Low Countries. In his text Boethius (*c.* 480–524) narrates the reversal of fortune he suffered when, after many years of faithful service as civil servant at the imperial court of Theodoric, he was disgraced and imprisoned in Pavia. He recounts how he is being comforted by Philosophy while meditating on the inconstancy of fortune. Ultimately Boethius was to be cruelly tortured and executed.

The edition is most impressive. First, there are the dimensions of the book. Secondly, there is the whole conception of the project. Arend de Keyser's ambition was to produce an edition of the *De consolatione philiosophie* which would provide the text, its Flemish translation and a commentary. The author of the translation, the second to be made after Jacobus Vilt's 1460s version, has so far remained anonymous. He is probably to be identified with the person who mentions in the prologue that he corrected the first book of the translation in his own hand and deposited it in the library of St Veerle's in Ghent. The authorship of the extensive commentary in Flemish is even more mysterious. It is obviously the work of a talented scholar who was thoroughly acquainted with the text.

Arend de Keyser started printing in Oudenaarde and moved to Ghent in 1483. The *De consolatione philosophie* was his most ambitious work. The popularity which Boethius enjoyed at that time probably prompted Arend de Keyser to risk the heavy investment which the project necessitated. The typefaces de Keyser used for this edition were those he had already been using for his editions issued at Oudenaarde. Whether the sales of the Boethius met Arend de Keyser's expectations is not certain. We do not know how many copies came from his presses, but at his death in 1490 his widow was left with the task of disposing of one hundred copies. Over fifty copies survive in libraries all over the world.

The copy now Cambridge University Library, Inc. 2.F.7.1

(3465) shows the first stage in the illumination process. As early printers were originally unable to supply types with elaborate penwork initials they preferred to leave space open for an initial to be painted in by hand. The next step in the decoration process consisted of painting miniatures in the space provided for them, in this case at the beginning of each of the five Books.

The copies of the Fitzwilliam Museum (Sayle 338) and of the Cambridge University Library (Inc. 1.F.7.1 (3464)) are among the only twelve known surviving copies where the space left open for miniatures and penwork initials has been filled in. The miniatures were executed according to two sets of exemplars. The compositions of the first set of miniatures can be found in the Fitzwilliam Museum copy, while the Cambridge University Library copy represents the second set. The subject of Book I is one element which differentiates the two sets. In the first set, the illustration of Book I focusses on Philosophy chasing away three muses, while the second set features Philosophy in all her splendour. Both scenes, but particularly the second one, follow Boethius' text. The compositions of the miniatures based on the second set of exemplars also differ from the first set. In the second set the image is divided into two parts, one featuring Boethius' cell, the other a city view or landscape. Another example of the first set is to be found in a copy at the British Library, London (IC 50105) and in the Cambridge University Library copy of Colard Mansion's edition of *De consolatione philosophie*. The compositions are similar and even the colours have been respected. Another example of the second set can be found in the other illuminated copy in the British Library, London (IC 50106). Here also the compositions are extremely close to one another. For Book V the miniatures evoke the passage where Philosophy compares good fortune with finding treasure by accident. The compositions in both sets are different, one staging the episode in a town square, the other in the countryside.

As well as the figurative illumination, the Cambridge University Library copy has had delicate marginal decoration added in the Ghent-Bruges style. This includes animals and flowers on a plain coloured background.

The genesis of the illustrated Boethius of Arend de Keyser can thus be reconstructed as follows. A number of printed copies were bought by a bookseller who entrusted them to artists who had to fill in the initials. A select number of them, on demand, were then sent to a miniaturist's workshop in Bruges which had access to two sets of illustrations for the *De consolatione philosophie*. At the specific request of the buyer, borders were added.

The suggestion that the copies were illuminated in Bruges rests on the fact that all illuminated copies which do reveal a provenance have a connection with Bruges. The Fitzwilliam

Cat. no. 58 fol. 285r, Book V

Museum copy has a note dated 1542 which mentions the name of Cobrysse. The Cobrysses were a famous Bruges family who played a prominent political role during the sixteenth century. Guillaume is the first member of the family to be recorded and may well have been the owner of the book in the 1540s

(J. Gaillard, *Bruges et le franc ou la magistrature et leur noblesse*, Bruges 1864, Supplement, p. 364).

Fitzwilliam Museum, Cambridge (57)
Lent by the Syndics of Cambridge University Library (58 and 59)

AA

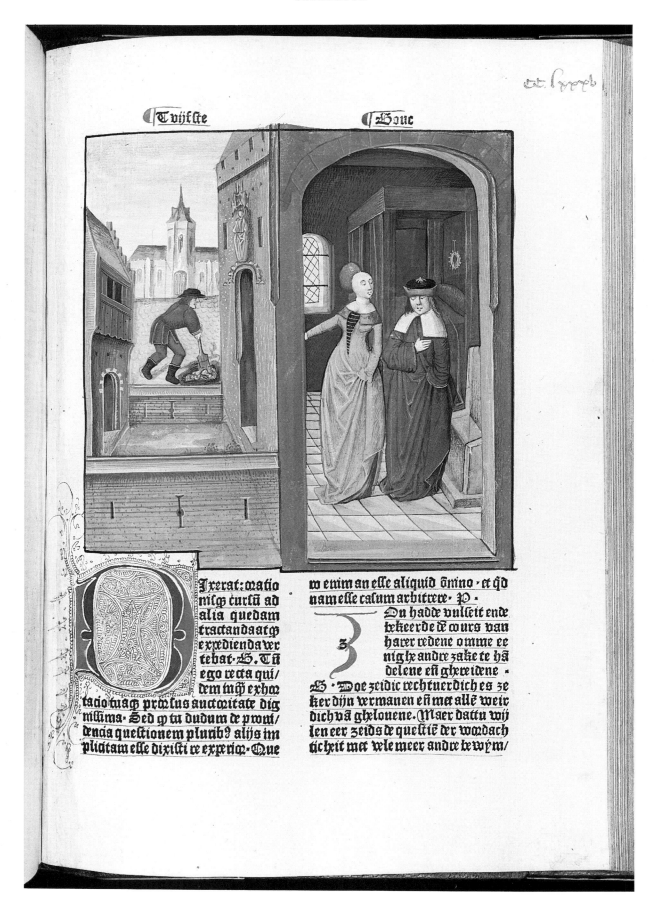

Cat. no. 57 fol. 285r, Book V, *Philosophy instructs Boethius on the good fortune of finding a treasure on one's land*

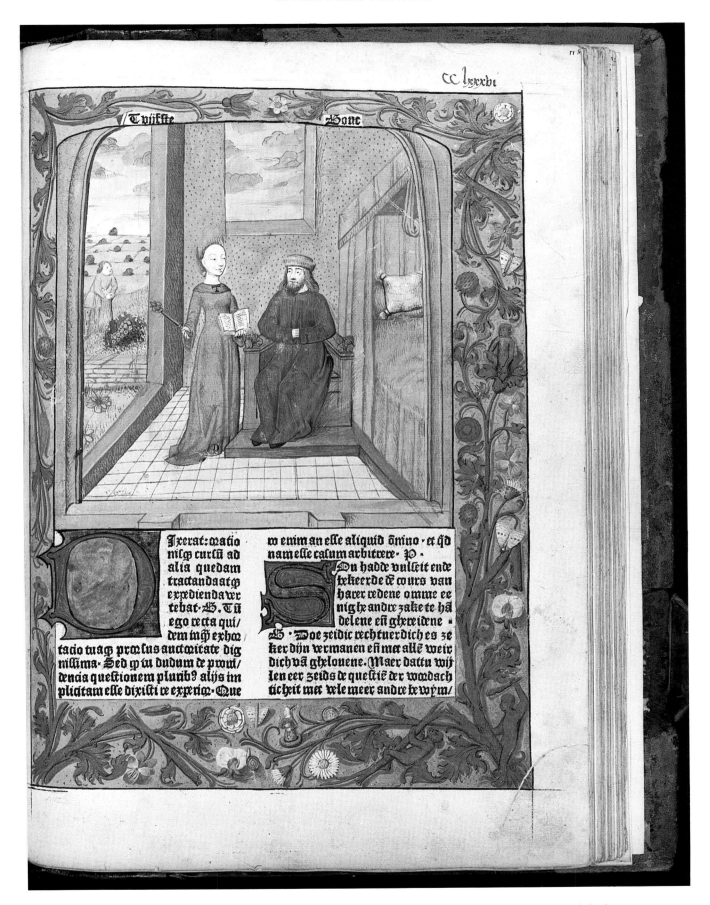

Cat. no. 59 fol. 286r, Book V, *Philosophy instructs Boethius on the good fortune of finding a treasure on one's land*

60

Fragments of a Book of Hours

Ghent, Arend de Keyser, 1488–90

Printed on paper with the de Keyser 1:97B type. Twenty-two fragments with eighteen
woodcuts. Original size of the Book of Hours: 130 × 100 mm

Provenance: Vergauwen; purchased by Cambridge University Library, 1884 *Accession no.* Inc. 6.F.7.1 (3466)
References: Conway 1884, pp. 351–9; Oates 1954, no. 4005; Hellinga 1966, 2, pl. 124; Machiels 1973, p. 57–63

These cuttings, together with some other fragments in the Kongelige Bibliotek, Copenhagen, are the only known remnants of what once must have been a splendid Book of Hours. In fact they are part of the first Book of Hours printed in the Low Countries. Arend de Keyser opted for a luxurious edition with at least twenty-five woodcuts. Two woodcuts offer indications that the book was aimed at Ghent and the region of eastern Flanders. One woodcut and prayer in the Copenhagen fragment are dedicated to St Hermes, a Roman martyr whose relics had attracted many pilgrims to Ronse, fifty kilometres east of Ghent, since the ninth century. The other woodcut shows the Virgin Mary and St Albert of Sicily. The presence of this twelfth-century Carmelite, whose cult had been confirmed in 1476 by Sixtus IV, indicates a Carmelite connection for the Hours. The Carmelite convent of Ghent played an important role in the town's spiritual life and it seems probable that the Carmelites commissioned the edition to assist their congregations in their spiritual life. The woodcut of St Peter and St Paul and a lay person saying a rosary may function as an exemplar.

The woodcuts are among the finest produced in the Low Countries in the fifteenth century. Arend de Keyser or the commissioners of the edition selected an artist with a great sense of monumentality. He integrates all the developments of contemporary manuscript painting, such as close-ups, into his woodcuts. The same is true for the delicate borders which surround some of the woodcuts. It is not necessary to see these as imitations of the borders included in Hours printed in France. Rather, they resemble the *trompe-l'œil* borders of manuscripts produced in Ghent and Bruges around this time, more specifically, the borders of motifs painted on black backgrounds. Although fragments of a calendar for a Book of Hours with Carmelite connections (Utrecht, Universiteitsbibliotheek) have been connected with the Cambridge/Copenhagen Book of Hours, I agree with Machiels (1973) that it is unlikely that they were ever part of one and the same edition.

Lent by the Syndics of Cambridge University Library AA

Cat. no. 60, *St Martin*

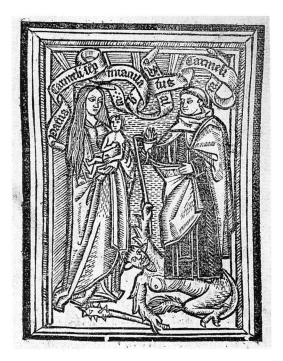

60, *The Virgin and St Albert of Sicily*

61

L. Valla, *Elegantiarum linguae latinae libri*

Cologne, Arnold TherHoernen, 1476

Printed on paper

Provenance: Kloss sale, Frankfurt am Main 1835; Robert Buchanan; Samuel Sandars; his bequest to Cambridge University Library, 1894 *Accession no.*SSS 40.16 (3165)
References: Oates 1954, no. 3694; Arnould 1991, 1, pp. 39–41

Laurentius Valla (1407–57) was one of the most popular and influential Italian humanists. His work on the Latin language, *Elegantiarum linguae latinae libri*, in which he summarises Latin grammar and offers advice on how to write it elegantly, was circulating in Bruges even before the first edition appeared in Rome in 1471. As early as 1463, Flemish humanists such as Johannes de Veris advocated the text to replace the old grammars of Priscian (sixth century), which were used throughout the Middle Ages.

The Cambridge University Library copy of the Ther-Hoernen edition is exceptional in three respects. First, it is a rare copy of the oldest edition of the *Elegantiarum linguae latinae libri* to be printed in Germany. Secondly, it is still in its original blind-stamped binding. Three different stamps were used: a fly, a fleur-de-lis and a triangular dragon. While dragons form a frame, the other two stamps fill the lozenges which devide the centre of the board. The dragon, fly and fleur-de-lis are typical of Bruges, where binders such as Jan Guillebert used them (see cat. no. 69). The fore-edge is goffered and there are traces of two clasps and cornerpieces. A parchment label indicates the author and the title of the book on the front board. As was often the case with exported books, this copy travelled to Bruges in loose quires and was then bound, probably at the request of a purchaser. This reader must have been concerned to acquire a superior copy, which would as far as possible resemble a manuscript. He therefore requested the copy to be decorated, a request which provided it with its third exceptional feature. The desire to rival manuscripts entailed justifying all the pages indi-vidually. One person went through the book and drew lines in red ink, one by one. This was a time-consuming practice and for a printed book had no purpose other than decoration. The same or another artist also added paragraph marks, rubrication and line endings. Then foliate and delicate penwork initials with animals in the eye of the letter were added. To make the copy even more attractive, a full border was painted at the beginning of the prologue. This border style is typical of Bruges. Among the striking characteristics are the use of silvery acanthus, the presence of two-stemmed flowers, which separate in upward and downward directions, and a gold and red U-shaped frame. These particular features can be found in a number of incunables and manuscripts which appear to have a Bruges connection. In manuscripts they occur in a Book of Hours in Melbourne (State Library of Victoria, MS. *f096/R66Hb) and two manuscripts of Raphael de Mercatellis (Holkham Hall, MS. 318 (see cat. no. 75) and Ghent, Universiteitsbibliotheek, MS. 72). In printed books, borders of the same style can be traced in an Ovid, *Opera*, Venice, Jacobus Rubeus, 1474 (formerly Abram's collection; Sotheby's, London, 16–17.11.1989, lot 91), a *Biblia Latina*, Basel, Johannes Amerbach, 1481 (Bruges, Stadsbibliotheek, Inc. 3863) and an *Ovide moralisé*, Bruges, Colard Mansion, 1484 (Paris, Bibliothèque Nationale, Rés. g.Y.c 1002). It is therefore most likely that the illumination was done in Bruges as well. The borders of the Cambridge University Library copy bear particular similarities to the Bruges *Biblia Latina* where the motif of two acanthus leaves emerging from a ring is also to be found. The fact that borders of a similar style are found in manuscripts as well as printed books demonstrates once more that during the 1470s and 1480s artists were equally involved in decorating printed books and manuscripts.

Lent by the Syndics of Cambridge University Library AA

Cat. no. 61, blind-stamped binding with fly, fleur-de-lis and dragon

Cat. no. 61, beginning of Prologue, with full border decoration

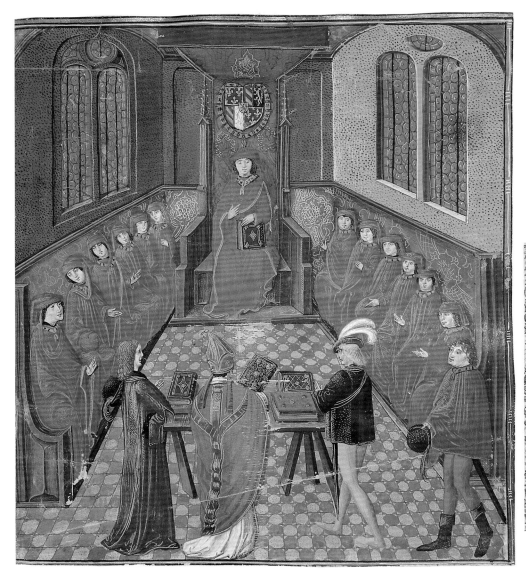

Cat. no. 47 fol. 129r fragment (left) and fol. 0v fragment (right),
reconstruction as parts of one page

177

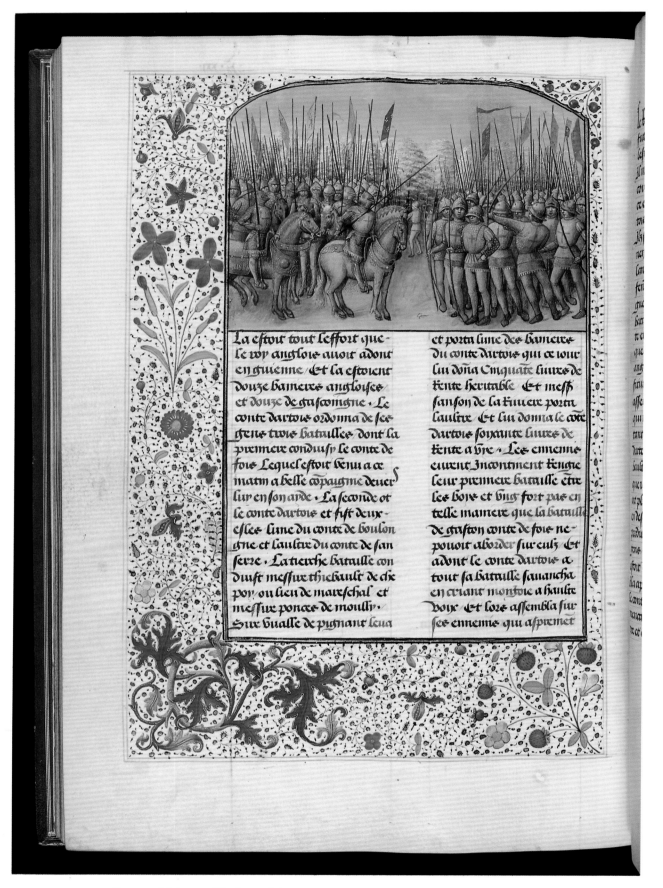

La estoit tout leffort que le roy angloise auoit adont en guienne Et la estoient douze banneres angloises et douze de gascomgne Le conte dartois ordonna de ses gens trois batailles dont la premere conduisy le conte de fois Lequel estoit venu a ce matin a belle compaigne deuer sur en son arde La seconde ot le conte dartois et fist deux esles lune du conte de boulongne et laustre du conte de san serre La tierche bataille conduist messire thiebault de chepoy ou lieu de mareschal et messire ponces de moulli Sur buaille de pignant leua

et porta lune des banneres du conte dartois qui ce iour lui dona Cinquante liures de rente heritable Et mess sanson de la riuiere porta laustre Et lui donna le cote dartois soixante liures de rente a vie Les ennemis eurent Incontinent rengie leur premere bataille entre les bois et bury fort pas en telle maniere que la bataille de graston conte de fois ne pouoit aborder sur eulz Et adont le conte dartois a tout sa bataille sauancha en criant monioie a haulte voix Et lors assembla sur ses ennemis qui asprement

Cat. no. 48 fol. 121v, *The Count of Artois conquers Bordeaux and Gascony for the King of France*

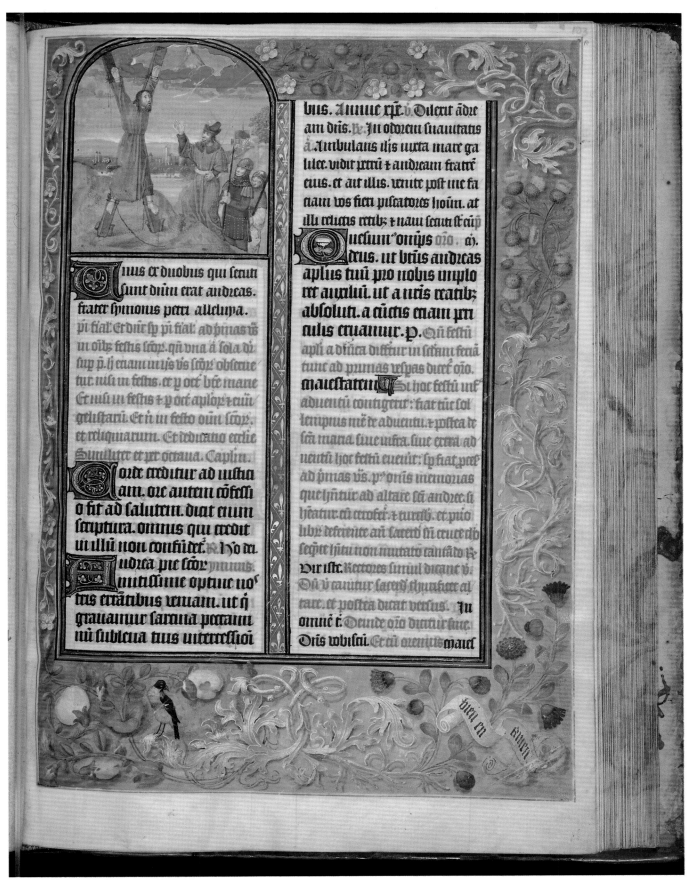

Cat. no. 49 fol. 103r, *St Andrew*

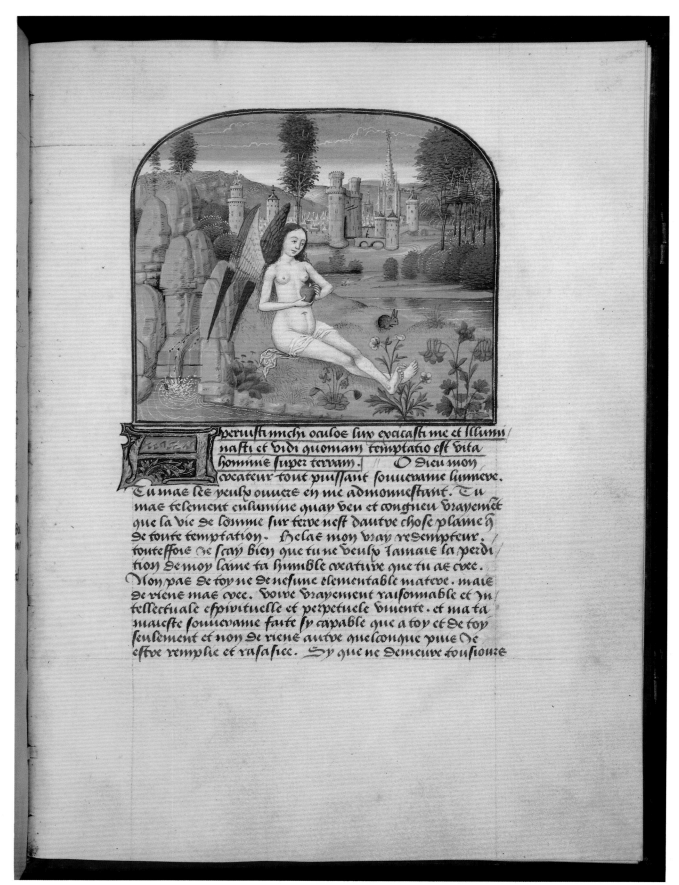

Cat. no. 50 fol. 31r, *The Soul personified as a Woman in Dialogue with her Heart*

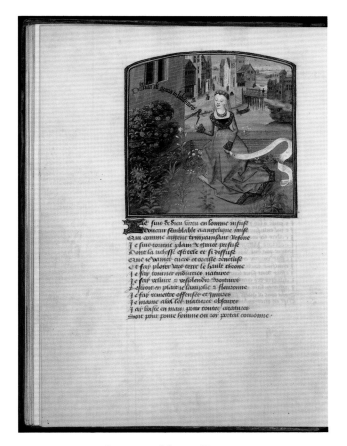

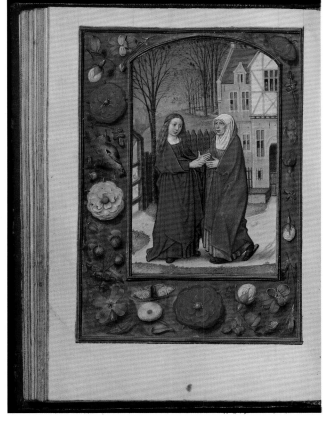

Cat. no. 51 fol. 27v, *Eloquence*

Cat. no. 52 fol. 60v, *The Visitation*

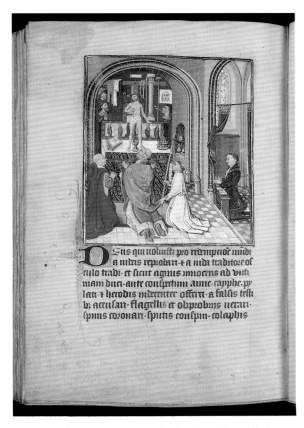

Cat. no. 46 fol. 253v, *Philip the Good and the Mass of St Gregory*

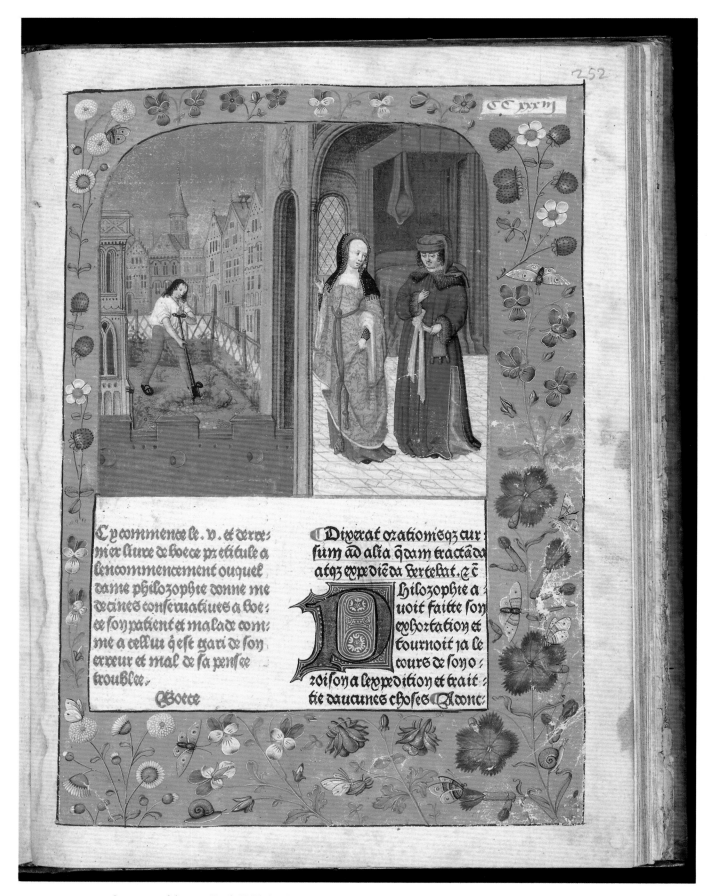

Cat. no. 55 fol. 252r, Book V, *Philosophy instructs Boethius on the good fortune of finding a treasure on one's land*

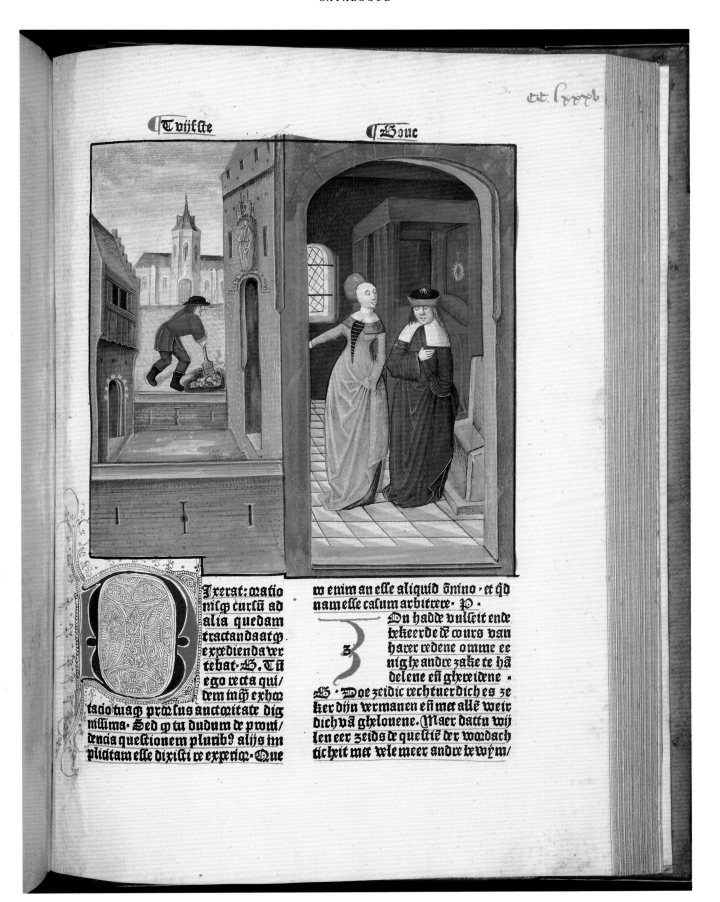

Cat. no. 57 fol. 285r, Book V, *Philosophy instructs Boethius on the good fortune of finding a treasure on one's land*

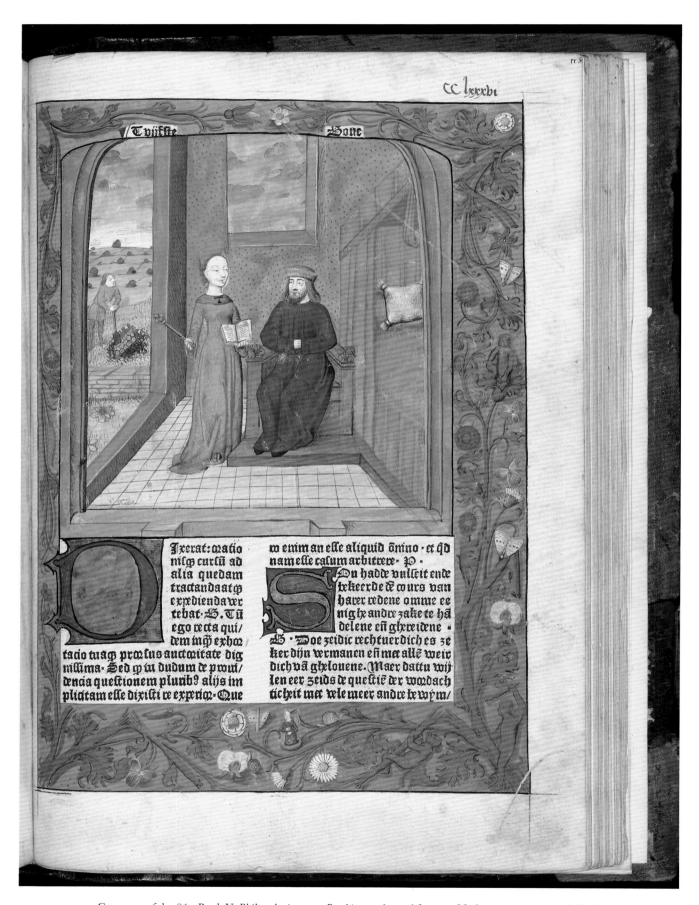

Cat. no. 59 fol. 286r, Book V, *Philosophy instructs Boethius on the good fortune of finding a treasure on one's land*

Cat. no. 53, *Ecce Homo*

Cat. no. 72 fol. 121r, border with the coat of arms of Jan Crabbe

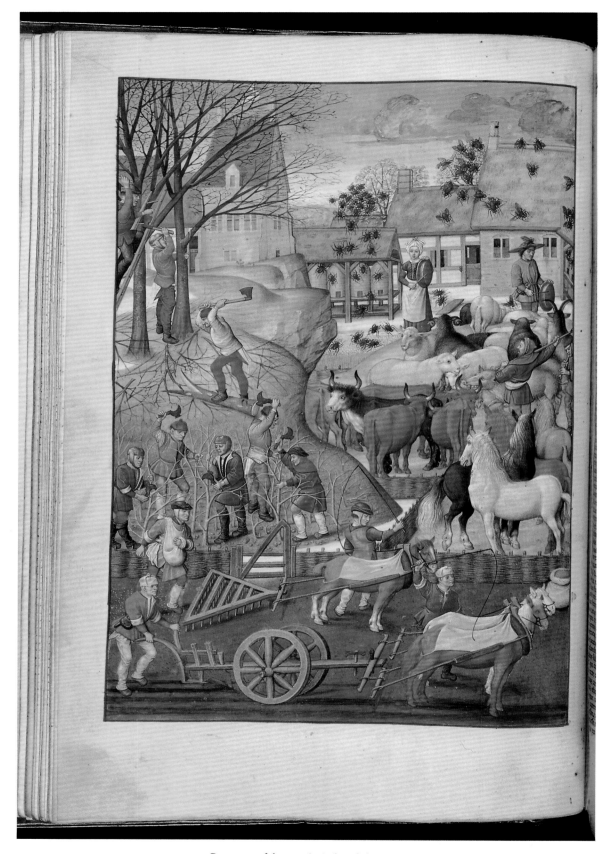

Cat. no. 71 fol. 41v, *Agricultural Activities*

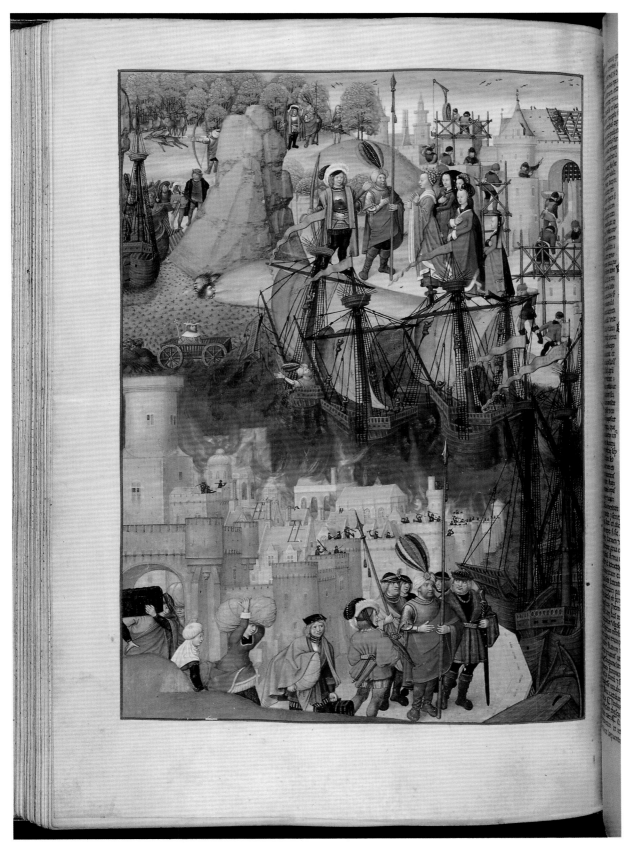

71 fol. 122v, *Dido and Aeneas*

Cat. no. 74 fol. 1r, border with the episcopal coat of arms of Raphael de Mercatellis

Cat. no. 75 fol. 145v, *In praise of Garlic*

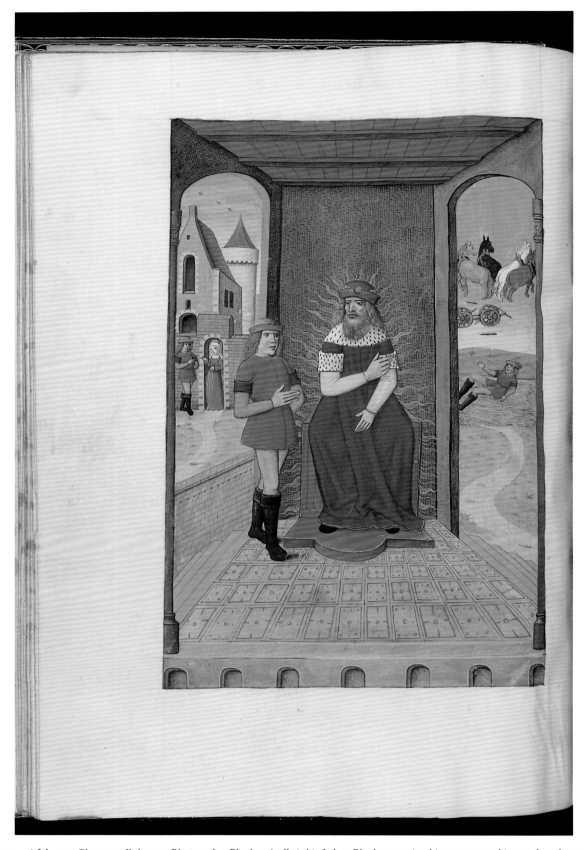

Cat. no. 76 fol. 25v, *Clymene tells her son Phaëton that Phoebus Apollo is his father; Phoebus promises his son to grant him any boon he may ask; Phaëton tumbles from the sun-chariot which he has borrowed*

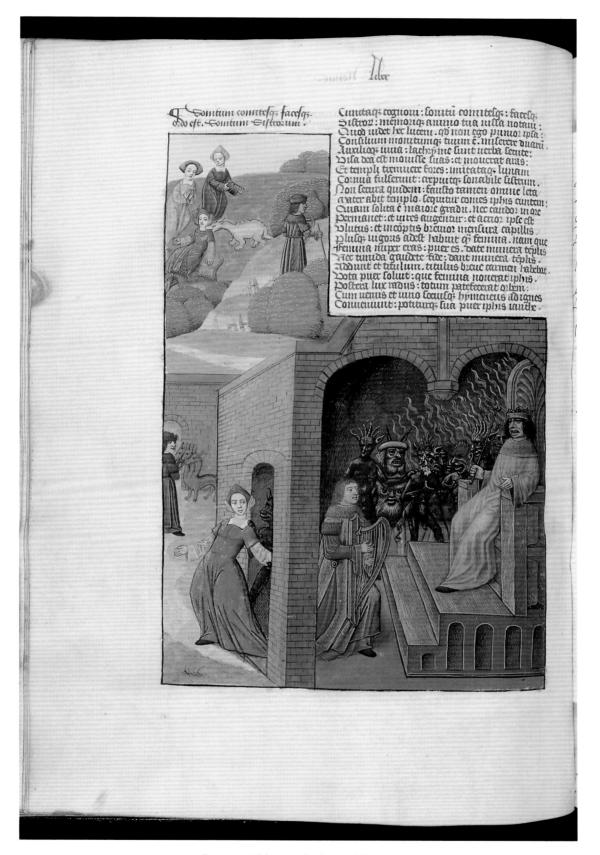

Cat. no. 76 fol. 101v, *Orpheus and Eurydice*

Cat. no. 62 fols. 1v–2r, *The Last Supper* and *Crucifixion*

62

Petrus de Rivo, *Opus responsivum ad epistolam apologeticam Pauli de Middelburgo de anno, die et feria dominicae passionis*

Leuven, Ludovicus Ravescot, *c.* 1488

Printed on paper with the 1:80G type

colour plate on facing page

Provenance: Monastery of Bethlehem, Leuven (Pertenet monasterio beatae Marie in Bethleem prope Lovanum); Van de Velde; Borluut de Noortdonck; Vergauwen collection; purchased by Cambridge University Library, 1884 *Accession no.* Inc. 3.F.2.9 (3294)
References: Conway 1884, pp. 134–8; Oates 1954, no. 3825; Hellinga 1966, 1, p. 63 and 2, pl. 219; BMC, 9, p. 168, Leuven 1975, pp. 261–2 and 553–4

Ravescot was master of many aspects of the Leuven book-trade. He started his career as miniaturist, then went on to printing, letter-cutting and book-binding.

During the 1480s one of the topics which fascinated the Leuven academics was the calculation of the date of Easter. Two protagonists played an important role in the discussion: Paulus de Middelburgo and Petrus de Rivo. Paulus was born in Middelburg and, having graduated in Leuven, went back to his home town to teach philosophy. In 1479 he was appointed professor of astrology at Padua. His calculations contributed to the change in the calendar which the Church implemented in 1582. Petrus de Rivo, a professor of philosophy at Leuven, strongly opposed Paulus' views and presented his arguments in this book. It is introduced by four fine woodcuts, which in this copy have been coloured. The woodcuts are by the so-called Second Leuven Cutter who probably borrowed compositions from paintings. The composition of the Last Supper may have been inspired by Dieric Bouts' altarpiece for the St Pieters church of Leuven, although the treatment of space is clearly not as successful. Around the table Christ and his twelve apostles are gathered. Judas is shown on the left, in sharp profile. The texts beneath the woodcuts clearly state Petrus de Rivo's position with regard to the date of the event depicted.

Lent by the Syndics of Cambridge University Library AA

63

Reynaert the Fox

Antwerp, Gerard Leeu, 1487–90

Printed on paper with the G. Leeu 4:100G type.
There are five fragments of various sizes, three of them with a woodcut.
The original size of the book must have been 205 × 125 mm

Provenance: removed *c.* 1850 from an 'old Dutch book' by Edwin Tross, Paris; identified and bought by F. Culemann, Hanover; purchased by Cambridge University Library, 1870 *Accession no.* Inc. 4.F.6.2 (3367)
References: Conway 1884, pp. 76 and 249; Prien 1882; Reissenberg 1886; Breul 1927; de Keyser 1939(1); de Keyser 1939(2); Oates 1954, no. 3903; Hellinga 1966, 2, pl. 142; Utrecht 1972, pp. 30–9 and 47–50; Brussels 1973, p. 290; Varty 1980; Witton 1980; Goossens 1983, pp. 9–10

The three woodcuts exhibited here are part of only seven known surviving fragments of the first edition in Flemish verses of the story of Reynaert the Fox. The popular story of the fox who ruled over the animal kingdom by virtue of his shrewdness first originated in Flanders at the end of the twelfth century. Master Nivardus of Ghent called his poem on the fox's adventures 'Isengrinus'. The story spread all over Europe, while other versions were also produced in the Low Countries. Around 1480 Hinrek van Alckmer published a commentary to a slightly adapted version of the poem 'Reinaert Historie'. It is this version which is contained in the Cambridge University Library fragments and through which Reynaert's fame would spread over the German-speaking world, culminating in Goethe's adapted version 'Reineke Fuchs'.

These fragments have been associated with the printer Gerard Leeu and the workshop he had established in Antwerp in 1487. Precise dating proves difficult as the fragments do not provide any explicit information and the watermark is not securely datable. The three surviving woodcuts are of great art historical importance as they were the source for the woodcuts in later Flemish, German and English editions. Three episodes from the Reynaert story are illustrated. The first one depicts Reynaert stealing a chicken from the priest of Blois. In the background Isengrin the wolf is trapped in the priest's barn because he has eaten too much to leave the barn through the window by which he entered. He is falsely accused of the theft of the chicken and beaten. Ultimately Reynaert has to drop his prey. The second woodcut shows Reynaert in the company of Grimbert the badger entering the poultry yard of a nunnery. The third can be reconstructed through a woodcut of the 1498 Lübeck edition of a Low German translation of the text, which used the Leeu woodcut as a source. It evokes the appearance of the contrite Reynaert at the court of King Nobel, the lion. Only the tail of the lion is still visible, just above the head of Bruin, the bear, who is involved in a conversation with Tibert, the cat. Conway (1884) and De Keyser (1939 (1)) ascribed the woodcuts to the 'Haarlem Cutter', named after this artist's woodcuts for the printer Jacob Bellaert in Haarlem. The 'Haarlem Cutter' seems to have moved to Antwerp together with Gerard Leeu in 1487, where he produced many woodcuts for him. He remained active there until the end of the century. His style is vivid and he excels in the characterisation of animals.

Lent by the Syndics of Cambridge University Library AA

Cat. no. 63, *Reynaert and the Priest of Blois*

64

Aesop, *Fables*

Antwerp, Gerard Leeu, 1486

Printed on paper with the G. Leeu 5:82G type

Provenance: Purchased by Cambridge University Library, 1873
Accession no. Inc. 3.F.6.2 (3351)
References: Conway 1884, pp. 93–5 and 259–64; GKW no. 349;
Oates 1954, no. 3887; Hellinga 1966, 2, pl. 150; BMC, 9, pp.
187–8

Gerard Leeu was one of the most productive printers in the late
fifteenth-century Netherlands. He started his career in Gouda,
where he printed the city's first books in 1477. In 1484 he moved
to Antwerp where he became a much appreciated contributor to
the town's intellectual life. In 1492, Leeu's career came to a
brutal end when he was fatally wounded in a quarrel with one of
his employees, the letter-cutter Henri van Symmen. Leeu pub-
lished a large number of illustrated editions in Gouda as well as
in Antwerp. Some of the woodcuts included in his editions were
designed by his own artists but this was not so in the case of the
Aesop. Leeu had woodcuts made based on those which had been
used for previous Aesop editions in Ulm, Augsburg and
Strasburg. It was possibly during a trip to Venice in 1483 that
Leeu met the Strasburg printer Heinrich Knoblochtzer and
negotiated the loan of the woodcuts which Knoblochtzer had
used in his 1481 Aesop edition. The extent of exchange between
various European printers and the popularity of these particular
woodcuts is further indicated by the fact that later Aesop edi-
tions, such as the 1484 by Caxton, also borrowed woodcuts from
the same series. Not only the woodcuts but also the font of this
book are a reminder of Leeu's trip to Venice. In Venice Leeu
had contacts with a fellow printer, Reynaldus de Novimagio,
who sold him a font which would become Leeu's third type.
Leeu's fifth type which is used here is a derivative of type 3.

The fables of the sixth-century BC Greek author Aesop were
very popular during this period, and in the West they circulated
mainly in the Latin translation of Avianus. The four fables which
are illustrated here are: 'Of the vulture and the other birds', 'Of
the lion and the fox', 'Of the sick ass and the wolf' and 'Of the
buck and the three lambs'.

Lent by the Syndics of Cambridge University Library AA

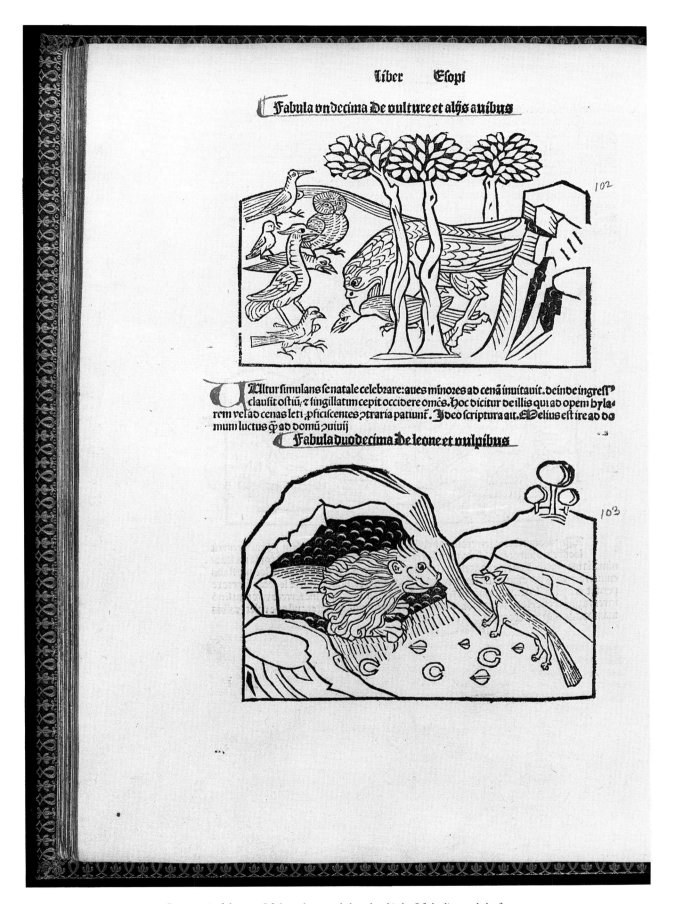

Liber Esopi

Fabula vndecima De vulture et aliis auibus

Ultur simulans se natale celebzare: aues minozes ad cenã inuitauit. deinde ingress⁹ clausit ostiũ, z singillatim cepit occidere omẽs. Hoc dicitur de illis qui ad opem bylarem vel ad cenas leti pficiscentes ptraria patiunt. Jdeo scriptura ait. Melius est ire ad domũ luctus qp ad domũ puiuij

Fabula duodecima De leone et vulpibus

Cat. no. 64 fol. 57v, *Of the vulture and the other birds, Of the lion and the fox*

65

Ludolphus de Saxonia, *Leven ons Heeren Ihesu Christi*

Antwerp, Gerard Leeu, 1487

Printed on paper with the G. Leeu 4:100G type

Provenance: Charles Lilburn; Frank McClean; his bequest to the Fitzwilliam Museum, 1904 *Accession no.* Sayle 178
References: Conway 1884, pp. 56–7, 77; Sayle 1916, no. 187; Schretlen 1925, pp. 33–7; Hellinga 1966, 2, pl. 142; BMC, 9, pp. 189–90; Indestege 1952; Lane 1982

Ludolphus de Saxonia (*c.* 1295–1377) was a monk of the Charterhouse of Strasburg. His main work is the *Vita Domini nostri Iesu Christi ex quatuor Evangeliis*, a vivid and accessible dialogue between Scripture and man. This text brings together the four Gospels and many other things of value to the Christian believer. It was especially popular among the laity. The Dutch text is an adapted and abbreviated version of Ludolphus' original text. Leeu was the first to publish the Dutch translation which underwent various reprints. This edition contains 146 woodcuts, cut by three different artists. The woodcuts attributed to the Second Gouda Cutter had already been used in a 1482

edition of the Passion of Christ. They are in a coarse style with heavy lines. The second woodcutter, the so-called Antwerp Cutter, provided the majority of the woodcuts. He has a rather clumsy style and lacks a sense of perspective, but embodies the late fifteenth-century evolution towards narrative presentation. Rather than focussing on a single episode, images often include various episodes of the same story. Here, three episodes of the betrayal by Judas are represented. In the main scene Jesus appears before Pilate, while in two subsidiary scenes Judas returns the coins which he was paid for the betrayal of Christ and hangs himself. The third artist was originally active in Haarlem and had come to Antwerp in 1486, probably in the employ of Gerard Leeu. He cut the most elegant woodcuts in the book. He had a monumental style, attached great importance to space and individualised his protagonists.

Fitzwilliam Museum, Cambridge

AA

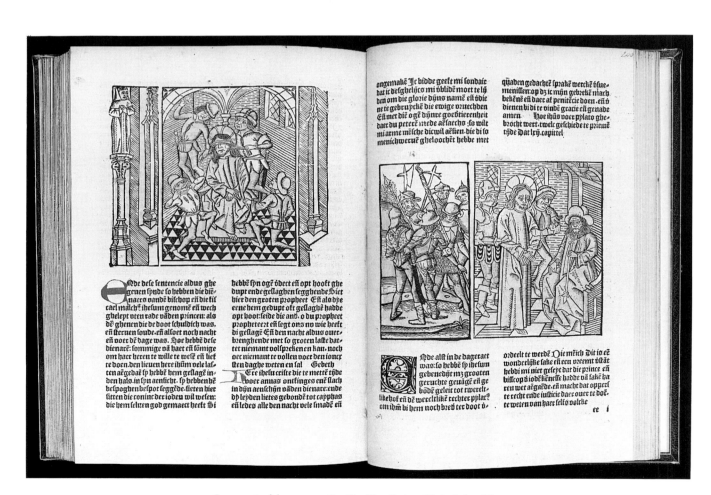

Cat. no. 65 fols. 147v–148r, *The Flagellation, Christ before Pilate*

66

Admission to the Confraternity of St James the Great in Compostela

Antwerp, Dirk Martens, 1497

Printed on paper with the D. Martens 2:72G type. 362 × 288 mm

Provenance: Sir Stephen Gaselee; his gift to Cambridge University Library, 1934 *Accession no.* Broadsides 0 (4096–4097) *References*: Oates 1954, no. 3998; Hellinga 1966, 2, pl. 196; BMC, 9, pp. 204–5

These are two slightly different versions of the document admitting people to the Confraternity of St James of Compostela and requesting the faithful to contribute to the building of a new hostel for pilgrims in Santiago de Compostela. At their arrival in Compostela pilgrims were traditionally offered hospitality. By the end of the fifteenth century the accommodation had become inadequate and the king and queen of Spain, Ferdinand and Isabella, took the initiative for a splendid new building. In order to raise money for the project, Alphonsus de Losa, the deputy apostolic notary at Compostela, asked the faithful to contribute to the building costs in exchange for some indulgences.

Dirk Martens (1446–1534) was the first to introduce print-ing in the Southern Netherlands. After training in Venice he established the first printing workshop of the Southern Netherlands at Aalst in 1473. After nine years in Spain where he was active as book importer, Martens returned to his native town and set up a second workshop. Apart from a four-year move to Leuven (1497–1501), Martens pursued his career in Antwerp. In this harbour town, Martens became a focus for humanist authors and published the works of Erasmus.

In a corner is a small circular representation of St James with his traditional iconography: the wide hat with a cockle shell and the staff with the bag and a book, an allusion to the Epistle of St James. The text around this figure 'Virga et baculus tuus ipsa me consolata sunt' ('Thy rod and staff, they comfort me', Psalms 23.4) is a clear invitation to the faithful to take up their staffs for the good cause. Traces of a seal are visible at the bottom of both documents.

Lent by the Syndics of Cambridge University Library AA

Cat. no. 66, admission document to the Confraternity of St James the Great in Compostela

67

Cronyke van Brabant

Antwerp, Roland Van den Dorpe, 1498

Printed on paper with the R. Van den Dorpe 1:98G type

Provenance: The Hague, Koninklijke Bibliotheek; acquired by Cambridge University Library in the 19th century *Accession no.* Inc. 3.F.6.9 (3461)
References: Conway 1884, pp. 185–8 and 314–7; Oates 1954, no. 4001; Brussels 1973, pp. 507–9; Hellinga 1966, 2, pl. 260

We know very little about Roland Van den Dorpe. Only ten editions are known to have come from his presses between 1496 and 1501, when his widow starts signing the editions. The Brabant Chronicle is the most important work published by him. It consists of two parts. The first one presents the qualities of the cities and peoples of the duchy. In the second part, the major historic events of the duchy are described. Van den Dorpe has taken care

to insert numerous woodcuts in his work. As is often the case with the illustrated editions of the period, some woodcuts are repeated within the same book and re-used for other editions by the same or other printers.

Two or three artists seem to have been involved in this project. Battle scenes are favourite subjects. The armies clash with each other as two anonymous masses. No soldier is personalised, but dramatic details such as rolling heads and soldiers trampled by horses are prominent. The woodcut shown here portrays the 1338 battle which Edward III fought against the king of France, Philippe V. Edward's soldiers, backed by the army of John, Duke of Brabant, clash with the French cavalry.

Lent by the Syndics of Cambridge University Library AA

Cat. no. 67, *Battle of the Army of Edward III against the French*

68

Flemish binding on Boethius, *De consolatione philosophie*

Cologne, J. Koelhoff, 1481

297 × 215 mm

Provenance: 'Exlibris Petri Roreli Anno 1650'; King's College
Accession no. XV.2.4
References: Chawner 1908, no. 19; Hobson 1929, pp. 34–6

The remarkable aspect of this book is its binding. It is a Flemish blind-stamped binding with four stamp-motifs: a wyvern, a portrait head, a rebus and a star, used at the intersections of the triple lines which divide the cover up in lozenges. These stamps were used by a workshop in Leuven, active between the 1470s and 1500. Among the twenty-two bindings which have been attributed to this workshop, only three use the stamp of the portrait head. This incunable also had two clasps, remains of which are still visible. At the top of the front cover the title of the book has been written on the leather in ink in a cursive script.

The fact that a Flemish binding is found on a Cologne incunable is hardly surprising. It was customary for books to be exported unbound. The binding would be added when the book had reached its final destination. By circulating unbound, books were less heavy and less bulky and this helped to reduce transport costs. Moreover, there were numerous commercial and intellectual contacts between Cologne and Leuven. Cologne which was an important centre for the printing industry exported many of its books to the Flemish and Brabant towns.

Lent by the Provost and Fellows of King's College, Cambridge

AA

Cat. no. 68, Flemish blind-tooled binding

69

Binding by Jan Guillebert on Josephus,

Antiquitates Judeorum and *De bello judaico*

c. 1473. Place of printing unknown

410 × 295 mm

Provenance: Hugh Damlett; his bequest to Queens' College, 20 April 1476 *Accession no.* Inc. C.11-20
References: Searle 1867; Plaistowe 1910, p. 7; Hobson 1929, pp. 28–31

As an ink inscription on the cover reveals, this volume contains the work of the antique author Josephus Flavius (AD 37–95). The place of printing is not known, but the date of the bequest of the book indicates that the date of printing must be before 1476. The binding clearly shows that the book passed through Bruges. The blind tools used on this binding, the rayed rosette, the small and large triangular dragon, the small and large fleur-de-lis, are typical stamps used by the binder Jan Guillebert, nicknamed the Meese or 'titmouse'. He learned his skills from Jan de Klerc who registered him as apprentice at the guild of St John the Evangelist in Bruges in 1467. He remained active in this town until his death in 1489.

A small hole at the top of the back cover shows that the book, which was bequeathed to Queens' College by Hugh Damlett in 1476, was originally part of a chained library. This is one of the very few books from Queens' fifteenth-century library which has survived. The library of Queens' College is known to have been a chained one. To protect the books from being stolen they were fastened with iron chains to library shelves or lecterns. The result was that the reader had to consult the book in the library. *Libri catenati* have only rarely survived intact and *in situ*. A famous exception is the medieval library of Zutphen, in Holland. The other marks on the cover are remains of clasps which pressed the book together, thus preventing the paper from curling, and bosses which served to protect the leather when the book was lying flat on the lectern.

Lent by the President and Fellows of Queens' College, Cambridge AA

Cat. no. 69, Binding by Jan Guillebert

Monastic libraries and the introduction of humanism in Flanders

Alain Arnould

Towards the middle of the fifteenth century, Italian humanist texts started to arrive in Flanders. The import of humanistic ideas, which centred on a renewed interest in classical authors, was channelled through the numerous commercial contacts which already existed between Flemish towns and northern Italy. At first Bruges played a crucial role in this movement because of its prominent group of Italian merchants, but later Leuven and Antwerp developed as the main intellectual centres of the Low Countries. The new ideas of humanism were warmly welcomed by various parts of Flemish society. University circles included prominent intellectuals such as Antoine Haneron, the tutor of the young Charles the Bold, or Johannes de Veris, teacher and tutor at Oudenburg and Leuven and later employed at the court of Charles the Bold. On the other hand there were the monastic circles whose enthusiasm for the humanistic ideas is shown in this exhibition through manuscripts of two monastic bibliophiles: Jan Crabbe and Raphael de Mercatellis.

We know very little about the youth of Jan Crabbe. He made a spectacular entry onto the politico-religious scene when in 1457/9 he was appointed abbot of the prestigious and immensely wealthy Cistercian monastery of Ter Duinen in Bruges. As abbot of this monastery he collected a substantial library, twenty-three volumes of which survive in libraries all over the world. The texts included in his library ranged from traditional medieval to humanist authors. Crabbe's humanistic inclinations also express themselves in the visual appearance of his manuscripts, which imitate Italian humanistic examples. Jan Crabbe's artistic interests were not confined to manuscripts. He is known to have commissioned paintings from Hugo Van der Goes and Hans Memling for his monastery. Crabbe was not only an active bibliophile, he also had the welfare of his monastery at heart. His death in 1488 signalled the end of a successful chapter in the history of the Ter Duinen monastery.

Raphael de Mercatellis played an even more prominent role in introducing humanism to the Low Countries. He was more directly in contact with Italy on account of his family ties. Raphael de Mercatellis was one of the numerous illegitimate children of Philip the Good, born in Bruges around 1437. His mother married an Italian merchant who had established himself in Bruges and who passed his name on to Raphael. After attending university in Paris, Mercatellis was appointed abbot of the small monastery of St Pieters in Oudenburg in 1463. During

his term as abbot there, he still spent a large part of his time in Bruges and collected manuscripts, an interest well in line with the Burgundian court tradition. Eight manuscripts which he collected during his term at Oudenburg are known to have survived, one of which is present in this exhibition. They are characterised by strong influences from Italian humanistic manuscripts. In 1478 Mercatellis was appointed abbot of the much more famous St Bavo monastery in Ghent. In his capacity as abbot of this monastery he was able to develop his bibliophile passion to its fullest extent and he assembled the first humanist library in the Low Countries. In total, his library contained nearly one hundred volumes. The wide variety of subjects included in the library range from travel literature to astrology, history, classical authors and philosophy. They testify to the intellectual commitment of Mercatellis and to his interest in humanist authors and ideas. Although many texts which Mercatellis had copied were available in printed editions, he preferred the more imposing and traditional format of manuscripts.

As well as being a book lover, Mercatellis was heavily involved in Burgundian politics. On various occasions he served the duke on diplomatic missions abroad. He also belonged to the select number of courtiers who in 1482 had to approve the wedding plans of Margaret of Austria with Charles, dauphin of France (Paris, Bibliothèque Nationale, MS. fr. 15597). When Mercatellis died in 1508 the Burgundian court lost its last important bibliophile and the St Bavo monastery an extravagant and prodigal abbot. Among the sixty manuscripts from his library which survive today in various libraries in Europe and the United States, four have been reunited for this exhibition – the first time since the library was dispersed in the sixteenth century. Three of them come from the library at Holkham Hall which, with a total of fifteen Mercatellis manuscripts collected by Thomas Coke, owns the largest number of Mercatellis manuscripts outside Belgium.

When comparing the achievements of the monastic collectors Jan Crabbe and Raphael de Mercatellis, it is clear that Mercatellis was more consistent in acquiring humanistic texts and that he collected manuscripts on a much larger scale than Jan Crabbe. Although Raphael de Mercatellis' library is not free from medieval influences, his collection is more in tune with future intellectual developments than Jan Crabbe's. The latter's manuscripts included a large number of authors who would have had their place in a traditional medieval library. In Mercatellis'

case, manuscripts of Italian humanistic authors and translators form a large proportion of the texts. This may be due to the fact that Mercatellis' book collecting continued until twenty years after Crabbe's death. Indeed, during the period when both were active book collectors, that is in the 1470s and 1480s, Crabbe's and Mercatellis' manuscripts display some similarity in their appearance. Both patrons opted for manuscripts copied in a *fere humanistica* script, preferring a single textblock to a two-column layout, and often restricting illumination to acanthus borders. In the late 1480s Mercatellis gradually abandoned his preference for a humanistic appearance in his manuscripts. His manuscripts

have vast dimensions, are written in a heavy gothic script; the layout consists of the traditional two columns and extensive cycles of illustrations are not uncommon.

In this exhibition a selection of manuscripts from the libraries of Flanders' two most prominent monastic humanists and bibliophiles is for the first time brought together in one room.

References: On J. Crabbe, see N. Huyghebaert, 'Abbaye des Dunes, à Koksijde et à Bruges', *Monasticon Belge*, 3ii, pp. 403–5; Bruges 1981 (by N. Geirnaert), pp. 176ff.; on Raphael de Mercatellis, see Derolez 1979; Arnould 1991, esp. pp. 8–29, with further bibliographies.

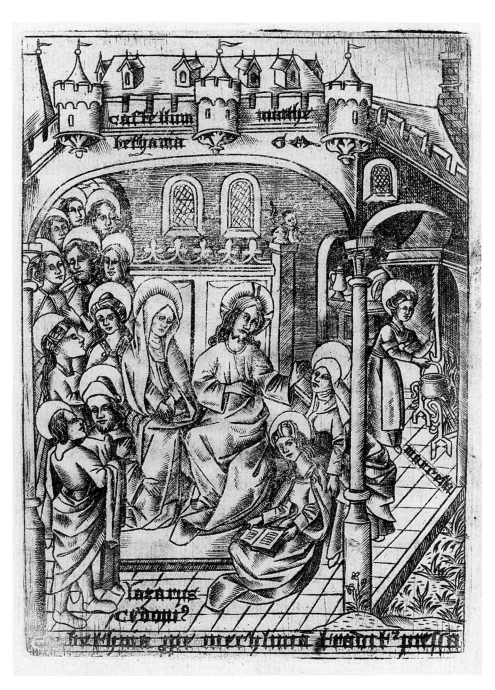

Cat. no. 70 fol. 15, *Christ's Visit to Bethany*

70

Psalter and prayerbook of Luciëndal

c. 1485, Sint Truiden

Illuminated manuscript on paper, 190 × 135 mm, ii + 235 + ii folios

Provenance: St Truiden, Luciëndal, a member of the Van Heestert family; Sister Anna Puettaerst; William Crashawe; T[homas] C[omes] S[outhampton]; Henry Wriothesley, earl of Southampton; his gift to St John's College, 1635 *Accession no.* Hs. G.6
References: Bradshaw 1889, pp. 247–53; James 1913, pp. 207–9; Ampe 1962; Hollstein, 13, p. 92; Mauquoy-Hendrickx 1974

This manuscript shows the contrast in content and general appearance between traditional monastic manuscript production in Flanders at the end of the Middle Ages and the progressive bibliophily of a few distinguished intellectual collectors.

The St John's College manuscript consists mainly of a psalter, but at the beginning and end other prayers have been included. In the middle of the list of Psalms for the various nocturnal prayers is an obituary from the monastery to which the manuscript belonged. Besides some saints, anniversaries of the nuns and their relatives, benefactors and chaplains have been entered. Among the benefactors are the names of famous contemporaries such as Louis de Bourbon, Prince-Bishop of Liège (29 August, d. 1482), Elizabeth of Bavaria (20 October) or Jan Laet Van Borgloon (15 October), a famous physician and astrologer. At least three nuns used the manuscript, two of whom added names to the calendar. The first owner was Sister Van Heestert, given that she uses the first person to enter her parents, brothers, sisters, aunts and uncles ('Janes Van Heestert mijn brueder' (27 January)), she was probably responsible for the copying of the manuscript. After completion of the manuscript she continued to add names of many of her relatives to the calendar. On 23 April Lysbeth Van Heestert is described as 'onse werde mater' and 'ons lieve moye', our worthy mother and beloved aunt. Since Lysbeth Van Heestert is known to have been prioress of the Augustinian house of Luciëndal in St Truiden around 1479, the provenance of the manuscript is obvious. The owner of the book must have been a niece of Lysbeth Van Heestert who was a nun at the priory of Luciëndal. The Van Heestert family was well represented in the monastery since, besides her prioress and herself, Lysbeth's sister Geertruy was also a member of the community. During the early years of the sixteenth century Sister Anna Puettaerst owned the book. Later another nun added further names to the calendar.

The priory of Luciëndal was founded by 1421 and it adhered to the Order of the Regular Canonesses of St Augustine. The Augustinian provenance of this manuscript is confirmed by the presence of prayers to St Augustine (fols. 187–91). Only eight surviving manuscripts are known to have been owned by the Luciëndal priory. In some of these eight codices, colophons suggest that they were made at the priory itself. A Sister Woutryt signed a manuscript in 1463 (Brussels, Koninklijke Bibliotheek, MS. II 2454). Another manuscript from Luciëndal, Ghent, Universiteitsbibliotheek, MS. 895, raises conservation problems due to the iron content of the ink which bites into the paper, as does the St John's manuscript.

The decoration of the St John's College manuscript is remarkable in two respects. A large red and blue initial with purple, red, blue and gold penwork introduces the Psalms. It was probably drawn by a nun, who was a member of the community. The second remarkable feature of the decoration of this manuscript is an engraving which was inserted between fols. 14 and 16. It represents Christ's visit to Bethany. Mary sits at Christ's feet reading, while Martha encourages her sister to get up and help her in the kitchen. In the background, a servant is busy preparing a meal. The engraving contains various inscriptions. Some of them refer to the episode: 'Castellum Bethania', 'Marthe', 'Marcella' and 'Lazarus Cedonius'. The image is based on a chapter of the *Legenda Aurea*, the popular collection of the lives of the saints by the Dominican Jacobus de Voragine, which recalls Christ's visit to the house of Mary and Martha. In the *Legenda Aurea* Cedonius is the name of the blind man whom Christ healed (John, 9) and Marcella is Martha's servant. Lazarus, Cedonius, Mary Magdalene and Martha are said to have gone together to Marseilles after Pentecost. At the bottom of the print, another text refers to the artist who made the engraving: 'Ex bethnia prope Machlinam traditur pressa'. On the wall of the house at Bethany the artist has even indicated his initials 'GM'.

We may infer that the engraving was produced by an artist called the GM Monogrammist who was working at the Augustinian convent of Bethany near Mechelen. The print served as an exemplar for a slightly different dotted print of the same subject (Hollstein, 13, p. 92). The œuvre of GM is confined to engravings. Besides the one shown here, his monogram can be found on an engraving with the Vision of St Gregory and in another inserted in a printed Book of Hours now in Lambeth Palace, London. This engraving represents St Catherine of Vadstena, and in it GM mentions that he is working from Dendermonde. The subject points to a connection with the Bridgittines of that town. GM's engravings seem to have been popular especially among the Bridgittines. One can conclude that GM was a wandering artist, concentrating his activities in convents around Mechelen. His real identity remains to be discovered.

The binding is another indication of the provenance of Luciëndal. Back and front board are covered with three floral and six figurative stamps (lion, dragon, monkey, pelican, rose and lamb). The same stamps can be found on other books from the Luciëndal priory.

Lent by the Master and Fellows of St John's College, Cambridge

AA

71

Virgil, *Collected Works* with the *Commentaries* by Servius and Donatus

1473, Bruges

Illuminated manuscript on vellum, 350 × 245 mm, i + 256 folios

colour plates, pp. 186–7

Provenance: Jan Crabbe; De Baenst; Thomas William Coke, Holkham Hall 1818 *Accession no.* MS. 311
References: London 1953–4, p. 163, no. 610; Hassall 1970, pp. 32–3 and pls. 158–60; Bruges 1981, pp. 188-192; Kren 1983, pp. 56–7; Courcelle 1984; Dogaer 1987, pp. 113, 131 and 159–60; Kren and Rathofer 1988, p. 239; Cambridge 1992 (by N. Geirnaert); Kren 1992, p. 192, note 17

This splendid manuscript was made for Jan Crabbe, abbot of the Ter Duinen monastery. His monogram was painted in one of the borders and, originally, his coat of arms would also have featured in one initial. However, the manuscript came into the hands of a member of the De Baenst family in Bruges, possibly during the fifteenth century, who painted his coat of arms on fol. 9v over that of Jan Crabbe. The manuscript contains all the works of Virgil with the commentaries of the late antique authors, Servius and Donatus, plus an appendix by Mapheus Vegius.

The manuscript consists of two parts; only volume I is exhibited. A date at the end of the first volume mentions that the manuscript was finished on the feast day of St Thomas Aquinas (7 March), 1473. The companion volume has a slightly later date, 24 March 1473, the vigil of the feast of the Annunciation. This feast was the beginning of the calendar year in Italy but not in Flanders, where the new year normally started at the Annunciation (27 March) or Easter. This has led Geirnaert (in Bruges 1981) to suggest that these two volumes were written by Italian scribes active in Bruges. The script used in this codex, as in other Crabbe manuscripts, is the *fere humanistica*. By the use of Roman capitals and round letters it approximates to the humanistic script common in Italy, but some features of the gothic script remain. It is therefore still possible that the scribe was Flemish and that he was working under Italian influence, possibly in a workshop run by an Italian scribe.

Of all the illustrated Virgils produced in northern Europe, this copy contains the most exquisite illustrations. Its three miniatures introduce the three major works of Virgil. At the beginning of the *Eclogues* or *Bucolics* (fol. 9v), a miniature with a pastoral scene features two shepherds, Tityrus and Meliboeus, in conversation. The *Georgics* opens with a splendid scene which surveys all the major agricultural activities (fol. 41v): bee-keeping, sheep, pig, cow and horse farming, harrowing, sowing and ploughing the land, and pruning trees. To accompany Virgil's best-known work, the *Aeneid*, a third miniature (fol. 122v) stages the story of the hero of the work, Aeneas. When the Trojans were defeated, Aeneas and his father Anchises had to leave the burning town and embark for an unknown destination. During their wandering, Aeolus, the keeper of winds, was told to destroy the Trojan fleet. Neptune interfered and calmed the waters of the Mediterranean. Aeneas ended up on the northern coast of Africa where, during a hunting party, he heard of Dido, the queen of Carthage. In the last scene, Dido leaves her city, which is in full expansion, to meet Aeneas with whom she falls in love.

The attributions of these three miniatures have raised contradictory suggestions. The miniatures were first attributed to the Master of the Prayerbooks of *c.* 1500. Pächt (London 1953–4) preferred an attribution to the Master of Margaret of York. Geirnaert (Bruges 1981) rejected both attributions and, noting the stylistic difference between the *Bucolics* miniature and the others, claimed to see the work of the Master of the Dresden Prayerbook in the *Bucolics* miniature. Kren (1983) argued for an attribution of the *Georgics* and *Aeneid* miniatures to the Master of the Prayerbooks of *c.* 1500. Brinkmann (Kren 1992) argued that the artist of Fitzwilliam 268 (Cat. no. 21) also painted the *Bucolics* miniature.

It is indeed probable that different hands worked on the illustrations. This is corroborated by codicological evidence. The *Bucolics* miniature is painted in the middle of the text in a totally regular quire, the *Georgics* and *Aeneid* miniatures are painted on separate leaves which have been inserted into the volume. The attribution of the latter to the Master of the Prayerbooks of *c.* 1500 is convincing, especially when compared with the Nassau *Roman de la rose* (London, British Library, Harley MS. 4425). The delicate rendering of textiles, the landscapes with their very high horizons, the static attitude of the figures, the somewhat affected nod of the heads and the bright palette are characteristics common to both volumes. A link between Fitzwilliam Museum MS. 268 (cat. no. 21) and the *Bucolics* miniature is perhaps a little more difficult to establish. In the Fitzwilliam Museum Book of Hours, the figures are less dumpy and the trees less finely detailed.

The manuscript is still in its original binding. It consists of wooden boards covered by leather which is decorated with blind-tooled motifs (fleur-de-lis, little dragons and rosettes). This is very similar to the bindings of other Crabbe manuscripts and is probably from the workshop of Antoon Van Gavere, the Bruges bookbinder.

Lent by Viscount Coke and the Trustees of the Holkham Estate

AA

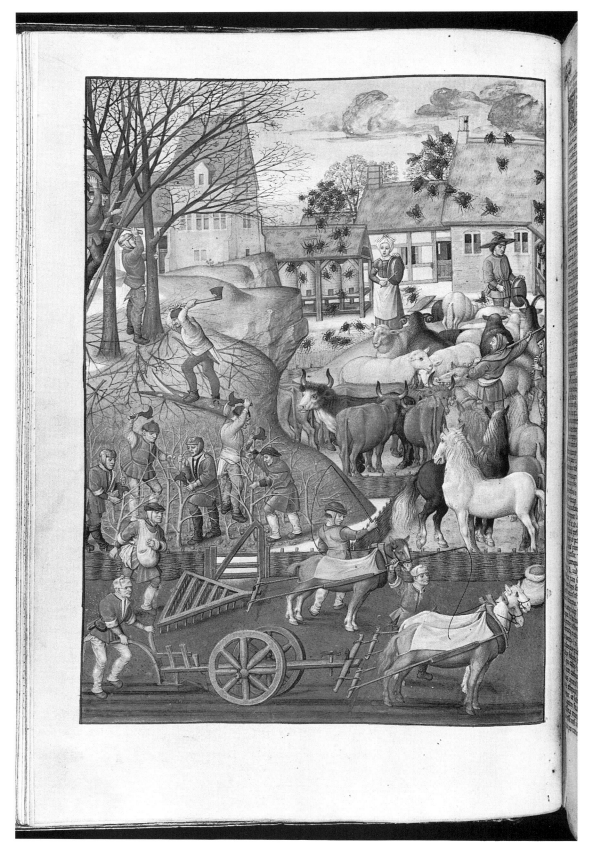

Cat. no. 71 fol. 41v, *Agricultural Activities*

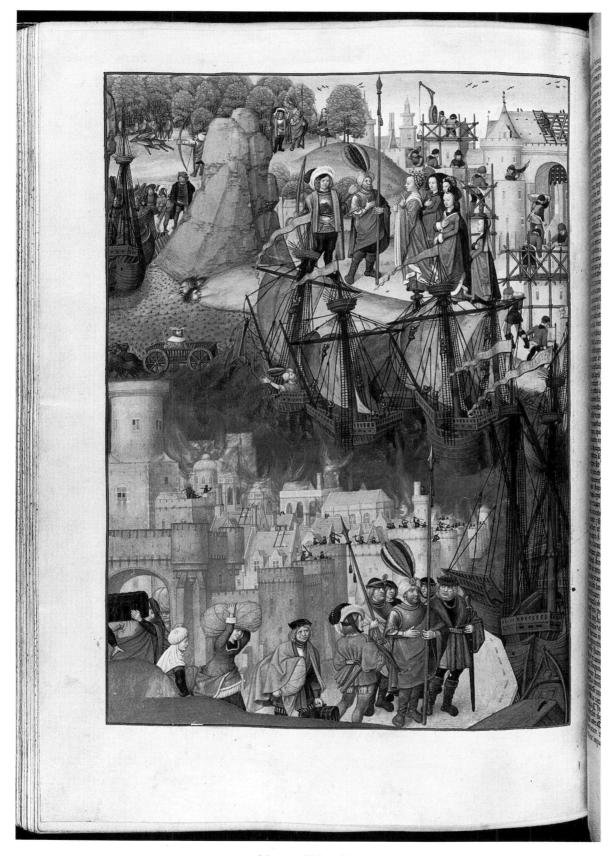

71 fol. 122v, *Dido and Aeneas*

72

Works of Julius Caesar

1474, Bruges

Illuminated manuscript on parchment, 257 × 180 mm, 244 folios

colour plate, p. 185

Provenance: Jan Crabbe; John Moore (?), bishop of Ely; Royal Library; given to Cambridge University Library 1715 *Accession no.* MS. Nn.3.5

References: Cambridge 1856, 4, p. 477; Cambridge 1992 (by N. Geirnaert)

This manuscript contains the commentaries of Johannes Andreas de Bossis on the works attributed to Julius Caesar. The manuscript demonstrates very well the influence of Italian culture on late fifteenth-century Flemish book production. Geirnaert (in Cambridge 1992) has suggested that this manuscript, together with a few other manuscripts produced for Jan Crabbe, was written by Italian scribes active in Bruges. Three scribes writing in a *fere humanistica* copied the Cambridge Crabbe codex. The same script can be found in other Crabbe manuscripts, which were commissioned around 1473, and which Geirnaert has attributed to a workshop where Italian scribes worked and in which the Greek scribe Georgius Hermonymus was involved. In my opinion we cannot exclude the possibility that Flemish scribes copied the Italian humanist script from Italian humanist manuscripts which were circulating among the Italian community in Bruges. Georgius Hermonymus may well have played an essential role in encouraging Flemish scribes to copy Italian manuscripts. It is, of course, also possible that Flemish and Italian scribes collaborated. A manuscript in Rimini, Bibliotheca Gambalunghiana, Sc-MS. 92, containing Petrarch's *Trionfi* in Italian, is relevant in this discussion (Canova, Meldini and Nicolini 1987, pp. 143–6). There is evidence to suggest that this codex is a Flemish product. First, the border illumination is without doubt related to the acanthus borders painted in Bruges during the 1470s. Secondly, the script is reminiscent of the Flemish *gothica rotunda*. The 'est' abbreviation and the decorative seriph under some letters point to a northern script rather than to a genuine Italian humanistic one. The Rimini codex, like the Crabbe manuscripts, was produced in Bruges by Flemish scribes who imitated Italian humanist manuscripts.

The second Italian influence in the manuscript may well reside in the source of the text. The complete works of Julius Caesar were not a very common work at the time and it is very possible that a printed source may have served as exemplar. Two editions of the complete works of Julius Caesar had already appeared in Venice and Rome (GKW, nos. 5863 and 5864), and a scribe like Georgius Hermonymus could well have brought such an edition with him when staying in Bruges, probably in 1473.

The decoration of the manuscript remains, however, thoroughly Flemish. The coat of arms of the abbot of the Ter Duinen monastery has been included in two places in the manuscript. At the beginning of each of the principal texts marginal decoration has been painted. Geirnaert has suggested that the borders are of the same style as those painted in an Ovid printed in Venice (see Sotheby's, London, 16–17.11.1989: the Abram collection, lot 91). There are, however, important differences between the two border styles. None of the borders of the Abram Ovid has been framed in a red and blue line as is the case in the Crabbe Caesar. The palette of the Crabbe Caesar is much lighter than in the Abram Ovid and the motifs are also different in both volumes. The stylistic difference can be checked by comparing the Crabbe Caesar with the Mercatellis Horace (cat. no. 75) or the Valla incunable (cat. no. 61), both volumes with borders similar to the Abram Ovid. A stylistically much closer comparison for the borders in the Crabbe Caesar is a manuscript with a French translation of Boethius (König 1991, pp. 182–3). Palette, choice of motif and design indicate a similar origin.

The binding with its brass clasps and corner pieces is similar to that of other Crabbe manuscripts. Within a frame of triangular dragon stamps, lozenges with rose and fleur-de-lis motifs fill the board. Bindings with such characteristics are associated with the Bruges binder Antoon Van Gavere (1459–1505 or 1516).

Lent by the Syndics of Cambridge University Library AA

Cat. no. 72 fol. 121r, border with the coat of arms of Jan Crabbe

73

Alexander literature: Cicero, *Tusculanae quaestiones*

c. 1472, Bruges

Illuminated manuscript on parchment, 327 × 230 mm, 158 folios

Provenance: Raphael de Mercatellis; Algernon Peyton; his gift to Peterhouse, 1666 *Accession no.* MS. 269
References: James 1899, pp. 341–3; Derolez 1979, pp. 41–4; Derolez 1982, p. 146; Robinson 1988, p. 110; Arnould 1991, I, pp. 50–9

This manuscript was commissioned by Raphael de Mercatellis during his term as abbot of the monastery of St Pieters at Oudenburg. Large parts of the text were copied from an incunable. This is a common phenomenon in Mercatellis' library. The exemplar for Quintus Curtius' *Historia Alexandri Magni* was a 1471 Venice edition.

Peterhouse MS. 269 is a fine example of the manuscripts produced for Mercatellis which testifies to his humanistic inclination during this period. The layout in one textblock, the absence of figurative illumination and the style of script reflect Mercatellis' attempt to imitate contemporary Italian manuscripts as closely as possible. The script is particularly remarkable. Three scribes have collaborated in this manuscript, using the same script. It is characterised by rounded letters, the presence of elegant serifs on end t's and r's and the use of capitals at the beginning of chapters. In some variants of this script a dotted abbreviation stroke and a very peculiar abbreviation for the verb 'esse' occur. This style of script can be labelled *fere humanistica* because, although it is still rooted in the traditional Burgundian script of the *textualis formata*, it also displays some of the characteristics of the Italian humanist script. *Fere humanistica* was in fashion among the humanist bibliophiles in Bruges in the late 1460s and early 1470s. Altogether thirteen manuscripts written in this particular *fere humanistica* can be listed: Bruges, Rijksarchief, Oudenburg 1bis; Brussels, Koninklijke Bibliotheek, MS. 14887; Cambridge, Peterhouse, MS. 269; Ghent, Universiteitsbibliotheek, MSS. 2 and 5; Haarlem, Stadsbibliotheek, MSS. 187 C 13, 187 C 14 and 187 C 15; The Hague, Koninklijke Bibliotheek, MS. 129 C 5 and 129 E 21; London, British Library, Add. MS. 17381; New York, Pierpont Morgan Library, MS. M. 353 and Wolfenbüttel, Herzog August Bibliothek, MS. Novi 857. All, except the New York and The Hague manuscripts have a connection with Mercatellis, although they were not always part of his private library. The New York manuscript, a *Postilla super vetus Testamentum* of Nicolaus de Lyra, is particularly important because it is signed and dated: Johannes Aveloos 1467 (fols. 164v and 265v). We do not know who Johannes Aveloos was, but his name indicates a Flemish origin. He clearly underwent influence from the Italian humanist script, through direct contact in Italy, through Italian manuscripts which circulated in Bruges around that time, or through the presence of Italian scribes in Bruges. The script encountered in the manuscripts just quoted could therefore be localised in a workshop which I propose to call the Johannes Aveloos workshop. This does not imply that Johannes Aveloos was the head of the workshop, only that he played a part in it. Mercatellis was one of its most regular customers, although other unidentified collectors may also have commissioned manuscripts from it (for instance the The Hague and New York codices). It must have been situated in Bruges, as neither the small local school nor the monastic community at Oudenburg would have had at least five scribes who could devote themselves to the copying of manuscripts. Its activity is concentrated during the 1460s and 1470s. After that date no example of this *fere humanistica* script is known to have survived.

The illumination of the manuscript is limited to marginal borders at the beginning of each text. They were painted in the manuscript in three stages. First came the delicate borders surrounded by a single frame which is filled with acanthus leaves curling from blue to gold. Fine flowers and fruits such as daisies, strawberries and grapes are inserted between the acanthus motifs. The white background is spotted with black points and gold dots. Stylistically, they relate to the borders in manuscripts connected with the workshop of Willem Vrelant. The borders in the first quire of the Curtius text are different from the rest of the manuscript. They have motifs with shell gold and blue acanthus, intermingled with various pale-coloured flowers and surrounded by a double frame. The bracket border on fol. 22r is unique among Mercatellis manuscripts. It is the only instance where the painter has preferred to paint motifs in *trompe-l'œil* on a plain coloured blackground rather than on a white background. Doing so he tunes into a style which was very fashionable from the 1480s onwards and which has come to be known as the Ghent-Bruges style.

The initials display a similar variety to the borders. Those in the first quires are simple red and blue penwork initials. While the first border style accompanies standard foliate initials, the initials of fols. 22r and 22v are different: the former includes a daisy and a strawberry bush, while the latter is a grosser foliate initial.

In various places in the manuscript Mercatellis had heraldic motifs painted. They consist of his Oudenburg coat of arms (fols. 1r and 146r), his mysterious monogram SLY or LYS (fols. 22r and 78r) and his ownership claim (fol. 158v), added to the manuscript in 1495.

Script and illumination of this manuscript are typical for the eight manuscripts which are known to have survived from Mercatellis' time in Oudenburg. The total extent of Mercatellis' library in Oudenburg is unknown, as the earliest catalogue of the library of the St Pieters monastery, compiled by Sanderus in 1641, does not specify who acquired the volumes.

Lent by the Master and Fellows of Peterhouse, Cambridge (*on deposit in Cambridge University Library*) AA

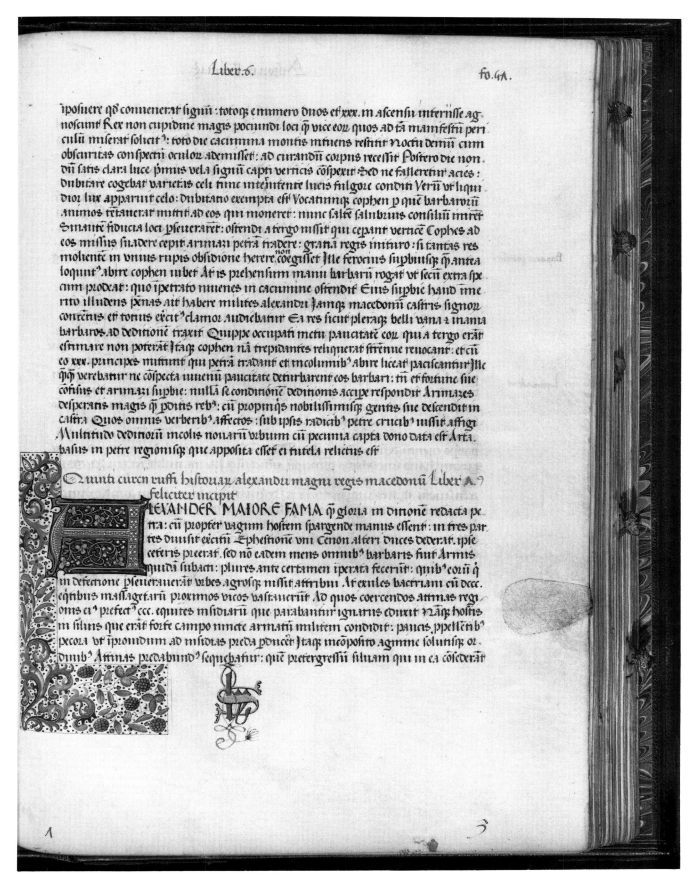

Cat. no. 73 fol. 57r, monogram of Raphael de Mercatellis

74

St Augustine, *Interpretatio in Epistolas Sancti Pauli*
and St John Chrysostomos, *De laudibus beati Pauli apostoli*

c. 1500, Bruges

Illuminated manuscript on parchment, 500 × 350 mm, iv + 221 folios

colour plate, p. 188

Provenance: Raphael de Mercatellis; Canons of the St Bavo Cathedral, Ghent; Gaspar de Guzman, Duke of Olivares, Seville; Gaspar de Haro; Discalced Augustinians, Lyons; Thomas Coke, Holkham Hall *Accession no.* MS. 133
References: de Ricci 1932, p. 12; Derolez 1979, pp. 252–5; Arnould 1991, 1, pp. 247–8

This manuscript entered the library of Raphael de Mercatellis while he was abbot of the St Bavo monastery in Ghent during the early sixteenth century. The borders which are included in the codex are typical of Mercatellis manuscripts of this period. They consist of a standardised succession of acanthus leaves, flowers and other motifs. On fol. 1r the combined coat of arms of Mercatellis' family, of the St Bavo monastery and of the bishopric of Rhosus in Cilicia, of which Mercatellis had been appointed titular bishop in 1487, has been included in the border. As is clear from this manuscript, and could be demonstrated by other Mercatellis and non-Mercatellis manuscripts produced in the very late fifteenth and early sixteenth century, the fashionable Ghent-Bruges border style was not the only pattern available. The border style with acanthus and floral motifs on a white background, which had been at its height during the 1470s, continued to be in demand.

As is often the case with Mercatellis manuscripts, the text was copied from a printed edition, in this case Ulrich Gering's 1499 Paris edition of the Pauline texts (BMC, 8, p. 31). The text of the Pauline Epistles is written in a large *textualis formata* while the Commentaries of Augustine are written in a *hybrida formata*. There are three possible layouts for copying a text with its gloss. One is to write the commentary between the lines of the text. A second method is to write the text *en bloc* and the gloss or commentary around it (see cat. no. 75). Here a third layout is used: text and commentary succeed each other in a regular two-column ruling.

The reasons why Mercatellis favoured manuscripts above printed books can only be guessed. It could well be that he preferred manuscripts to impress his fellow courtiers with an artistic medium which was in vogue at the Burgundian court. It is, however, also possible that of some texts only a single printed copy might be available and that therefore copying into manuscript was the only way of owning a particular text.

The manuscript is also important because it offers us a rare insight into the price of manuscripts in late medieval Flanders and because it helps us to evaluate Mercatellis' expenses when assembling his library. This is indeed the only Mercatellis manuscript which tells us anything about the financial implications of the abbot's bibliophily. At the bottom on the verso of the last folio of each of the quires a hand has written down in brown ink 'iiii £ x s p' (4 ponden 10 schellingen parissis). As the manuscript has twenty-eight quaternions, its total cost must have been £126. This amount is not as unambiguous as it might appear. The accountant has not specified what he priced at that amount. Was he alluding to the price of a quire of unwritten parchment? Does it indicate the price of the parchment and the copying? Was it the price of the copying without the parchment? Or was it the price of the quire once the paragraph marks, the initials and the few borders of the manuscript were completed? The last possibility may be excluded as the price for quires with borders is the same as for quires without borders. One way round the problem is to compare the daily wage of craftsmen in Bruges around 1500. If a scribe's salary is comparable to that of a master mason, that is an average of 10 Flemish groot a day, one could estimate the manuscript at 210 days of work. In the case of Holkham Hall MS. 133 with its 221 folios, this would work out at a little more than ten folios (recto and verso) each day. Considering the large size of the volume (500 × 350mm; text columns of 340 × 235mm; 63 lines) this could well be too much for one day's work. In that case, the salary of the scribe was probably lower than 10 Flemish groot. With the added cost of a red silk binding this would produce a total of around £150 for MS. 133.

However we calculate it, we cannot deny that Mercatellis spent an enormous amount of money on his books. It is hard to know whether he used his private funds rather than the monastery's resources for his purchases. The investigations conducted by Leoninus after the abbot's death allude to the fact that he did not strictly separate the two incomes. This unscrupulous attitude is another, less glamorous, side of Mercatellis.

Lent by Viscount Coke and the Trustees of the Holkham Estate

AA

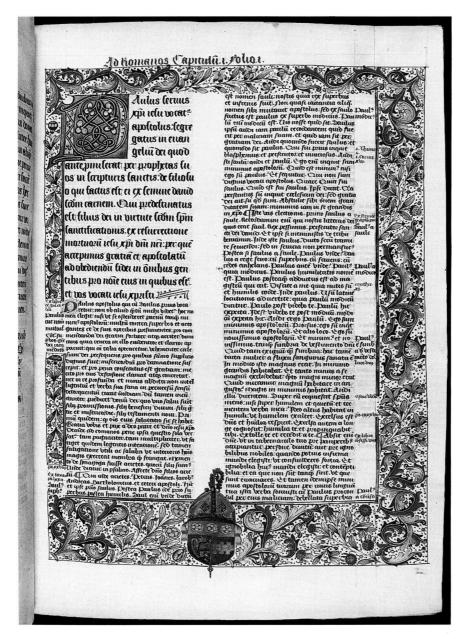

Cat. no. 74 fol. 1r, border with the episcopal coat of arms of Raphael de Mercatellis

74 fol. 28v, price indication at the end of a quire

75

Collected works of Persius and Horace

c. 1485 and 1500, Bruges

Illuminated manuscript on parchment, 405 × 295 mm, 233 folios

colour plate, p. 189

Provenance: Raphael de Mercatellis; Canons of the St Bavo Cathedral, Ghent; Gaspar de Guzman, Duke of Olivares, Seville; Gaspar de Haro; Discalced Augustinians, Lyons; Thomas Coke, Holkham Hall *Accession no.* MS. 318
References: de Ricci 1932, p. 26; Hassall 1970, pp. 38–41; Derolez 1979, pp. 134–8; Arnould 1991, 1, pp. 39–41; 179–80 and 2, pp. 48–53

The abbatial coats of arms and the 'LyS' monograms in the eyes of initials in various parts of the manuscript make it clear that

this large manuscript once formed part of Raphael de Mercatellis' library. It illustrates perfectly the evolution which can be traced in his manuscripts. As has been demonstrated in the Peterhouse manuscript (cat. no. 73), the early codices of Mercatellis were close imitations of Italian manuscripts. When Raphael de Mercatellis became abbot of the St Bavo monastery in Ghent, his taste gradually changed: the script and layout of the manuscripts revert to traditional gothic features and the illustrations become more and more prominent.

This is particularly noticeable in the parts of the manuscript

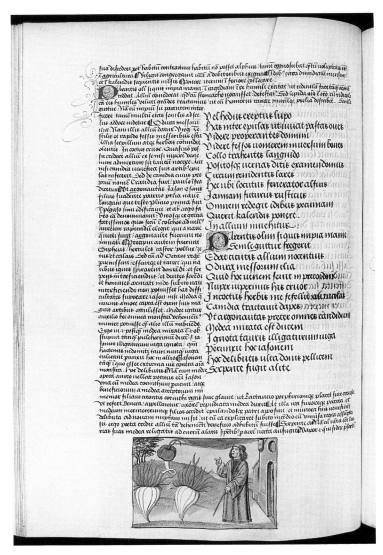

Cat. no. 75 fol. 145v, *In praise of Garlic*

which contain the Horace text. Mercatellis had the text of Horace and the Commentary of Christophorus Landinus copied from a printed exemplar, most probably from an Italian incunable. The scribe has written Horace's text in a large *cursiva formata*, and the commentary is written around it in a smaller version of the same script. This probably happened during the early 1480s. The result was a sober, unillustrated but imposing manuscript of the works of the Latin poet. It was only ten to fifteen years later that Mercatellis requested that illustrations be painted in the lower margins. This decision was probably made after Mercatellis had seen the edition of Horace by Grüninger (Strasburg 1498), which included woodcuts for every scene. These woodcuts then served as exemplar for the additional miniatures in the Mercatellis codex. Because of the different layouts of the manuscript and the Grüninger edition it was impossible to include all the woodcuts. The artist had to select the image according to the space available in the manuscript. Moreover, the illustrations of the Strasburg edition were often composed of two or three modules which, put one next to the other, formed one continuous image. In the manuscript, the artist has united these different woodcuts into one miniature.

There are two reasons for dating this manuscript around 1485. First, there is the style of the borders. They belong to a group which were painted in manuscripts and incunables at a workshop in Bruges. They are characterised by the presence of silvery acanthus leaves. Other books which are decorated with borders in this style are an Ovid, printed in Venice by Jacobus Rubeus in 1474, an *Ovide moralisé*, printed by Mansion in Bruges in 1484 (Paris, Bibliothèque Nationale, Rés. g.y.c 1002), a Bible printed in Basle by Johannes Amerbach in 1481 (Bruges, Stadsbibliotheek, Inc. 3863), a Book of Hours of about 1485 (Melbourne, State Library of Victoria, MS. *fo96/R66Hb), a manuscript with the *Chronicles* of Froissart (Antwerp, Plantijn-Moretus Museum, MS. M.15.6) and one other Mercatellis manuscript (Ghent, Universiteitsbibliotheek, MS. 72). Second, because the coat of arms in the manuscript does not include his episcopal emblems, it must predate 1487, the year when Mercatellis became bishop of Rhosus.

Lent by Viscount Coke and the Trustees of the Holkham Estate

AA

Horatius Flaccus, *Satyres*, Strasburg, Grüninger, 1498. Fitzwilliam Museum, Sayle 29, fol. 94r, *In praise of Garlic*

76

Ovid, *Metamorphoses, De arte amandi, De remedio amoris*;
Ausonius, *Epigrammata*; Ovid, *Pulex, Philomena, De medicamine facei, Nux*;
Petrus Berchorius, *Ovidius moralizatus*

c. 1495, Bruges

Illuminated manuscript on parchment, 410 x305 mm, 293 folios

colour plates, pp. 190–1

Provenance: Raphael de Mercatellis; Canons of the St Bavo Cathedral, Ghent; Gaspar de Guzman, Duke of Olivares, Seville; Gaspar de Haro; Discalced Augustinians, Lyons; Thomas Coke, Holkham Hall *Accession no.* MS. 324
References: Dorez 1908, pp. 92–4; de Ricci 1932, p. 27; London 1953–4, p. 162, no. 608; Hassall 1970, pp. 15–7, pls. 33–7; Smets 1975, p. 304; Van Acker 1977, p. 180, note 153; Derolez 1979, pp. 255–60; Arnould 1991, 1, pp. 186–98

This manuscript from the library of Raphael de Mercatellis is interesting for its relation to printed editions. As far as the texts are concerned, three of the works of the Roman poet Ovid (48 BC–AD 17) *Metamorphoses*, the *De arte amandi* and *De remedio amoris* were copied from the printed edition of Conradus Sweynheym and Arnoldus Pannartz, not before 18 July 1471 (BMC, 4, p. 14). Petrus Berchorius' *Ovidius moralizatus* was probably copied from a manuscript source since there was no printed Latin edition of the text.

The miniatures were planned along with the copying of the text. In some instances the miniatures share the space of a page with the text, which shows that the illustrations were part of a coherent plan. In others, the miniatures are painted on single folios. These single leaves were inserted in the normal quires to complement the regular illustrations (fols. 13v, 25v, 62v, 71v, 82v and 137v). It is probable that this was done at a slightly later stage since the running titles at the top of the pages were separated by the insertion of the illustrations. The relation of the sixteen illustrations to the woodcuts of the French translation of the Berchorius' *Ovidius moralizatus*, the *Ovide moralisé*, published in Bruges in 1484 by the printer Colard Mansion, is also interesting although not direct. Some of the miniatures such as that of Phaëton (Book II) or that of Cadmus (Book III) appear to be closely related. Others, such as those illustrating the story of Pyramus and Thisbe (Book IV), bear some resemblance. The majority of the miniatures have, however, nothing in common and it is therefore wrong to state, as Pächt has suggested (London 1953–4), that the miniatures were copied from the woodcuts of the Mansion edition. A more likely conjecture is that miniatures and woodcuts both depend on a lost source. Either the miniatures, or the woodcuts, or both, were freely adapted from this source.

In the search for the exemplar of the Ovid miniatures two other contemporary Flemish *Metamorphoses* need to be taken into account: Copenhagen, Kongelige Bibliotek, MS. Thott 399 and Paris, Bibliothèque Nationale, MS. fr. 137. The first dates from the 1480s and consists of a French translation of the text, preceded by a French prose version of the first chapter of Berchorius' *Ovidius moralizatus*, which surveys the various Roman gods. It is illustrated with miniatures of various sizes at the beginning of each book (Nørgaard 1963). The Paris Ovid, which was commissioned by the famous bibliophile Lodewijk van Gruuthuse during the 1480s, also consists of a French translation of the *Metamorphoses* and has miniatures as well as numerous historiated initials. While the miniatures with the presentation of gods in the Paris manuscript show remarkable parallels with Mansion's *Ovide moralisé*, the illustrations of the *Metamorphoses* themselves are very different, in format as well as in composition. For the Copenhagen Ovid, it has been suggested that its illustrations were related to the woodcuts of the Mansion edition. The similarity of the woodcuts and miniatures of the Roman gods is indeed striking, but it is not clear whether the woodcuts served as exemplar to the miniatures or vice versa, or even whether both were dependent on a third set of illustrations. The woodcuts of the *Metamorphoses* themselves also bear some resemblance to the Copenhagen miniatures, but there is no systematic borrowing in either direction. The illustrations of the Gruuthuse manuscript are even less closely related to the woodcuts and develop other subjects.

The woodcuts and the Mercatellis miniatures share the same narrative approach. They consist of various episodes from the life of one or more protagonists. The way in which the chronology of the scenes is presented is not always from top to bottom and from left to right. In the miniature to Book XIV, however, the narrative does work from top to bottom. Myscelus is asked in a dream to leave his native country. After being arrested for leaving the country clandestinely, he is brought before a court. When the pebbles used for casting the verdict all miraculously turn white, Myscelus is allowed to leave the country and sails off to found Croton where he will be buried. In a leap across history Pythagoras is then shown teaching Numa Pompilius! On the whole it is left to the beholder to work out the succession of episodes. This deciphering must have required some background knowledge of mythology as many of the depicted episodes are rare iconographic subjects. The only guidance offered to the reader for deciphering the iconography are some banderoles which, in some instances, name the figures in the story.

The manuscript has a full-page frontispiece. Within a frame of acanthus and flowers are Raphael de Mercatellis' initials 'R M', his puzzling monogram 'LyS' and two circles. One features

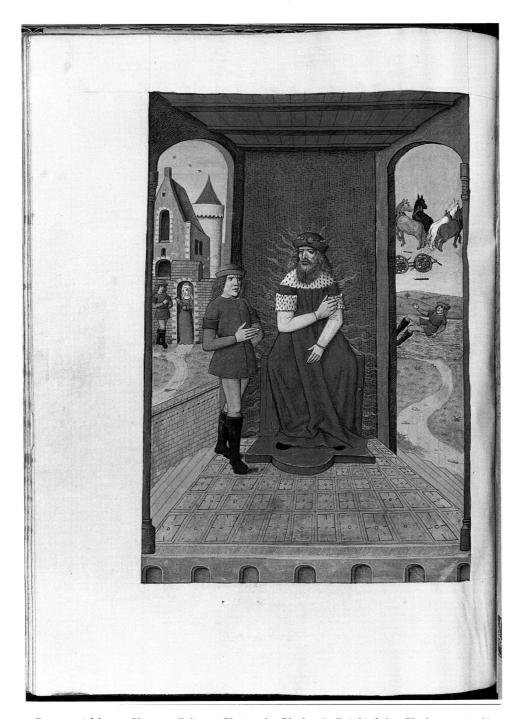

Cat. no. 76 fol. 25v, *Clymene tells her son Phaëton that Phoebus Apollo is his father; Phoebus promises his son to grant him any boon he may ask; Phaëton tumbles from the sun-chariot which he has borrowed*

the story of Prometheus who goes up to heaven to steal the fire and bestow its power upon the human race. The upper circle shows a hierarchy of angels dominated by the Holy Spirit. They surround the matter out of which all things were made, indicated by the word 'yle'. This composition was copied from the wood-cut of the same subject in Hartman Schedel's *Nuremberg Chronicle*, printed at Anton Koberger's press in 1493. This does not necessarily provide a *terminus post quem* for the manuscript because the frontispiece page appears to be an added folio. The

manuscript should nevertheless be dated during the last years of the fifteenth century. On the opposite page, a full border with Mercatellis' episcopal coat of arms indicates it was written after 1487, the date of his appointment as bishop of Rhosus. A comparison between the script and illumination style of this and other Mercatellis manuscripts points towards a date well in the 1490s.

Lent by Viscount Coke and the Trustees of the Holkham Estate

AA

219

76 fol. 101v, *Orpheus and Eurydice*

The coinage of the Burgundian Netherlands

Peter Spufford

When the hitherto separate and independent principalities of the Low Countries were united under the rule of Philip the Good in the years around 1430, each individual 'country' had its own coinage, and indeed its own tradition of coinage stretching back for many centuries. Because of the economic integration of the whole area from the Somme to the Ems the coinages of all the individual states circulated together throughout this 'monetary province', so that the states already to some extent shared a common currency as well as a common economy before the Burgundian unification. Moreover, despite the enormous variety of coinages that were circulating, there were already some elements of uniformity amongst them, for there had been a long sequence of monetary conventions between individual princes since the thirteenth century. The basis of many of these agreements, for example that of 1384 between Joanna (or Jeanne), duchess of Brabant, and Philip the Bold (see cat. no. 79), was the money of the county of Flanders, which, because of the dominant economic role of Flanders, had become the dominant coinage in the mixed currency of these principalities.

One of the first common institutions to be created by Philip the Good for all his principalities was a common coinage. This was planned in 1433, and was effectively an extension of the coinage of the county of Flanders to the other lands at the expense of their indigenous coinages. The intention was to produce identical coins in a single central mint in each of five principalities, Flanders, Brabant, Namur, Hainaut and Holland, differing only in the titles of the ruler and a small symbol (for instance, a fleur-de-lis in Flanders and a lion in Brabant). In the event the Namur mint was never opened, so that the common coinage was only issued in four principalities. The principal silver coin of the new coinage, the stuiver or patard, was consequently known as a 'vierlander' (see cat. nos. 84 and 85). In effect the dubbele groot (double gros) of the county of Flanders had become the common silver coin of the whole Netherlands. As well as the four Burgundian mints that issued identical coinages the other principalities which were still not directly under Burgundian rule, the bishoprics of Liège and Utrecht, the duchies of Guelders and Cleves, and the tiny independent city states of the northeastern Netherlands all produced their own versions of the Burgundian coinage.

Although the Netherlands formed an independent 'coinage province', they were none the less open to the influences of the surrounding countries with which there were such strong polit-ical and commercial links. The coinages of England, of France and of the Empire (Germany) therefore circulated to a considerable extent in the Netherlands and helped determine the types of coinage which were minted there. This was particularly true of the gold coinage which had an international circulation. The fourteenth-century lammen (moutons) of Flanders, Liège and Brabant (see cat. no. 77) derived from French royal gold moutons, as did the schilds (écus à la chaise) of Liège and Flanders (see cat. no. 78), from French royal écus, whilst the early fifteenth-century nobles of Flanders (see cat. no. 80) had English prototypes. The gold rijder (cavalier) of Philip the Good, issued as the common gold coinage for all his principalities from 1433, derived its type from the French franc à cheval of the previous century, and its weight standard from the salut being issued on behalf of Philip's then preferred claimant to the throne of France, the young Henry of Lancaster (see cat. nos. 82 and 83). Another French influence was the doctrine, first clearly formulated by Nicolas Oresme in the 1360s, that money belonged to the community rather than the prince, and was therefore never to be changed, and in particular never debased, without the consent of the community, effectively of the nobility in assemblies of estates. The unified coinage was consequently extremely stable from its inauguration in the 1430s to the civil wars of the 1480s when Maximilian, in the mints that he controlled, produced debased coin for the first time for over half a century. Imperial (German) influence was not apparent until the issue of Andriesgulden (florins of St Andrew) struck from 1466 onwards (see cat. no. 89). These were of the same standard as the gulden (florins) of the Emperor and the Rhineland electors, and closely related to the latter in type. Between the rijders and the Andriesgulden Philip the Good from 1453 issued leeuwen (lions) and two-third leeuwen as his standard gold coins (see cat. nos. 86 and 87). These handsome pieces were of a weight, standard and type unlike any contemporary pieces struck elsewhere in Europe and should perhaps be interpreted as making a statement that Burgundy was a totally new independent state and that Netherlanders, as a different nation, needed a different coinage from other peoples.

The new policies of Charles the Bold, inaugurated when he took over the government in the last year of his father's life, can be seen not only in the 'imperial' Andriesgulden issued from 1466, but even more in the new silver coinage of 1474, issued as the new coinage for the new kingdom that he was then hoping

to achieve within the empire. The rather plain dubbele stuiver (double patard) (see cat. no. 88) was replaced as the principal silver coin by the elaborate dubbele vuurijzer (double briquet) (see cat. no. 90). Charles' appreciation of the antique resulted in the invitation to his court of Giovanni Candida, one of the leading neo-classical medallists of the early Italian Renaissance. Whilst in the Netherlands he produced a magnificent classical medal of Charles himself (cat. no. 91), as well as a number or others.

Charles' death at the battle of Nancy in 1477 had no effect on the coinage of the united Burgundian Netherlands. The coinage of his daughter Mary and of the early years of the reign of his grandson Philip the Handsome remained the same as that introduced by Charles in 1474 (see cat. no. 92). However the civil wars of the 1480s for the control of the young Philip the Handsome did make for alterations in the coinage. Mary's widower Maximilian claimed to exercise the government during Philip's minority, and minted a variety of issues on his behalf. Some of these were magnificent new denominations of a scale never before minted in the Netherlands, or indeed anywhere north of the Alps, like the magnificent reaals of gold and silver (see cat. nos. 94 and 95), so called to emphasise that Maximilian had become a *king* (of the Romans). The silver reaal was the northern equivalent of the new large silver testone of northern Italy, and like them bore, for the first time, a naturalistic portrait of the ruler. It is interesting to notice that whereas in Italy the first Renaissance portrait medal preceded the first portrait coin by thirty-three years, 1439 to 1472, in the north the first portrait coin followed only thirteen years after the first portrait medal. Such magnificence must not conceal the fact that Maximilian was deliberately manipulating the coinage for profit, in a way that no ruler had done since the arrival of the Burgundians in Flanders a century before. He needed any income he could obtain, from whatever source, to pay the German troops that he was desperately employing to suppress the opposition to him. His son's subjects claimed that Maximilian had no right to govern, and ran an alternative government in Philip's name. They too minted coinage in the name of Philip, but deliberately struck traditional denominations (see cat. nos. 96 and 97) to emphasise their legitimacy. In 1489 the brief period of monetary manipulation came to an end, and the tradition of sound money, so much preferred by the nobility and all who lived on fixed incomes, reasserted itself.

Philip's majority and the reign of his son Charles (later the emperor Charles V) saw the continuation well into the sixteenth century of the monetary patterns of the fifteenth-century Netherlands. The Andriesgulden were succeeded, for example, by Philippusgulden (cat. no. 100) and Carolusgulden. In other words the national coinage created, out of that of the county of Flanders, by Philip the Good for his newly united group of territories remained the coinage of the Burgundian state until the revolt of the Netherlands against the government of his great-great-great-grandson and namesake nearly a century and a half later.

References: The standard catalogue of the coins of the Burgundian Netherlands, after their unification, is van Gelder 1960. A commentary is provided by Peter Spufford, *Monetary Problems and Policies in the Burgundian Netherlands 1433–96*, Leiden, 1970.

Coins and medals

Mark Blackburn

WENCESLAS AND JOANNA, DUKE AND DUCHESS OF BRABANT (1355–83)

77

A gouden lam of their second coinage (*c*.1362–71), struck at Vilvoorde

Obverse: +AGN' DEI QVI TOLL' PCCA' MVDI MISERERE NOB', Lamb of God left, holding a cross with pennant, IOH' DVX in exergue. Reverse: +XP'C VINCIT XP'C REGNAT XP'C IMPERAT, ornate cross fleury with a rose at the centre and a lis in each angle. Gold. Weight: 5.99 g.
Provenance: Bought Spink, March 1939; ex R. C. Lockett; ex Glendining sale 29.2.1956, lot 226; given by the Friends of the Fitzwilliam to the Fitzwilliam Museum, 1956 *Accession no.* CM.51–1956
References: Witte 1894–9, no. 389

Fitzwilliam Museum, Cambridge

Cat. no. 77, Wenceslas and Joanna of Brabrant, a gouden lam (*c.* 1362–71)

PHILIP THE BOLD, DUKE OF BURGUNDY (1363–1404), COUNT OF FLANDERS (1384–1404)

78

A gouden schild of his first coinage (1384), struck for Flanders at Mechelen

Obverse: +PHILIPPVS DEI GRA COM' Z DNS FLAND', duke in armour, with sword and wearing a garland of roses, seated on a gothic throne, his hand resting on the shield of Flanders. Reverse: +XPC VINCIT XPC REGNAT XPC INPERAT, an ornate cross fleury in a quatrefoil. Gold. Weight: 4.50 g.
Provenance: Bought Bourgey 16.4.1963 *Accession no.* Grierson collection 11,525
References: Deschamps 1861–2, pl. 6.5

Fitzwilliam Museum, Cambridge, Grierson loan

Cat. no. 78, Philip the Bold, a gouden schild (1384)

JOANNA, DUCHESS OF BRABANT (1383–1406), WITH PHILIP THE BOLD

79

A rozebeker groot of 1384–7, struck for Brabant at Leuven

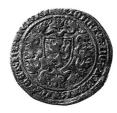

Obverse: +IOH' DVC BRAB PHS' Z DVX BORG' Z COM FLAND', two shields (Brabant-Limburg and Burgundy), with a chaplet of roses above and three flowers in the field. Reverse: +MONETA NOVA BRABANTIE ET FLANDRIE, shield (Brabant) upon an ornate cross with zoomorphic decoration. Silver. Weight: 2.12 g.
Provenance: Bought Franceschi 6.1.1970 *Accession no.* Grierson collection 12,760
References: Witte 1894–9, no. 414

Cat. no. 79, Joanna of Brabant with Philip the Bold, a rozebeker groot (1384–7)

Fitzwilliam Museum, Cambridge, Grierson loan

JOHN THE FEARLESS, DUKE OF BURGUNDY (1404–19), COUNT OF FLANDERS AND ARTOIS (1405–19)

80

A noble of the second coinage (1409–18), struck at Ghent

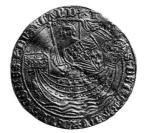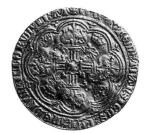

Obverse: +IOHS DEI GRA DVX BVRG COMES Z DNS FLAND, the duke standing in a ship holding a sword and shield (Burgundy-Flanders). Reverse: +IHC AVTEM TRANSIENS PER MEDIVM ILLORVM IBAT, an ornamental cross with crowns and lions in the angles and I (for *Iohannes*) in the centre. Gold. Weight: 6.81 g.
Provenance: Ex L. A. Lawrence; bought Glendining 17.5.1950, lot 164 *Accession no.* Grierson collection 7,316
References: Deschamps 1861, pl. 10.25

Cat. no. 80, John the Fearless, a nobel (1409–18)

Fitzwilliam Museum, Cambridge, Grierson loan

JOHN IV, DUKE OF BRABANT (1415–27)

81

A dubbele groot ('dobbelen penninck Jans') struck at Vilvoorde or Maastricht (1417–19)

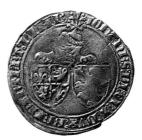

Obverse: IOHANES DI GRA DVX BRABANTI ET LIMB, two shields (Burgundy-Brabant-Limburg and Brabant), surmounted by a crested helmet. Reverse: +MONETA NOVA DVC BRABANTI ET LIMBVR, a cross with in the quarters a lion double queued (1), two lis (2 and 3), and a lion simple (4). Silver. Weight: 4.82 g.
Provenance: Bought Franceschi 29.6.1958 *Accession no.* Grierson collection 10,002
References: Witte 1894–9, no. 443 var.

Cat. no. 81, John IV of Brabant, a dubbele groot (1417–19)

Fitzwilliam Museum, Cambridge, Grierson loan

PHILIP THE GOOD, DUKE OF BURGUNDY,
COUNT OF FLANDERS (1419–67)

82

A rijder of the first unified coinage (1433–), struck for
Flanders at Ghent

Obverse: PHS DEI GRA DVX BVRG Z COMES FLANDRIE, in the
exergue FLA'D', the duke in armour on horseback riding right;
the horse's mantle decorated with Burgundian firesteels.
Reverse: +SIT NOMEN DOMINI BENEDICTVM AMEN (firesteel),
shield (Burgundy) on a cross fleury. Gold. Weight: 3.44 g.
Provenance: Bought Glendining sale 3.5.1951, lot 25 *Accession no.*
Grierson collection 7,887
References: Deschamps 1861–2, pl. 21.44; van Gelder 1960, 2–2

Fitzwilliam Museum, Cambridge, Grierson loan

Cat. no. 82, Philip the Good, a rijder of Flanders (1433—)

83

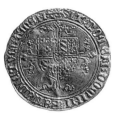

The same issue struck for Brabant at Brussels

Obverse: PH'S DEI GRA' DVX BVRG' BRAB' Z LIMBVRG, in the
exergue BRAB', design as last. Reverse: as last. Gold. Weight:
3.61 g.
Provenance: Ex Sir Charles Oman; J. R. Porteous
References: Witte 1894–9, no 468; van Gelder 1960, 1–1

Lent by J. R. Porteous

Cat. no. 83, Philip the Good, a rijder of Brabant (1433—)

84

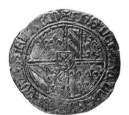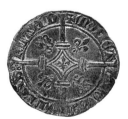

A stuiver or dubbele groot vierlander of the first unified
coinage (1433–), struck for Flanders
at Ghent

Obverse: +PH'S DEI GRA DVX BVRG' Z COMES FLAND', the arms
of Burgundy. Reverse: +MONETA NOVA COMITIS FLAND', an
ornate cross with two lions and two lis in the quarters, and a lis
(for Flanders) in the centre. Billon. Weight: 3.03 g.
Provenance: Bought Tinchant 10.5.1946 *Accession no.* Grierson
collection 2,849
References: Deschamps 1861–2, pl. 21.46; van Gelder 1960, 9–2

Fitzwilliam Museum, Cambridge, Grierson loan

Cat. no. 84, Philip the Good, a stuiver or dubbele groot vierlander
of Flanders (1433—)

85

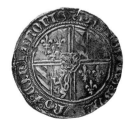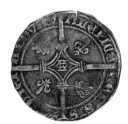

The same issue struck for Hainaut at Valenciennes

Obverse: +PHS DEI GRA DVX BVRG' Z COM HANONIE, design as
last. Reverse: +MONETA NOVA VALENCENENSIS, design as last but
with a gangway (the badge of Valenciennes) in the centre. Billon.
Weight: 3.24 g.
Provenance: Bought Seaby 12.1946 *Accession no.* Grierson collec-
tion 1,782
References: Chalon 1848, no. 163, van Gelder 1960, 9–3

Fitzwilliam Museum, Cambridge, Grierson loan

Cat. no. 85, Philip the Good, a stuiver or dubbele groot vierlander
of Hainaut (1433—)

86

A gouden leeuw of 1454–60, struck for Brabant
at Brussels

Obverse: PHS DEI GRA DVX BVRG BRAB DNS ML', lion under a gothic canopy, flanked by Burgundian firesteels. Reverse: +SIT NOMEN DOMINI BENEDICTVM AMEN (firesteel), shield (Burgundy) on a cross fleury. Gold. Weight: 4.23 g.
Provenance: Bought Franceschi 23.3.1950 *Accession no.* Grierson collection 5,654
References: Witte 1894–9, no. 470; van Gelder 1960, 3–1

Fitzwilliam Museum, Cambridge, Grierson loan

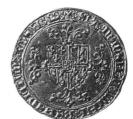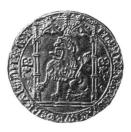

Cat. no. 86, Philip the Good, a gouden leeuw (1454–60)

87

A two-thirds gouden leeuw of 1454–5, struck for
Flanders at Bruges

Obverse: PHS DEI G DVX BVRG CO FLAND, design as last. Reverse: similar to last. Gold. Weight: 2.82 g.
Provenance: Ex Venray hoard, 1957; bought Schulman 7.5.1958
Accession no. Grierson collection 9,727
References: Deschamps 1861–2, pl 21.52; van Gelder 1960, pl. 21.52

Fitzwilliam Museum, Cambridge, Grierson loan

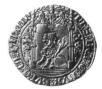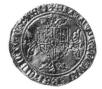

Cat. no. 87, Philip the Good, a two-thirds gouden leeuw (1454–5)

88

A dubbele stuiver of 1466–7, struck for Brabant
at Leuven

Obverse: +PHS DEI GRA DVX BVRG BRAB Z LIMB, shield (Burgundy) in a trefoil border. Reverse: +SIT NOMEN DOMINI BENEDICTVM AM, cross fleury with lion in centre. Silver. Weight: 3.09 g.
Provenance: Bought Franceschi 14.4.1947 *Accession no.* Grierson collection 4,342
References: Witte 1894–9, no 486 var.; van Gelder 1960, 8–1

Fitzwilliam Museum, Cambridge, Grierson loan

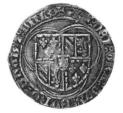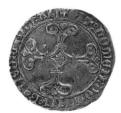

Cat. no. 88, Philip the Good, a dubbele stuiver (1466–7)

CHARLES THE BOLD, DUKE OF BURGUNDY
(1467–77)

89

An Andriesgulden of the second coinage (1474–7),
struck for Flanders at Bruges

Obverse: SANCTVS ANDREAS, St Andrew standing with head half left holding a cross, with a mullet below the saint. Reverse: KAROLVS DEI GRA CO FLAND, shield (Burgundy) upon a cross pattée. Gold. Weight: 3.38 g.
Provenance: ex Christie 26.2.1991, lot 157
References: Deschamps 1877, p. 241; van Gelder 1960, 32–3

Lent by J. R. Porteous

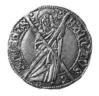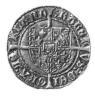

Cat. no. 89, Charles the Bold, an Andriesgulden (1474–7)

90

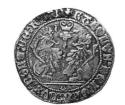
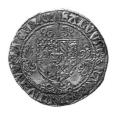

A dubbele vuurijzer of 1474, struck for Flanders at Bruges

Obverse: +KAROLVS DEI GRA DVX BORG CO FLAN, two lions with a firesteel (*vuurijzer*) between them, in the exergue a mullet. Reverse: SALVVM FAC POPVLV TVV DNE 1474, shield (as last) upon a cross fleury. Silver. Weight: 2.94 g.
Provenance: Ex Lord Grantley; ex Glendining sale 18.12.1944, lot 3765; bought Baldwin 17.5.1950 *Accession no.* Grierson collection 7,348
References: Deschamps 1861–2, pl. 13.65; van Gelder 1960, 34–3

Fitzwilliam Museum, Cambridge, Grierson loan

Cat. no. 90, Charles the Bold, a dubbele vuurijzer (1474)

91

A cast medal of Charles, attributed to the Italian artist Giovanni Candida working in the Low Countries as secretary to Charles the Bold, 1472–7; possibly issued in 1474, during the siege of Neuss

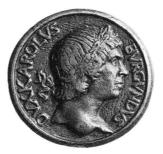

Obverse: DVX KAROLVS BVRGVNDVS, laureate bust right. Reverse: IE LAI EMPRINS BIEN EN AVIENGNE (the duke's motto in French, 'I have undertaken it, may it succeed'), a ram (representing the Fleece) between two firesteels inscribed VELLVS AVREVM ('Golden Fleece'), within wreath. Bronze. Weight: 32.75 g.
Provenance: Henry Oppenheimer; his gift to the Fitzwilliam Museum, 1910
References: Hill 1930, no. 828; Pollard 1984, no. 186

Fitzwilliam Museum, Cambridge

Cat. no. 91, Charles the Bold, a bronze portrait medal attributed to Candida (possibly 1474)

MARY OF BURGUNDY, DUCHESS OF BURGUNDY (1477–82)

92

An Andriesgulden of 1477–8, struck for Brabant at Antwerp

Obverse: SANCTVS ANDREAS, St Andrew standing, with head half right, holding a cross. Reverse: MARIA DVCISS' BD' BR' Z LI' (hand), shield (Burgundy) upon a cross pattée. Gold. Weight: 3.30 g.
Provenance: Ex Prince de Ligne; bought Sotheby 26.6.1968, lot 151 *Accession no.* Grierson collection 12,466
References: Witte 1894–9, no 514; van Gelder 1960, 37–1a

Fitzwilliam Museum, Cambridge

Cat. no. 92, Mary of Burgundy, an Andriesgulden (1477–8)

93

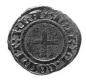

A dubbele mijt, struck for Flanders at Bruges

Obverse: (lis) IN NOMINE DOMIN, gothic M (for *Maria*). Reverse: (lis) MARIA COMIT FLA, short cross. Black billon. Weight: 1.25 g.
Provenance: Ex Lord Grantley; ex Glendining sale 18.12.1944; bought Baldwin 17.5.1950 *Accession no.* Grierson collection 7,436
References: Deschamps 1861–2, pl. 18.78 var.; van Gelder 1960, 46–3b

Fitzwilliam Museum, Cambridge, Grierson loan

Cat. no. 93, Mary of Burgundy, a dubbele mijt (1478–82)

PHILIP THE HANDSOME, DUKE OF
BURGUNDY (1482–1506); PERIOD OF HIS
MINORITY (1482–95)

94

A gouden reaal of 1487, struck for Holland
at Dordrecht

Obverse: +MAXIMILIANVS DEI GRA ROMANORV REX SEP' AVG', Maximilian enthroned, with orb and sceptre. Reverse: +TENE MENSVRAM ET RESPICE FINEM MCCCCLXXXVII, crowned shield of the Holy Roman Empire. Gold. Weight: 14.72 g.
Provenance: Bought Hess/Bank Leu sale 29.10.1957, lot 212 *Accession no.* Grierson collection 5,323
References: Chijs 1858, pl 17.1 var.; van Gelder 1960, 64–6

Fitzwilliam Museum, Cambridge, Grierson loan

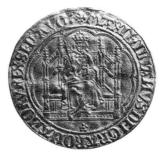
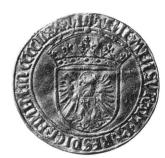

Cat. no. 94, Philip the Handsome, a gouden reaal (1487)

95

A zilveren reaal of 1487, struck for Brabant at Antwerp
or Mechelen

Obverse: +CVSTODIAT C'ATOR OI'M HVI'LE' S'W' SW' 1487, half figure of Maximilian, as king of the Romans with sword, orb, and crown. Reverse: (firesteel) DET TIBI I'T'RIS V, (firesteel) TVT Z I'CEL' GLORIA, monogram of Maximilian and Philip. Silver. Weight: 6.05 g.
Provenance: Bought Franceschi 5.7.1955 *Accession no.* Grierson collection 8,774
References: Witte 1894–7, no. 556; van Gelder 1960, 67–1

Fitzwilliam Museum, Cambridge, Grierson loan

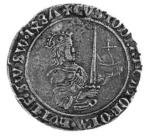
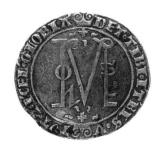

Cat. no. 95, Philip the Handsome, a zilveren reaal (1487)

96

A gulden struck at Ghent in 1488, while Flanders was in revolt (1488–92)

Obverse: BAPTISTA PROSPER ADESTO, St John holding a lamb, over a shield (Flanders). Reverse: PHS' D' G' ARC' AVST' B' CO' FLA, shield (Austria-Burgundy (1 and 4), Burgundy (2 and 3), and Flanders (centre)) upon an ornate cross, with GAND in the quarters. Gold. Weight: 3.23 g.
Provenance: Ex Tollemein; ex Pflieger; bought Franceschi 1.10.1951 *Accession no.* Grierson collection 8,008
References: Deschamps 1870, pl. 16.26; van Gelder 1960, 142b

Fitzwilliam Museum, Cambridge, Grierson loan

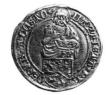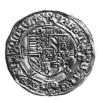

Cat. no. 96, Philip the Handsome, a gulden struck by the town of Ghent while in revolt (1488–92)

97

A stuiver struck at Ghent in 1488, while Flanders was in revolt

Obverse: +EQUA LIBERTAS DEO GRATA 1488, lion of Flanders. Reverse: PHS' D' G' D' B' CO' FLA'DRIE, design similar to last. Silver. Weight: 2.94 g.
Provenance: Bought Franceschi 25.9.1958 *Accession no.* Grierson collection 9,932
References: Deschamps 1870, pl. 17.29; van Gelder 1960, 143a

Fitzwilliam Museum, Cambridge, Grierson loan

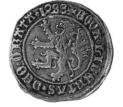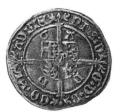

Cat. no. 97, Philip the Handsome, a stuiver struck by the town of Ghent while in revolt (1488)

98

A quadruple stuiver of 1489, struck for Brabant at Antwerp

Obverse: PHI ARCHIDVCIS AVSTRIE BVRGVNDI BRA (hand), Philip in armour standing with a sword and supporting a shield (Austria-Burgundy (1 and 4), Burgundy (2 and 3) and Flanders-Tyrol (centre)). Reverse: MAXIM'LIA' REX ROMAN' PAT 1489, crowned shield (the Empire) over a cross fleury. Silver. Weight: 6.23 g.
Provenance: Bought Elsen 6.2.1985 (*Elsen List* 75, January 1985, no. 164) *Accession no.* Grierson collection 14,459
References: Witte 1894–9, no. 576; van Gelder 1960, 82–1

Fitzwilliam Museum, Cambridge, Grierson loan

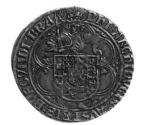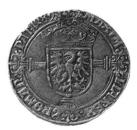

Cat. no. 98, Philip the Handsome, a quadruple stuiver (1489)

PERIOD OF PHILIP'S MAJORITY (1495–1506)

99

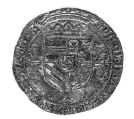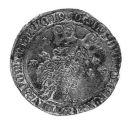

Cat. no. 99, Philip the Handsome, a zilveren vlies (1496)

A zilveren vlies of 1496, struck for Brabant at Antwerp

Obverse: PH'S DEI GRA ARCHID' AVSTE DVX B'G B', crowned shield (Austria (1), new Burgundy (2), old Burgundy (3), Brabant (4) and Flanders (centre)), upon a cross fleury. Reverse: (lion) INICIVM SAPIENCIE TIMVR DOMINI ANNO 1496, a fleece suspended below two firesteels. Silver. Weight: 3.39 g.
Provenance: Bought Tinchant 1.4.1947 *Accession no.* Grierson collection 4,205
References: Witte 1894–9, no. 605a var.; van Gelder 1960, 110–1

Fitzwilliam Museum, Cambridge, Grierson loan

100

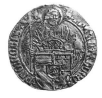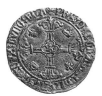

Cat. no. 100, Philip the Handsome, a Philippusgulden (1499–1506)

A Philippusgulden of Philip's final coinage (1499–1506), struck for Brabant at Antwerp

Obverse: S PH'E INTERCED PRO NOBIS, St Philip holding a cross and a book, above a crowned shield (as last). Reverse: +PH'S DEI GR'A ARCHID' AVSTE DVX BVRG' BRA, cross fleury with two crowns and two lis in the quarters and a lion (for Brabant) in the centre. Gold. Weight: 3.25 g.
Provenance: Bought Delmonte 25.4.1947 *Accession no.* Grierson collection 4,638
References: Witte 1894–9, no. 598 var.; van Gelder 1960, 115–1b

Fitzwilliam Museum, Cambridge, Grierson loan

CHARLES V, DUKE OF BURGUNDY (1506–56), KING OF SPAIN (1516–56), EMPEROR (1519–56)

101

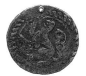

Cat. no. 101, Charles V, a dubbele mijt (1543–56)

A dubbele mijt of Brabant, struck at Antwerp, 1543–56

Obverse: [hand] CA D G V IMP HISP REX 15[], portrait of the emperor right wearing a radiate crown. Reverse: lion rampant left, with tail double queued. Brass. Weight: 1.39 g (pierced).
Provenance: Not recorded; Fitzwilliam Museum
References: Witte 1894–9, no. 694; van Gelder 1960, 198–1b

Fitzwilliam Museum, Cambridge

BIBLIOGRAPHY

Van Acker 1977 – K. Van Acker, 'De librije van Raphaël de Mercatellis, abt van Sint-Baafs en bisschop van Rhosus', *Archief- en Bibliotheekwezen van België*, 48, 1977, pp. 143–98

Alexander 1970 – J. J. G. Alexander, *The Master of Mary of Burgundy: a Book of Hours for Engelbert of Nassau: The Bodleian Library, Oxford*, London, 1970

Ampe 1962 – A. Ampe, 'Aantekeningen bij een zestiende-eeuws handschrift uit Dendermonde (Hs 4407-08 der KB te Brussel)', *Handelingen Koninklijke Zuidnederlandse Maatschappij voor Taal- en Letterkunde en Geschiedenis*, 16, 1962, pp. 9–54

Anzelewsky 1959 – F. Anzelewsky, 'Die drei Boccaccio-Stiche von 1476 und ihre Meister', in *Festschrift Friedrich Winkler*, Berlin, 1959, pp. 114–25

Armstrong 1957 – C. A. J. Armstrong, 'The Burgundian Netherlands 1477–1521' in G. R. Potter (ed.), *New Cambridge Modern History*, i, Cambridge, 1957

Armstrong 1983 – C. A. J. Armstrong, *England, France and Burgundy in the fifteenth century*, London, 1983

Arnould 1991 – A. Arnould, 'The art historical context of the library of Raphael de Mercatellis'. Ph.D. dissertation, 2 parts, Ghent, 1991

Atkinson 1897 – T. D. Atkinson, *Cambridge described and illustrated*, Cambridge, 1897

Baldass 1925 – L. Baldass, *Joos van Cleve, der Meister des Todes Mariä*, Vienna, 1925

Baldass 1944 – L. Baldass, 'Die Entwicklung des Bernart van Orley', *Jahrbuch der kunsthistorischen Sammlungen in Wien*, Neue Folge 13, 1944, pp. 141–91

Beenken 1951 – H. Beenken, *Rogier Van der Weyden*, Munich, 1951

Bergen-Pantens 1967 – C. Van den Bergen-Pantens, 'Un tableau votif de Philippe Hinckaert', *Le Parchemin* 14th series, 121–2, 1967, pp. 213–17

Birmingham 1936 – *Catalogue of an heraldic exhibition*, Birmingham City Museum and Art Gallery, 1936

BMC – British Museum, *Catalogue of the books printed in the XVth century now in the British Museum*, London, 1963–85, 12 vols.

Boon 1964 – K. G. Boon, 'Two designs for windows by Dierick Vellert', *Master Drawings*, 2, 1964, pp. 153–6

Bradshaw 1889 – H. Bradshaw, *Collected Papers . . . comprising memoranda and communications*, Cambridge, 1889

Breul 1927 – K. Breul, *The Cambridge fragments (Culemann fragments)*, Cambridge, 1927

Brinkmann 1987 – B. Brinkmann, 'Neues vom Meister der Lübecker Bibel', *Jahrbuch der Berliner Museen*, 29–30, 1987–8, pp. 123–61

Browne and Seltman 1951 – A. D. Browne and C. T. Seltman, *A pictorial history of the Queen's College of Saint Margaret and Saint Bernard commonly called Queens' College, Cambridge*, Cambridge, 1951

Bruges 1902 – *Exposition des Primitifs flamands et d'art ancien*, Bruges, 1902

Bruges 1956 – *L'art flamand dans les collections britanniques et la galerie nationale de Victoria*, Bruges, Groeninge Museum, 1956

Bruges 1981 – *Vlaamse kunst op perkament*, Bruges, Gruuthuse Museum, 1981

Brussels 1959 – *De Gouden Eeuw der Vlaamse miniatuur*, Brussels, Koninklijke Bibliotheek, 1959

Brussels 1967 – *De librije van Filips de Goede*, Brussels, Koninklijke Bibliotheek, 1967

Brussels 1973 – *Le cinquième centenaire de l'imprimerie dans les anciens Pays-Bas*, Brussels, Koninklijke Bibliotheek, 1973

Brussels 1977 – *Charles le Téméraire 1433–1477*, Brussels, Koninklijke Bibliotheek, 1977

Buren 1993 – A. Van Buren, 'Dreux Jean, the Grandes Heures of Philip the Bold and the problem of collaboration in Flemish manuscripts', *in press*

Cambridge 1856 – Cambridge University Library, *A catalogue of the manuscripts preserved in the Library of the University of Cambridge*, Cambridge, 1856–67, 5 vols. Reprint 1979

Cambridge 1960 – Fitzwilliam Museum, *Catalogue of paintings . . . Dutch and Flemish Schools*, by H. Gerson and J. W. Goodison; *French, German, Spanish Schools*, by J. W. Goodison and D. Sutton, Cambridge, 1960

Cambridge 1966 – Fitzwilliam Museum, *Illuminated manuscripts in the Fitzwilliam Museum: an exhibition to commemorate the 150th anniversary of the death of the Founder Richard, 7th Viscount Fitzwilliam of Merrion*, by F. Wormald and P. M. Giles, Cambridge, 1966

Cambridge 1976 – *William Caxton: a celebration of the quincentenary of the introduction of printing into England*, Brian Jenkins, Cambridge, University Library, 1976

Cambridge 1979 – Fitzwilliam Museum, *All for art: the Ricketts and Shannon collection*, Cambridge, 1979

Cambridge 1988 – Fitzwilliam Museum, *The Dutch Connection: the founding of the Fitzwilliam Museum*, Cambridge, 1988

Cambridge 1989 – Fitzwilliam Museum, *Treasures of the Fitzwilliam . . .*, Cambridge, 1989

Cambridge 1992 – 'Fifteenth-century manuscripts in Cambridge collections: proceedings of the conference held at Wolfson College, Cambridge, 6–8 September 1991', *Transactions of the Cambridge Bibliographical Society*, 10ii, 1992

Campbell 1974 – L. Campbell, 'Robert Campin, the Master of Flémalle and the Master of Mérode', *The Burlington Magazine*, 116, 1974, pp. 634–46

Campbell 1985 – L. Campbell, *The early Flemish pictures in the collection of Her Majesty the Queen*, Cambridge, 1985

Canova, Meldini and Nicolini 1987 – G. Canova, P. Meldini and S. Nicolini, *I codici miniati della Gambalunghiana di Rimini*, Rimini, 1987

Cardon 1989 – H. Cardon, 'Vlaamse verluchte handschriften vóór Jan Van Eyck (ca.1400–1420): een verkenning', *Middeleeuwse handschriftenkunde in de Nederlanden 1988*, Nijmegen, 1989, pp. 215–28

Chalon 1848 – R. Chalon, *Recherches sur les monnaies des comtes de Hainault*, Brussels, 1848

Chawner 1908 – G. Chawner, *A list of the incunabula in the Library of King's College, Cambridge*, Cambridge, 1908

Chijs 1858 – P. O. van der Chijs, 'De munten der voormalige graafschappen Holland en Zeeland', *Verhandelingen van Teyler's Tweede Genootschap*, 26vi, 1858

Cinq-Centième Anniversaire de la Bataille de Nancy, Annales de L'Est, Mémoire 62, 1979

Cockshaw 1984 – P. Cockshaw, 'De la réalisation d'un livre à sa destruction: l'exemplaire de l'histoire de la Toison d'Or de Charles le Téméraire', *Liber amicorum Herman Liebaers*, Brussels, 1984, pp. 201–12

Colledge 1978 – E. Colledge, 'South Netherlandish Books of Hours made for England', *Scriptorium*, 32, 1978, pp. 55–7

Colvin 1878 – S. Colvin, 'Etudes sur quelques maîtres graveurs du xve siècle. Le maître dit des sujets tirés de Boccace: Boccace et Mainardo Cavalcanti', *L'Art*, 13ii, 1878, pp. 149–52, 180–2

Colvin 1895 – S. Colvin, *A brief catalogue of the pictures in the Fitzwilliam Museum*, Cambridge, 1895

Constable 1927 – W. G. Constable, *Catalogue of pictures in the Marlay bequest, Fitzwilliam Museum, Cambridge*, Cambridge, 1927

Conway 1884 – W. Conway, *The woodcutters of the Netherlands in the fifteenth century*, Cambridge, 1884

Conway 1921 – W. Conway, *The Van Eycks and their followers*, London, 1921

Conway 1927 – W. Conway (ed.), *Catalogue of the loan exhibition of Flemish and Belgian art, Burlington House, London, 1927: a memorial volume*, London, 1927

Courcelle 1984 – J. and P. Courcelle, *Lecteurs païens et lecteurs chrétiens de l'Enéide: les manuscrits illustrés de l'Enéide du Xe au XVe siècle*, Paris, 1984

Davies 1968 – M. Davies, *National Gallery Catalogues. The Early Netherlandish Schools*, London, 1968

Davies 1972 – M. Davies, *Rogier Van der Weyden: an essay, with a critical catalogue of paintings assigned to him and to Robert Campin*, London, 1972

Derolez 1979 – A. Derolez, *The Library of Raphael de Mercatellis*, Ghent, 1979

Derolez 1982 – A. Derolez, 'The copying of printed books for humanistic bibliophiles in the fifteenth century', *From Script to Book*, Odense, 1982, pp. 140–60

Deschamps 1861–2 – L. Deschamps de Pas, 'Essai sur l'histoire monétaire des comtes de Flandre de la maison de Bourgogne', *Revue Numismatique*, 2nd series, 6, 1861, pp. 106–39, 211–37, 458–78; 7, 1862, pp. 117–43, 351–65, 460–80

Deschamps 1870 – L. Deschamps de Pas, 'Essai sur l'histoire monétaire de la maison d'Austriche, et classement de leurs monnaies (1482–1506)', *Revue Numismatique*, 2nd series, 14, 1869–70, pp. 86–114, 243–66, 319–34

Deschamps 1877 – L. Deschamps de Pas, 'Supplément à l'essai sur l'histoire monétaire des comtes de Flandre, des maisons de Bourgogne et d'Austriche', *Revue Belge de Numismatique*, 33, 1877, pp. 238–44

Destrée 1928 – J. Destrée, 'Le Maître dit de Flémalle: Robert Campin', *Revue de l'Art Ancien et Moderne*, 53, 1928, pp. 3–14, 81–92, 138–52

Destrée 1930 – J. Destrée, *Le Maître de Flémalle (Robert Campin)*, Brussels, 1930

Dogaer 1987 – G. Dogaer, *Flemish miniature painting in the 15th and 16th centuries*, Amsterdam, 1987

Dorez 1908 – L. Dorez, *Les manuscrits de la bibliothèque de Lord Leicester à Holkham Hall, Norfolk: choix de miniatures et de reliures*, Paris, 1908

Doutrepont 1909 – G. Doutrepont, *La litérature française à la cour des Ducs de Bourgogne*, Paris, 1909

Dubois 1987–8 – H. Dubois, *Le Maître à la Vue de Sainte-Gudule: contribution à l'étude critique de son œuvre*, Mémoire, Université Libre de Bruxelles, Brussels, 1987–8

Dubois 1989 – H. Dubois, 'Sources d'inspiration du Maître à la Vue de Sainte-Gudule et de son atelier', *Annales d'Histoire de l'Art de d'Archéologie*, 9, 1989, pp. 39–52

Eames 1977 – P. Eames, 'Furniture in England, France and the Netherlands from the twelfth to the fifteenth century', *Furniture History*, 13, 1977

Earp 1902 – F. R. Earp, *A descriptive catalogue of the pictures in the Fitzwilliam Museum*, Cambridge, 1902

Eisler 1989 – C. Eisler, *The Thyssen-Bornemisza collection: early Netherlandish painting*, London, 1989

Farmer 1981 – J. D. Farmer, 'Bernard van Orley of Brussels', Ph.D. dissertation, Princeton University, 1981

Fierens-Gevaert 1927–9 – H. Fierens-Gevaert, *Histoire de la peinture flamande des origines à la fin du XVe siècle*, Paris and Brussels, 1927–9, 3 vols.

Ffoulkes 1913 – C. Ffoulkes, *Decorative ironwork from the XIth to the XVIIIth century*, London, 1913

Friedländer 1916 – M. J. Friedländer, *Von Eyck bis Bruegel: studien zur Geschichte der niederländische Malerei*, Berlin, 1916

Friedländer 1923 – M. J. Friedländer, 'Die Brüsseler Tafelmalerei gegen den Ausgang des 15. Jahrhunderts', *Belgische Kunstdenkmäler* (ed. P Clemen), 1, Munich, 1923, pp. 309–20

Friedländer 1924–37 – M. J. Friedländer, *Die altniederländische Malerei*, Berlin, 1924–37, 14 vols. Vols. 12–14 published in Leyden

Friedländer 1967–76 – M. J. Friedländer, *Early Netherlandish painting*, comments and notes by N. Veronee-Verhaegen, Leyden, 1967–76, 14 vols. and Supplément

Friedman 1981 – J. B. Friedman, *The monstrous races in medieval art and thought*, Cambridge (Mass.), 1981

van Gelder 1960 – H. E. van Gelder and M. Hoc, *Les monnaies de Pays-Bas bourguignons et espagnols 1434–1713*, Amsterdam, 1960

Genaille 1976 – R. Genaille, 'L'Oeuvre de Jean Bellegambe', *Gazette des Beaux-Arts*, 6th series, 87, 1976, pp. 7–28

GKW – *Gesamtkatalog der Wiegendrucke*, Leipzig, 1925–

Godenne 1957 – W. Godenne, 'Préliminaires à l'inventaire général des statuettes d'origine malinoise, présumées des XVe et XVIe siècles', *Handelingen van de Koninklijke Kring voor Oudheidkunde, Letteren en Kunst in Mechelen*, 61, 1957, pp. 47–127, pls. I–LVIII

Goodison 1930 – J. W. Goodison, 'Two wings of a Flemish triptych', *The Burlington Magazine*, 57, 1930, pp. 89–91

Goossens 1983 – J. Goossens, *Die Reynaert-Ikonographie*, Darmstadt, 1983

Grant 1969 – M. Grant, *Cambridge*, London, 1969

Green 1887 – E. Green, 'Remarks on the fifteenth-century diptych of Chevalier Philip Hinckaert, Chastelain de Tervueren, in Brabant', *Archaeologia*, 50, 1887, pp. 72–80.

Grössinger 1992 – C. Grössinger, *North-European panel paintings: a catalogue of Netherlandish and German paintings before 1600 in English churches and colleges*, London, 1992

Hamilton Palace 1882 – *The Hamilton Palace collection: illustrated priced catalogue*, London, 1882

Hand 1978 – J. O. Hand, 'Joos Van Cleve: the early and mature paintings', Ph.D. dissertation, Princeton University, 1978

Hand and Wolff 1986 – J. O. Hand and M. Wolff, *Early Netherlandish painting: the collections of the National Gallery of Art: systematic catalogue*, Washington, 1986

Hassall 1970 – W. Hassall, *The Holkham Library: illuminations and illustrations in the manuscript library of the Earl of Leicester*, Oxford, 1970

Hasse 1894 – C. Hasse, 'Roger von Brügge', *Kunststudien*, v. 8, Breslau, 1894, pp. 1–44

van Hasselt 1960 – C. van Hasselt, *Fitzwilliam Museum, Cambridge: exhibition of 15th and 16th century drawings*, Cambridge, 1960

Hellinga 1966 – L. and W. Hellinga, *The fifteenth-century printing types of the Low Countries*, Amsterdam, 1966

Hellinga 1976 – L. and W. Hellinga, 'Caxton in the Low Countries', *Journal of the Printing Historical Society*, 11, 1976/7, pp. 19–32

Hellinga 1991 – L. Hellinga, 'Importation of books printed on the Continent into England and Scotland before *c.* 1520', *Printing the written word: the social history of books circa 1450–1520*, ed. by S. Hindman, Ithaca, 1991

Hill 1930 – G. F. Hill, *A corpus of Italian medals of the Renaissance before Cellini*, London, 1930, 2 vols.

Hill and Pollard 1967 – G. F. Hill and J. G. Pollard, *Renaissance medals from the Samuel H. Kress collection at the National Gallery of Art*, London, 1967

Hindman 1977 – S. Hindman, 'The case of Simon Marmion: attributions and documents', *Zeitschrift für Kunstgeschichte*, 40, 1977, pp. 185–204

Hindman 1989 – S. Hindman, *Four miniatures by Simon Bening*, London, Hazlitt, Gooden and Fox, 1989

Hobson 1929 – G. Hobson, *Bindings in Cambridge libraries*, Cambridge, 1929

Hoffman 1969 – E. W. Hoffman, 'Simon Marmion Reconsidered', *Scriptorium*, 23(2), 1969, pp. 243–71

Hoffman 1973 – E. W. Hoffman, '"The Master of the altarpiece of St Bertin": a problem in attribution', *Scriptorium*, 27(2), 1973, pp. 263–90

Hollstein – F. Hollstein, *Dutch and Flemish etchings, engravings and woodcuts ca. 1450–1700*, Amsterdam, in progress

Houtte 1977 – J. A. van Houtte, *An Economic History of the Low Countries 800–1800*, London, 1977

Hughes 1984 – M. Hughes, 'Margaret of York, Duchess of Burgundy, diplomat, patroness, bibliophile, and benefactress', *The Private Library*, Spring 1984, pp. 3–78

Huizinga 1919 – J. Huizinga, *Herfsttij der Middeleeuwen*, Haarlem, 1919

d'Hulst 1953 – R.-A. d'Hulst, 'Le Maître de la Vue de Ste-Gudule et les retables de la Passion de Geel et de Strängnäs II', *Bruxelles au XVe siècle*, Brussels, 1953, pp. 133–53

Husband 1991 – T. B. Husband, *Stained glass before 1700 in American collections: silver-stained roundels and unipartite panels* (Studies in the history of art, Monograph series, 1), Washington, 1991

Indestege 1952 – L. Indestege, *Tboec vanden leven ons Heeren Iesu Christi (Gerard Leeu, Antwerpen 1487)*, Antwerp, Vereeniging der Antwerpsche Bibliophielen, 1952 (Tweede reeks, 3)

James 1895 – M. R. James, *A descriptive catalogue of the manuscripts in the Fitzwilliam Museum*, Cambridge 1895

James 1899 – M. R. James, *A descriptive catalogue of the manuscripts in the library of Peterhouse*, Cambridge, 1899

James 1900 – M. R. James, *The Western manuscripts in the library of Trinity College, Cambridge*, Cambridge, 1900

James 1907 – M. R. James, *A descriptive catalogue of the manuscripts in the library of Gonville and Caius College*, Cambridge, 1907

James 1912 – M. R. James, *A descriptive catalogue of the McClean collection of manuscripts in the Fitzwilliam Museum*, Cambridge, 1912

James 1913 – M. R. James, *A descriptive catalogue of the manuscripts in the library of St John's College, Cambridge*, Cambridge, 1913

Judson and van de Velde 1978 – J. R. Judson and C. Van de Velde, *Book illustrations and title-pages* (Corpus Rubenianum Ludwig Burchard, 21), 2 vols., London, 1978

Kerrich 1829 – T. Kerrich, *A catalogue of the prints which have been engraved after Martin Heemskerck*, Cambridge 1829

Key [n.d.] – W. Key: *Catalogue of paintings and drawings bequeathed to the University of Cambridge by the late Lord Viscount Fitzwilliam in the year 1816*, Cambridge, [n.d.]

De Keyser 1939(1) – P. De Keyser, 'Bijdrage tot de ikonografie van de Reinaert: de Reinaert houtsneden der "Cambridge Reinaert fragments", een werk van den "Haarlemsen Meester"', *Album philologum voor Th. Baader*, Nijmegen, 1939, pp. 209–24

De Keyser 1939(2) – P. De Keyser, 'A propos de l'iconographie du "Reinaert" au XVe siècle. Du "Dialogus creaturarum" 1480 au "Reinke de Vos" 1498', *Gutenberg Jahrbuch*, 1939, pp. 158–64

König 1991 – E. König, *Das goldene Zeitalter der burgundischen Buchmalerei 1430–1560. Leuchtendes Mittelalter 3. Katalog 27.* Rotthalmünster, Antiquariat Heribert Tenschert, 1991

Köster 1984 – K. Köster, 'Gemalte Kollektionen von Pilgerzeichen und religiösen Medaillen in flämischen Gebet- und Stundenbüchern des 15. und frühen 16. Jahrhundert', *Liber amicorum Herman Liebaers*, Brussels, 1984, pp. 485–535

Kren 1983 – T. Kren, 'Flemish manuscript illumination 1475–1550', *Renaissance painting in manuscripts*, London, 1983, pp. 2–85

Kren 1992 – T. Kren (ed.), *Margaret of York, Simon Marmion and the visions of Tondal*, Malibu, 1992

Kren and Rathofer 1988 – T. Kren and J. Rathofer, *Simon Bening: Flemish Calendar Clm 23638 Bayerische Staatsbibliothek, München*, Luzern, 1988

Kupfer-Tarasulo 1979 – M. Kupfer-Tarasulo, 'A Rosary Psalter illuminated by Simon Bening', *Quaerendo*, 9(3), 1979, pp. 209–26

Lane 1982 – B. Lane, 'The Genesis woodcuts of a Dutch adaptation of the Vita Christi', *The early illustrated book: essays in honor of Lessing J. Rosenwald*, Washington, 1982

Lehrs 1902 – M. Lehrs, 'Der Meister der Boccaccio-Bilder', *Jahrbuch der Königlich Preussischen Kunstsammlungen*, 23, 1902, pp. 124–41

Lehrs 1921 – M. Lehrs, *Geschichte und kritischer Katalog des deutschen, niederländischen und französischen Kupferstichs im XV. Jahrhundert*, Vienna, 1921, vol. 4

Leuven 1975 – *Dirk Bouts en zijn tijd*, Leuven, 1975

Levine 1989 – D. H. Levine, 'The Bruges Master of the St Ursula Legend re-considered', Ph.D. dissertation, Indiana University, Bloomington, 1989

Lieftinck 1969 – G. Lieftinck, *Boekverluchters uit de omgeving van Maria van Bourgondië c. 1475–1485*, Brussels, 1969

London 1892 – *Exhibition of pictures by masters of the Netherlandish and allied schools of XV and early XVI centuries*, London, Burlington Fine Arts Club, 1892

London 1927(1) – *Flemish and Belgian art 1300–1900*, London, Royal Academy of Arts, 1927

London 1927(2) – *Loan exhibition of Flemish and Belgian art: illustrated souvenir*, London, 1927

London 1927(3) – *Flemish and Belgian art (1300–1900)*, London, 1927

London 1935 – *Catalogue of the exhibition of early Flemish painting*, London, Tomás Harris Ltd, 1935

London 1936 – *Gothic art in Europe (c. 1200–1500)*, London, Burlington Fine Arts Club, 1936

London 1953 – *Drawings by old masters*, London, Royal Academy of Arts, 1953

London 1953–4 – *Flemish art 1300–1700*, London, Royal Academy of Arts, 1953–4

London 1959 – *Treasures of Cambridge*, London, Goldsmiths' Hall, 1959

Lyna 1927 – F. Lyna, *Le mortifiement de Vaine Plaisance de René d'Anjou; étude du texte et des manuscrits à peintures*, Brussels, 1927

McClure 1988 – I. McClure, 'The Training Programme', *Hamilton Kerr Institute Bulletin*, 1, 1988, pp. 9–11

Machiels 1973 – J. Machiels, *Arend de Keysere 1480–1490*, Ghent, 1973

McKitterick 1986 – D. J. McKitterick, *Cambridge University Library; a history: the eighteenth and nineteenth century*, Cambridge, 1986

Manuel 1939 – *Manuel de la conservation et de la restauration des peintures*, Paris, 1939

Marlier 1964 – G. Marlier, 'Le Maître de la Légende de Sainte Ursule', *Antwerpen Koninklijk Museum voor Schone Kunsten. Jaarboek*, 1964, pp. 5–42

Marrow 1984 – J. Marrow, 'Simon Bening in 1521: a group of dated miniatures', *Liber amicorum Herman Liebaers*, Brussels, 1984, pp. 537–59

Massing 1991 – J. M. Massing, 'Three panels by the Master of the View of Ste-Gudule in the Chapel of Queens' College, Cambridge', *The Burlington Magazine*, 133, 1991, pp. 690–93

Mauquoy-Hendrickx 1974 – M. Mauquoy-Hendrickx, 'Une dernière hypothèse (?) au sujet de l'Ecce Panis Angelorum du couvent de Béthanie (Malines) portant le millésime 1467', *De Gulden Passer*, 52, 1974, pp. 176–90

Meder 1919 – J. Meder, *Die Handzeichnung, ihre Technik und Entwicklung*, Vienna, 1919

Michel 1930 – E. Michel, 'Rogier Van der Weyden et le Maître de Flémalle', *Revue de l'Art Ancien et Moderne*, 57, 1930, pp. 267–76

Monasticon belge – *Monasticon Belge*, 1928–90

Moore 1988 – A. W. Moore, *Dutch and Flemish painting in Norfolk: a history of taste and influence, fashion and collecting*, London, 1988

Nørgaard 1963 – H. Nørgaard, 'Sankt Ovid, tekstligt og billedmaessigt om metamorfosernes forvandling', *Fund og Forskning i det Kongelige Biblioteks Samlinger*, 10, 1963, pp. 7–26, 163–64

Oates 1954 – J. C. T. Oates, *A catalogue of the fifteenth-century books in the University Library Cambridge*, Cambridge, 1954

Pächt 1947 – O. Pächt, *The Master of Mary of Burgundy*, London, 1947

Pächt and Thoss 1990 – O. Pächt and D. Thoss, *Die illuminierten Handschriften und Inkunabeln der Österreichischen Nationalbibliothek: Flämische Schule*, Vienna, 1983–90, 2 vols.

Panofsky 1969 – E. Panofsky, 'Erasmus and the visual arts', *Journal of the Warburg and Courtauld Institutes*, 32, 1969, pp. 200–27

Pearson 1887 – K. Pearson, *Die Fronika: ein Beitrag zur Geschichte des Christusbild im Mittelalter*, Strasburg, 1887

Périer-D'Ieteren 1984 – C. Périer-D'Ieteren, *Les volets peints de retables bruxellois conservés en Suède et le rayonnement de Colyn de Coter*, Stockholm, 1984

Pevsner 1954 – N. Pevsner, *Cambridgeshire* (The Buildings of England), Harmondsworth, 1954

Philadelphia 1941 – *John G. Johnson collection: catalogue of paintings*, Philadelphia, 1941

Philadelphia 1972 – *John G. Johnson collection: catalogue of the Flemish and Dutch paintings*, Philadelphia, 1972

Plaistowe 1910 – F. Plaistowe, *Early printed books to the year 1500 in the library of Queens' College, Cambridge*, Cambridge, 1910

Plotzek and Euw 1982 – J. Plotzek and A. von Euw, *Die Handschriften der Sammlung Ludwig*, Cologne, 1982

Plotzek 1987 – J. Plotzek, *Andachtsbücher des Mittelalters aus Privatbesitz*, Cologne, Schnütgen-Museum, 1987

Plumptre 1810 – A. Plumptre, *A Narrative of a Three Years' Residence in France*, London, 1810, 3 vols.

Pollard 1984 – J. G. Pollard, *Medaglie Italiane del Rinascimento nel Museo Nazionale del Bargello: I. 1400–1550*, Florence, 1984

de Poorter 1978 – N. de Poorter, *The Eucharist series* (Corpus Rubenianum Ludwig Burchard, 2), London, 1978

Popham 1932 – A. E. Popham, 'Robert Campin. St Catherine', *Old Master Drawings*, 6, 1932, p. 8, pl. 10

Van Praet 1829 – J. B. B. Van Praet, *Notice sur Colard Mansion*, Paris, 1829

Prevenier and Blockmans 1983 – W. Prevenier and W. Blockmans, *The Burgundian Netherlands*, Antwerp, 1983; English trans., Cambridge, 1986

Prien 1882 – F. Prien, 'Zur Vorgeschichte des Reinke Vos', *Beiträge zur Geschichte der Deutsche Sprache und Literatur*, 8(3), 1882, pp. 1–53, esp. 8–20

Principal pictures 1912 – *The principal pictures of the Fitzwilliam Museum, Cambridge*, London, 1912

Reissenberg 1886 – K. Reissenberg, 'Reinhart Fuchs', *Altdeutsche Textbibliothek*, 5, 1886, esp. pp. xii–xiv.

de Ricci 1932 – S. de Ricci, *A handlist of manuscripts in the library of the Earl of Leicester at Holkham Hall, abstracted from the catalogues of William Roscoe and Frederic Madden*, Oxford, 1932

Rietstap 1884–1954 – J. B. Rietstap, *Armorial général précédé d'un dictionnaire des termes du blason*, 2nd ed., Gouda etc., 1884–1954, vols. 1–2, 1–6 (plates), 1–7 (supplément)

Ringbom 1965 – S. Ringbom, *Icon to narrative: the rise of the dramatic close-up in fifteenth-century devotional painting*, Åbo, 1965

Robinson 1988 – P. R. Robinson, *Catalogue of dated and datable manuscripts c. 737–1600 in Cambridge libraries*, Bury St Edmunds, 1988

Rogers 1982 – N. Rogers, 'Books of Hours produced in the Low Countries for the English market in the fifteenth century', M.Litt. dissertation, University of Cambridge, 1982

Roosen-Runge 1981 – M. and H. Roosen-Runge, *Das spätgotische Musterbuch des Stephan Schriber in der Bayerischen Staatsbibliothek München*, Wiesbaden, 1981

Rouzet 1975 – A. Rouzet, *Dictionnaire des imprimeurs, libraires et éditeurs des XVe et XVIe siècles dans les limites géographiques de la Belgique actuelle*, The Hague, 1975

Royal Commission 1959 – Royal Commission on Historical Monuments, *An inventory of the historical monuments in the City of Cambridge*, London, 1959, 2 vols.

Sass 1970 – E. K. Sass, *Studier i Christiern II's ikonografi*, Copenhagen, 1970

Sayle 1916 – C. E. Sayle, *Catalogue of the early printed books bequeathed to the [Fitzwilliam] Museum by Frank McClean*, Cambridge, 1916

Scailliérez 1992 – C. Scailliérez, 'Entre enluminure et peinture: à propos d'un paysage avec St Jérôme pénitent de l'Ecole ganto-brugeoise récemment acquis par le Louvre', *Revue du Louvre*, 2, 1992, pp. 16–32

Scharf 1953 – A. Scharf, 'The exhibition of old master drawings at the Royal Academy', *The Burlington Magazine*, 95, 1953, pp. 351–6

Schöne 1938 – W. Schöne, *Dieric Bouts und seine Schule*, Berlin, 1938

Schretlen 1925 – M. Schretlen, *Dutch and Flemish woodcuts of the fifteenth century*, [n.pl.], 1925

Searle 1867 – W. Searle, *The history of the Queens' College of St Margaret and St Bernard in the University of Cambridge 1446–1569*, Cambridge, 1867

Smets 1975 – L. Smets, 'De invloed van de gravures uit Hartmann Schedel's Wereldkroniek op de miniatuurkunst: bijdrage tot de studie van de verluchte handschriften uit de librije van Rafaël Mercatel', *Bijdragen tot de geschiedenis van de grafische kunst opgedragen aan prof. dr. L. Lebeer*, Antwerp, 1975, pp. 292–306

Smeyers and Cardon 1990 – M. Smeyers and H. Cardon, 'Merktekens in de Brugse miniatuurkunst', *Merken opmerken: merk- en leestekens op de kunstwerken in de Zuidelijke Nederlanden en het prinsbisdom Luik; typologie en methode*, Leuven 1990, pp. 45–70

Sonkes 1969 – M. Sonkes, *Dessins du XVe siècle: groupe Van der Weyden*, (Les Primitifs flamands, 3; contributions à l'étude des Primitifs flamands, 5), Brussels, 1969

Sosson 1970 – J. P. Sosson, 'Les travaux publics de la ville de Bruges XIVe-XVe siècle: les matériaux, les hommes', *Collection Histoire Pro Civitate* [Octavo series], 48, 1970

Spufford 1970 – P. Spufford, *Monetary Problems and Policies in the Burgundian Netherlands 1433–96*, Leiden, 1970

Spufford 1983 – P. Spufford, 'The college pictures', *Queens' College Record*, Cambridge, 1983, p. 7

Strohm 1985 – R. Strohm, *Music in late medieval Bruges*, Oxford, 1985

Temple 1906 – A. G. Temple, *Illustrated catalogue of the exhibition of works by the Early Flemish painters*, London, 1906

Terlinden 1965 – C. Terlinden, *Charles Quint, Empereur des deux mondes*, Bruges, 1965

Testa 1986 – J. Testa, *The Beatty rosarium. A manuscript with miniatures by Simon Bening*, Doornspijk, 1986

Tolnay 1939 – C. de Tolnay, *Le Maître de Flémalle et les frères Van Eyck*, Brussels, 1939

Treasures [n.d.] – *Treasures of the Fitzwilliam Museum*, Cambridge, [n.d.]

Treasures 1989 – *Treasures from the Fitzwilliam Museum*, Cambridge, 1989

Trusted 1990 – M. Trusted, *German Renaissance medals: a catalogue of the collection in the Victoria and Albert Museum*, London, 1990

Tschudi 1898 – H. von Tschudi, 'Der Meister von Flémalle', *Jahrbuch der Königlich Preussischen Kunstsammlungen*, 19, 1898, pp. 8–34, 89–116

Urbach 1987 – S. Urbach, 'Research report on examination of underdrawings in some Early Netherlandish and German panels in the Budapest Museum of Fine Arts', in *Le dessin sous-jacent dans la peinture. Colloque VI*, Louvain-la-Neuve, 1987, pp. 45–61

Utrecht 1972–3 – *Naar de letter 5. Reinaert de Vos*, Utrecht, Instituut De Vooys, 1972–3

Uytven 1974 – R. van Uytven, 'What is new socially and economically in the sixteenth-century netherlands', *Acta historiae Neerlandicae*, 7, 1974

Valentiner 1913 – W. R. Valentiner, *Catalogue of a collection of paintings and some art objects: II (Flemish and Dutch paintings)*, Philadelphia, 1913

Van der Wee 1975 – H. Van der Wee, 'Structural changes and specialization in the Industry of the Southern Netherlands 1100–1600', *Economic History Review*, 2nd ser., xxviii, 1975

Varty 1980 – K. Varty, 'The earliest illustrated English editions of "Reynard the Fox"; and their links with the earliest illustrated continental editions', *Reynaert, Reynard, Reynke: Studien zu einem mittelalterlichen Tierepos*, ed. by J. Goossens and T. Sodmann, Cologne, 1980, pp. 160–95, esp. pp. 190–2

Vasari Society 1906–7 – *The Vasari Society for the Reproduction of Drawings by Old Masters*, 2, London, 1906–7

Vaughan 1970 – R. Vaughan, *Philip the Good*, London, 1970

Vaughan 1973 – R. Vaughan, *Charles the Bold*, London, 1973

Veronee-Verhaegen 1992 – N. Veronee-Verhaegen, 'A retrouver: un "Saint-Sébastien" par le Maître de Sainte-Gudule', *Bulletin Koninklijke Musea voor Schone Kunsten van België* 1988–91, pp. 175–85

Vertue 1938 – G. Vertue, 'Note Book V', *The Walpole Society*, 26, 1938

Walker Art Gallery 1963 – Liverpool, Walker Art Gallery, *Foreign Schools: catalogue*, Liverpool, 1963 (text), 1966 (plates)

Wayment 1972 – H. Wayment, *The windows of King's College Chapel, Cambridge* (Corpus vitrearum medii aevi, Great Britain, Suppl. 1), London, 1972

Wayment 1982 – H. Wayment, *King's College Chapel, Cambridge: the great windows. Introduction and guide*, Cambridge, 1982

Wayment 1988 – H. Wayment, *King's College Chapel, Cambridge: the side-chapel glass*, Cambridge, 1988

Wayment 1991 – H. Wayment, 'A collection of 17 pieces of stained glass', *National Art Collections Fund Review*, 1991, pp. 174–5

Weale 1872 – J. Weale, 'Documents inédits sur les enlumineurs de Bruges', *Le Beffroi*, 4, 1872, pp. 238–339

Weizsäcker 1900 – H. Weizsäcker, *Katalog der Gemälde-Galerie des Städelschen Kunstinstituts in Frankfurt am Main*, Frankfurt am Main, 1900

Wéra 1951 – M. Wéra, 'Contribution à l'étude d'Albert Bouts', *Revue Belge d'Archéologie et d'Histoire de l'Art*, 20, 1951, pp. 139–44

Wieck 1989 – R. Wieck, *Time sanctified: the Book of Hours in medieval art and life*, Baltimore, 1988

Wilensky 1960 – R. H. Wilensky, *Flemish painters, 1430–1830*, London, 1960, 2 vols.

Winkler 1913 – F. Winkler, *Der Meister von Flémalle und Rogier van der Weyden: Studien zu ihren Werken und zur Kunst ihrer Zeit mit mehreren Katalogen zu Rogier*, Strasburg, 1913

Winkler 1924 – F. Winkler, *Die altniederländische Malerei: die Malerei in Belgien und Holland von 1400–1600*, Berlin, 1924

Winkler 1925 – F. Winkler, *Flämische Buchmalerei des XV. und XVI. Jahrhunderts: Künstler und Werke von den Brüder Van Eyck bis zu Simon Bening*, Leipzig, 1925

Winston-Salem 1963 – *Collectors' opportunity*, Winston-Salem, N.C., Gallery of the Public Library of Winston-Salem and Forsyth County 22.4.–3.5.1963

Winter 1950 – C. Winter, *Treasures in Cambridge*, London, 1950

Winter 1958 – C. Winter, *The Fitzwilliam Museum: an illustrated survey*, London, 1958

de Winter 1985 – P. de Winter, *La bibliothèque de Philippe le Hardi, Duc de Bourgogne (1364–1404): étude sur les manuscrits à peintures d'une collection princière à l'époque du 'style gothique international'*, Paris, 1985

Witte 1894–9 – A. de Witte, *Histoire monétaire des comtes de Louvain, ducs de Brabant et marquis du Saint Empire romain*, Antwerp, 1894–9, 3 vols.

Witten 1983 – *A mirror of manuscripts – speculum manuscriptorum*, Southport (Conn.), Laurence Witten Rare Books, 1983, catalogue 18

Witton 1980 – N. Witton, 'Die Filiation der frühesten Handschriften und Drucke der Reinaert II-Gruppe', in *Reynaert, Reynard, Reynke: Studien zu einem mittelalterlichen Tierepos*, ed. by J. Goossens and T. Sodmann, Cologne, 1980, pp. 1–159

Wolf 1982 – H. Wolf, *Die Meister des Breviarium Grimani*, Berlin, 1982

Wormald and Giles 1982 – F. Wormald and P. M. Giles, *A descriptive catalogue of the additional manuscripts in the Fitzwilliam Museum acquired between 1895 and 1979 (excluding the McClean collection)*, Cambridge, 1982, 2 vols.

Wright 1976 – C. Wright, *Old master paintings in Britain*, London, 1976

INDEX OF NAMES, PLACES, MANUSCRIPTS AND INCUNABLES